Teaching Photography

Big Sur Bridge; by Pat Stanbro, Brooks Institute of Photography, CA, student of Christopher Broughton

Teaching Photography

Tools for the Imaging Educator

Glenn M. Rand
Brooks Institute of Photography

Richard D. Zakia
Professor Emeritus
Rochester Institute of Technology

ELSEVIER

AMSTERDAM • BOSTON • HEIDELBERG • LONDON
NEW YORK • OXFORD • PARIS • SAN DIEGO
SAN FRANCISCO • SINGAPORE • SYDNEY • TOKYO

Focal Press is an imprint of Elsevier

Cover photograph: *Untitled; 2000 by Don Holtz, Lansing Community College, MI, student of Glenn Rand*

Acquisitions Editor: Diane Heppner
Project Manager: Paul Gottehrer
Assistant Editor: Cara Anderson
Marketing Manager: Christine Degon Veroulis
Cover Design: Cate Barr
Interior Design: Julio Esperas

Focal Press is an imprint of Elsevier
30 Corporate Drive, Suite 400, Burlington, MA 01803, USA
Linacre House, Jordan Hill, Oxford OX2 8DP, UK

♾ Recognizing the importance of preserving what has been written, Elsevier prints its books on acid-free paper whenever possible.

Library of Congress Cataloging-in-Publication Data
Application submitted.

British Library Cataloguing-in-Publication Data
A catalogue record for this book is available from the British Library.

ISBN 13: 978-0-240-80767-6
ISBN 10: 0-240-80767-7

For information on all Focal Press publications
visit our website at www.books.elsevier.com

06 07 08 09 10 11 10 9 8 7 6 5 4 3 2 1
Printed in the United States of America

To our teachers, colleagues and students...our past, our present, the future.

And to the photographic educators who met in 1962 to discuss this emerging discipline. The meeting took place at the Eastman House and was organized by Nathan Lyons. Participants included: Charles A. Arnold, Jr., Oscar Bailey, Walter Civardi, Robert Forth, Bill Hanson, Ken Josephson, Jerome Liebling, Sol Mednick, C. B. Neblette, Beaumont Newhall, Walter Rosenblum, John H. Schulze, Art Sinsabaugh, Aaron Siskind, Henry Holmes Smith, John Szarkowski, Adrian L. Terlouw, Jerry N. Uelsmann, Clarence H. White, and Minor White.

Contents

1

2

3

Asking Questions: Turning Inquiry into Knowledge 33

4

Technique Education...Tools 49

5

Creativity Education 71

6

Understanding the Nature of Problems, Solutions, and Assignments 95

7

Critique...Advancing Learning with Words 123

8

Measuring Education...Tests, Grades, and Evaluations 145

X

9

Evaluating Education 169

10

The Environment 191

11

Planning and Changing 221

14

Teachers on Teaching 293

Appendix

Example Assignments 325

XV

By Mary Virginia Swanson, as a student at Arizona State University, AZ

Foreword

Influence and Inspiration

The photography community is rich with imagination, inspiration, and artistry. Our friends, colleagues, and community share an enthusiasm for creativity. The medium of photography is the means whereby we express these qualities. At our best we have the power to encourage, inspire, and inform others. In our role as teachers, we can nourish ideas in the classrooms, assist our students with clarity of vision and purpose, and share our passion for our medium and field.

As a young student unsure of whether my creative calling in photography would be as a photographer, a photographic historian, or one who worked in some capacity with photographers and their images, I discovered that surrounding myself with new ideas created a range of opportunities and challenging adventures, all of which contributed to the personal and professional individual I am. I believe we must offer students an educational environment with a diversity of techniques, variety of opinions, and a wealth of resources, including libraries abundant with books and periodicals, open access to the world wide web, the voices of professionals active in all aspects of creative life, and opportunities for interaction and the interchange of ideas. We owe it to our students and the photographic community to provide the most extensive range of inspiration for their enrichment and advancement.

The essence of teaching, and the purpose of this book, is to help the teacher in guiding individuals toward finding their creative voice, and reaching the inspiration and motivation to progress in their work.

We must also help our students to define and deliver their work to a broader audience.

As I reflect back on what I have learned about photography and how I have applied it to my life and teaching, many individuals contributed to shaping my professional aspirations and voice. I urge you to bring similar influences to your students.

My professors at Arizona State University, where I completed my BFA (Ceramics) and my MFA (Photography), were important early influences.

My teaching was influenced by Barbara Jo Revelle's Introduction to Photography class, a free-for-all: cut, paste, paint, layer—whatever you wanted to do with your photograph was acceptable. By removing self-imposed constraints and the "precious" nature of this new art form, students were encouraged to experiment with the medium from day one. Creativity first, command of craft followed. One's imagination was free to run wild.

Bill Jay's inspired teaching put history, not just the history of photography, into perspective. The invention of photography occurred when innovation in many sectors were ripe for discovery. Bill helped his students understand how their chosen medium was informed by many creative expressions—that scientific invention, music, literature, design, and performance all contribute to creating our collective cultural voice. Placing content in context is indispensable to interpretation, innovation, and a creative life. Exploring cultural history is imperative in any course of study.

James Hajicek encouraged me to explore my interests in working with other artists, editing/sequencing and mounting exhibitions, promoting inquiry and curiosity about our field. I consider it one of our responsibilities as educators to advise students of the path to effectively bring one's work to those most likely to appreciate and be moved by it. Take your teaching beyond the making of art to *sharing* art, working together to identify an admiring and appreciative audience. An expanded community returns dialogue, confidence, and ultimately, creativity to every artist.

Lastly, Ansel. All of us who had the pleasure of working with Ansel Adams observed his gift for influencing, inspiring, encouraging, and celebrating creativity in aspiring photographers, no matter what their level of work, expertise, and accomplishment.

In his autobiography, Ansel spoke to this challenge in the opening paragraphs of Chapter 20, "Teaching" from his autobiography:

"Recently, a young photographer brought his portfolio to me and asked for my comments. It was immediately apparent that he was attempting serious work. A few of his images were quite fine; all were refreshing because he was trying to establish a personal vision, to "see." Unfortunately, his craft varied in quality, and he often used two octaves of tonal value for six octaves of potential expression."[1]

How could I communicate my thoughts to this young man without in any way dulling the bright edge of his enthusiasm? I refused to give insincere approval or captious disapproval. I attempted a rational discussion with the photographer on the problems and dedication involved, because I feel obligated to be frank. A critique is an evaluation of shades and levels of capability. What if Alfred Stieglitz in 1933 had dismissed my work with a shrug? It is easy to say that if I believe in myself I would not be swayed by the opinion of others. But the right word at the right time can have immense significance, and thus I explained to the young artist the excitement I felt in his attempt as well as the challenges ahead for him.

Our responsibility as teachers and mentors is a serious one, particularly for students who demonstrate sincere interest in professional growth and who seek tutelage. I am fortunate to have been mentored by respected members of our industry, and in turn, to mentor emerging professionals. Carroll T. Hartwell, Curator of Photography, The Minneapolis Institute of Arts, and later Janet Borden, then Director of the Robert Freidus Gallery in NYC, both helped me understand the full arc of an artist's career, and the important role curators and gallerists play within this cycle. I strive to provide my interns and students with a professional, well-rounded orientation to our profession and the important roles they can perform as they mature. I urge everyone to bring a sincere commitment to your function in education, remembering those who helped you learn and grow through your life. If an internship program placing your students with professionals does not exist, establish one. Whether they ultimately make their living with cameras or with photographs, this window on professional life in our field will serve your students and program well.

I first began to acquaint myself with our larger photographic community through volunteering at regional and national meetings of the

[1] *Ansel Adams: An Autobiography*, by Ansel Adams and Mary Street Alinder, New York Graphic Society ©1985, excerpt from first edition clothbound edition page 309; Little, Brown and Company, first edition paperback edition 1996, fourth printing, page 262.

Society for Photographic Education, with which I continue to participate today. My colleagues and I explain to student volunteers that they will evolve into our rich field of future artists, curators, photo editors, authors, publishers, teachers, and others who will move our field forward.

The tools our students utilize today to explore, communicate, and create are astonishing, and will unquestionably lead to a greater understanding of the global community than we can imagine. All will find their place among their peer group, and the roles they will play will contribute to the rich tapestry of the photography industry. Encourage your students to explore a wide range of professional roles; you will never know just what will ignite their energy and attention, and advance them forward.

- **Influence**: Somebody or something able to affect the course of events or somebody's thinking or action.
- **Inspire**: To encourage people into greater efforts or greater enthusiasm or creativity.

Within *Teaching Photography: Tools for the Imaging Educator*, the authors, the many contributors, and their students have provided you with much to consider and apply to your teaching, and to your creative life. Thoughtful, inspirational reading lies ahead.

Mary Virginia Swanson
January 2006

Introduction

Teaching is a noble profession and we are blessed to be part of it.

This book approaches the collaborative nature of learning. In highlighting the way learning is assisted by teaching, we note that the actualization of this book was made possible by the support and efforts of many individuals. Most important has been the support of those closest to us. It is the continuing commitment from our lifelong mates, Sally and Lois, that provides us with the ongoing support required for our efforts. Their understanding of the demands and requirements continues to enable our sharing our ideas with you and others who will use these writings.

The way this book was envisioned included the voices of many beyond our own. We asked our friends and their friends to contribute to expand the view of teaching photography. Many of those who submitted contributions were unknown to us prior to our starting this project, but have earned our thanks and respect, both for their submissions of writing and their students' images and for taking part in interviews. To access many we used the outreach of the Society for Photographic Education and the Photographic/Imaging Education Association, which expanded our personal contact lists. Particularly we wish to thank Mary Virginia Swanson for the foreword she contributed for the book.

Part of the endeavor would not have been possible without the efforts of Diane Heppner, our editor, along with the assistance of Paul Gottehrer our production editor and the other diligent staff of Focal Press.

Finally, we wish to thank you for choosing to pursue teaching photography and selecting this book to assist you in your quest.

GR/RZ

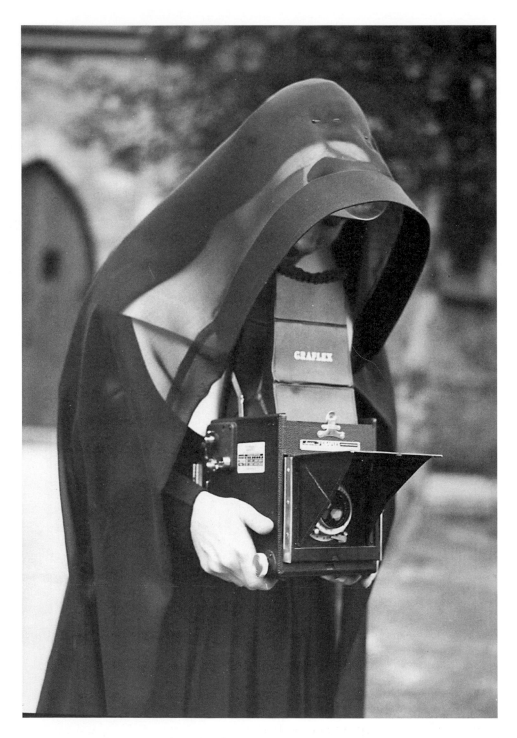

Sister Mary Margaret; 1952, by Richard Zakia, Rochester Institute of Technology, NY, student of Leslie Stroebel

"Hey Teach...": Two Histories of Changing Direction and Mindset

"You cannot teach a man anything; you can only help him find it within himself."

Galileo Galilei

From Richard D. Zakia

Some of us enter teaching through the front door and others, like myself, through the back door. I had never entertained the desire to become a teacher but feel fortunate and blessed for having spent 34 years working with students and assisting them in their learning. My interest in teaching was fostered by teachers who I have had, particularly my college teachers. I find it interesting to journey back and visit those years as a student and recall the influences some teachers have had on me.

After discharge from the Navy in 1946, and then again from the reserves in 1952, I applied to the University of Rochester. During my interview, the admissions officer looked at my high school record and bluntly told me that I was not college material. Disappointed and discouraged but not defeated, I decided to try the Rochester Institute of Technology (RIT). I had the good fortune of meeting with the Director of the Photography Department, a warm and benevolent man who was willing to accept me on probation.

It was as a student at RIT that my latent interest in teaching began to surface. Credit must be given to the faculty at that time and to the

school's student-friendly environment. My teachers, I discovered, had different personalities and each had a different approach to teaching, but all seem to have the student's interest at heart. Ken Bain, in his book *What the Best College Teachers Do*, writes that contrary to popular beliefs, a teacher's personality plays little to no role in his or her effectiveness as a teacher. I certainly found this to be true in my experiences as a student.

Here is a brief profile (alphabetical) of each of my teachers; they not only motivated me to learn but also to become interested in teaching, although I did not realize it at the time:

Ralph Hattersley—A person who was laid back, constantly searching and questioning photography and life, and posing thought-provoking questions to students.

C.B. Neblette—A somewhat shy Virginia gentleman, Neblette was the Director of the school and also taught a course in the History of Photography from a technical point of view. He was an outstanding and innovative administrator. With the faculty's approval, he had the students elect their own representative to attend all faculty meetings. This made me realize that students were indeed an integral part of the learning process and should have a voice. I was fortunate enough to have been a representative for a year.

Beaumont Newhall—A quiet, thoughtful person and a scholar who projected a deep love for the history of photography and for photography as an art form.

Al Rickmers—He taught statistics, something in which students were not the least bit interested. What did it have to do with photography? Rickmers realized the lack of interest and would spend the first class session on selling the idea of how relevant it was, not just to photography but also to life.

Bill Shoemaker—A roly-poly, jolly teacher who often used interesting metaphors to lessen the pain of having to learn chemistry.

Les Stroebel—Taught how to be well prepared for class and for labs, and how to design test questions that are valid and fair and to grade accordingly.

Hollis Todd—He projected confidence as a teacher and would encourage students to ask questions in class. Once a student challenged what he had written on the blackboard, which surprised the entire class, since we were only freshman. Todd looked at what he had written, then turned around and, looking straight at the student, said, "You are right, I was wrong." To this day, I have never heard a teacher honestly admit such a thing in

4

a classroom. Another experience I shall never forget is my great difficulty with Analytical Geometry. I was really struggling to get a C grade on the final, which would have taken me off probation. I knew I did poorly on the final test and expected a D grade at best. Todd seemed to be aware of my concern and that I had really been struggling in the course and giving it my best. To my delight and surprise, he gave me a C-minus instead of the D that I probably deserved. From this I learned that if you have to make a tough decision and might err, err in favor the student.

Minor White—A soft-spoken gentleman, a fine art photographer, author, poet, and publisher of *Aperture*. I learned how to spend time looking at and carefully studying photographs and sequencing them, opening up to the other arts, including dance and Eastern ways of thinking.

A common thread with all these teachers was an openness to teaching, learning, and inquiry. If a student wanted to present some relevant material to the class, he or she was encouraged and invited to do so. On several occasions I did just that, and looking back at this, I now realize my latent interest in teaching was fermenting.

After graduating with a BS in Photographic Science, I worked at Kodak for a few years in what was then called the Color Technology Division. It was a peach of a job, a great place to work, and carried many benefits. However, something was missing. I soon realized I was more interested in teaching than I had thought.

In 1958 I was invited to join the Department of Photography at RIT, now called the School of Photographic Arts and Science. In my first year of teaching, Hollis Todd was my mentor and he was most helpful. After a few months of teaching, I felt that something was not right and began to question my teaching. I soon realized that I had been so influenced by my mentor that I was unknowingly trying to emulate him. It wasn't working. One has to be true to oneself. (A similar problem occurred with some of Minor White's students. When they graduated and went on to do their own work, their photographs looked much like Minor's.)

In my second year of teaching, I found myself continually questioning my role in the classroom. What was my function as a teacher? How do students learn? What is the purpose of testing and what are we measuring? Such questioning led me to search for answers in a graduate program in education psychology at the University of Rochester. Ironically, I received my doctorate from the school that had first rejected me.

5

Purdue Union; 1963, by Glenn Rand, Purdue University, IN, student of Vernon Cheek

From Glenn M. Rand

It was a pivotal moment in my travels through education. I was teaching in a small college in the mountains of Virginia and had been transplanted from teaching for six years in a Big Ten university. After being in my job for a month, a student approached me and cut to the heart of what my profession was to become.

In a conversation about why we were at the college the student stated, "Hey Teach, learn me." There was no answer, just a moment that the whole process became clear. He was there to learn and my role would be to assist him in that quest. Before that point the word "teach" was an active verb, but the student put it into its proper place, as a noun. Teach was a role, not an activity, and certainly not the outcome.

Prior to this point of clarity my direction was to be a "teacher." That meant that the teaching was an end point. Teaching represented a goal, employment, and a purpose. It far surpassed the concepts involved in the education of the students. The outcome of teaching was education for others, and, of course, education would necessarily happen if the teaching were strong. The teaching method would override anything else in the situation. The need for education in that form was a well thought out process of presentations, materials, and methods. It had been an issue of finding the most successful way of presenting the content of the courses assigned to me. Thus preparation and presentation were the primary sources of teaching, and this misconception is widespread in all education today. As a colleague erroneously told me many years later, he "needed only two weeks head start on the students and he could teach anything."

Then the statement..."Hey Teach, learn me": Presentations, materials, and methods no longer sufficed to evaluate the educational process, and actually were very far behind the real measure, students' learning. Though I might be involved in the students' learning, I would not be able to accomplish learning by any student by myself, regardless of my talent as a teacher.

When "Teach" became a noun in the process, it was obvious that my role in education—as a valve, through which learning was poured into the students during the activity of teaching—stopped, and changed to a support role, in which learning was a process that the students would pursue. Like a shot, the critical issue was no longer only how well the materials were presented nor the content. It became instead a search for what would be learned. Now the success of what I was doing

7

depended critically on others' outcomes compared to their goals, not on my activities alone.

At that point I had an unusual benefit to finding a new paradigm for learning and teaching that never seemed an advantage before. Having been diagnosed with a learning disability early in life, my increase in knowledge required the circumvention of traditional education. Particularly, it not only depended on classroom teaching but also on figuring out how to learn. For years, I used others to "learn me." Many taught to me, and while their efforts may not have infused me with knowledge, some helped me learn.

The issue became realizing that learning happens for individuals in different ways, not based on a cookie cutter approach that uses the same tool for each student, for learning is a desire that has many paths expressed by many people. The goal is not to follow someone else's path, their teaching, but to use any good path or a number of paths that get you to an individual goal. Success is not following solely pre-determined curricula or outlines, but the desire to learn needs to be turned into the kernel that grows into knowing…the valuable thing in education is learning, not teaching.

In this light, education as a profession becomes a means of encouraging and inspiring others to see. Inspiration alone can lead to seeking out other routes to learning, and the role of "Teach" is to provide those inputs and methods that can create learning, not to look at the method being taught as the only way to show learning. The challenge is in taking any eagerness the individual presents and then looking for ways to turn the energy created by the inspiration into methods for learning. Our methods are only tools and we must understand that just as at times, in photography, we use a reflective meter, there are other times that incident metering will do a better job—this is also a strategy for our roles in the learning of others. Clearly, some methods work for some individuals while others do not. To assist our students we need to change the way we look at teaching and the many technologies we use to teach. Each is a path that some will find helpful, but none fits all.

In photography, just as technology is a tool for making images, teaching is the tool for learning. Some tools are better for some than others. Our job is to assist the learners by making available various learning opportunities to our students.

8

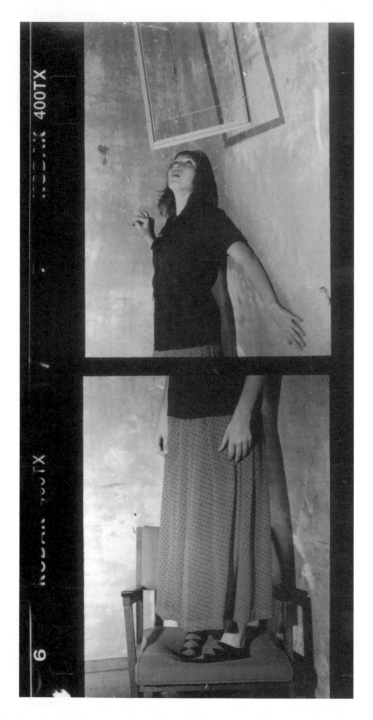

By Kristina Budels, Princeton Day School, NJ, student of Elaine Hohmath-Lemonick

Learning, Knowing, Owning

"It's a very ancient saying,
But a true and honest thought,
That if you become a teacher,
By your pupils you'll be taught."

Oscar Hammerstein, from *The King and I*

There are three separate stages of mastery of any skill or knowledge set. In photography this is particularly apparent. When we look at the range of photographers from the first introduced novice to the master we can observe these three levels in action. With making a non-metered exposure on an overcast day the novice will ask or look up how to calculate the exposure, and as they progress they will go through this path less and less. At a point they will no longer need to look it up: they will rely on their memory of an exposure chart that told them the exposure. When the photographer has internalized non-metered exposure they react to the light condition by just setting the exposure controls. Those who have internalized this skill do not look up or refer to a memory of what they have looked up—they simply apply the correct camera setting.

Another way of viewing these three levels can be seen when learning a second language. First, as the vocabulary is learned, a dictionary is used to translate and understand meaning. With knowing, the vocabulary has been memorized and recognizing the second language word involves extracting the mental meaning translated from the conversation. Thoughts are likewise constructed in the first language and then mentally changed into the second language for transmission.

With owning, there is no first or second language. You converse and get meaning in either the first or second language, and the thoughts and meanings exist without translation. Owning in photography is working in the language and meaning and methods of photography without translation or transliteration.

"1. Teaching is never just a system or technique.
2. Teaching is not teaching but rather working with.
3. Have an honest love to teach and share, and a commitment to values.
4. Be brave, assume everything is legitimate.
5. Be more a searcher than a finder.
6. I wear pink glasses—I am highly optimistic.
7. Every success can pollute.
8. Provide a wide range of freedom to create.
9. You must push a person away from his competence."

Gyorgy Kepes
Massachusetts Institute of Technology, MA

12

Learning

First you learn. Learning is a journey, not a point of reference. Learning starts with an introduction to material, ideas, or concepts. Depending on the complexity of the learning task, the abilities of the learner, and the resources provided, the journey would take various numbers of steps and varying time.

Learning has been defined as an activity that produces a meaningful change in behavior. This means that learning is active, not passive. It does not happen through osmosis. There have been numbers of studies and a sizeable amount of research into how this journey progresses. While divisions of learning range from three to eight major types of learning, they all have similar ideas within them.

There are many maps to how learning happens. These commonly include learning from perceptions, relationships, conditioning, motor activities, episodic situations, problem solving, and emotional under-standings. While these aspects of learning photography are separated for discussion, it needs to be realized that for the most part several are active at any one place in the process.

"We think too much about effective methods of teaching and not enough about effective methods of learning."

John Carolus, S.J.

Perhaps the most noted map is Bloom's Taxonomy, which defines three domains of learning—cognitive, affective, and psychomotor. In Bloom's these are further divided for a more complete picture of how learning happens. For this model of the learning activity, cognitive learning involves learning mentally, in areas of "knowledge." This is an intellectual set of learning, including building mental data, the comprehension and application of the data, analysis, synthesis, and evaluation. Bloom's second area is affective or emotional learning. This second area includes valuation and organization of values and perceptions. Last in Bloom's domain structure are psychomotor learning activities. These include awareness, readiness, reaction, and response learning from simple to complex, adaptation, and orientation.

"I think all of Bloom's applies to teaching photography. Give the students experiences in all domains and realms. You need to use not only the cognitive domain and the affective domain but also the psychomotor domain. It is a natural progression, it is the way we think."

Art Rosser
Clayton State College and University, GA

13

To better view this taxonomy we can look at how various aspects of imaging education are described within the various learning domains. Within the cognitive domain, that defines gaining knowledge and facts. Materials in areas such as photographic history and the science of imaging that are learned to support the other domains and producing photographs are easily seen as part of the cognitive domain. The cognitive materials are not learned simply to possess knowledge, but as the underpinning for producing photographs or as support knowledge for function associated with other domains. It is sometimes easier to discuss areas of the cognitive domain in the aspects of teaching because they can be viewed methodologically within the traditionally defined education.

While the cognitive domain is about gaining knowledge, learning in the affective domain can be seen as being about learning about how to appreciate the world around us. Areas within the affective domain such as aesthetics and interpretation of photographs use items gained in the cognitive domain to support this domain's learning. This domain defines how we perceive, value, and organize photographs.

"Young children, as artists, have not yet been taught how not to see."

Sally Rand
Lansing Community College, MI

14

Finally, of the three domains, there is the psychomotor. This is learning how to actually make your human system make photographs, e.g., learning to follow the action in an athletic event to be able to capture the critical moment. The learning in this domain is the most physically active. Beyond the kinesthetic assumption there is a strong perceptual portion of this domain. This is learning to use the sensory system to coordinate activities that will end in a successful photograph.

Bloom's is not the only approach we can use to view learning in photography. A more recent approach by Howard Gardner, professor of education at Harvard, reminds us that students do not learn, remember, perform, and understand the same way. He postulates that there are multiple intelligences and identifies these seven: Linguistic, Logical-mathematical, Spatial, Musical, Bodily-kinesthetic, Interpersonal, Intrapersonal. On this basis, one would expect a student with logical-mathematical multiple intelligences to do well in a technical photography program, whereas a student with a spatial and musical intelligence should do well in a fine art photography program. One could speculate that effective teachers and chairpersons have high intrapersonal multiple intelligences. An advisor or counselor would do well with a high interpersonal intelligence. A dancer, to be successful, would need to possess a bodily-kinesthetic intelligence.

Regardless of the way we break up the way learning propels knowledge and understanding we can see that learning is a concept that differing types of learning will be easier for some than others. Many aspects of learning photography can fit into more than one of these learning styles. Therein lies the strength of coming to helping others learn photography with differing approaches. What works for some will be less effective for others, but there are other avenues to assist the learners.

"There are as many different learning styles as there are teaching styles. The challenge for a teacher is to be constantly aware of this and work to assist each student in his way of learning."

Anonymous

Of the many aspects of photography that follow through from the earliest to the most advanced is exposure. Early in the learning the learning will be memorization, episodic learning, and the building and application of mental data. As the learning progresses it will move to learning in areas of perceptual awareness, analysis, and evaluation. When the learner moves to the concepts of the zone system and measured

photography the problem solving uses most of the aspects of the cognitive domain. As the learner moves beyond the technical aspects of exposure, they will move into more of the affective domain. The learners will start to learn the emotional and value aspects of photography. Then, when the learner internalizes exposure ideas and concept steps, on their travel they move between all the learning domains. This is also true with the other major areas of photographic capture and processes.

Exposure is more in the cognitive domain than in the other two domains. Many activities in photography rely more on the other two domains, particularly with advanced ideas moving the learner into affective learning. Learning to critique must start in the affective domain in learning, to see and value one's own and others' pictures.

Psychomotor learning is involved in the capture of a photograph. First one must develop an awareness of what is to be photographed and how best to capture what is being experienced. One could think of this as visualization, the first and perhaps the most important stage in creating a photograph for the serious photographer. Then comes the positioning of one's self and camera, and the readiness to click the shutter at the right moment.

One of the assignments that Minor White would give his students verges on the psychomotor type of learning. A student walks around in a particular environment looking for something to photograph. When he becomes aware of what he wants to capture, he sits quietly with camera in hand and eyes closed, thinking about what is in front of him. At some point in his thoughtfulness, he slowly opens his eyes, beholds what he sees, and photographs it.

15

"Learning is a process, removing the care about making mistakes, enables the students to explore and attempt new things."

Betty Lark-Ross
Chicago Latin School, IL

Starting Learning

Regardless of what area of photography education or training, the learning is a set of steps along a path to success. This is the key to understanding how to better affect the learner. Though the path may be easiest seen in one domain or style of learning, there are other ways to assist the journey to the final goal. In Eastern thought it is said, "One destination, many paths."

An issue of the learning journey is, how do you get the first step to happen? To answer this question photographer/teacher John Sexton relates, "The single most important thing Ansel [Adams] shared with me was an excitement for photography. By inspiring me he made learning photography automatic; he created a sponge for learning photography. He turned on the switch with excitement, then he provided the information needed to succeed." In John's words, "The teacher has to be there to create an interest and then be there with technical support."

We are not Ansel Adams but still need to turn the switch on for those who have come to us to learn. The ways we find to inspire our students will go a long way to start the learning journey with vigor. Examples of what can be done, a history of previous successes, is one way. Depending on the success of previous learners, this will be effective to activate learning.

One of our colleagues who taught statistics to photo students discovered on his first class session that the students felt no need to learn statistics and had little interest in the subject other than it was a required course. To remedy the apathy, he spent the next two sessions, not in teaching statistics, but rather on "selling" them on the importance of statistics, not just to photography but to their whole way of thinking. Once they bought into this, the path to learning was cleared.

A particularly good way to encourage is to show work beyond expectations. This gives exciting goals for learning. This tends to be very effective in intermediate learning situations. If there is very strong work from learners at the same level as those starting this step in learning, that can be shown in connection with high-level examples reinforcing the goal of the learning. Comparing learners' excellent work with established photographers provides positive examples. When others see that someone at their level has made exceptional work that is compared to high-level work, they can transfer their own goals to that of comparing favorably.

While the level of learning shown in the assembled photographs may be beyond the reach of the learners, encouraging trying to attain the level shown provides the confidence that will be required of them to reach their goals. It is as important to encourage as it is to present information and methods. The earlier in the learning process, the more importance the encouragement will be in turning on the switch.

As an example, assemble a group of visually exciting work including the best historical work from an individual at the level of learning desired. It is quite common that early learners in photography will make astounding images that will compare well even with work of established photographers. After presenting the group of images to the learners, challenge them to find the "learner's" image. If the historical image is strong it may be difficult for others to correctly discern the work at their level of learning. When this happens the new learners transfer their perception of their status as photographers to a higher level. A major switch was just turned on.

Regardless if the difference between the "learner's" image and the established photographers' images is found, there are benefits to this approach. When the new learners are asked to define the reasons for their choices or the qualities that formed their decision, they internalize the steps they will need to accomplish to attain the goal level of learning.

The caveat for the learning journey is that it is very dependent on the level of the learner. This leveling is both biological and experiential. Approaching issues before the learner is ready or prepared is counterproductive. For the most part, photography is a vertical learning paradigm going from one related and interconnected subject to the next. The sequential nature of photographic learning reinforces the concept of the learning journey. As the learner progresses they do not stop using previous learning but continue it on to succeeding steps of process or information.

17

"Certain subjects yield a general power that may be applied in any direction and should be studied by all."

John Locke

When Ralph Hattersley was teaching at RIT, one of his former students had landed a position in Hollywood creating glamour photographs of movie stars. Ralph asked him to send some of the photographs he had taken for the students to look at, and he did. Hattersley placed the photographs on a display panel in the classroom and had the students study the photographs for a time. After about 20 minutes of looking and talking among themselves, he asked them to comment on the photographs. They all had high praise for the work. When they finished praising the work, Hattersley shocked them by pointing out a number of ways the photographs could have been improved. The

students were stunned and will long remember not to be taken in by glamour when assessing the quality of a photograph.

Photographic learning also has levels of mathematics and science embedded in most areas. Because of these interrelationships of subjects and expanding technical levels, sequencing of learning is important. Part of the learning may need to be simple math and science.

"'Reinventing the wheel' is more than a cliché. It is a process...a learning process."

Lois Arlidge-Zakia
University of Rochester, NY

18

Because of the linear nature of the photography process, there is a need for the learner to become aware and internalize the way the parts fit together. This includes more than simply understanding that there are interrelated parts of photography. To make the most out of the learning, the algorithm of the photographic process must become part of the learning path. Therefore, like much of math and science, the way this system relates its parts is as important as the information that makes up the steps. Or, as has been said in Gestalt Philosophy, the whole is greater than the sum of its parts.

When we look at the various levels of education in photography we see that these facets of the way the learning is structured means that effectively helping others learn entails being aware of "age-appropriate learning" for younger learners. While this book does not deal with the developmental stages in learning, it is clear that the human brain develops and that certain aspects that will be learned in photography will have to wait for the physiological development of the learner to reach a level where certain concepts can be learned. This is true for both technical and aesthetic aspects of photography.

Learning Objectives

Particularly with the linear steps of photographic learning, objectives are useful. A learning objective is exactly that, the measurable end point of a part of the learning or learning sequence. By conceiving of what the learner will be able to demonstrate because of the learning activity, the measurement of learning is not what was taught but rather the outcome of the teaching. For many situations these are required for institutional

measures. This means that the learning can be "objectified" and made measurable against stated learning outcomes.

Learning objectives have over the years taken on aspects that are useful. First objectives need to be shared with the learner. This prepares the learner for reasonable expectations of the learning. By having an expectation of what they will gain in the learning process, the learner can be aware of their progress toward the learning objective.

"If you do not know to which port you are sailing, no wind is favorable."

Lucius Annaeus Seneca

Next, objectives are written in an active voice based in the outcome demonstration. The active voice allows the learner to understand what will be learned and the measurement or standard that will be used to judge learning. Specific language better communicates this concept of outcome-based objective. Descriptors such as *demonstrate, list, calculate, perform,* etc. give the written objective its active voice. For example, within the cognitive domain the objective could be to name three important 20th-century woman photographers; in the affective domain it might require writing a critique of Edward Weston's photograph, "Nude 1936"; and within the psychomotor domain it might specify to demonstrate the proper set-up of a view camera to correct for perspective when photographing a tall building.

On a legal side of objectives, there have been situations where poorly written objectives have created liabilities for institutions, when learning objectives are not met. This makes choosing the voice to write the objective critical. Because of the litigious nature of society today, some individuals see that the objective written in the syllabus is a guaranteed contract to be used when learning success does not happen. If institutional pressures are to avoid liability, then a more passive objective should be written that places the responsibility on the learner. If very active-voiced objectives are written, then strict scrutiny, measurement, and evaluation of the learning activities need to be applied.

The measurement of the learning will need to be finer as the objective becomes more specific. In writing a general objective for a course there is more to consider if the methods of measurement are greater. With a specific technique-based objective the measurements are tightly aligned with the peculiarities of the technique.

19

To illustrate the differences and a form of written learning objectives let us look at both a course-based and a specific objective for a learning activity.

"Upon successful completion of this course the student should be able to describe and explain how a digital system captures and processes the image light to a completed image."

"Upon successful completion of this unit the student will be able to acquire a printable negative with color negative film using the 'Sunny 16 Rule.'"

Knowing

Knowledge is a goal of learning. While not the end of all learning, it is naturally seen as the end for the first part of the journey. We say that we learn to know. However, knowledge is not the same thing as knowing.

While learning changes behaviors, knowing is the internal construct that allows for continuation of the learned changes and the categorization and organization of information, data, processes, and ideas. It is the ability to recall these aspects of our memory that characterizes knowing. Knowing is the ability to recall and apply the data, concepts, and meanings from the learning activity.

"My nightmare is creating disciples; someone told me that 'students were not a glass to be filled, but a lamp to be lit' (Church Teaching Today, © 1998). I don't want people to say, 'Bob told me.' But if I can light the spark of their understanding then it is limitless."

Bob DiNatale
Ben Franklin Institute of Technology, MA

In photography there are many things to be learned and a knowledge base continuously expands. This means that knowing happens in components of the complex processes. Because of this modular aspect of photography, the learner will come to knowing for various portions at different times. Because of individual differences, coming to knowing will be similar to learning with different orders and speed for arriving at this stage of the cognition process.

As we know more, we generate interconnected "look-up-tables" (LUTs) for the various parts of photography we have learned. The interconnected nature of photographic methods, processes, and knowledge involves many groupings. As knowing increases, the interconnections

20

are strengthened by the synergy between the mental LUTs. From these synergies, further learning can happen based on syntheses that strengthen the interconnections. Once knowing happens, the learner can move toward mastery. Mastery is this synthesis of information and data from the LUTs for a specific area of photography. Mastery becomes a transitional part of the journey as well as one way to view the end point of the learning journey.

Look-Up Table for Basic Daylight Exposure (BDE) from Brooks Institute of Photography

Light condition	Light value	Exposure
If the shutter speed is 1/ISO		
Sunny Day	BDE	f-16
Sunny on snow or sand	BDE + 1 stop	f-22
Hazy	BDE – 1 stop	f-11
Normal cloudy but bright	BDE – 2 stops	f-8
Overcast or open shadow	BDE – 3 stops	f-5.6
Lighted signs (to see the color)	BDE – 5 stops	f-2.8
Stage lighting (bright stage)	BDE – 5 stops	f-2.8
The following settings will require adjusting shutter speed as well as f-stop		
Bright city streets (Times Square)	BDE – 6 stops + 6 stops	
Fireworks, night football, store windows, stage lighting (spot lighting)	BDE – 7 stops + 7 stops	
Night baseball, inside schools and churches (well lit)	BDE – 9 stops + 9 stops	
Flood-lit buildings	BDE – 11 stops + 11 stops	
Distant city	BDE – 13 stops + 13 stops	

21

While traditional learning is one route to knowing, it is not the only way. Two ways that can be seen as effective ways to reach this level of

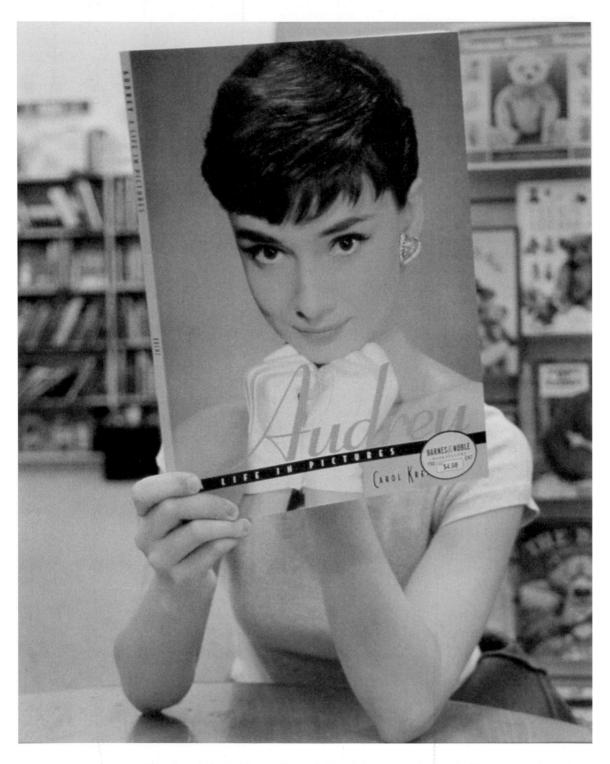

Audrey; by Emily Crichton, Albion College, MI, student of Gary Wahl

learning use experiential or mystical learning. Apprenticeships function as experiential learning, even to the point that in many cases the apprentice will perform many tasks that are seemingly unrelated to the goal of the learning, but either reinforce other learning experiences or direct learning by tangential effects. But most important in the apprentice experience is that younger learners interact with other individuals with more knowledge or experience. The purpose of extended apprenticeships, life experiences, is to apply acquired knowledge to ongoing efforts that move the known ideas or facts to part of life.

> "As a photographer you test your equipment and go with it; as a teacher you need to be able to present more than just your way of doing something."
>
> Dirk Fletcher
> Harrington College of Design, IL

The other way of knowing is innate. In the Eastern, American Indian, and other philosophies and mysticisms, the way of "knowing" is often spoken of as using the Heart-Mind. This means that the knowing, not intellectual or learned, is found in a non-mental construct. For these types of thought the act of knowing is about the way of learning more than about the end point of learning. The aspect of knowing is not what you can read in a book. In Eastern thought the act of knowing comes from within. It is not that far from Galileo's statement of "finding it within himself." In many of these philosophies there is a concept for heart that includes more than the organ that pumps blood and more than the mind's reasoning. This is a soul or persona beyond the ability of Western ideas to logically objectify learning.

Perhaps the most important concept in this knowing is that it is not intellectual: it does not come from the mind. Many of the Eastern philosophies reject intellectualization of thought. Instead they place their effort in understanding from life, as opposed to understanding from intellect. In this philosophy, photography can be learned from doing as well as in a curriculum.

Owning

The highest point in the learning journey is when what has been learned is owned. This is where there is no longer knowledge retrieval for application. With owning there is no mental interaction required to make the

23

type of photography that is desired. Owning means that you extend what has been learned and know from a conscious to an innate function.

Often we perceive mastery as owning; however, it is a transitional point between knowing and owning. Mastery is the use of previous learning with ease. We see masters of photography as those who continually produce exceptional images with a combination of vision and technique. These individuals seem in total control. This is possible while seamlessly moving from LUT to LUT.

Truly owning is not interacting with the mental portion. It is making photographs with full confidence that the image will be what was intended. Owning at its most powerful is like an athlete in the "Zone," that magical time when things just go the way they should without coaxing or referring back to a mental space.

In making a digital photograph as an example of this concept, you look at using a personal exposure system that you have learned, tested, and experimented with for years. At the beginning, learning is how the f-stops, shutter speeds, light, and post-exposure computer processing affect the production of an image. Then you gained a knowing control of the materials and processes so that you no longer looked at notes or a manual to assure control. This became easy and you felt mastery of making the image.

In the continuation of this example, you go to make a digital photograph and, as you start to work, the LUTs interact with ease and f-stops, shutter speeds, and all the other parts that make an image dominate the mental aspects of photographing. Then at some point the concentration of dealing with the ideas is pushed aside. At this point the knowledge changes to owning. The photographic process becomes an extension of all the learning and knowing that has come before, and reliance is not an issue. You have accomplished what the learning journey was for...you own this area of your photography.

It is not an all or nothing idea; rather it is a concept of differing abilities. The goal in photography is owning the methods, processes, and knowledge, but it is unlikely that all areas of the field will be owned by anyone. There will be areas that are owned, while in other areas knowing is exhibited and still others are still being learned.

Assisting Learning

We normally think of assisting others in their learning quest as the role of teaching. And that is a good basic name for this task. So how do we teach?

24

The most important part of "teaching" is to align the learning style, learning type, and learner's abilities. This means that we need to take into account issues of age, mental and intellectual readiness, desire, and complexity of the material to be taught.

In many cases formal educational pacing covers the age readiness issue. For the most part, primary, secondary, high school, and college institutions take care of assigning a level to the learner who will be taught. Through matriculation controls, the learning abilities for the learner are established. While not as clear, even in the less formal accessible areas of workshops, self-assessment is used to determine similar levels of readiness and abilities in any cohort of learners. Regardless of how the levels are established, our part addresses how we match learning to the level of the learner.

As mentioned previously, age appropriateness is the first and perhaps the easiest area of matching that we will encounter. Particularly in the younger years there are some concepts that will go over the abilities of many learners, if they are not at a high enough developmental stage to acquire the type or meaning of the material. While not directly addressing age appropriateness, the concept of "learning, knowing, owning" will follow learners as they grow from youth to adolescent to adult. Beyond the type of knowledge, the domain or type of learning is better approached with an idea of the age of the learner in mind. Young learners will be better with psychomotor and basic perceptual learning activities. For the very young it may be just the idea of holding the camera and reacting to an object in front. The complexity of the ideas of exposure and process may be too mentally difficult for the very young.

With development of the learner's mental abilities, the idea of switching from simply acquiring an image is exchanged with ideas of looking for images and learning of the time basis of photography. At this point, ideas in line with more perceptual constructs of looking for pictures become good tools for bringing the learner into the temporal nature of photography. In terms of the domain we can move to the earliest cognitive stages of learning. While doing this it should not be expected that the learner create a knowing space, but instead should start to generate the ideas that this may happen in the future. Learning activities that expand the areas and their connections in photography are appropriate at this point. The learners will tend to compartmentalize the various aspects of photography and this is also appropriate to teaching this material.

At the point in time, we can see younger students starting to put together the relationships between premier visual ideas and how photography can communicate those ideas. When this happens the learner is ready to move both to more cognitive learning and to beginning to create LUTs. This will move the student toward knowing; however, it cannot be assumed that the learner has actually accomplished this level and that more learning will be involved to create the mental data needed for knowing.

By the time learners enter secondary education, they have started to create their knowing spaces. This means that with many tasks that the learner will be reacting in a knowing manner. The learner can then move forward into more advanced cognitive domains and can start synthesizing the interactions between the photographic process and their ideas and wishes to communicate.

In advanced levels of the secondary education, learners have moved solidly into "knowing" and are intellectually ready to engage in areas that will advance their learning in more affective domains. At this level the learners will be expanding their visual perceptive skills. Also they will start to become involved in valuation considerations at higher and higher levels. As the learners proceed through the secondary level of learning, emphases need to start moving toward integration of visual concepts and how they relate to technical processes.

It is at this level of learning that critique can become more valuable. Because the learners are starting to "know" portions of photography, they will be able to use critique statements to their benefit as they are expanding learning.

Learners who progress to either advanced academic or vocational standing, through entering collegiate or vocational educational settings or entering into apprentice situations in the workplace, will start to exhibit mastery, particularly within technical aspects of photography. While we would like to be involved in others' mastery, it is an aspect of an individual's learning when knowing changes, through mastery, to owning portions of the photographic process.

As learners advance they will start to synthesize information from LUTs with visual concepts coming from their perceptions or from instruction designed to move them from tactical to aesthetic issues. This would indicate that, with the learning path, activities and avenues for investigation and research need to engage in synthesizing known techniques and emerging ideas of aesthetics.

The adult learner exhibits the qualities that might be anticipated from the novice through points of mastery. Through workshops, individuals will advance through levels depending on their desire, preparation, and ability to learn. When looking at aligning learning activities for adults/workshop learners, the strategy is to first ascertain the readiness of the learners for the educational objectives.

Expectations of Passing through Learning Levels

Though many students will pass through courses, schools, colleges, and universities, this in no way will indicate the level of learning that they have accomplished. It is normal for a person to be stuck at the level of knowing without ever reaching the point of owning. The level of study does not indicate the amount of photography that a person has mastered. Nor does accomplishment of a grade or degree deny that someone without that grade or degree has no knowledge. The path of learning does not require formalized education or evaluation.

"Rather than having all the answers, have all the questions. The answers are not going to help the student but the questions will."

Barbara Houghton
Northern Kentucky University, KY

27

This is also true for portfolios. Since portfolios are our selection from larger bodies of work, they do not show the totality of the learning process but only the best of the work accomplished through a period of time.

The expectation for learning within less formal educational opportunities will be more dependent upon the entering desires and abilities of the learner. As we will discuss later, workshops are not always about learning and thus in a workshop the potential for defining learning depends upon the reason the individual shows up for the workshop.

Also part of the discussion of expectations of learning is the reality that curricula accentuate certain types of learning at the expense of other areas of learning. This is a continuing controversy between technical education and artistic education. It is not uncommon to find individuals with many years of study having a vast knowledge in how to discuss images, and limited abilities in how to make photographs. The inverse of this situation is also common.

Though we may not have expectations for the level of learning, it is important that we determine the type of learning as we prepare our

curricula. Because early learning is more information-based, it is easier to plan. If our intention is to have "knowing" as a result of the learning, then this is not as clear-cut in the planning process, though testable. "Knowing" can be tested but owning cannot be. Thus any relationship between the learning path to owning or mastery is the hardest education to create. For the most part owning will happen beyond formalized educational processes.

Further, expectation fulfillment for the learner is the only true method of ascertaining the success of learning. This may or may not align with our goals for the educational construct that we are in.

Learning Is Change

As was defined at the beginning of this chapter, learning is as an activity that produces a meaningful change in behavior. Though there are many models that explain these changes, from the standpoint of assisting others in learning, two methods seem appropriate. These are transitional change and transformational change.

Transitional change is effective. It changes the learner by moving them from one point within the informational field to another. This typifies learning processes and much of the cognitive domain. In this type of change, the learner amasses information that functions to give the impression of movement through the information field. This defines moving along the learning path, e.g., moving the learner from using average metering to using selective tone metering. It changes the tool they have and how it is used.

Transformational change is affective. When transformational change happens the learner alters their way of incorporating knowledge and this changes how they use what they have learned. Transformational learning synthesizes and rearranges information to allow taking on the new way of seeing. This would be the transformation of having a learner change the way they perceive the visual world to implement the Zone System: reacting to the light as no light being Zone 0, middle tone light as Zone VI, and bright light as Zone X, rather than thinking about how they will just measure the light.

Eric Liu, on the Diane Rehm Show (01.27.05), has said that transformative teachers must listen to learners to be able to assist them in reaching their educational goal. In order to transform there is a need to understand not just the goal of the learning, but also the environment and starting points for the learner.

28

An illustration for a *New York Times* advertisement showed Central Park with people enjoying a lovely Sunday afternoon reading the newspaper, with some walking around, some sitting on benches or the grass, some roller skating, a few walking their dog, and a couple in a boat on a pond in the park. Everyone seemed to be pleasantly occupied reading the *Times*. Below the illustration, in large, bold headlines, were the words OPEN MINDS FLOURISH IN AN ENVIRONMENT OF TRANQUILITY. As a teacher, think of this each time you enter your classroom environment, but be cautious: A colleague who taught at RIT at the time that Carl Chiarenza, Bruce Davidson, Pete Turner, and Jerry Uelsmann were students there had his own idea of where open minds might flourish. He held class in a local bar named Jake's. The students loved it and it was the talk of the campus until the director of the school found out. Being a sympathetic administrator, he did not forbid the practice. Rather, he invited the faculty member to his office and asked if he would hold class on campus because of legal concerns.

Humor

29

Learning does not need to be hard nor does it need to be only serious. Humor can be very effective in preparing the learner to accept new information. Often levity is considered counter to learning programs but the opposite is most often the case. Using humor utilizes mental capacities in similar ways that new learning does.

Much of humor is based on the juxtaposition of unrelated information. In a similar way, if we wish for learners to accept new ideas, we need the mind to function in a manner similar to the reaction used in humor. This action—connecting new and unrelated information—can create the desired learning. Therefore, having fun, laughing, and telling jokes can be excellent methods to prepare the mind to learn.

Who Is Responsible for Learning?

We must look at the responsibility that we place on ourselves as teachers and on our students as learners. It must be seen that the responsibility for planning the path of learning falls to the teacher. This is similar to the role of a travel agent who plans the trip but does not take it. The learner is the traveler on this path. The better the path, the easier the travel. But in the end it is the learner's responsibility to learn, not the teacher's. Teachers facilitate learning.

Learning Photography

It can be said that photography is actually one of the most modern of arts, not just in terms of its contemporary nature but by the fact that it pulls together parts of the modern world, as a communication medium and in its reliance on the technology of making pictures. Since the introduction of photography in 1839 and now with the introduction of digital imaging it can be said that to be a master photographer/imager one must learn a high level of technology along with the sophistication of the artist.

The end product of photography is a visual language. The comment that "a picture is worth a thousand words" reinforces this concept of the photograph as communication. And just as the written word has multiple parts in the construction of a story, so a photograph has multiple parts in constructing the image. A verbal language has thousands of words and an image has thousands of image elements. Where the written language uses pencils or keyboards to enter the words, photography uses its processes and technologies to capture the parts of the picture. In these two examples we see that the verbal language as well as the photographic language use tools to create their elements for meaning. In this way we can see that to effectively teach photography we need to teach a technique and a concept of meaning.

While the technology of making an image can stand by itself, the technology by itself does not necessarily create meaning. The meaning comes from the way that the artist utilizes elements to communicate intent. The image maybe a product of the technology, but the meaning is a product of the artist. True mastery in photography is accomplishment of both technique and aesthetics. If we look at photographs in museums we will see that they exhibit the mastery of technique but also that they have an artistic value. Therefore, to assist learners in striving to this level, we must teach both.

"For me, the intellect is always the guide but not the goal of performance. Three things have to be coordinated and not one must stick out. Not too much intellect because it can become too scholastic. Not too much heart because it can become schmaltz. Not too much technique because you become a mechanic."

Vladimir Horowitz

Making photographs/images is a divided approach to the end product. It is not that either part can be disregarded, only that each part plays its specific role in creating the final image as seen by an audience. Though the photographer can learn either the technology or the aesthetics of image making, it is clear that to master the medium you need to know both. This means that the learning paradigm in photography must include richness in both technology and aesthetics. For the teacher this means that approaching the idea of photography also needs to include teaching technology/technique as well as teaching artistic ideas.

For photography and imaging this art/technique duality can be defined as knowing "how" to make pictures and "why" we make images. In the next two chapters we will discuss the "how" of teaching the techniques and the "why" of teaching the aesthetics of photography. In making the division between techniques and aesthetics we need to address how we will teach each of these portions. We must recognize that these areas of concern we define for learning photography will be dealt with somewhat differently. This does not mean that we will use different presentation methods to teach these areas, but that our approach and expectations for outcomes will vary.

31

"All truth passes through three stages. First it is ridiculed. Then violently opposed. Finally, it is accepted as being self-evident."
<div align="right">Arthur Schopenhauer</div>

By James Walsh, Salisbury College, United Kingdom, student of John Martin

3

Asking Questions: Turning Inquiry into Knowledge

"Good teaching is more a giving of right questions than a giving of right answers."

Josef Albers

Too often we assume that individuals are in the class that offers what they are interested in learning. While this is most often the case, there will be times when individuals' attention drifts in and out of the class, all while they are sitting there. This makes helping them learn difficult. There is, however, a key event that can assist the teacher in increasing the opportunity for learning. This is when someone asks a question.

In most situations the fact that a student is asking a question is an indication that his or her mind is open for knowledge to enter. The student has identified a gap in his understanding or knowledge, sees this as a need, and wishes to fill this gap and advance his learning goals.

When students indicate their interest in filling in the gaps and rounding out their knowledge by asking a question, they are usually at the height of their learning potential. They have already identified their need and it provides the teacher with an opportunity to not only assist a single inquiring student but to also assist others. The opportunity presented is to clear up one student's question and perhaps expand the audience and/or the subject of the question to include more pertinent information.

"The notion that questions lead to more questioning brought life and progressive movement to my classes."

Nicholas Hlobeczy
Case Western Reserve University, OH

Who Is Asking What?

We hope that students will be asking questions to expand their learning. Primarily the teaching/learning process needs to be open to have questions interjected into the process. While this may be formally structured into the flow of instruction or informally available at random points within the process, the students will be benefited from feeling comfortable about asking questions. In most evaluations of teaching there is a query that addresses the students' ability to ask questions, and their comfort level in so doing, within the course or with that instructor. The response is indicative of the effectiveness of the teaching/learning process.

34

"The origin of thinking is some perplexity, confusion or doubt."

John Dewey

In the flow of learning, early questions can be most beneficial. Within the learning process, the first learned bits of knowledge or processes mark the progress of correctly learning. Questions at this point use answering to strengthen the learning process. When a "first learning" question is asked, the student's mind is very open to take in more information and correctly learn from the interchange.

The concept of a "first learning" question assumes that the question is coming from interest in furthering learning at the first introduction to the material, but this is not the only case. There are several other reasons that people ask questions—to clarify, impress, and quarrel.

While a question asked to achieve clarification is similar to a question asked to gain new knowledge, there must be an understanding on the part of the answerer that this kind of "clarifying question" requires an approach that reinforces the learning that has already taken place. Clarifying means that parts of or all of the knowledge or learning have been gained but not totally engrained. Often this type of answering will need to be in a form different from that of the original presentation of the material or process. If the answer is in the same terms as originally presented, then there

is a good chance that the reasons that the learning did not totally happen may be revisited.

"I hear and I forget. I see and I remember. I do, and I understand."
 Chinese proverb

One of the major problems with "being two weeks ahead of the students" is that the methods to answer clarifying questions may not be within control of the teacher. If the teacher has just learned the material, it may be difficult to have the knowledge to adjust the answering process to enable the student to see and learn from the new descriptive statement.

While being fresh to the materials limits clarifying answers, being stuck creates another problem. Often success, or perceived success, with the presentation of materials leads the teacher to return to this method of presenting the material again. Ineffectual instructors often fall into stressing their original presentation without clearing up the incomplete knowledge. This approach locks the student into a learning pattern that did not provide them with clarification of the materials. If the questions are clarifying, then flexibility in answering becomes important for success, for both the student requesting clarification and for others who will gain from this questioning interaction.

There will also be times when questions become avenues to assist students with their learning by being a diagnostic tool. Often students will be in a class that is beyond their preparation or abilities. In these situations, defining the students' potential problems while they are traveling further through the course provides an opportunity to help them either to understand what avenues may assist them in their learning goals or to choose to take a different path.

From the outset we find that not all questions are designed to evoke answers. Beyond the concept of the rhetorical question, there are questions that are asked to prove the asker's knowledge or the respondent's ignorance. The reasons for these questions have little to do with improving the learning process but more to do with establishing status. Here, the teacher must avoid being provoked and deal with the question in a way that sets an example for the rest of the class.

"He must be very ignorant for he answers every question he is asked."
 Voltaire

35

Though the intent of the student may not be to increase their or others' learning, questions can still be used to assist learning. If there is a caveat, it is not to get trapped by the situation. Though the instructor may not be able to satisfy the true intent of the questioner, it will be best if a similar approach to first learning or clarifying questions is taken. Consistency in approach may defuse the situation when a provoking question is asked, and it still allows the teacher to address others and their needs.

Also, we can see that in some cases the question is an end and becomes the answer. Potentially well-constructed questions become prime avenues for self-actuating answers. As in the game of "Jeopardy," the "Jeopardy Question" is one where the answer appears before the question. The answer exists and then there is a definitional choice to find the question that fits with the answer just given. Frequently the answer placed in the question is incorrect and compounds the problem that the question is required to solve. This may simply be a need for interaction, and not an attempt to fill a gap or clarify learning.

Regardless of why and which students ask questions, questions are important to effective learning. Therefore, one of the important roles of the teacher is to stimulate questions.

> *"If you do not ask the right questions, you do not get the right answers. A question asked in the right way often points to its own answer. Asking questions is the A-B-C of diagnosis."*
>
> Edward Hodnett

In his book *Big Russ and Me*, Tim Russert, NBC moderator and editor of *Meet the Press*, writes about a high school experience that supports the importance of asking challenging questions. During his first class in English, the students were asked to take out a sheet of paper and to describe what they observed when they walked into the building for the first time. The question stunned him. He was not being asked to memorize something, as in many of his classroom experiences, but rather to "think, to remember, and to *observe*."

A Method to Ask Questions

It is curious, with the importance of question asking in education, that seldom is there any instruction in how to ask. There is of course the admonition to "raise your hand" but little or no discussion of how to formulate a question, when to ask, or what to expect as an answer.

While this book is addressed to teachers, the "question asking" discussed here is the students' portion of the learning process. It will be the students' learning and their questions, thus it is their responsibility to ask and assure that their questions are answered. It may be an important part of the teacher's ability to assist students by giving guidance how to ask questions. As an approach we can look at four ideas to effectively use question asking as a benefit to learning.

"Computers are useless. They can only give answers."

Pablo Picasso

One...Ask Early

It is important that questions are asked when the learner becomes aware that there is a misunderstanding or gap in the learning flow. The more vertical and sequential the learning, the more important it is to use a question to clear up missing or misconstrued information. Some students are hesitant about asking questions because it shines the light on them as either "not knowing" or "lacking understanding" or because they just do not want to stand out.

It is significant that if one student is missing the point, then it is likely that others in the class will also be having some problems grasping the learning objective. Thus the student who asks the question will be assisting others, and often assisting the teacher by identifying a point that was not clearly explained.

37

"Students should be reminded from time to time that asking questions in class is an important part of learning, just as good test questions on an exam are."

Hollis Todd
Rochester Institute of Technology, NY

Asking a question to clarify the learning objective gains in importance as the information becomes embedded in other objectives. If the gap in learning happens in a concept that has sequential objectives, then missing the knowledge in an early step may make learning the entirety difficult or impossible as the learning objectives progress.

Two...Use Understandable Words

Photography and its education use specific language and jargon. This means that some students will not always be familiar with the words used to explain and answer questions. Because of the flow of instruction,

subject-specific words, concepts, and jargon may all cause some learning problems for some students. While the conceptual area of learning will be what we want to address with questions and answers, the words may get in the way of both the learning and the understanding of the answers to questions.

It is important that the language of questions and answers be within the comprehension of the students. This is accomplished in two ways. First the student needs to ask questions in their own vocabulary. If a student does not know the meaning of the word "chromatic" it is unlikely that they can successfully ask a question using words such as "apochromatic lenses" or "chromatic aberration." The jargon just gets in the way and students should be encouraged to ask the question so that they understand the verbiage of the question.

Likewise it is unlikely that learning will be complete if the answer to a question is in terms that the student does not understand. It is important for the question answerer to modify their answer to form the answer in the language that will be understood by the student asking the question. If the student asks the question that misuses the jargon, then the question needs to be answered without the jargon.

"No matter how good teaching may be, each student must take responsibility for his own education."

John Carolus, S.J.

Three...Get an Understandable Answer

The expectation of an answer is a particularly important part of becoming skilled at asking questions. In too many situations students ask questions that are or are not answered, but seldom expect more than words from the teacher. Because of the teacher/student relationship the expectation is often that the teacher will give an answer but that it may not expand knowledge or fill in the gaps in learning. In many situations there is an expectation for an answer but not necessarily for an understandable answer.

As simple as it seems, the quality of the experience for the student depends on their repeated fulfillment of getting usable information from their question asking. It is easy for students to give up on an answer when the teacher speaks the terms but does not connect

with the students. This happens for many reasons but fine-tuning the understandability experience will help both the asker and answerer.

Just as it is common for students to use jargon and vocabulary to ask questions that are beyond their understanding, it is also quite common for answerers to use terminology beyond the students' level to understand totally. It becomes important for both parts of the questioning dialogue to be using the same language. It is incumbent on both parties to be aware of the issues of using understandable and meaningful words. For this reason it is best if the level of language used in the answer is the same as was used in the question asked.

Another common problem comes from the teacher's side of the questioning process. Since questions open such a great potential to expand learning, teachers often jump in with information beyond the students' readiness to take in the new materials. The opportunity is lost when the material extends beyond student readiness for the new materials, and instead puts up a new barrier to effective learning. In this situation the student may even tune out the answer to their own question because they are overloaded with information that confuses or pressures them.

39

Four...Sequencing Questions and Answers
Though questions should be asked early, students need to understand that sometimes the answers to their questions will come later in the learning sequence. For many learning situations the sequence of the learning process assists, and asking questions out of the proper time-frame can make learning more difficult.

Although not a step in the questioning method, an answer must materialize from the question. There are times when the teacher will not immediately have the answer for the student. In these situations the teacher needs to give the student an assurance of an answer in the future and stick with that arrangement. If the teacher cannot answer immediately, there should be an answer later.

Answering Questions

Just as there is logic to how to ask questions, there is a reasonable scheme for how to answer the questions. This includes the time required, how to answer, relation to previous learning, who should answer, and the level of the answer.

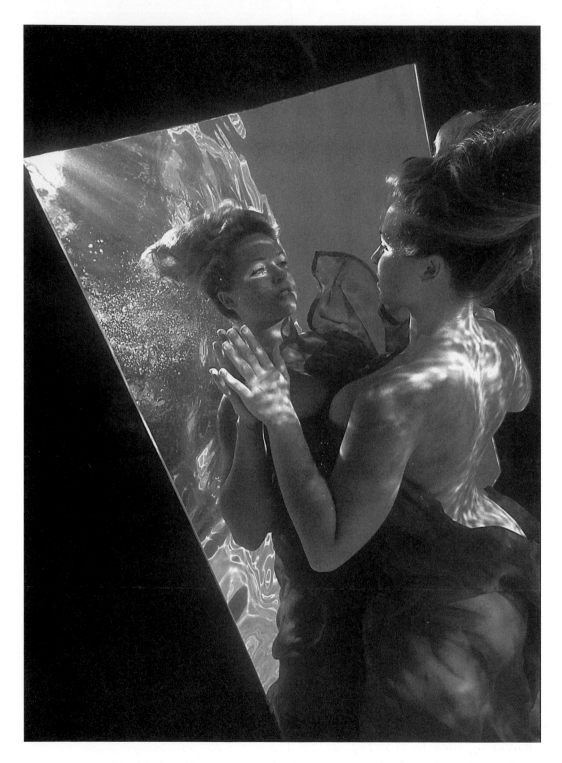

By Matthew Meier, Brooks Institute of Photography, CA, student of Nino Rakichevich

Time

Within the discussion of time requirements are considerations of the amount of time and timing situations for answering. In course planning, it is important to include time for questioning. Though such time can be placed at the end of a lecture or meeting, this will sometimes move the answer away from the moment when the learning needs to be cleared up or reinforced. The more formal the presentation of materials, the more likely the questions will be moved to the end, if planned for at all.

> *"The shorter the time between stimulus and response [question and answer] the more effective the learning."*
>
> B.F. Skinner

When there is an expectation that there will be time for questions at the end of a session, questions during the session can be avoided altogether. But time must be allotted and questions then encouraged as planned. In a public lecture a notorious photographer stated at the end of their presentation, "I don't need to answer questions...do I?" This stopped the audience and ended the discussion that could have been promulgated by the lecture. This same type of reaction can happen when question periods are pushed too near to the end of a class meeting, leaving an inadequate amount of time to address questions.

The first time the material or class is taught, the flow and relationship between instruction and questioning is not clear. In this situation the material should be viewed as providing an open, temporal approach to allow for questions to work their way into the instruction. The questioning time will assist in developing stronger courses. The areas of the material that promote questions may become part of the future instructional structure, because the questions reveal problems that the learners have with the materials. This also allows for an encore presentation and teaching that gives a better understanding of the materials. However, even if the material's subsequent presentation is changed to answer questions brought up in a first presentation, the need to answer questions indicates that some part of the course material presents a potential learning issue for the students.

For the most part, questions are better answered when first asked. As mentioned earlier in this chapter, this is where you want vertical information questions to be asked...early. Providing time for questions

41

and answers within a class structure does not mean that the instruction is improper or lacking, but is part of realizing that those coming to learn may have differing abilities. The questioning time allows evening out of the learning pace for all in the class.

One of the most useful times for questioning is prior to presenting sequential material. This is true whether within a class or between classes. The concept of relating previous materials to subjects to be learned provides the vertical learning paradigm needed in much of image making. Particularly after breaks in the flow of instruction, times provided for questions bring back the train of thoughts required to increase learning.

How to Answer

Perhaps the greatest difference in the perception of teaching is the way questions are answered. Answering needs to be more than just a response. Often the answer relates the response to how the person asking the question got to the point of asking the question. For the best effect, the answerer needs to incorporate an understanding of the history of learning to this point, the basis of the questioning, and how the answer can be used to expand learning.

"I would want a student to ask a question that I could answer with a question that would cause them to come up with the answer. They could figure it out with what they already know. My question is aimed at getting them to realize that they have a knowledge base that they can draw upon."

Jane Alden Stevens
University of Cincinnati, OH

Successfully answering requires adjustment to the type of answer within the situation. Questions and thus answers take on many styles, ranging from the simplest form of the direct answer to paradoxes. The main elements of effective answering are relating the type and level of answer to the type of learner, their expectations, and the learning affective nature of the answer.

As with the original presentation of the material, answers can range from direct to abstract. The easiest to consider in terms of time and complexity are direct answers. These give the asker a short but complete description, to fill the gap in information or learning.

While reinforcing, seldom does an answer in the same words as the concept that was originally presented satisfy the asker. In many situations a simple, direct answer will suffice. This is particularly true when the question is checking a fact or correctness of a method. The earlier in the learning, the more appropriate a direct answer will be.

Direct answers are efficient but not always the best way to stimulate learning in the long run. While often the asker wants only a direct solution to their immediate problem, in the long term this can frustrate further learning. With a single-problem solution, the learning stops with the answer. This answering paradigm limits potentials outside the direct application to the question asked. The answerer needs to see this potentiality, to avoid stopping learning with a correct response.

"One of the root things I immediately get at in all of my classes is how to ask questions. I ask the students about asking open-ended questions and closed-ended questions. With closed-ended questions you get no real information. So I tell the students to ask open-ended questions that lead to real information and a larger understanding of their own work."

Steve Ashman
Savannah College of Art and Design, GA

43

For these situations, approaches to answering other than direct, factual, or method-based answers may net greater results. Preparation to answer in this situation requires looking ahead to the learning that will follow, and pushing the answer into those sequential or related realms.

More involved are the sequential answers that can move the askers from where they are, through the vertical learning steps, to fill in the requested information. One of the greatest aids to effective question answering is using concepts that the learner already knows or owns. In this way the questioner's learning history can be used as a platform to build the answer and the questioner can categorize the answer into their existing knowledge. Since photography is normally a sequence of steps, answering process questions with a sense of the linearity of the process facilitates stronger answers, particularly when the questioner can be encouraged to ask the question based on their knowledge of steps in the sequence. This allows the answer to be framed from a point of existing knowledge.

Answering within the sequence of learning or a string of problems also shows how understanding the purposes and placement of the answer solves problems. At a lecture, the noted designer R. Buckminster Fuller was asked, "How do you order the details and parts of a complex set so that you can find a way to a solution?" Fuller dismissed the question as not that hard, and said "I only ask *the* right question." While it might have seemed arrogant, it was the best answer that could be given. In complex sequential-based problems, only ask the "right," the correct, the most important question and then other facets can fall into place. If the questioning and answering return to the earliest place of misunderstanding or gap in the sequential learning string, likely the right question has been asked. In this situation the answerer needs to assist the learner to move back through the string of related questions to the base, the "right" question, to facilitate a motion of learning, enabling the vertical learning to happen in an easier way.

"To be on a quest is nothing more or less than to become an asker of questions."

Sam Keen

Returned restructured questions can also be used to have the learner revisit their own learning to answer their own question. This type of question can be used with any level of learner. For newer learners the returned question lets the asker gain confidence by relying on their own knowledge. However, this method of answer can become tiresome and ineffective if overused. With overuse, learners with the need for direct answers will avoid asking rather than face the task of answering their own question.

Particularly with more advanced learners answering questions can be used to move the question/answer dialogue to a change from filling in gaps in knowledge to increases in education. Abstract answers define subject without a finite answer. These are aimed at a larger scope of education rather than either simple process or information. The intent of an abstract answer is to direct the thought toward the subject in general terms and allow the asker to learn by discovery or synthesis.

Last and most complex are paradoxical answers. These advanced questions use problems or questions to engage the learner with a conundrum that will tweak the learner's interest in developing his or her own answers. The paradox is the type of question that either has an apparent solution that through common sense seems contradictory

but nonetheless is perhaps true, or is unanswerable under the structure that is used to define the problem. Paradoxes are common and they add an unusual amount of complexity to problem solving. The paradox often promotes or requires creativity for solution to make it past the common sense aspects of solution.

> "I still remember, as a student some 50 years ago, a question put to me by Professor Hollis Todd. He asked me that if I was out in the rain without an umbrella, would I get wetter if I ran or if I walked. I still puzzle over the question on occasion."
>
> Richard Zakia
> Rochester Institute of Technology, NY

The classical paradoxes—such as Zeno's Paradox, "How many grains of sand do you need to remove from a heap of sand before it is no longer a heap of sand?"—pose logical quandaries that make solution difficult. Also within the concept of paradoxes are those that are self-referent. Self-referencing paradoxes assert and deny themselves. You can use logic to arrive at a contradiction. Epimenides' Paradox, "I am a Cretan, all Cretans are liars," is such an example. The purpose of using a paradox, like koans from Eastern thought, can be used to move the advanced learner to inner examination that expands knowing and owning.

It can be frustrating when questions go unanswered. It is one of the roles of the answerer to ease the frustration as much as possible. The frustration happens when learning is close and it is stopped after the questioner requests information needed to continue understanding. Good answers normally go a long way to help in these situations and poor answers increase frustration.

45

Who Answers?

All types of answers are appropriate for most learners; however, younger learners, both young in age and early to photography, may not function as well with more abstract or leading questions. But there is an issue of who should answer which questions. There are advantages to having the asker, as mentioned in the preceding section, or other sources in a group answer the question.

Within the classroom situation, opening the answer to other students to answer can have positive and negative implications. On the positive side, when another student answers the question it reinforces

the learning for both the asker and the answerer. If this approach is to be used, then it needs to be specified as to how and when another student answers another student's question. The real benefit to using this paradigm is that the vocabulary and method of answering may be more apropos for the class.

"No man becomes a fool until he stops asking questions."

Charles Steinmetz

However, allowing one or a small number of students to always answer can set up a hierarchy, causing envy and distrust toward those answering regularly. Even if the questions and answers are spread around, there will be a need for the instructor to answer. Particularly when time lags between the asking of a question and response, it becomes important for the leader of the class to put the class back on track by providing the answer.

In situations where there are multiple levels of learners present, such as in an open lab, it is likely that students will turn to other students rather than approaching the teacher. This is both for convenience and to avoid being seen as not knowing or being perceived as troublesome. While seldom seen as a concept of most educational strategies, this is one of the most common and most effective learning methods. Since this method of learning will happen anyway, the role of the instructor is to maintain control, as much as possible, such that students do not answer others' questions in ways that will injure their learning process.

An external resource for answering questions is to refer to the textbook. Since the book and reading in it are required, when the answer is clearly in the pages, the book can answer. If the answer is not satisfactorily found in a book, one can easily search the Internet for more information.

Learning from Questions

While the concept is to answer the question, it is important to listen when the question is asked. It is possible that the question may be the route of the misunderstanding. When the question asked is incorrect, before answering the question the misunderstanding needs to be cleared up. This will often answer the question by itself.

In another way, many questions start the same way, and thus listening is important to assure that the question answered is the one that was

asked. If the answer is not appropriate to the question asked, it will further muddle the knowing of the learner.

Questions often are more essential in the presentation of materials than simply clearing up misunderstandings. Since questioners are often formulating thoughts as they ask their question, they can give assistance to the teacher on how to approach the subject. The learner is trying to put together how their mind is accepting the instruction. Then they base their questioning on that learning activity. Through listening to the question's structure the instructor can restructure presentations to better address the subject matter of the material being asked about and either not being understood and/or causing confusion.

The Answering Imperative

Above all, for learning to be effective, when the learner's mind is open the teacher needs to proceed. Since the question normally means that the mind wants part of the learning process, the teacher needs to be sure that the answer happens. While there are many ways that an answer can be given or directed, it needs to happen. Realizing that the answering process affords the opportunity to reinforce, reintroduce, and/or present new learning to the student, teachers need questions and then need to assure the answer.

One of our roles as teachers is to get students to ask questions.

"The wisdom of the wise and the experience of the ages are perpetuated in questions."

Benjamin Disraeli

47

By Susan Olson, Colorado Mountain College, CO, student of Buck Mills

Technique Education...Tools

"To a child with a new hammer, everything looks like a nail."

Anonymous

At the beginning of this chapter we need to say that while the chapter is centered on technique, many of the discussions are equally applicable to areas of instruction that are more cognitive in concept. Unlike learning in other disciplines, learning in photography is heavily technique involved, and all theory and history come back to the application of technique. So while several parts of this chapter do not specifically address technique, it is always there.

Regardless of what medium one is using, technique is an integral part of creating an image. A painter needs to learn how to mix paints to create a particular color and to know the archival quality of the paint, and how and when to use certain types of brushes. A sculptor needs to know how to use the various tools available to create form, and how to select the material (stone, wood, metal) to be used. A photographer needs to know the various camera types available, how to use them, and which is best for the job at hand— 35 mm, SLR, large format. Technique is important in choosing and operating scanners, printers, Photoshop, and the like. Technique is also important in teaching, for there are many ways to facilitate learning, depending upon whether the learning is cognitive, affective, or psychomotor.

Teaching to a Moving Target

In opening this discussion of teaching technique, we need to address one of the major issues in photographic education today. This is the ongoing change from silver halide-based photography to digital imaging. In reality, since its introduction, photography has been an art form in transition. However, today the rate of change is accelerating.

This change brings into focus the reality that education in many areas of technology happens beyond the scope of the teacher/learner interchange. We have individuals coming to us to assist them in their learning journey, as change in technology impacts the learning they have already accomplished. We are also seeing individuals coming to us with more information about emerging technology than has been normal in the past.

"Technique is what you fall back on when you are out of inspiration."
Rudolf Nureyev

50

Today, even with the rapid change in technologies used to make pictures, we still find that we must teach technique and aesthetics as they apply to making pictures. Looking for teaching methodologies that will address change is not the issue. We will find that the changes in imaging and photography apply to the tools used to make pictures and have little effect on the way these visually capturing arts are taught. So while the teacher must now shift from the silver-based to the digital format, there is no need to radically change our thinking about how we teach imaging.

The real impact of change in teaching a subject is that it reinforces our need to continue our learning journey. The need to increase our knowing and mastery of changing technology is critical to our success in helping others with their learning photography.

"The problem is that students and photographers to a certain extent get hung up on the paraphernalia of what they are actually shooting with. They think that it is important if they are shooting on film or with digital, if they are shooting small or medium format or 5 × 4. The only requirement that dictates what they shoot on is what is going to happen to the picture at the end. But the principles are exactly the same."
Ian Kent-Robinson
Salisbury College, United Kingdom

Technology and Technique

There is a difference between technology and technique. Technology is always part of technique, but teaching the technology of photography is not the same thing as teaching the technique. The technique is the application of the sciences and technologies with the methodology to produce pictures.

With conventional silver halide photography, for example, an understanding of how the relationship between exposure, development, and density can be described in terms of a graph (Density vs. Log Exposure) is important to acquire. This is most helpful when looking at an image to determine whether exposure or development needs adjustment and how much is needed. A variation of the D–log E curve is used when working with curves in Photoshop. Learned concepts and techniques from conventional silver halide photography are easily transferred to similar concepts in digital photography.

Some detailed photographic technology is required in teaching technique, but not all or necessarily in great depth. In early stages of learning photography, the level of technology can be greatly lowered. As the learner advances through the photographic sequence, technology will inevitably make its way into the learning. The technology can be integrated or addressed separately from making photographs.

"Technique is only a vehicle."

Callum Innes

Whether approached as science or as technical information, the technology that enables photography can be seen in many cases separately from its application. Usually when we wish to separate the technology form the technique, a course or lecture about the "Science" of photography is used. It is clear that though we may wish to teach the technology of photography, the technology alone will not produce excellent photographs. It only allows the physical making of photographic marks.

While there is an important place for teaching the technology and science of photography to image makers, it must be clear that this is supporting information and not the act of photography itself. After the first photographs, shown as evidence of the viability of the

51

processes, few images demonstrating only the technology have been hailed as great images.

"Taking the edge off the technical learning. Treating the technical as though it's a friend not a foe. Being happy in front of the students as well. Make it enjoyable, make them appreciate what they are doing."
Andrew Moxon
Savannah College of Art and Design, GA

A Philosophy of Tools in Photography

Just as there are tools that will be important to learn to make photographs, there also tools that will enable us to assist others in their learning. In approaching the teaching of technique we are dealing with the tools to help others learn the tools of photography.

To understand the "technique education" side of photography we must look at what we are actually teaching. While it is easy to say that we are teaching the various techniques and methods used in making photographs, this only explains the first portion of our task.

We are discussing an approach to the technology involved in image making—how photographs become objects. We can use this as representing "making marks" that will later communicate the meaning of the photograph. However, the technology used to make the photograph is only the first part needed to give meaning to the photographic image. In this way we are defining the process of making the image as a tool to create the marks.

If we return to our discussion of photography as a visual language we can think of the physical making of the images as the words and structure of the language. This means that the various parts of the photographic process, from capture through presentation, are the devices that will be used to communicate the information but not the meaning.

"The artist can know all the techniques in the world, but if he feels nothing, it will mean nothing."
Chen Chi

Photography represents a constructed vision of the world. Just as any other construction, we will require tools to accomplish our tasks. Within a verbal language our tools are grammar and syntax. In the

visual language of photography our tools are the methods, techniques, and processes that create the photographic image. Tools are needed in photography as a way to make the art, but the tools...the techniques, regardless of how well executed, are not the art.

Common tools include, but are not limited to, physical equipment and materials used in photography such as light meters, cameras, films, and sensors. We can also look at processes such as development, the Zone System, printing, and finishing as tools. It will often be the case that a learner will be opposed to a particular tool. However, it is one of the roles of the teacher to use education to expand the learner's toolbox. For an example, when Bruce Davidson was a student, he was "married" to his 35 mm camera and was not interested in learning about a view camera. He told his professor that he would never use one, so why bother to learn about it. The professor patiently convinced him that it was important and an integral part of the course. So he learned how to use a view camera, but not with much enthusiasm. Some years later he found himself using a view camera to photograph East 100th Street, which became a book classic and one of his signature pieces. He tells this story to remind learners to keep an open mind.

53

Learning the Tools

If we analyze the tools needed to produce photography, we see that we are dealing with interrelated linear techniques. There are many single tools that gain in importance as they are used together. It is the Gestalt saying, "The whole is greater than the sum of its parts." We need to lead the learners through the techniques with an understanding that it will be through the interrelation of the single techniques that photography happens.

"Putting together an appropriate set of building blocks, trying to move logically through what digital photography is but what the students want to do is to see it as a Photoshop 1 class. So what I try to do is to impress the students that all things technical are tools that serve an end. And that end is making pictures."

Barry Anderson
Northern Kentucky University, KY

Teaching tools easily fall into the concept of learning as a path through an informational field. Because we will be teaching an

information-laden area we can use many differing approaches to providing the learners with the photographic tools. As stated at the beginning of this book, there are many paths that we can take and some will be more appropriate than others.

Traditionally in education, we use lectures, laboratories, and out-of-class work as methods to help others learn. Just as there are many different paths to learning, the appropriateness of choosing any particular method for presentation or assisting learning is as much dependent on the learners as it is on the materials. If we define the types of teaching for technique into concept of presentation, directed work, and independent work, then we can assign different orientations to the learning and how these can facilitate each type of learning.

As in any technologically based art, the steps of the processes used often define the technique and the way we will learn the art. In photography the technique is the most linear learning part. Teaching techniques in photography and imaging has the learner progress through a series of interrelated steps.

54

"What makes photography different is its dependency on materials and processes. These need to be addressed, understood, and controlled before serious creative work can be done by the students. If we do not deal with these issues and simply allow them to do 'ART' with little understanding of the processes they work with, it is allowing them to play in the sandbox. Not serious! Too many photography faculty dismiss the technical issues as not worthy of serious consideration and concentrate on the critical visual and intellectual issues posed by the students' work. I have no problem with the intellectual focus of the critique, but would like to see a more balanced approach."

Hans Westerblom
Ryerson Polytechnical University, Canada

Learning technique in photography is like arithmetic learning; the learning is a series of processes to reach specific answers. With photography we want the learners to have results with specific outcomes from the related steps...defined outcomes from defined processes. Because we know the outcome desired from the learning activities, we can relate this success of the learning to the specific step or process. If the learner is following the steps needed to make the proper exposure, the answer will be seen in the outcome on the film or in the histogram.

The level of the learner is important when contemplating how the steps will be put together. It is far more important for beginning learners to have successful outcomes than it will be with more advanced learners. Early steps in learning techniques need to provide opportunities to accomplish easily the goals of the process. Thus, in developing a strategy to introduce new learners to photography, there must be a concept that the learner will leave the process with acceptable results that reinforce their interests and the goals of the early learning.

Early learning in these steps should be filled with successes so that later learning will produce repeatable outcomes. It is the repeating of simple steps that builds up a reservoir of increasing technique. The materials need to be arranged to bring the learner up the technique path supported by successes. It is an issue of steady progress without giving up the technique gains between steps, and the early successes reinforce this idea.

"Photography has to teach tools...not rules."
<div align="right">Dennis Keeley
Art Center College of Design, CA</div>

55

The step process in early learning of technique is best in small portions that can be easily augmented by succeeding steps. The presentation or demonstration of the techniques is best handled in monitored instruction or directed laboratories. As the learners advance from simple successes the material can also be accelerated to be larger interrelated techniques.

With a simple structure of technique, the areas for failures will be restricted. This allows for easier correction and improvement. This strengthens the teaching/learning dialogue, with corrections solving the learner's error by simple technique modification. While correct technique is the goal, it is not assumed as the starting point. If errors occur in the beginning they will be small and easily seen and corrected. This allows their correction along the learning path in small steps, enabling the learner to become skilled at a higher level of technique.

When the learner becomes more familiar with the processes involved and they push the processes, they will make errors that allow for correction, leading to more advanced techniques. This will repeat positive learning to the benefit of their photography. Beyond the movement through correction to easier technique control, the repeat ability in technique that the learner will strive for is the real goal.

Helene; by Andrew Davidhazy, Rochester Institute of Technology, NY, student of Richard Zakia

Therefore, the issue facing intermediate instruction in photography is to build replication of technique to reinforce the positives and allow for correction of native outcomes.

Leslie Stroebel's book, *View Camera Technique*, 7th edition, can be used as an example. It was first published many years ago and is still in print and is still used by students learning photography. The contents of the introduction to the book lists some of the tools involving technique:

1.1 View Camera
1.2 Ground-glass Viewing
1.3 Lateral, Vertical, and Angular Adjustments
1.4 Interchangeable Lenses
1.5 Flexile Bellows
1.6 Large Film Support
1.7 Camera Support
1.8 Advantages and Limitations of View Cameras

After the learner becomes familiar with a view camera and its various adjustments, the book continues with a progressive sequence of advanced techniques. Well-structured books, such as *View Camera Technique*, give good roadmaps to teaching technique. In these texts there has been a pedagogical structure imposed on how to see the learning of specific tools.

As the learner advances, the opportunities to perfect technique come from investigating nuances in the various steps that they have already learned, know, or have mastered. However, it must be realized that even though the learner is advancing they are still involved in a series of steps. Though we might expect the advanced learner to be expanding their visual vocabulary, the outcomes of their efforts still must conform to specific expectations in order to advance their technique to the levels of mastery and, finally, owning.

57

"Perfecting a good technique in the use of tilt and swing adjustments on the back of the camera to control image shape, and the use of tilt and swing adjustments on the front of the camera to control image sharpness, requires practice in making the proper adjustments with a variety of subjects until the procedures become automatic—so that attention can then be shifted to the more subjective factors required in the production of effective photographs."

Leslie Stroebel
Rochester Institute of Technology, NY

Presentation Technique

There are a number of techniques that a teacher can use to assist the learner, depending upon the type of learning desired. While this chapter is about teaching technique, and others deal with other concepts and teaching platforms, the subjects in all these chapters cross back and forth through the idea of teaching photography and imaging. For this reason the subjects discussed in any of these chapters apply to all appropriate approaches in photography.

Lecture

Because photographic technique is an application of the technology, lecturing can be only tangentially associated with the highest level of learning of how to make photographs. These aligned areas include many areas of the technology, history, and theory that make for a fuller understanding of photography. This does not mean that there is no place for lecturing to assist learning technique, but that it is only that this method of presentation will not be where the majority of the learning takes place.

Lecturing is a transfer of information in a one-way direction; it supports learning in the cognitive domains but is not as effective for the application-based activities. Effective lecturing introduces and/or instructs the technologies and science that support the technique supporting quality picture making.

"Chemistry, camera designs, and computers can overshadow the classroom learning experience. In presenting the fundamentals of these and other elements, students see the synthesis between science and creativity. By demystifying the technical side, they become less anxious and more engaged with their craft."

Bill Davis
Western Michigan University, MI

The concept of the teacher as an actor on the stage is not totally correct; a lecture is primarily a one-directional presentation, with information going from the presenter to the learners. While it is advantageous to have questions within the lecture format, this does not need to be formalized either. The instructor can move throughout the group of learners and from the formal or informal as

58

determined by the material, depending on the presentation style of the instructor, the needs of the learners, or requirements of the educational provider.

The length of lectures and the communication skills of the presenter influence the success of a lecture. An old axiom points out that "the mind can absorb only as much as the posterior can stand." As Albert Einstein pointed out, time is relative; thus the ability to stimulate and engage the learners determines how long "long" is. Beyond the length, the clarity, tone, and liveliness of the presentation also make the lecture positive for the learners. Though the ability to connect and communicate is important in all parts of teaching photography, it is particularly important in a lecture. It can be said that teaching is a performance and the lecture is where this shows the most.

The critical item for the creation of a successful lecture is the planning. While it is not required that an outline or written lecture be prepared, it certainly is recommended. Particularly with the linear nature of the technique of photography, a good flow of information will assist the learning process. Of course, slides or digital presentations provide the organization that holds the information in its planned flow. A projection-supported lecture allows the visual preference of photography learners to assist them in acquiring the information from the lecture.

59

"Technical knowledge is not enough. One must transcend techniques so that art becomes an artless art, growing out of the unconscious."
Daisetz Teitaro Suzuki

Depending on the size of the lecture and the presentation methodology, the use of examples of technique are a real advantages of the lecture format. Even with larger groups present, the lecture format allows the presenter to concentrate the learners' attention to specifics of the technique. While this book is not about instructional technology, in today's instructional milieu there are many presentation methods that expand the lecture format. Many media can be used to illuminate and expand the information coming from a lecture. Photography is a visual art and even if the information flow is in one direction, the ability to present a visually interesting presentation makes the lecture more effective.

Successful lecturing provides an efficient way to provide large amounts of information to a cohort of learners. While this is the least

personal method of instruction, it is effective as part of an overall approach to presenting technique.

Note Taking

What the students write, what is printed, and why the learners need to write it down are at the heart of note taking. Since the lecture is a single-direction event, note taking is the way the learner becomes more active in a lecture situation. Notes assist learning in several ways. First, because the learner has become more active in the learning process there is a stronger likelihood that learning will take place. It is known that the more times information is perceived, the better the learning. By taking notes the learner immediately reinforces the memory of the information. Second, notes provide a method to review information and/or study. Also, in many cases, information recorded as notes can become a personal "hard copy" LUT.

To assure that the note taking is a learning activity, a follow-up needs to take place. The most common approach to monitoring note taking is to grade notebooks on a regular basis. However, there are other methods, including use of "open note" testing and creations of "lab books." The concept of open note testing will be addressed in a later chapter. The lab book is a linear (page-numbered) volume in which the learner can add examples and other writings to build a reference volume. Because the lab book concept uses a linear note-taking process, there is a burden placed on the instructor to assure the proper flow of material and examples for inclusion. A notebook utilizing a loose-leaf binder allows for less linear presentations because the notes can be rearranged to give a good flow to the information.

"I believe the students are learning when, as a group, they are taking notes. When their heads are looking down and snapping back up I think they are getting it. When they are moving slowly or not taking notes they are probably not getting it."

John Tonai
Brooks Institute of Photography, CA

Another way to assist the learning process is to prepare lecture notes. These can be elaborate or sparse. They are as much an aid to the lecturer as the learner. Particularly helpful to the learner are illustrated "empty notes." Illustrated empty notes are notes that include

the illustrations that will appear in the lecture without the names and words that describe the illustrations. The learner is then given the ability in the lecture to pay attention and take notes without needing to take time to draw the diagrams or illustrations that are in the lecture. This will enhance the lecture's information because the learner writes in the term or name related to the images, and that action reinforces the learning.

With the growth of Power Point® and other computer-generated presentations, the creation of empty notes has been simplified. To allow the note-taker to fill in the information, the preparation of the presentations often means removing terms and names as well as restructuring illustrations. Where there are animations or sequences, the cells may need to be condensed, combined, or augmented. However, regardless of the way the information is presented, notes need to be thought of as a tool used by the learner in concert with the presentation.

Demonstrations

61

More practical for assisting others' learning technique is a demonstration. There are basically two types of demonstrations, lecture and simultaneous demonstrations.

> *"Once you have really 'heard' what the artist has expressed, it is simple—and fascinating—to work back, step by step, through the technique. Thus one may share in the task of creation."*
>
> Edwin Jewell

A lecture demonstration is a method of presenting information and the steps of a technique. As the name indicates, this is a hybrid of the presentation style of a lecture for the purpose of a demonstration. In this type of demonstration the learners are observing, taking notes, or otherwise following the steps through the technique. The advantage to this type of demonstration is that it can be presented to large groups. Because of the nature of the lecture demonstration, it can be accomplished in any location. The critical issue in presenting in this format is the ability of the learners to accurately view the steps. However, because the lecture demonstration is passive for the learners, media can be used to facilitate the learners in seeing the steps accurately. If, for example, the lecture demonstration is to be used to introduce the

students to a view camera and the class size is large, a video camera and monitor can be put in place to show the various components of the camera and how they function.

Simultaneous demonstrations are active for the learners. These have the learners follow the technique as it is demonstrated. This is a slow method to work through a demonstration, but it is very effective, especially for new learners who are unfamiliar with equipment or processes. As important as it is for the learners to be able to see the demonstration steps, there must also be a way for the instructor to reinforce accurate (and correct inappropriate) actions of the learners. When this involves the use of computers, there are several software packages that allow both monitoring and correction of interconnected units.

Preparing for Demonstrations

Preparation is important for all types of demonstrations. Even if the demonstration has been done many times before, it is best to go through a preparation sequence to assure that the demonstration shows the technique desired.

> *"One must learn by doing the thing; for though you think you know it, you have no certainty, until you try."*
>
> Sophocles

There are two issues facing the preparation of a technique presentation. These are the preparation of the presentation itself and the preparation of the learners.

As mentioned previously, many presentation tools lend themselves to technique education. Regardless of the type presentation chosen, the outcome desired is a perfection of technique for the learners. This means that the planning for these presentations needs to consider how the steps involved in the technique will be processed by the learners, leading them to their success.

> *"One mustn't let technique be the consciously important thing. It should be at the service of expressing the form."*
>
> Henry Moore

Since technique is a step-based idea, the teaching of technique lends itself to modularization of the steps. In approaching the modules, all

portions, for the learners' success, must be included in each unit. This does not mean that the totality of photography must be included from the beginning. If there is to be success in any specific step, planning for presenting the step needs to include the information for the learners' success in that step. As an example, if we look at making a first photograph, there is a need to have the learner be able to succeed at framing a picture, but not necessarily to know how all of that relates to processing of the image. Particularly for newer learners the steps in the technique to be learned need to be small in concept, so that they do not overwhelm the success.

If we return to using a text to assist in preparing to teach a particular technique, we can see that to demonstrate how to make a high-contrast film-based image, you might use the chapter by J. Seeley in *Darkroom Dynamics* (edited by Jim Stones) as a guide to modules that can be used to prepare a demonstration. In using this method you will see a highlighted outline to assist the learning process. To follow this example, we see the sequencing for a presentation: this sees a demonstration as including the materials, setting up, making a film positive, making a litho film negative, and making a final high-contrast print. Your knowledge and experience will fill in the modules, using the text as assistance in setting up the demonstration.

In planning for a demonstration it is important to do more than look to the outcome of the learning. Part of the planning for the demonstration is to work through how all the learning takes place. This includes assurance that those who wish to learn from the demonstration can adequately see the individual steps and that the steps accomplish the learning objectives. Even though the steps for the technique may be part of the teachers' knowledge base, the demonstration should be worked through.

The run-through of the demonstration can have specific beneficial parts. With a run-through, the instructor has the opportunity to check the availability of equipment and materials required for the demonstration and to make sure that the time allotted for the demonstration is adequate for the learning objectives. There is nothing more disappointing in a demonstration than to have to explain something that the learners expected to see demonstrated.

As part of the preparation for the demonstration, check the visibility of the steps. This may mean that you need to consider multiple passes through the technique to enable smaller groups to see the critical steps.

63

Because a person is present at the demonstration does not ensure that they have seen the technique.

The technique needs to be demystified. This is part of the preparation of the learner. Many novices coming to photography see that there are difficult tricks that they will need to discover to master the medium, which is perceived as an obstacle to their easily learning the technique. While some advanced technique may be more difficult, the techniques used in photography are not mysteries. The instructor needs to convey this idea. As John Sexton has said, "I do not know any great photographers who have secret techniques." It becomes the role of the demonstrator to show that the mystery is there to be mastered.

"The mysterious is the fundamental emotion which stands at the cradle of true art and science."

Albert Einstein

A good way to prepare for the learners' successes is to develop handouts that the students can use as they go through the technique demonstrated. Preparation of handouts is a sound method for the instructor to organize the demonstration. The linear pattern codified in the handout will support both the demonstration and the activity that the learners will use in the up-compilation of the technique.

Handouts that are used as part of a demonstration need to transition from the demonstration to the application of the technique. When the handout can be used directly to reinforce the technique demonstrated, it becomes a stronger part of the growth of the learning. With this in mind, the design of a working handout should not only consider the steps in the technique but also how the learner will use the handout. When the handout is to be used directly in the field, its size should be taken into consideration. The ability to take a handout into the field or darkroom allows the learning process to continue as the learner applies the technique. Depending upon the design and function of the handout, the techniques can be guided through the steps delineated in the handout. Beyond the size of the handout, ideas such as laminating the handout or sizing it to fit within existing notebooks or field guides should be taken in consideration. The LUT shown in Chapter 2 was part of a card handed out at Brooks Institute of Photography. This allows the learner to carry this BDE Chart into the field as they make photographs.

It must be clear that a working handout is not the same as a lecture note. Notes should be designed to help the learner in understanding

the technology, while working handouts need to be designed and constructed to assist the learner in using the steps of the technique.

Laboratories

While lectures provide an opportunity to give learners the background and knowledge base for photography, it is in the laboratory that techniques are perfected. Just as demonstrations can involve learners in the laboratory on different levels, there can be varying levels for the instructor. There are primarily three differing levels of involvement in three types of lab situations: directed, monitored, and open.

> *"Technique serves creativity. You need a refined level of craft in order to express yourself. One does not substitute for the other, they are independent and when someone has control of their craft, they are capable of what Ernst Haas referred to as 'poetic response,' then the possibility of something transcending pure technique is there."*
>
> Craig Stevens,
> Savannah College of Art and Design, GA

65

The directed lab allows the learner to work on specific techniques with the direct involvement of the instructor. Just as in a lecture demonstration, the time needed to perform each step of the technique must be taken into consideration when planning the laboratory. Directed labs, also known as technical laboratories for accreditation purposes, are highly structured learning environments where the instructor works directly with learners to assure that the technique is properly applied the first time. In this lab structure, the instructor is commonly in the lab along with the learners. This provides direct instruction to the technique. Whether in the computer lab, darkroom, or in the field, the instructor's role is to interact with the learners to assure that the steps of the technique are properly executed. In a Photoshop® lab the instructor might be interconnected through software to each learner's computer or might move throughout the lab facility to assist learners as problems arise. This might include showing a learner how to access particular menus or how to adjust a curve; the teacher's interaction will simplify the learning activity. A note of caution: it may be detrimental to learning for the teacher to perform the desired activity rather than to demonstrate and then monitor the learner as he or she applies the same steps.

Directed labs have the greatest importance early in the learning sequence. They are very important for new learners, but as learners progress through the photographic concepts, the need for directed labs diminishes. While the directed lab provides direct instruction on the application of technique, as the level of science in the curriculum increases, the directed lab format becomes problematic, both from the standpoint of working with each learner and from pure time considerations.

As students advance through the techniques, the need for directed labs is reduced; directed labs are then easily replaced by monitored labs. The monitored lab provides learners with access to an individual with knowledge of the technique being learned, without the requirement that the instructor be in the laboratory environment.

An issue arises with the qualifications of individuals assigned as lab monitors. For liability as well as educational reasons a level of qualification needs to be established for those monitoring laboratories. It is not necessarily enough to have as monitor someone who has gone through the lab. If the monitor does not know the material and lacks a level of mastery of the technique being performed in the lab, their ability to address problems that the learners have with the technique may create deficiencies that will need to be addressed by un-teaching and re-teaching the material technique.

"The students need tools. I see technical knowledge about photography as essential tools."

Lex Youngman,
Wingate University, NC

While a staff employee may meet the liability requirements of the lab, it may be important to restrict their role in teaching the technique. This can be particularly problematic since it is beneficial to have the learners view the support staff as authority figures and as a source of knowledge. If the opportunity exists, it is probably best to have a fully qualified instructor monitoring laboratories. With larger laboratory situations there is the potential that staff employees may not have the skills in the techniques the learners are studying. However, with a staff employee manning the instructor's station, a learner may ask for technique help, regardless of the staff employee's qualifications. This is simply a result of the staff person's presence, not affirmation of his or her skills. It is possible that the staff person does have the requisite

skills, but if a technique requires a specific application sequence, then their skills as a photographer or as a staff employee do not necessarily translate into their abilities as a teacher.

Of course, many lab situations are neither directed nor monitored. Open lab situations provide opportunities for the learners to utilize lab facilities or work on assignments within a structured environment, without direction or monitoring. The effectiveness of an open lab is often determined by the priorities, independence, and determination of the learner.

One of the major advantages to an open lab and at the same time one of the major detriments is that the learners will share information among themselves. It is important to realize that the learners will find comfort in asking others for assistance when they believe that the assistance offered will be on their level of comprehension. This is true whether the learners asked are from the same or from a more advanced cohort. Just as with staff, it is important to realize that misinformation about technique from a fellow learner may be a problem as the learner progresses.

Whether directed, monitored, or open and independent, the laboratory provides the opportunity to apply the techniques learned in lectures or demonstrations. The lab structure allows the highest level of learning through doing. For learning technique, this is where the action is!

67

Correcting Technique

Whether in a laboratory or in other learning situations, correcting technical problems provides a strong learning activity. The use of the correction process provides an opportunity to teach far more than the technique that was improperly accomplished. However, correcting technique can become frustrating for the learner who has erred in their technique. Because of potential embarrassment, a balance must be struck between the need to new show corrections to a large group of learners and the personal effect on one individual. One method of use lies in the correction mode; to instruct is to provide a review for all learners, whereas corrections are discussed without identifying where the problem was detected.

"We learn from our mistakes; not to, is a bigger mistake."

Anonymous

Because photographic techniques are linear, correcting problems relates to first defining the point at which the steps have gone awry. This many times requires the instructor to demonstrate the process from the beginning or to start at a logical point in the process, where the students have demonstrated mastery. Adequately correcting the problem requires assurance that the step where the problem arose is visible. With the linearity of photography, there is the potential that the source of the problem will not be evident until very late in the process. Thus, solving the problem will require backtracking into this sequence of steps, to reach the point to make the correction.

Within a structured laboratory there is the opportunity to bring learners together to provide collective direction to problems as they arise. This is most helpful particularly with cohorts of newer learners, because they all tend to run into the same problems. However, care should be taken to use the same "non-personal" demonstration location within the laboratory whenever possible. This will provide the learners with an opportunity to clearly see the correction process without attaching the problem to any particular individual.

Knowing and Perfecting Technique

Knowing technique is demonstrated by its application. There is a decision made by the instructor that either the learners will be able to apply the technique easily or that they will strive to know and own the technique. There are many ways that techniques of photography can be applied without consideration for the underlying knowledge of the technique. Though shortcuts provide quick successes for the learner, they short-change the process. Learning photography is a long journey and the shortcuts do not provide the understanding needed to solve advanced problems, if they fall outside the prescribed steps used in the shortcut.

The decision as to the use of shortcuts is most closely aligned with the level of the learning expected. With new learners, it is often important to provide easy successes that will encourage further learning. As learners advance in their photographic skills, it becomes more important that they understand the "whys" of technique and not just the steps involved in how to perform the technique. In discussing knowing his skill set, the all-time great golfer Jack

Nicklaus said, "I'm impressed by players who ask why a shot turned out the way it did rather than how to execute it properly. If you discover why something happens, the execution part becomes much easier" (*Golf Digest*/April 2004).

"To be a good photo instructor you have to be technically and artistically competent and have a good imagination...you need to be willing to think outside the traditional box."

Art Rosser
Clayton State College and University, GA

69

By Marilyn Bridges, Rochester Institute of Technology, NY, student of Richard Zakia

5

Creativity Education

"Conventional education makes independent thinking extremely difficult."
Jiddu Krishnamurti, *Education and the Significance of Life*

Techniques are the tools of photography and creativity represents the desired outcome of photography...the implement and the object. It becomes important that we define the difference between how we will make a photograph—the technique, and why we will make a photograph—the creativity that goes into the image. In the last chapter we discussed the idea of assisting learning of the techniques of photography. In this chapter we will concentrate on ideas of helping others learn about creativity and how to be creative.

We must understand that creativity is not the sole province of fine art. All problem solving, communication, and concept development can be creative. Therefore, there is as much potential for creativity in engineering, science, mathematics, journalism, and teaching, to name just a few, as there is in art. When the Apollo 13 spacecraft was on a disastrous return flight from space, it was the creative problem solving of NASA engineers that saved the lives of the astronauts. Albert Einstein's great leap—relating energy, mass, and the speed of light in a "simple" formula, $E = mc^2$—was a creative leap. Charles Babbage, who originated the modern analytical computer, the forerunner of what we have today, was creative. Alfred Eisenstaedt, who spent most of his life photographing for *LIFE* magazine, was called "the father of photojournalism." Many of his photographs have become icons. Teachers

also can be creative in their approach to teaching. But art is often reduced to being synonymous with creativity, even though it is both limiting and inadequate to define creative activities.

In approaching a concept of learning in photography, we must recognize that there are two distinct parts of what we will teach and how those ideas will be used. Learners need an understanding of creativity and becoming creative. If there is a difference between creativity and being creative, then there must be a difference between teaching creativity and teaching learners to be creative.

First we must see a slight learning difference between what can be confused as the same thing, creativity and being creative. Educationally, creativity is the verbal expression of the creative activity. We can address creativity without the learner being creative. Being creative is active, while creativity can be passive.

With this small difference in understanding within creativity, the concept of aesthetics works its way into this discussion. When we wish to use aesthetics we are looking for the answer to one question, "What is art?" This question is about art and aesthetics, not about creativity. Looking at the question allows us to view creative activities only through the artistic approach. There are no preconditions within art that make creativity something that is only involved with art. Though the area of aesthetic study normally resides at a higher level of education, the pursuit of the answer to the aesthetic question incorporated in this academic area can be useful in transitioning from creativity to being creative.

"Teaching creativity is knowledge-based, being creative is studio-based. We can know of creativity but being creative takes effort. Creativity can be expressed and discussed while being creative must be done."

Jack Mann
Wittenberg University, OH

Aesthetics, Perception, and Meaning

"What is Art?" This is an adaptation of the classic question of aesthetics. Since photography is an art, this is also the basic question of the meaning of photography. In endeavoring to answer that question, certain ideas need to be addressed. These are the threads common to all art: how art functions, the involvement of the audience in the artistic event, and implications of the artistic intent.

These three threads, common to all art (in our case how photographs function and implications of the artistic intent of the photographer), lead us to the answer to the aesthetic question. Art, including photography, does not exist in a vacuum and must affect a viewer beyond the moment when the viewer is simply viewing the art. (What if you built a website and no one visited?) This effect of/on the "audience" is the involvement with the artistic event, and the way the viewer perceives the visual stimulus involves us in discussing how art works. Assisting learners to understand this relation between the audience and how the audience will process and use artists' photographs is a big step toward learners becoming creative by finding unique ways to communicate to the audience.

"Only an individual can imagine, invent or create. The whole audience of art is an audience of individuals."

Ben Shahn

Within this approach, cognition of images needs more than attending to an image. The visual art that has been produced within the digital environment (we now see) is the basic level of art. It is important to realize that there are controlling factors for dealing with the art, and those factors are the perceptual constructs of the audience.

Since the audience takes charge of the art, understanding the art is mediated by perceptual systems. Whether from external perception (psychophysics) or from the other extreme of internally manipulated perception (subjective phenomenology), the actions of the percept are controlling factors in the appreciation and understanding of visual images. To a certain extent the photographic art is the province of the audience, whether it is viewing a monitor or seeing a printed output. The first two parts of the aesthetic equation are both found at the viewing end of the art.

73

"After three years of experimentation, 'The Bathers,' which I consider my masterwork, was finished. I sent it to an exhibition and what a trouncing I got!"

August Renoir

The third idea mentioned above is the importance of artistic intent. This is the sole province of the artist. The assumption that any knowledge of artistic intent allows for better understanding of a

visual image is fraught with problems. When asked, learners will often reply, "that's the way I wanted it," and then, if able, intellectualize the aspects that the audience had not perceived. While intentionalism has its place in the discussion of art, it can only distract from understanding how art works.

"Most of my photographs are compassionate, gentle, and personal. They tend to let the viewer see himself."

Bruce Davidson

The mind is in control of both aesthetics and meaning. As we will see, the concept of meaning becomes central to being creative. With the effects of mind on the aesthetic as well as the encoding and decoding of photographs to become meaning, aesthetics and meaning are mediated by the perceptual system. This is not far from the original meaning of *aesthetics*, from Greek, denoting "sharp to the senses." *Esthétique Scientifique* (1865) by Charles Henry and *Naturalistic Photography for Students of the Arts* (1889) by Peter Henry Emerson further the reliance of art on perception with dialogue about the importance of perceptual understanding in the creation of art. In his pamphlet, Emerson presents understanding perception as one of the parts of study for successful education for the photographer. Within this approach, perception of images needs more than just attending to an image. The photographic art that has been produced, the image we see, is no more than a representation of things without meaning. It is given meaning by the viewer and it may not be the meaning the photographer intended.

"Art is not an object but an experience."

Josef Albers

It is the addition of meaning that moves the photograph to its artistic level. This is also where the creative energy of the photographer shows through most clearly. Artists have something to say and we must assist others in finding ways to put meaning into their photographs.

Though artists often do not consider their audience or art's nature as they create, obviously these considerations must be dealt with when considering teaching creativity. Understanding perception enables the photographer to communicate meaning and thus

their art to the viewer. Controlling how the perception functions for the viewer allows the photographer to be more effective and more creative.

"Memory images serve to identify, interpret, and supplement perception. No neat borderline separates a purely perceptual image—if such there is—from one completed by memory or one not directly perceived at all but supplied entirely from memory residues."

Rudolf Arnheim

Whether teaching creativity or aesthetics, while important, these are not teaching how to be creative. Teaching creativity, perception, and aesthetics are guides for the learner to see creativity. However, we want the learners to be creative.

"I try to give a sense of curiosity...questioning as to why. It is often about asking the question 'What if?' When successful I see people not accepting the standard fare that is put in front of them. I see people questioning more, asking more and see people exploring images more than they would otherwise, they approach things differently if you get through to them. It is like they make a jump from one state of reality to another kind of reality, or let's say a reality that is not real. When they realize that the world is not concrete, that it is flexible and malleable...that you can have a number of realities depending on your perceptual perspective.

The real teaching happens one-to-one, it's the 'Ah Ha' experience that happens one-to-one. And often that 'Ah Ha' experience comes very stressfully. What you see is very interesting, you see them struggling with what they have always felt to be true and they see that coming unstuck. There is a sense of internal confusion and then this clarity comes. When the clarity happens it all just falls into place.

I think that we kid ourselves if we think that there is a mass production way to do this, you can do your mass lectures and get people excited, but it is that little bit of finishing that gets people over the edge where they become fluid thinkers rather than concrete thinkers that happens one-to-one."

Siegfried Marietta
Griffith University, Australia

Communicating a Unique Voice

At a lecture in Tornio, Finland, the audience was asked how many languages they spoke. Because Finland is a small country with a unique language and a sizable minority lingual population, multilingual speakers are the norm. Most said that they spoke three to five languages. Then they were asked, "How many languages do you need if you have nothing to say?" When we look to teaching people to be creative, we are looking at how we will help others find and use their own unique voices...how to help them find the ways to communicate things that they want or need to say through their photographs—and perhaps even to encourage the learner to find a passion that requires voice to illuminate their desires and meanings.

"I have nothing to say and I have said it."

John Cage

The power of the visual language to communicate beyond the verbal is key to teaching creativity in both its active and passive forms. Photography, as many other arts, can give meaning to things that are beyond words. As was discussed in the previous chapter, in photographic language the techniques are the syntax and grammar of this visual language and the creative process provides the meaning (semantics). It is not an issue of the tools but it is what the tools allow and help you say.

"For young learners, my role is to make them see what is around them and try to their best to show us what they see. I tell them that everyone sees around them but many times there is more to their stories if they don't include every single thing in the picture, to get up close and take parts of things and those parts of things would give a better view with more imagination. Pay attention to the small things."

Emily Stay,
Gilmour Academy, OH

Though design elements are sometimes presented to exemplify creativity, they are only tools for the communication that is important to be creative in photography. Design elements give a style, look, and dynamism and become the underpinning for successful communication.

If design elements and the tools only present the pieces of meaning, what drives differentiation of the creative? The unique voice is what we then see as the definer of the creative and art. "Originality, then, is what distinguishes art from craft. We may say, therefore, that it is the yardstick of artistic greatness or importance." H.W. Janson states this in his book, *History of Art*, and goes on, "Unfortunately, it is also very hard to define; the usual synonyms—uniqueness, novelty, freshness—do not help us very much, and the dictionaries tell us only that original work must not be a copy, reproduction, imitation or translation."

"Shall I tell you what I think are the two qualities of art? It must be indescribable and it must be inimitable."

August Renoir

If creativity is to be linked with a unique communication value of photography, then teaching people to be creative is about teaching people to find things to say that communicate what they see and/or feel. For younger learners, many times our most important job is to assist learners to understand how they will find something to say as well, but we will be successful in helping others to be creative when we help them find "their" voice for their views.

That is the real path to being creative and teaching others to be creative—expressing uniqueness. This can be stressed through lectures, examples, assignments, and critique. However, it is an issue of freedom of expression and we must admit that the uniqueness is not described in difference but in individuality. People can and do see and say things in similar ways. In assisting others to learn their own voice, many times we need to direct people to see the difference between following fashion and following their feelings.

"You can teach creativity by teaching habits of the mind, taught to be fluid in their mind, to search for remote relationships between subjects. You have to set students on a pathway seeking information and constantly striving to do their best."

Betty Lark-Ross
Chicago Latin School, IL

As we can consider any journey through learning and knowing to owning for technique, we can also approach the same journey for creativity. Similar to technique, we can see a method of learning to

77

be creative as a somewhat linear process of steps that ultimately resides in the learners' understanding of how they will communicate through photography and finally going out to just be creative.

Ruth Foote, photography instructor at Owens Community College, Toledo, Ohio, has a nice method to help her students find their voices. As is true of most of photography, she uses the tools of technique to bring her students into seeing their unique visions. Her approach, as she teaches basics of imaging, is to have her students take their contact sheets and cut the individual frames apart. At this point the students are asked to arrange the pieces to create groupings of similarities. This is repeated using differing filters for separation and association. The outcome is that the students start to see that they have a way of seeing and a preference for other visual structures. They will also be able to see how they migrate to similarities in subjects.

This can be done in a computer through any of the "contact sheet" enhanced programs, though it tends to be less instructive for the students. The physicality of separating and moving the images allows the students more time to realize more about their visual language as parts are realized. For some, it will even allow kinesthetic learning to assist with finding language. Also, because the pieces are loose, they need not be linear in any way.

"An association is often said to be a matter of contiguity, which means a neighborhood of two items in space or time or both. We know that this condition, a short distance between objects, favors their unification in perception."

Wolfgang Kohler

Technique versus Creativity

The technical ability to easily reproduce the world realistically came to fruition with the introduction of photography. The introduction of photography meant that artists did not need to struggle with realism but did need to find a unique point of view that would give voice to their ideas.

"One of the challenges in teaching photography is balancing technical and visual instruction, especially regarding digital technology. Though it may seem obvious when a compelling image is poorly printed, it is often less apparent when a beautifully crafted print has little meaning."

Terry Abrams
Washtenaw Community College, MI

From a visioning assignment; by Howard Call, Owen Community College, OH, student of Ruth Foote

While teaching others to be creative in photography tends to be at a higher intellectual level than photographic technique, it must be seen that the creative is not necessarily tied to technique or vice versa. Too often, particularly with younger learners, the success exhibited in technique is misconstrued as being creative. It is natural for learners to see their triumph in photographic technique as accomplishing a creative act. It must be clear to the teacher as well as to the learners that technical aplomb and being creative are two distant and separate concepts. As a new teacher, Barbara Houghton, of Northern Kentucky University, was challenged by students about imaging technology that was outside her expertise. Being a new teacher at the time, she asked her friend, Robert Heinecken, what to do. He said to "tell them that you don't know and you don't care, because that is not the way you make art. You don't need to know everything."

If we must look for messages to encourage creativity we must look for ways that do not solely stress the technique. While the technique is important in successfully communicating meaning, techniques alone seldom provide the meaning of a photograph. Therefore, teaching creativity is not about how to make a photograph but about why we want to make a photograph.

> "I live in my own world. I go about looking, seeing, studying, observing, but the world I create is my own."
>
> Thomas Wolfe

Technique can be objectified, while the creative problem resides outside the technique regardless of how different the tool is that is used. Thus teaching others to be creative is more an extension of the persona than of photography itself.

Breathing in Photography

At a recent lecture, photographer John Sexton shared a concept of inspiration. He stated that the meaning of the word "inspiration" comes from "breathing in." Breathing, of course, is a naturally occurring event for healthy humans—bringing air into the body is how life is sustained. As John went on, it was clear that *to be inspiring* is to help others learn to bring in the concepts of life. For learners, "breathing in" life experiences becomes the source for being creative.

Teaching others to be creative is not magical, but it is inspirational. Inspiration is what teachers must give to the learning photographers

that will enable them to make images that go beyond technique to include meaning.

One of the best ways to show technique is by looking at examples of technique. This can also be said for creativity: examples of meaningful images can inspire learners to see avenues that they might be able to use to express their creativity. The same can be said for dealing with creativity. Examples of successful photography illustrate as well as inspire learners to find their voice through photography.

Different or Creative

Too often creativity is approached by telling learners that they must strive for difference and that this is the maximum method to express their creativity. This has little validity, or at least in the parlance of design, "There is nothing new." Being different for difference's sake does not exhibit creativity or communication, only difference. The mere fact that the work takes a different technique approach does not automatically provide the communication that is needed: it just makes the work technically different.

Learners need to realize that their quest is for uniqueness and not difference. This may be an issue of looking at their subject differently, but this is not a priority of being creative. Within photography there are many instances of people working in similar ways and still giving the viewer unique communication. Artists working in what is called "straight photography" have always had different approaches to their visual world. Uniqueness is an issue of vision and style, not technique. Most often difference and novelty show in technique, and uniqueness is exhibited in point of view.

Uniqueness may be "outside the box." Many times, thinking outside the box is easier if a person is kicked out of the box—the role of a teacher may be pushing the learner out of the box of their comfort level. A method that can be successfully used to assist learners is to have them look in a different direction as they photograph—away from the direction they normally use to make their photographs. This may be accomplished by having them look down as they shoot, instead of looking through the viewfinder, or by having them hold the camera at arm's length. However, this type of project only touches on the major emphasis that must be used. Normal camera use can lock conventionality into the learner's process. Looking askance is one approach to making photographs, just as differing techniques are also

81

approaches to using tools. Creativity may need to be a different view, but difference must give the unique voice to the photograph to qualify as creative.

The idea of looking in a different physical direction becomes a metaphor for approaching the creative concept from different points of view. We need to assist learners in approaching their concepts by taking views that do not necessarily correspond to their previously expressed ideas or concepts. This approach is not novelty for novelty's sake, but is meant to assure that the idea of communication uses the best avenue to reach an end result. The reason for novelty is that it has an effect on the audience, attracting their attention and thus allowing better communication from photographer to audience. Photographs need not look physically different, but it is important that they communicate in the unique voice, representative of their maker's creativity.

"I do not photograph nature. I photograph my vision."

Man Ray

Technical creativity is most often found as an expression of experimentation. To make technical creativity a valuable imaging tool, experimentation needs to be replicated to achieve a purpose. While this type of creativity can be encouraged, it has to become clear to the learner that technical creativity is short lived. Creativity expressed by manipulating a technique can quickly become only a tool and can lose its communicative impact. If learners spend a majority of their time on creating new ways to produce photographs, they have limited their voice to the technical and have stifled their ability to present issues outside technique.

Using Art

"I don't show my own work in an intro class because I don't want the students hung up on what they think I expect. I tell them outright that I will never give them an assignment to make a photograph that you have to make. I want you to figure out how you want to address the assignment. I make my own photographs...I don't need you to make my photographs. I want you to figure out how to make your photographs because it is not about what I like."

Rebecca Nolan
Savannah College of Art and Design, GA

Looking at photographic art can have a major impact on learning to the creative. As learners mature in their photographic skills, looking at bodies of work can help clarify what is meant by a unique voice. Though it is interesting and informative to view single images, a body of images presents the learner with more information about how to

While it is important to learn the history of photography, this is different from purely looking at and discussing images. The chronology of photography has much to say about how artistic movements and genres interrelate. It is the process of looking at images, with a concentration on the images in front of them, that provides learners with the best potential for using other photographs to inspire creativity.

It is important, along with looking at art, that learners discuss, interact, analyze, and derive meaning from the images. For the most part, this restricts this type of learning to promoting creativity for more mature learners. The choice to look at and analyze bodies of work pushes this type of activity into a more structured educational interaction. Whether through the use of books, slides, exhibitions, or artist presentations, this tends to promote dialogue about images. The outcome of this activity should not be seen as promoting the copying of the stylistic constructs of the images, but rather as the way of coming to understand artistic communication.

As discussed earlier in this chapter, this type of learning activity is somewhat passive. The effort needs to center around the concept of creativity as a stimulus to being creative.

"There are two ways you can be influenced by other's work. You can go after the work and allow yourself to be influenced by it as someone who loves that work, emulates the work and works in a similar way. And you'll work through it if you are honest with yourself and you keep challenging yourself....Or you can go at someone else's work as a frightened insecure person who doesn't know what in creation you are going to do but...you 'kinda' like this, and that will let you get the assignment in...and you will be in trouble."

Barry Anderson
Northern Kentucky University, KY

83

Photography may be the art that is being taught in a class, but it need not be the only art that is used to teach creativity. A broad understanding of communication techniques within various artistic disciplines gives learners a better grasp of the potentials of photography. By bringing into

the class examples in the performing arts and the musical arts as well as in the visual arts, the instructor can help learners relate to and understand communication, meaning, and passion while making strides toward being creative with the photographic tools they are learning to use. It is well to remember that art is not limited to the visual, nor is creativity.

Learning Creativity from Nonlinearity

Frederico Fellini said in an interview, "Every one of my films starts with confusion." On the advanced end of the discussion of creativity, and ways to engage the learner in creativity, is the area of nonlinearity. Being creative, the event, at its most astounding level, is often nonlinear. It does not come from logic in Cartesian scientific methods, continued directional research, work, or experimentation to solve problems, but many times the greatest impact of creativity appears serendipitously.

Part of nonlinearity is the concept of chaos. Chaos is often defined as randomness and lack of discipline. It is neither...instead, chaos can be defined by rigorous mathematics and creativity resides at its boundary.

Within chaos and thus creative activities that use nonlinear dynamics, close inspection shows several factors, including similarity or reoccurring structure. Similarity, not copying, is an important point in the nonlinear world. As iterations control the development of a system, reoccurring forms emerge regularly. Just as this happens within nonlinear systems, it is a method of working photographically. By including nonlinear aspects into the creation of photographs we develop a dynamical system. As this creative system continues, we can see the individual images as fractals that move from one image to the next, growing and passing the creative emphasis and further delineating one photograph into a series.

"You need chaos in your soul to give birth to a dancing star."
Friedrich Nietzsche

Dynamical systems can look as stable as granite or as fluid as magma. Creativity can also tip from stability to chaos, and this can be either very good and reinforcing or destructive to the photographic process. When we wish to understand a dynamical system, we try to identify the changes from stability and the initial condition. Our goal is to assist learners to push the system to the boundary to find the point just short of instability to maximize the creativity.

By Aaron Abram, College Poole and Bournemouth, United Kingdom, student of Roy Winspear

Regardless of a system's structure, there is a force that holds creative patterns together. These are called "attractors." The attractor in learning creativity is an idea that will dominate the passion of the photographer. For our purposes in this discussion, an attractor is a concept that affects all parts of the mental and physical processes of making images. Like a string that restricts the path of a weight moving on the end of the string, within post-modern photography the concept of the intellectual-ized narrative became an attractor promoting differing aspects of a written dialogue in the photograph, rather than having the image tell the story.

Different interpretations of a scene, the "initial condition," lead to differences in images of the scene, and this is a way to see non-linearity in image making. The uniqueness of the artist's voice allows different photographers to approach the same scene and come away with dissimilar images. This divergence of expression needs to be exploited to increase the creative learning potentials. Learners are provided with a creative way to look at making photographs, not by reducing the scene (reductionism) but by defining their unique reaction to the initial condition. That reaction becomes the attractor in the dynamical system and the means to communicate from the scene.

"One of the concepts I introduce to my photography students is that they are learning a new language; it is another way of communicating. In the Peace Corps, while in Turkey, we were told by an old gentleman a proverb that said...'Bir dil, bir adam...Iki diler, iki adamier'...One language, one man,...two languages, two men."

Lex Youngman
Wingate University, NC

Observing a learner's photography for a period of time and within the structure of a class might indicate that a style of picture making has developed, yet a completely different way to make pictures could be just as natural. It is at this point that an instructor can "bump" the learner, or encourage the view of a changeable "intransitive" structure. A system can stay in equilibrium success-fully, maintaining only one of many ways of looking at an idea of making photographs, until an outside force encourages a change. Bumping is a role to help others to be creative. Turbulence is the reality of a system reaching a critical point where the forces within

the system can no longer easily allow calculation that predicts action. When you look at the system near chaos, you can see the turbulence...that is creativity.

Creativity must start somewhere, and order is a reasonable beginning point. Order is the background that creativity happens in front of. It is very important to acknowledge the history and linearity provided by the *status quo*. The quiet order of normality, the structure of the common, the regimen of history—all permit the creative process to extend beyond expectations and to project its turbulence against a stable structural background.

Within nonlinearity are several other areas beyond chaos. Two of these areas bear on this discussion of creativity. These are self-organizing criticality and coherent structures. Both of these structures relate to life cycles of art and creative endeavors.

The easiest way to define self-organized criticality is to describe an avalanche of sand. As individual grains of sand build up in mass, the load settles and shifts to find equilibrium. At a critical point, equilibrium disappears as one or more grains slide, changing the balance. This causes more grains to lose their stasis until an avalanche occurs. The trauma of the avalanche returns the system to equilibrium. Conditions in the organization of the grains determine the size or duration of the slide.

87

We need to look at ideas as self-organizing in the way paradigms propagate. Earlier we mentioned that paradigms were a method that can be applied to solving groups of problems. When a paradigm becomes strong, it is because it has used this same characteristic to start an avalanche of followers.

Solitons (a word introduced in the 1960s to describe a solitary wave motion) are nonlinear structures exhibiting a unique one-time concept. A tsunami is a soliton. A tidal wave gets started by a disturbance of small consequence on the ocean bottom, far at sea, and as the sea moves the soliton is created by the shape of the bottom. As the disturbance reaches shallow waters, the force of the bottom pushes the wave up. The 2004 tsunami in the Indian Ocean created only about a 1.5 foot (0.5 m) rise in the ocean's surface at sea, but 40 or more feet (13 m) at various locations on the coasts. The unique thing about solitons is that they move in a coherent form until dissipated through entropy or until they crash into something, such as the shore. Regardless of the cause of the wave, it moves across the sea as a single force.

These two nonlinear effects, avalanches and solitons, are mentioned in this discussion because they define the way creativity becomes part of our history. Movements in art tend to be self-organizing and either create an avalanche or slip to equilibrium. In photography we saw this with "Pictorialism." A movement takes hold and similarities of creative thought emerge because there are similar "attractors" working within the structures that are solving visual problems...being creative.

If a movement organizes itself in a way so that it can continue, then we can see the soliton as a genre or school. Fads in fashion or art movements are flashes in the pan. In neither case is creativity responsible for the effect. Formalized creativity can be seen as an attribute being dragged with the avalanche or riding the wave.

Embedded within the walls of an institution are the local conditions that make creativity possible. Of all the factors that lead to understanding creativity through nonlinear thought, foremost is the idea of the "local condition." Within nonlinear development the local condition, the starting point, determines the end. It is more than just where the creative process starts, but also what is around when it starts influencing the outcome. Abraham Lincoln said, "What has once happened, will inevitably happen again, when the same circumstances which combined to produce it, shall again combine in the same way." While the same attractor is at work, the results will be different if the initial condition is not the same.

The influences—faculty, community, the availability of equipment, fellow students, and space—will affect the outcome of the creative process. It is within the learning process that the creative energies can start. What is present will act as an attractor around which creativity can emerge. What is present becomes the algorithm, and as a group we can self-organize, perhaps to the critical point. These are the things that can develop creativity.

Watch Out! They're Stopping Creativity

It seems strange that institutions that are self-acclaimed as the stronghold of creativity, schools, colleges, universities, and departments of art have a difficult time in accepting true creative behavior. This is a critical issue facing those in the education of photographic artists. What many art departments teach is not an increase of creative output, but rather improvement in current acceptable aesthetics. Just as being an artist takes commitment, so teaching can take on an aspect of

that commitment and it becomes a commitment to aesthetics rather than to the learning of others.

"I know that most men, including those at ease with problems of the greatest complexity, can seldom accept even the simplest and most obvious truths if it be such as would oblige them to admit the falsity of conclusions which they have delighted in explaining to colleagues, which they have proudly taught to others, and which they have woven, thread by thread, into the fabric of their lives."

Leo Tolstoy

As a discipline, criticism is also culpable for the poor state of creativity in both education and production. While critics talk about expanding the horizons of the art, the genres and schools of thought prevalent in artistic criticism of the day hold off inroads by other emerging or practiced directions. For many, the vested interest in continuation of any current artistic direction outweighs acceptance.

89

"Creative minds have always been known to survive any kind of bad training."

Anna Freud

Even something as seemingly benign as using faculty art in the creative lessons might appear as if it can stifle the desired outcome of helping others find their creative energies. The problem with using examples of faculty work as instructional aids is that learners will often wish to impress the teacher by doing work that looks like the teacher's, and thus having altered their own voices. This can mean that learning to be creative is sidelined by the wish to impress the instructor with "the most sincere form of admiration"...copying.

"Speak the speech I pray you as I pronounce it to you..."

William Shakespeare, from *Hamlet*

Building Outhouses

Creativity in and of itself means the act of creation, and the creation in this sense is as easily a snapshot as a narrative documentary photograph. Frequently an artificial divide is erected between creative photography

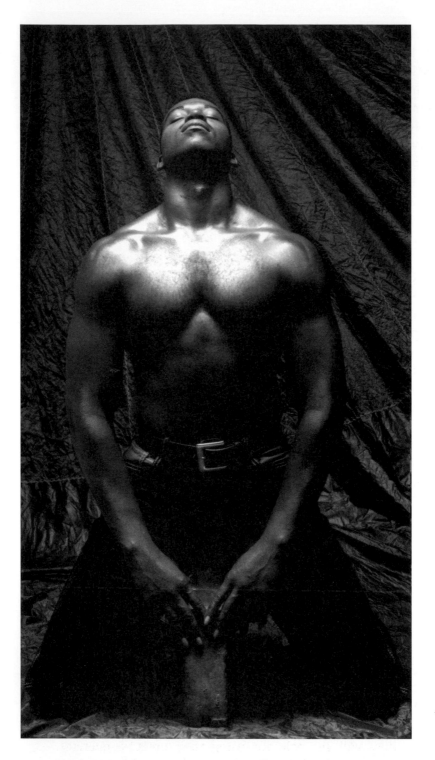

By Matthew Drake, Lansing Community College, MI, student of Ike Lea

and other forms of photography. This is misplaced and can stunt the growth of the learner in the approach to becoming creative.

Within artistic endeavors there is an intellectual battle to create differences among types of creative photographic utilization. Normally the distinction uses terms such as "high" or "fine" to separate "higher art" from a perceived lower form of art or craft, and particularly from commercial pursuits. It is not uncommon for those on the "fine art" side of photography to view creativity as in their domain and not part of, or as accomplished within, the applied side of photography.

Creativity exists in engineering as well as in photography, and of course even in building outhouses. Being creative is the major tool of all problem solving. The creative tool splits two ways—as applied creativity (commercial photography) and as expressive creativity (fine art photography). The *Focal Encyclopedia of Photography*, 3rd edition, lists about 100 different kinds of photography/photographers. Here are some of them: Aerial Photographer, Advertising Photographer, Biomedical Photographer, Fashion Photographer, Fine Art Photographer, Food Photographer, Forensic Photographer, Landscape Photographer, Military Photographer, Photojournalist, Portrait Photographer, Scientific Photographer, Sports Photographer, Wedding Photographer. These categorizations do not mean that any one title is restricted exclusively to commercial endeavors or that any one title inherently represents a higher level of self-expression. Rather, these are nothing more than titles that can be used, or misused, to classify, because they both have a place in both worlds. Many successful commercial photographers, such as Duane Michals, Joyce Tenneson, and Annie Liebovitz, exhibit and are recognized as artists. On the other side, recognized artists such as Michael Kenna and John Sexton have their art used for commercial ends. Once when Bruce Davidson was lecturing he was asked by a student if he considered himself a fine art photographer; he simply replied that he considered himself a photographer, period.

Viewing creativity as a tool and art as a step leads to a simple understanding—there are just three differences between the "fine" art photographers who revel in their self-expression in art and the applied photographic artist who works for mass consumption and commercial use. First, applied photographers know that they will use their creative energies in the pursuit of money. They know from the beginning of the job how much they will get paid for using their creative energies. "Fine" art photographers hope that when they finish the self-expression

91

that they will get some money for their efforts. Second, applied photographic artists freely admit that they use their creativity to provide sustenance, while "fine" artists rail against that fact. Last and most important, applied photographic artists solve other people's visual problems, while artists working on self-expression must define their own visual problems. Beyond these three differences, all photography uses the same tools, and universally all use creativity. This has been true from the beginning of photography. Thus photographic art is creative problem solving for the eyes and mind.

> *"Conditions for creativity are to be puzzled; to concentrate; to accept conflict and tension; to be born everyday; to feel a sense of self."*
>
> Erich Fromm

Understanding this difference between these two areas of photography is the realization that photographic art is not an end but merely a step. The creative energy used to make photography is a tool to give voice. Education often tells us that art, whether photography or another medium, is a zenith experience, but it is just another step of the life experience—a method for our unique voices to communicate.

Creative Success

Regardless of how learners arrive at their unique vision and voice, this alone will not sustain them to continue to make photographic art. At its most basic, the underlying differentiation between those who make it as artists for the long haul and those who do not is the passion they bring to their photography.

> *"I take the philosophical point, your edge as an artist is what you are passionate about. It's the only edge you've got. It is the teacher's obligation to help the students discover that. If they can find one pathway to passion for a limited time, that is enough."*
>
> Kim Krause
> Art Academy of Cincinnati, OH

In concluding this discussion and this chapter, it needs to be noted that critics often find it difficult to appreciate creativity in its first moments. In an article in *Art News*, November 1999, the following quotes were listed, revealing the way artists or art

movements were described at the beginning of their career or at the start of the genre:

> "Degas is repulsive." (Comment by a prominent art critic over 100 years ago)
> "Matisse is an unmitigated bore." (*Chicago Tribune*, 1913)
> "The Dada philosophy is the sickest, most paralyzing and most destructive thing that has ever originated in the brain of man." (*Art News*, re: 1921 Dada show)

93

Ferris Wheel; by Sasha Rudensky, Wesleyan University, CT, student of J. Seeley

Understanding the Nature of Problems, Solutions, and Assignments

"Physicists like to think that all you have to do is say, these are the conditions, now what happens next?"

Richard P. Feynman

95

One of the truths of photographic education is that we solve problems to learn. It is through learning by doing that we make the greatest strides in learning photography. In rough terms, the majority of the active learning situations in photography are seen in the assignments we give. Though we cannot deny that research is active in many cases, it is through use of cameras, computers, and processes that the learning happens at its highest levels. The assignment gives us a chance to direct discovery and learning.

While learning can include information acquisition, in photography most of the learning to make images is about solving problems within the processes and methods. Understanding the structure of problems, their solutions, and how to use this information to build assignments enables us to better assist others in learning photography. We will be taking a generalized view of problems and solutions and then applying these ideas to the creation of assignments in a way that assists our structuring education in photography.

We have chosen to approach the subject of problem solving in an abstract way first and then will move on to discuss assignments. This first

approach will be in a more theoretical manner because problem solving is involved in most areas of photography, and thus to concentrate on a few aspects would tend to miss how problem solving pervades and is at the core of learning photography. Also, we are enlightened by how the structures of the solution that are arrived at impact what we can do with problems in our educational pursuits.

Structure of Problems

Problems can be broken down into types, but as in any real world situation they will take on differing levels, dependent on the environment, the situation defining the problem, the tools available to solve the problem, and the person(s) trying to solve the problem. What we do find is a very limited set of structural attributes that vary in intensity within problem types.

"Teaching is also problem solving. You have to be flexible enough to spot the learning problems and be able to solve them."

John Tonai
Brooks Institute of Photography, CA

Complexity of problems is the first structural element we will delineate. We often try to define the problem/solution environment by the number of steps involved. It is oversimplifying to correlate the number of steps needed to present or solve the problem with its complexity. Complexity of a problem or assignment is often associated with difficulty in solution, but this may not be the case. In photographic education we need to look at the inherent complexity of various photographic processes. Shortening or easing the problem or solution to meet our educational objectives may be required.

Further, this complexity develops a linearity of problem/solution loosely based on the time consumed with solution. The temporal aspect of problem solving is of course important in the structure, but can lead us to misconstrue importance based on simplicity of statement or perceived time requirement for solution, rather than on difficulty of the problem. In this way we might see lighting and photographing glass as being more difficult than lighting and photographing an environmental portrait, not based on the difficulty of the problems but based on the time and steps involved.

We can also categorize complexity of problems based on how we see their dimensions or degrees of freedom. We might see a *linear*

single-dimensional problem as requiring simple general exposure through a simple equation; *path-determining* problems such as event photography that are linear in two dimensions as events needing more complex exposure; *deterministic two-dimensional* problems such as advertising photography as having degrees of freedom built into the problem set because of message control; *interactional three-dimensional* problems exemplified by free expression in fine art photography as having subject, intent, and technique as dimensions; *time-based three dimensional* problems such as documentary photography as working in four dimensions because of the addition of time constraints to the preceding concerns; *complex process manipulation* seen in computer animation within captured images as requiring problems to be solved in the preceding dimensions, in coordination with software functions, producing a five-dimensional problem; and we could continue through outer space to more and more dimensions.

> *"In [our] photography [program], we bounced back and forth between Minor White and Ralph Hattersley. We would go to Minor and we would learn the Zone System—and how to scrutinize a picture for an hour. At that time, most of the students thought he was really weird. In retrospect, it was a major part of our education—what a picture is and how you deal with it—every minute detail of it."*
>
> Carl Chiarenza

97

An important attribute that we sometimes overlook is the structural requirement for and accessibility to a solution. While some problem structures require solution or suggest its availability, other problems must be viewed as insoluble. We can accept that there will be a solution for finding an equivalent exposure, while it is not as clear that we can know if "straight photography" or post-modernism is more important. In some cases there will not be answers, just questions. The structure of a problem cannot avoid dependence on also defining the solubility of the problem.

Another structural element common to problem solving is that problems and their solutions often suggest, or are suggested by, a process. The processes vary but they have procedural or operational functions. In many ways these aspects of the problem structure do more to define the type of process than any other attribute. A developmental problem such as the Zone System defines the problem as a necessary condition of the procedure used to solve the problem.

In photographic learning, the rules for many parts of the process take on great import. The rule setting is the role of the teacher and creates the active path that learning will follow. This is most visible in the creation of assignments but is also clear in the structure of rules explained in demonstrations. Because so much of photography is made up of small and usually interrelated linear processes, the rules within and between these elements of the photographic process are needed to both do and learn photography.

Rules are pivotal in all problems, as they must be in developing assignments. This is because they define the processes and acceptability of solutions. The rules relate ideas, events, and steps of the process and/or actions needed to accomplish other ideas, events, steps, and/or actions. Part of understanding and preparing to solve a problem is in determining what rules will be used in the process. The inverse situation is also true; the knowledge you have for the problem determines the scope of the rules that have been used to set the problem. Therefore, explaining the rules that will be used for an assignment is critical if learning objectives will be accomplished. With a low level of knowledge built into the problem, the rules are weak; the structure will be less clear and solution more difficult.

"Determination and perseverance move the world; thinking that others will do it for you is a sure way to fail."

Marva Collins

In normal situations the rules take on an "If-Then" format. The rules become the way the structure and solution must function. In this strange twist, many times it is the rules of the problem set that determine solubility, and not the other factors within the problem set. An assignment that states that the student must make a portrait using continuous spotlights in the studio will produce different results than if the rules require the use of only window light. While in both cases a portrait is to be produced, the light quality differences will produce vastly different solutions.

An overriding rule that affects all other rules is "rules have exceptions," and this to some extent contradicts all rules. The way around this contradiction is that we must also have principles that supersede the rules. While rules are finite and tend toward precision, principles allow for both interpretation of the rules and creation of new rules as conflicts between rules emerge. If the principle for an assignment is to

have excellent photographs to critique, then the critique can continue even if a student does not meet all the expectations presented in the rules of the assignment.

Last, there needs to be a problem solver. Most problem solving is a human event that can add a creative aspect. While today's machines can "do" processes, their abilities to effect solutions must be programmed in, thus negating any claim to their being a creative machine. This brings in the mental aspect of the problem structure. Perhaps the hardest area to judge as structure is the mental aspect of the problem.

Types of Problems

To help us make better assignments leading to our stated learning objective, it is helpful to define problems. There are five distinctive problem types that can lead to different objectives in differing learning domains. These are technique, puzzles, experimenting, artistic, and paradoxes. Whether intuition, imagination, or ingenuity is used to solve the problems that are the basis of our assignments, problems function at differing mental/academic levels. While not totally exclusionary in the layout of this discussion, learning levels are presented hierarchically, with easier or less mature problem/solution structures presented first.

Technique

Technique problems in photography are like mathematics. For most of mathematics there are answers or expected outcomes for problems. Also, much of photographic technique is based on mathematical considerations such as measure and calculation. In the simplest sense then, photography presents the same workflow through its techniques and processes as does solving most mathematics. Photographic technique and math problems, after the simplest level, become tool-based problems. Above all else technique problems are process determined. They have a strong operational paradigm with very specific rules for working out the problem. Operationally these problems strongly tend to be determined by linear steps in processes that are well defined by rule sequencing.

The technique problem base is highly defined, in both statement at the start and in the outcome, by rules that are empirically found. Photographers, as mathematicians, are always studying and refining their outcome tracks that will open potential deviations of process or thought. Those who can handle the rigor of the rule structure and the underlying technologies reach the appropriate solutions. Both photographic

99

technique and mathematics require vertical learning, with each new step and complexity built on previous methods and processes.

For the most part technique problems, like mathematical problems, are solution specific...they have right answers that are repeatable.

"Many instructional arrangements seem 'contrived' but there is nothing wrong with that. It is the teacher's function to contrive conditions under which students learn. It has always been the task of formal education to set up behavior which would prove useful or enjoyable later in a student's life."

B. F. Skinner

Puzzles

Puzzles are a type of problem that requires skill or ingenuity to solve. While puzzles take ability to solve, they have set solutions. Within this group of problems we find extreme levels of mental complexity that function in multi-dimensions. While some puzzles can be solved mentally, puzzles tend to be physical realities. Basic puzzles may be solved without cognitive effort by using other skill sets or learned patterns of response. For these reasons, formulating puzzles for photographic education makes for an effective and a lighter educational style.

The basic structure of a puzzle has three requirements. First, puzzles must have specifically definable solutions. In this way they share the same rigidity of solutions that are found in technique and mathematics problems. There are not incomplete or partially correct solutions. The idea of a puzzle is to get to THE solution. If you are assembling a jigsaw puzzle of a cathedral, then a picture of a sailboat is not the anticipated solution. Next, the rules for solving the puzzle must limit the nature and scope of the solution. While the steps of solution can be reordered in many puzzles, a rule from outside the puzzle set is not acceptable: no going outside the boundaries of the maze or using parts from other puzzles. Last, the steps used to solve the problem must be well defined. If the rules are not sufficient for the puzzle, then new rules are instituted to better define the steps.

A good example is the Rubik's Cube. When it was developed, the puzzle creators had several contests that gave prizes to anyone who could solve it at all, and with the fastest times being hours. But soon after, children found that if you did not care about the logic of the moves, there were a series of moves that would solve the problem manually as opposed to mentally. The time required dropped to seconds.

While there is creativity in developing puzzles, there is less creativity in solving them. Within the solution framework of puzzles is the distinct ability to solve the problem by rote or memorization. Even when the perceptual requirement is changed, there is a similarity of process for solving families of puzzles. Thus, once the elements of block puzzles are learned, then other block puzzles become easier to solve. Similarly, by using the puzzle concept to create photographic learning, the problem solution of the puzzle can ingrain patterned learning that will be useful for further process or method learning.

Riddles are intellectual puzzles. They share several concepts of puzzles while remaining mental in solution and process. Riddles are heavily reliant on arriving at the proper solution through the proper process. These problems revolve about the process of acquiring the one and only correct solution. While they can be intuitively solved, for the most part they are logic based.

Critical in the riddle as a problem is the why of the riddle. Riddles are often teaching or humor involved, with creativity coming in as a tool of defining the logical process that will be needed. As we look at riddles they also appear to be trivial.

101

Experimenting

Experimenting, as a type of problem, is useful both in education and research work in scientific pursuits and in learning photography. It is not uncommon that learning happens exceptionally when the learner "discovers" how something works. Many photographers report the excitement of seeing their first print develop. While the single instance of seeing a print develop is exciting, even more exciting is learning the relation of the various parts of the printing process and how they affect the quality of printing. We have students making work-prints simply to see changes and to perfect their printing process, as well as to correct an individual print.

> "Experiential learning is more effective than lecture or demonstration, so I try to maximize opportunities for students to experience the concepts and techniques that I teach."
>
> Terry Abrams
> Washtenaw Community College

Experimenting assignments are pursuits of validation and finality of ideas and processes through tool usage, and not the development of

those processes and ideas. Both photographic and scientific problems used as assignments are limited in scope and are defined by the rules that will be used to solve each problem. For these problems we need to use our minds, teamed with tools and perception, to work within the defined existing structure of knowledge.

Of the protocols normally used, one of the most limiting situations is insisting that the criterion for selecting problems is that they surely have solutions. Experimental problems try to make refinements in an already defined idea. This means that most of the time the experimenting is working on an idea that has already been proved and that solution to the idea is a foregone conclusion before the assignment is given. By refining, as opposed to innovating, success is assured. These types of learning experiences prefer small improvements as opposed to creative leaps.

"Science is always wrong; it never solves a problem without creating ten more."

George Bernard Shaw

Artistic

When we think of creative problem solving we are often brought to the discussion of art. Our societies have invested in the arts the mantle of creativity. We even have courses entitled "Creative Photography." However, it is the creativity-generating problem that is discussed here. Thus it is incumbent on us to search through this type of problem solving to see if there are any structural attributes that might be shared within teaching photography.

Artistic problems have a unique application of the concept of solution. While there is specifically an outcome requirement, there is not a requirement for a particular solution. As strange as we might think that this statement is, success in most cases of artistic problem solving is the end product as opposed to the process of solving the problem. We see this in the success of artists of all persuasions. Looking at criticism, there is seldom comment on the problem that the artist saw, because more likely the critic was more involved in the outcome of the process than in solving any particular problem.

"I believe that art must reach out to the viewer, yet at the same time leave them with more questions. With ambiguous answers at best."

Anthony Andaloro

In many cases the artistic problem solving becomes defined as artistic production (outcome) searching for a problem to solve. There is no solution, even though there is a tangible outcome. With so much intent on the process and outcome, often these become the definition of the problem. Artistic production is specific outcome-based, but not solution-based. An artistically based assignment we often see is…"To create a portfolio of ten prints on a personal theme." In this way the artist's completion of the portfolio is seen as the same as a solution. Here creativity becomes descriptive within the development of the process, but not in solving problems. While society has said that artists are creative, they are not expected to solve problems but to produce work that reacts to society.

To conclude this portion of this discussion, let us speak about the issue of creativity in artistic problem solving. Artistic/aesthetic problem solving is not necessarily creative. The model of problem solving that is shown in the pursuit of art does not present a good model for other creative problem solving. With the lack of an external problem structure and limited restrictions for solutions, the potentials for creativity are high. However, the pressure for tangible artistic output restricts creativity in many cases.

Paradoxes

There are problem types that cut across all areas that need to be addressed. The most obvious of these is the paradox. This is the type of problem that either has an apparent solution that through common sense seems contradictory but nonetheless is perhaps true, or is unanswerable under the structure that is used to define the problem. Paradoxes are common and they add an unusual amount of complexity to problem solving. The paradox often promotes or requires creativity for solution to make it past the common sense aspects of solution.

We have all seen classical paradoxes such as Zeno's Paradox, "How many grains of sand do you need to remove from a heap of sand before it is no longer a heap of sand?" Such paradoxes pose logical quandaries that make solution difficult.

Within the concept of paradoxes are also those that are self-referent. Self-referencing paradoxes assert and deny themselves. You can use logic to arrive at a contradiction. Epimenides' Paradox, "I am a Cretan, all Cretans are liars," is such an example. (A particular favorite on true and false tests…"The answer to this question is untrue.")

103

Mathematics uses the term "paradox" for the midpoint, to suggest a borderline solution or exceptions that can be fixed with effort. This is important particularly in discussing what happens between bits of digital information in an image when the value falls between two binary units.

We will find that using paradoxes in teaching photography will cause difficulties if introduced too early in the learning process. Just as koan is used in Zen training to open the mind, to change the way the world is viewed, a paradox used in a photographic assignment will force the student to view solution outside the normal and regularized problem-solving procedure. Paradoxical assignments can be both very enlightening for the students and exceptionally frustrating.

"If you have an important point to make, don't try to be subtle or clever. Use a pile driver. Hit the point once. Then come back and hit it again. Then hit it a third time—a tremendous whack."

Winston Churchill

104

Solutions

Perhaps we should start by defining solutions into two basic ways. While sounding simplistic, solutions can be broken down into those that solve the problem and those that do not solve the problem. Though this seems too easy and flippant, it defines a basic structure that makes learning happen through the pursuit of solutions. This is not an issue of success of the solution as a stand-alone idea but rather as a statement of completion of the problem.

Non-solved problems arise in two ways: either the problem is not soluble or the solution is not about the problem the solver was addressing. Not solving a problem because it has no present solution is a realistic possibility in many cases, but more interesting is arriving at a solution for a problem you were not working on. The non-solved problem remains, but arriving at another solution is a key to being creative. Creativity often is not in solving the problem at hand but in recognizing that the solution reached has its own power and importance.

Christopher Broughton, Brooks Institute of Photography, tells the story of how when he was a young photographer he was trying to photograph a sand dune in black and white with a red filter. But he made a mistake. He had forgotten to calculate the filter factor into the exposure. He realized this on returning to his darkroom and prior to development

of the film, so he overdeveloped the film. While he was trying to solve a problem, to get the negative to print normally, he ended up solving another problem, of defining N+ development to increase contrast.

The fact that a problem has no solution is not saying anything negative about those who try to solve the problem. Some problems are not soluble at the time or with the tools at hand. They may be problems of a level that will remain unsolved until the time is right.

Because there is a potential that within the solution structure a "No" solution may occur, we need to ask: What can be done and what cannot be done? When we start from this premise we allow the problem to help with the solution or to help us realize that the solution we desire will not be at hand. If we wish to succeed, then we need to look at this first idea of solubility as an issue of encouragement. The lack of the desired solution often fits into learning because, for learning to happen, the journey to solutions may be more important than getting there.

"Problems and defeats are stepping stones to success."
 Guadalupe Quintanilla

105

Creative Solutions

The easiest problems are solved by an answer engine...a systemized approach that gives answers to questions. Today we are blessed with computers that make this discussion easier. We can look at the program of the computer as a set of steps that solves specific types of problems. This algorithmic approach is well suited for many of the interrelated concepts within learning photography. This means that the steps of the solution take on a rigid form that is based on consistently applied rules, with all variations included in the instructions. This might be an assignment for making a good negative from a given lighting situation. It will require moving through exposure reading, setting the exposure, and finally to development. Like an answer machine, the linearity of this methodological problem solving cannot be creative.

"You don't go out to take pictures, you are taken by pictures."
 Ernst Haas

Certain problem types, particularly artistic and paradoxical, are not suited to solution by a linear process, thus are not easily solved by an

answer machine. One of the main components of creative problem solving is the ability to look at the problem or potential solutions from outside the system. The answer machine approach is un-noticing...it cannot notice facts and data not provided or directed to attend to it. The machines cannot pursue data external to their field without first being instructed as to what and where to find the information. What is needed is to "jump outside" the problem/solution set to see avenues that are not visible from within the set.

Even some of the "creative problem-solving" techniques are answer machines and will fall short for the needs of teaching the creative needs of photography. The use of problems that force solution outside the normal or require the addition of rules or data out of the ordinary will infuse creativity. For example, having the assignment require the image to have an auditory quality, not a picture of a sound maker, will present a problem that cannot be taken through an answer machine. It requires the learner to try things that may produce a creative output. It may be in critique or as the image is discussed that the student's creativity will be seen. For the few who may succeed at such a difficult problem, the light will go on...for those who do not find a solution, the process and critique can be used to bring forward opportunities to discuss progress toward their own creativity.

106

"To attempt to 'do something in a new way' appears to some to be both a noble and foolhardy prospect at best. However, to form this tension between past and present, to reassess and reform, can also relate to or be viewed as a biological necessity, providing an equilibrium that, as Mumford has described, 'is necessarily unstable and is constantly upset by the continued act of growth.'"

Nathan Lyons
Visual Studies Workshop, NY

Types of Solution Strategies

Whether a machine or human problem solver is involved in our solution, we can define types of solution strategies. In fact, some people act like machines when solving problems. The extremes of actions are what we will call linear and nonlinear problem solving.

Linear problem solvers are consumed by the solution's process. They commit to a process and believe that if the process is finished,

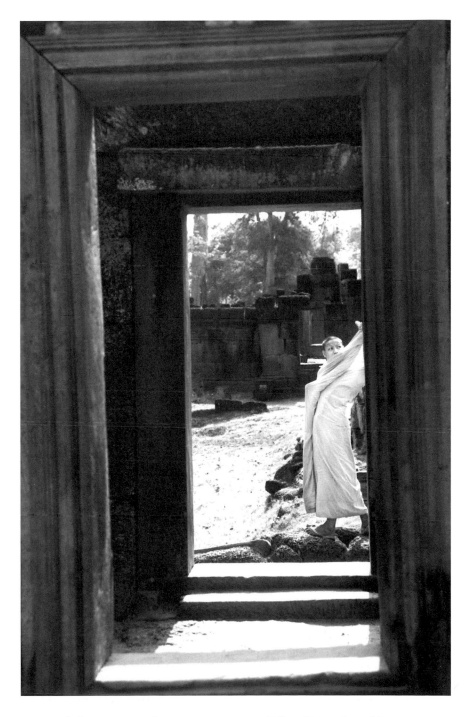

Monk; by Casey Woods, Austin Community College, TX, student of Sean Perry

then the problem will be solved. An assignment for these types of problem solvers is always defined by the rules. They tend work on only one problem or step at a time. If creativity is to creep into a linear solution, it will be in developing the process, but likely this means reading a new book, since linear thinking depends on previously discovered logic.

"To see if the students actually got the assignment, you should look at the path that they took. If you only look at the final critique it may appear that some have gotten it, some may have just happened upon it and did not actually get the learning, but if you see their progress you can see how they got it."

Gary Wahl
Albion College, MI

Nonlinear problem solvers are compulsive and do not commit to any process. Not starting until the last moment is not unusual for nonlinear problem solvers because they tend to be better under pressure and will often self-impose pressure if they need to get something done. Another way they self-impose pressure is by working on many problems at one time. They meet deadlines but continue to add complexity as they work, by flitting from one problem to the next, changing processes and arriving at each solution as it comes. This is very creative and hard to copy as a problem-solving system. The energy from one problem is shared with adjoining problems.

As we proceed in this discussion, we can easily see that what will become the crucial element in the probing of creative problem solving will be the people involved in solving problems. The difficulty with looking at solutions through their structures is how people function as part of and within structure.

There seems to be a widely held concept that the more the structure, the less freedom to be creative. Normally the rules that defeat creativity are those that restrict actions. To a large extent, as rules are added they will restrict solutions. On first blush this appears to be a strong case that the rule attribute of the structure reduces creativity in the solution. However, creativity abounds in some structures.

It is not that structure eliminates freedom; instead it promotes certain levels and kinds of freedom. Within structure there are ideas, such as information and interconnectivity, that provide the means for aspects of creativity to work their way into the system. Particularly in

108

open structures the rules of the set do not restrict information and energy, they focus it. The open solution structure accepts input during its process from beyond the bounds of the problem set, while a closed structure does not. Open structures exemplify creativity because they interact with their environments and absorb energy and new information as the solution emerges.

The rules for the structure can be one of two types. They can either be proscriptive or prescriptive. Proscriptive rules tell you what you cannot do while prescriptive rules tell you what you must do. This means that the structure of the problem will either direct solutions, such as a Zone System assignment prescribing process, or the problem will tell you concepts that cannot be used to solve the problem, such as in advertising photography guided by federal laws that forbid certain concepts. In either case, each provides a level of freedom that is encouraged by the types of rules used to structure the problem.

Types of Solutions

109

Just as it was helpful to realize that different types of problems function in different ways, it is a good to see the different way that solutions function.

Discovery

"Eureka"... I have found it. That is discovery—finding the solution because of awareness of difference, change, and/or newness. Discovery is most often an unplanned activity for the learner, but is not necessarily unplanned by the teacher. Younger students making photograms will often make discoveries about the way light penetrates various materials; these discoveries may someday serve them in working as photographers, printing negatives, and will inform them throughout their photographic careers. While the role of the photogram for the learner is to provide a way to make a picture, learning about light becomes the solution for upcoming problems. This is a prime example of how we use the concept of non-solution to bring us to another realization or to a solution we were not looking for.

"I know of nothing more inspiring than that of making discoveries for ones self."

George Washington Carver

The act of discovery includes more than seeing an anomaly; it requires identification of change in perception or application. The discovery takes place when the meaning that the discovery has on problems takes on its full scope of importance. This means that in the discussion of the photograms, these discoveries need to be included. Discoveries grow or diminish in their importance by the amount of effect they produce around them.

Evolution/Revolution

Often revolution is grouped and perceived as a more rapid form of evolution. The two concepts differ in time and visibility. During revolution change happens faster than with evolution, without the prime concern of problem solving. This said, with revolution usually some problems are solved. Revolution is not about the problems but is a method of change. Evolution, on the other hand, is all about solution and not about method of change. While we can create a series of assignments that may lead a student to evolve in their style or technique, revolutionary assignments will tend to be filled with energy but may not lead to learning or solution of problems.

110

"People seldom see the halting and painful steps by which the most insignificant success is achieved."

Ann Sullivan

Learners of photography normally evolve in the way they make images more than they are involved in revolutions of technique or aesthetics. Just as it is hard to see discovery because it deals with attributes not predetermined, evolution is difficult to see as a solution method because of its processes in reaching solution. The most important attribute of evolution's processes is its reliance on adaptation and feedback.

Innovation/Invention

Creativity in problem solving appears in both innovation and invention. These are the ways discovery and changes are used to actually solve problems. Innovation is the less strenuous of the two because it depends on a second level of discovery. When a discovery is perceived, the application does not always accompany. Innovation means that there needs to be a second step to the process that makes a discovery valuable.

When an innovation takes on a physical dimension, we see invention. All the attributes of the problem/solution set must be present along with the intellect directed to solving the problem. Within photographic education, these two problem-solving styles will be seen sparingly and most likely at higher levels of education.

"It is common sense to take a method and try it; if it fails, admit it frankly and try another. But above all, try something."

Franklin D. Roosevelt

Within our societies, we honor inventors for their insights and abilities. We see people who have a drive to apply discovery and form new "things" from emerging and changing ideas as the inventors. Their creativity is seen in the ways they manipulate their perception to be able to see the direct application (the innovation) and the physical result (the invention) of discoveries.

Resolution

111

The last type of solution is resolution. This is a solution that appears out of divergent parts of the problem set. Unlike evolution, it is not time based and people can be creative in resolving problems. The creativity comes in as observational and via juxtaposition of portions that allow for solution. Resolutions tend to be a negotiation among alternatives that open up potentials for solution that might otherwise be unobserved or unrealized. This is a working out of the problem set through investigation of various scenarios capable of providing solution. These solutions do not seem earthshaking because they are negotiated.

Since the artistic problem is more centered on the production of the product, the photographs, there are various avenues that will reach the outcome without actually solving the problem. This makes resolution a valid problem-addressing method, particularly with an ongoing body of work. As photographers work at making images they often select not the solution but one of many techniques or options to deviate from the present path. They may, for example, move from black-and-white to color, or straight to documentary photography to make the statements they wish more strongly. These decisions will bring about differently perceived works that may come closer to solution but are valued in their own right without the necessity of solving a problem. Many artistic problems do not have solutions...only resolutions.

Perhaps the easiest way to illustrate the differences and at the same time the interrelationships that can occur between many methods of solving problems and development of new ideas is to look at a brief history, from the introduction of photography through digital imaging. The introductions of the photographic processes in 1839 were examples of invention, and evolution of thinking and resolution through empirical research and discovery. As time went on there were improvements to the process of capturing light and making pictures. Many of the fine tunings of the methods represent both inventions and innovations. Problems were resolved as newer technologies and aesthetics were introduced. As we moved to our present, a revolution took place in areas tangential to imaging—the concepts of digital information processing and the information society's development. The revolutions in these areas forced imaging to evolve. While at its inception the introduction of photography was revolutionary for the art of making pictures, the move to digital imaging is evolutionary for photography.

Tools for Solving Problems

"To be a creative thinker one cannot rely only on logic. To be a rational thinker one cannot rely only on intuition. But the combination of logic and intuition provides the fuel for discovery."

Theoni Pappas

When we wish to assist others to learn to solve problems, and thus make better photographs, we have tools and methods to apply to the problems that face the learners. We can build into assignments paths that will tend to use certain tools for solving problems of photography. This is true of tools for learning technology and aesthetics. We will briefly discuss some but not all of the mental tools that can be used to solve problems. In photographic education, several solving tools, such as modeling, have limited application.

Logic
Logic is discussed first in this presentation of tools because it is seen as the major problem-solving tool of Western societies. As with most of our problem solving, this writing uses a type of logic as a tool for creating the structure of the presentations. Logic as a tool for solution is based on a strict structure—reasoning, ideas, and rules—not on the outcome. A good logical solution meets the statement of "goodness of

logic." That means the process follows the rules of logic and that those rules and processes are not linked to an ultimate solution. While most commonly correct in outcome, logic as a tool for solution can be flawed.

Logic is a conscious tool. It takes mental activity and at its most effective is a highly intellectual tool. When logic is in its highest form the thinking process becomes almost unobstructed as a stream of consciousness. Because much of photographic technology is a linear process, logic is a strong tool for teaching photography.

"Logic is the art of going wrong with confidence."

Morris Kline

Rote

Learning by rote is defining the way the learner will answer a specific question or solve a specific problem. The specificity is the issue. Rote problem solving works within narrow structural sets. The kids that can whiz through a Rubik's Cube are functioning this way. It is obvious that using rote in this way can solve the cube but not other types of puzzles. In photography, particularly for basic technique, rote solution has a great advantage. It leads to transferring the rote problem solving to knowing the technique and likely, when married to logic, to mastery.

113

Reduction

In certain types of problems the use of reduction of the set is a common tool for arriving at a solution. Particularly in the artistic, technical, or scientific areas problems are first approached by reducing the number of constructs in a problem. The idea is to simplify the path to a solution by eliminating aspects of the problem that are not important to the solution or that can be isolated and deferred. When viewed in terms of a technical problem this system works well. It is the concept mentioned earlier as "Asking only the right question." The more parts to the problem, the more attractive reduction appears.

This idea of reduction fits particularly well with technique. Many parts can function independently and within the same operating system. For example, in exposure the ISO, aperture, and shutter speed all can be used to compensate for lighting conditions. By reducing the variables, learning about the effects of only one is easier. With reduction of the problem, exposure can be set up to have learners come to a

solution using only one of the exposure variables. Reduction in this situation is holding ISO and shutter time constant, leaving the light in the scene as an independent variable and the f-stop dependent on the light.

Chance

> *"Give chance a chance."*
> Hans Richter

 Perhaps the least admitted to tool, yet the one that certainly can lead to solution, is chance. It is the least dependable tool for problem solving but is encountered by learners. The difficulty is that true chance is difficult to put into assignments in a consistent way. However, we should not assume that chance cannot be used to solve problems. While we may not be able to put chance into assignments with dependable outcomes, having the learners aware that this may arise throughout their learning can be useful.

> *"If we do not expect the unexpected, we will never find it."*
> Heraclitus

Enlightenment

With the enlightenment function, direct relation to the problem need not be present to reach a solution. It is often tied to discovery. The mind just snaps to a solution avenue with such clarity that you would have to be asleep to miss the solution. Since the ideas and solutions of enlightenment often happen in a near dream state, it is the ability to recover these ideas and solutions that is used to define the masters of many mystical pursuits. Enlightenment will be most useful for solving high-level problems and will be very difficult to build into assignments in photographic learning. This is a difficult concept for Westerners, since it is not part of our normal "logical" process.

 Not only is enlightenment like dreaming, it is closely related to humor. The same mental switch operations that allow you to see humor are in play when enlightenment takes place. Many scientists and researchers point to this fact in terms of a lot of laughter in association with major discoveries. Lewis Thomas, a noted scientist, said, "And I think one way to tell when something important is going on is by laughter." Both enlightenment and humor free the mind to see possibilities that the logical mind cannot see.

Visual and Verbal Problem Solving

An interesting problem-solving tool is to verbalize/visualize the solutions as they materialize. This is actually a perfecting tool more than an originating tool. Solutions coming from other tools often need codification to be understood. Particularly with mental constructs, the visualization and/or verbalization allow the idea to take on substance to be realized. When this solution process is public it takes on a differing form, by allowing interplay with other ideas. This is one reason that many disciplines require publishing of ideas and theories. It allows peers to react and perfect the constructs.

More important is the realization that as much as we might want, the likelihood is that there are many people who have ideas that, when added to our own, make for better solutions. New ideas are often not totally realized by the originator and this visualization/verbalization method makes it possible to use other sources to mature constructs. This is problematic if you need the credit solely for the idea, since others will have been involved. It is a decision based on whether the solution or the credit is more important.

Perhaps the greatest advantage to this tool is that it uncovers errors. This is because when we use the tangible, visual, written, or verbal, we make the solution open to others' and our own correction. This is the primary reason for open/group critiques.

115

> *"Education is the acquisition of the art of utilization of knowledge. This is an art very difficult to impart. We must beware of what I will call 'inert ideas,' that is to say, ideas that are merely received into the mind without being utilized or tested or thrown into fresh combinations."*
>
> Alfred North Whitehead

Feedback

Feedback is a mechanism that registers the state of the system as it compares to a desired state at a given time...it then uses this comparative information to correct deviations of problem solving. Feedback is goal oriented. The feedback for a system or process is the measure of the difference between the goal points and the present location.

For feedback to work as a problem-solving method there must also be process control for the solution—control that can adjust course, timing, or value in relation to the feedback measures. This requires the

problem solver, whether man or machine, to have the ability to effect change and not to just observe.

One of the most important features of feedback as a problem-solving tool is that it is not a static tool. Movement must occur for feedback to happen, fast or slow...feedback is about purpose, process, and progress and not about the status quo. If there is no change in the system, then feedback becomes unable to function.

"Being successful it is all about student feedback. You can see that the students have a good feeling about their own work and a feeling that they have really progressed. They are positive about themselves."

Ian R. Smith
Salisbury College, United Kingdom

An example of how this can "come a cropper" is the story of the instructor who sat outside the darkroom and gave feedback to the students as they brought out their prints for him to evaluate. In the process of learning to make prints, this seems like an optimum situation to use feedback for correction. However, since some of the students' results were not exhibiting change because of great negative density, the feedback was disregarded. The feedback became totally rejected when a student brought back the same test print three times and got new corrective action each time. The feedback needs to show movement toward the goal or it fails as a tool for problem solving.

Assignments

The most common way to use problems and solutions in photography is to structure them into assignments. The assignment as a tool puts together the various structural elements of the problem to move the learner through specific steps to an outcome that will support the overall objectives for the area of learning. Because the concept of the assignment is to use an activity-based learning method, the design of the assignment can go a long way to assure a desired outcome.

The learning presumably happens in a lecture, demonstration, or discussion, but it only begins there. To learn photography, assigned work (reading, problem solving, practice of skills, etc.) is necessary to continue the learning process. The teacher has such an attitude toward assignments.

Students often learn by a sad experience to look upon assigned work as drudgery or punishment. To the extent that they retain this attitude they fail to obtain the benefits that assignments offer. It is not uncommon for students to spend many fruitless hours on assignments. They often have little understanding of what they are required to do, and less comprehension of how to do it. In desperation, many students submit work that does not address the objective or in some cases may not even be theirs.

"No man can be a good teacher unless he has feelings of warm affection toward his pupils and a genuine desire to impart to them what he himself believes to be of value."

Bertrand Russell

There are three main virtues for giving assignments. First, assignments provide the practice that is necessary for learning photographic skills and tools. Without practice, the learning level will be poor. Next, assignments permit students to work at a pace more natural to them, partially free from the pressure of the clock as in a test situation. Students can take time to think about their work, to reference materials, and thereby to attend to more complex problems than can be usually put on a test. In many courses it is normal practice to assign a portfolio and/or term paper as an exercise in organizing, discussing, and criticizing ideas based on visual or academic research. Last, assignments permit the teacher to assess the kinds of abilities that are difficult to measure in tests, and therefore serve as grading devices.

117

"Set up visual problem-solving situations that gets students to think in ways they normally would not think so that they form a habit of setting up that type of situation for themselves."

Betty Lark-Ross
Chicago Latin School, IL

There are, however, disadvantages to assignments. To the extent that students are not practiced in the knowledge, tool, or learning objective, they may practice the wrong skills or may be completely baffled. It may take them several hours to solve a problem that they can handle in a few minutes if they had some help. Much of the time students spend on assigned work is wasted in misdirected efforts. Also, students resort to kinds of behaviors that interfere with their learning.

They postpone working on assignments until the last possible minute, they submit almost anything, regardless of its quality, and they try to meet the requirements without necessarily being concerned if the submitted work is appropriate for the assignment.

To create effective assignments we recommend the following guidelines:

1. Relate assignments to the objectives of the course, and make them pertinent to the subject matter. Never assign busy work.

2. Make assignments clear and definite. Write the assignment on the board, or, better, distribute printed directions.

3. Work out problem assignments yourself in advance, to detect blunders or common errors the students might encounter.

4. Assign small amounts of practice material frequently, instead of large quantities rarely. Students should expect some practices for nearly every class session, in addition to merely reviewing notes.

5. Set reasonable due dates and see that they are met. It is better not to downgrade late work, but instead to refuse to accept it altogether. The point to be made for the students is this: unless the practice material is worked on at the right time, the exercise is worthless or nearly so. Students will fight this policy, so it is well to prepare them for this policy more than once.

6. Make no assignment that you do not intend to correct and review. Such work is often depressing drudgery for the teacher, but if you do not treat the assigned work with respect, the students will not take it seriously either.

7. Return assignments with comments promptly, preferably before the session after they are submitted. Students need feedback as quickly as possible after the event if they are to profit from it.

8. Make assignments reasonable in terms of the time and effort required of the student. In many educational institutions, typical students are in class and/or studying 18 hours or more per day.

9. Once you have made an assignment, stick to it. Students sometimes try to persuade teachers to relax requirements and are most ingenious at devising excuses. Except in hardship situations, students should be held to the performance necessary for their learning.

10. Encourage students to submit written work, as well as major portfolios, in a well-organized format. Learning how to present material in an orderly fashion, properly cited and meeting

other educational requirements, is important. Furthermore, sloppy projects are hard to correct. By accepting untidy papers or poorly produced photographic projects, you are encouraging more of this kind of performance.

11. If an assignment is poorly done, find out what went wrong. Then repeat the material and assign additional practice items. On the assumption that the learning is important, it is clearly wrong to let go and move to new material. Students dislike re-doing assignments, but it is necessary for the teacher to convince them that trying again (and perhaps again) is an essential part of the learning process.

12. Help students to understand that to cooperate with other students or to work out assignments together is acceptable, but only if they take the right attitude. Students can learn from each other when there is a genuine attempt to complement each other's abilities. Merely copying is more than immoral...it is stupid.

13. When assigning an ambitious project such as a term paper or a major portfolio, check frequently on the students' progress. Set due dates for interim points such as the selection of subject, working title, tentative outline, thematic approach, etc. Such a sequence of the requirements helps students understand that the whole job cannot be done properly the night before it is due. This procedure also provides periodic opportunities for encouragement.

119

"The worst thing is to get an assignment back with a grade and two words as an explanation for the grade."

Buck Mills
Colorado Mountain College, CO

Model Approach for Building an Assignment

It is better to have a strong, rational method to develop assignments rather than trying to simply use a template for building an assignment. We suggest a linear process for the use of an assignment that influences the building of assignments. This system has six successive parts that are part and parcel of the learning-by-doing idea. This means that assignments are not afterthoughts but are seen as parts of the learning flow. This means that they are envisioned as part of the

learning progression and are contemplated and designed along with the course outline.

To make the most of the assignments we must start with the learning objective. As we lay out our course, we will define the learning objectives. This may be formalized in the syllabus format or outline, but as this conscientious effort takes place, the choice of active or passive learning must be made. When the choice is made to have the learners actively pursue the learning objective, an assignment is settled on. Though this is the point to decide if and how an assignment will flow in the learning process, the next step of the learning sequence, the teaching method, will affect the form of the assignment.

"I decide first and foremost what I want the students to learn, the outcome, and then create an assignment that they can use to learn not only the technique but also the creativity part."

Mark Olson
Community College of Southern Nevada, NV

120

The teaching method you choose should give direction to the assignment. For example, you may be using a computer-mediated lecture/demonstration method to present using curves to correct color bias. With this format for introduction of the material, an assignment will be developed that has the learner follow the steps from the demonstration. In this example an assignment might have the learner use the "Auto" RGB, RGB channels, and CMYK channels. Thus the requirements and directions for the assignment will direct the student to follow what was in the lecture or demonstration.

If you wish for the assignment to lead the learner to "discover" the points from a class, such as the effect of view camera movements on depth of field, then the material presented in class must include all the pertinent clues that will allow the success of the assignment, since that is when the learning will happen. In this example, the lecture will show the way the camera standards move and how this changes the focal distances inside the camera. The assignment will then have the learners photograph a horizontal surface from close to far away while moving the standard with positive and negative tilt. This will allow them to discover the effects of tilt on depth of field of a horizontal surface.

While not a separate step in this sequence, in the construction of the assignment, it is important to actually teach, lecture, demo, etc., as you model and to include the important information in the instruction.

After the teaching, the assignment is given. Clarity in the directions, requirements, and due date is critical. The assignment-based learning is the active part, and just as the learning objectives are important for the teacher to put into the lecture, the activity expectations are important for the learner.

"The mediocre teacher tells. The good teacher explains. The superior teacher demonstrates. The great teacher inspires."
William Arthur Ward

As discussed previously, the due date (the fourth part of this sequence) is important. The due date needs to be viewed in relation to two aspects of the learning sequence. First, the time provided between presenting the assignment and the due date must be sufficient for the learner to perform the learning tasks. Second, and more important, is that the due date needs to fit into the learning flow. When the date is chosen, there is a need to coordinate information to be learned or practiced through this assignment with learning that will follow or will be simultaneously occurring. It is a stronger learning sequence to have a due date for an equivalent exposures assignment be coordinated with a discussion of creative use of depth of field than to have the due date well after the class has moved on from lens and exposure dynamics.

121

The last two parts of the sequence are interchangeable for order, but must be completed. As already stated, the assignment needs to have consequences and value in the learning process...a grade. The graded assignments need to be promptly returned so that learning can continue. Regardless if it happens before or after grading, the assignment results need to be reviewed. This will reinforce the learning. When the assignment is creative, the review will be a critique.

"An understanding heart is everything in a teacher, and cannot be esteemed highly enough. One looks back with appreciation to the brilliant teachers, but with gratitude to those who touched our human feeling. The curriculum is so much necessary raw material, but warmth is the vital element for the growing plant and for the soul of the child."
Carl G. Jung

The appendix includes examples of assignments.

By Kyle Ferino, Rochester Institute of Technology, NY, student of Elaine O'Neil

7

Critique...Advancing Learning with Words

"Learn from the mistakes of others; you do not have time to make them all yourself."

Chinese Proverb

123

The largest potential for learning in photographic/imaging education is in the critique. There are several reasons for this statement. Through critique, issues of importance can be addressed based on students' work, thus transitioning between words and technique to a visual outcome. Though the discussion in this chapter mostly addresses group critiques, it will also apply to individualized critiques. Critiquing groups and individuals may be seen as different, though each situation provides the same basic opportunities for learning.

Critique at its origin is criticism, and all too often "criticism" is taken with its negative connotation. Frequently the critique is seen as a grading and/or comparison activity. It need not be. Though a point in the learning process that can provide an evaluation, it is really a much more powerful tool for stimulating and instructing. Most students are worried about grades and they think that a negative comment in the critique means that they are failing. Since more can be learned from failures than from successes, it makes sense to have the students in the critique accept the short-term negative comments as building blocks for their future success. As the Chinese proverb that starts this chapter states, mistakes are a part of learning. Despite the fact that we strive

for success for our students, the chances for learning from mistake-free work are limited.

"Criticism may not be agreeable, but it is necessary. It fulfils the same function as pain in the human body. It calls attention to an unhealthy state of things."

Winston Churchill

When setting up the critique, if it is projected as part of the learning process, then the students can come to the critique more open to practical positive or negative criticism, with an expanded view of how the process can enable them to produce better photographs.

Using Existing Effort to Expand Learning

The most important reason the critique affords such a great opportunity for learning is that the concept of the critique is based on the efforts of the students. The students have produced work that has technical aspects of the process and aesthetic content. This means that students' personal visions, training, skills, and artistic abilities are all included in their efforts to varying degrees. Because the students have a vested interest in validating their efforts, critiques open up occasions to give insight and learning.

As with question asking, the students come to the critique connected to the conversation that will ensue. With their attachment to the images, the students are already concerned about how the photography is seen. This readiness allows the leader of the critique to use the personal interests to induce further learning into the efforts that went into the photographs.

"I try to make my points about their work rather than making statements about photography in general, what is good and what isn't good. The more I can focus on the work the students have made and that they have brought with them, the more interested and the more they tend to listen and become involved in the process."

J Seeley
Wesleyan University, CT

With an atmosphere of attachment and constructive assessment a wide range of related topics can be visited. Particularly with group

124

critique, the range of instruction and inspiration that can take place expands. Beginner or intermediate groups will have many technical challenges and growing artistic expression as they try to expand their visual vocabularies. We might wish that all students would accomplish all the expectations for the photos to be critiqued, but this is not realistic. It is not an expectation of failure. The students are learning, and that includes trials and varying levels of success and failure.

There are higher probabilities of learning presented by the correction of flaws. Though successes are wonderful to share with all involved in the critique, corrective critique for each mistake or misapplication of a concept allows learning for all. The critique can be constructive and expansive for successful images as well. This promotes the idea that excellence is not the end but rather a step along the way. John Sexton makes this point well when he says, "You must strive for perfection and tolerate excellence." When students produce error-free images, the critique does not provide as many opportunities for learning because the success may be intuitive or accidental, and this does not translate well to learning for the individual or others.

125

"You work and work and work on the assignment and then you put it up and this is when the learning begins. When you start to look at what you've done right and what can be improved...If this is the first time you have seen this work from this far away then you've missed something!"
Jack Mann
Wittenberg University, OH

While the involvement of the learners in the creation of the image is key to their buy-in to the critique, it must be stressed to the learners that they will need to separate themselves from the work itself, to make the most out of the critique. It is not easy for learners, particularly new learners, to reduce their involvement in an image that they have made and to see it as an object on its own, something that is the center of the critique.

Celebration of Students' Efforts

Critique is also a point in the process of making images at which to create small or large celebrations of learning. If the critique will be meaningful for celebrating student efforts, then the grading must be stripped from the critique process. This will require the critic not enter into establishing a valuation for the photographs.

There is a certain fulfillment to coming to completion, even if the completion is only a step along a continuing path. Individuals benefit from seeing their work as part of a showing that receives critical review. It is where many of the learners wish to "go"; having their efforts looked at, analyzed, and discussed brings them a sense of progress.

There are two basic times for evaluative critiques: at some point in the learning process and as a culminating event. Each time plays a role in the continued development of the students' photographs. As a final event in a course, a critique needs to shift the balance from concentrating on progression to celebrating completion. If a course is the end of a sequence or there will be no subsequent work for some or all of the students, then celebration seems appropriate. It does not interfere with continuation to have a culmination for specific goals of the learning process.

Even when the critique comes in the middle of the learning sequence, celebration is an important portion of the critique. By using the critique in this way the student can look favorably on information and learning opportunities.

126

Evaluation Points

Critiques get in trouble when they become part of the grading of education. While critiques often coordinate with a requirement to apply grades, there is no need to use the critique as the actual grading vehicle. The evaluation in critique should center on growth. Whether growth by correcting errors or success in expectation, the evaluation done in the critique needs to relate to the learning path represented by the photograph being critiqued and to the images that will follow.

The evaluation in a critique needs to spend its time and mental energy and center on constructive assessment. This brings the evaluative effort within the critique to direct improvements in the process or vision. For a critique inside a curricular flow, the discussion should have a more process and aesthetic developmental function, while for a culminating critique, the discussion needs to look forward to how the work will function or grow in the future, after the course or curriculum.

When grading and critique need to take place at the same time, the students can gain more from the critique if the grade is calculated later. Within the discussion of the critique, grading evaluation distracts from the learning opportunities. Often when a student receives a grade they will tune out the rest of the critique.

Change in image following critique; by Cynthia
Norcross-Willson (critique by Peter Glendenning,
Michigan State University)

"It was the more successful critique because it was precise, showed by example and very specific. Least effective are general comments using terminology and jargon that the teacher knows that I don't."

Cynthia Norcross-Willson
Cheyenne, WY

Going Negative

Pointedly negative criticism has its place in the process. Several teachers have said that something positive should always be said about every student's work. This is not required and it must be accepted that there are times when all in the critique will progress by negative comments about the work. In these situations it is very important to be sure that the critique concentrates on the work only.

Perhaps it is best seen that when the critique deals with technique issues, the effect of negative criticism is easier on the learner and tends to lead to more constructive situations than when the negativity is aimed at the artistic efforts of the learner. There is a difference between telling a learner that they are doing it wrong (technical) and that they are doing it uniquely (artistic). The goal of the critique is hampered when the energy of the critique goes astray because the corrective alternatives get lost in negative comments. For this reason it might be a strong concept if the negative issues are handled in an analytical way, leaving the evaluation of the aesthetic out of the criticism.

"Minor White said, 'Honor thy response and honor thy neighbor's response.' In criticism you are trying to move someone to your point of view; in critique you have a shared experience where you are trying to move the artist to a stronger place...it is not a blood bath. When you are talking about the work, it is about the work; you are not talking about the person."

Craig Stevens
Savannah College of Art and Design, GA

Jumping-Off Points

The last basic potential for critiques is that they provide natural jumping-off points for advancing more in-depth concepts exhibited in the photographs. While the concept of a critique is to relate and discuss

128

an existing image, the ultimate value of critique is aimed at the techniques that will be used for creating images in the future.

Beyond the production of new images, the critique provides the ability to switch the subject to those ideas that are important to image making but that are not part of the process—subject, assignments, and even activities outside photography. The critique expands the photograph. When carefully applied, the discussion makes the image enter into a world larger than just photography.

Preparing the Critique

If there is a key to a successful critique, it is in the preparation that goes into the process. This is more than the students making the images ready to serve as the subjects of discussion. While the students need to prepare the work, success will come from all participants coming to the critique prepared for discussion. The totality of the leader's preparation feeds into the success of the event. The students' history, education, and familiarity with the types of images to be critiqued are the support for the successful critique.

129

"I think learning to talk about images is a task that you spend your entire life on. I don't expect verbal equivalence, but I think the point is that you need some kind of clues...Your career will benefit greatly if you can learn to articulate your visual and ideological concerns."
Jerry Uelsmann

The size and form of presentation will have a great effect on the success of the critique. There are times when work-prints and work-in-process images can be used, particularly in individual situations, but usually critiques should look at finished images. A "finished image" does not mean one that cannot be reworked or presented differently, only that it can stand as a completed image at the time of the critique.

Viewing images is key to a good critique. In a beginning course, students tend to make, or are assigned to make, small images. Also, many students will not come up to the front of a room to view an image up close. This degrades the quality of involvement for these students. Further, lighting of print images can be used to isolate and accent, to allow focusing on the images. For digital photography and slide-capable images, projection is a good method, since by projecting the images they will be large enough for all present to see. The drawback is that

print qualities are not well conveyed through projection. However, design concerns are benefited from projection.

Preparation for the critique also includes developing the proper atmosphere. If students assume that there will be a knock-down attack on their images, they will come into the classroom defensive. A defensive atmosphere blocks learning from happening. This obstruction to learning affects more than the image's creator: it spreads to the rest of the critique and stops the flow of knowledge for all. On the other hand, if students anticipate only pleasantries, they will come to the critique with a lighter mood, but without expecting or accepting problems that come to light in the discussions. To promote learning in the critique, the concept of knowledge expansion needs to be introduced at the start of the critique.

"Be ever so soft and pliable like a reed, not hard and unbending like a cedar."

The Talmud

130

While it is difficult, the images used in the critique need to be separated from the maker in most cases. Psychologists tell us that creating art is part of the id. As such, it will be hard for students to separate themselves from their work, but successful critiques do this. When images are shown in galleries or museums, the artist is far removed, and if this approach can be used with the students, they may be able to view "the" work instead of "their" work. Unless there is an obvious need for intentionalism, images need to stand on their own.

It is also important when setting up the critique's atmosphere to know what expectations the students have. The potential exists that what the leader sees as the reason for the critique is not what the students see. Do the students want only compliments or do they want to know what the leader thinks? Are they there to show, or to learn?

Most commonly, the critique is the culmination of an assignment. Since the objectives of the assignment and the flow of the course are defined, the instructor can prepare for likely problems or direct the discussion to include meaningful expansions. The leader of the critique can assure that the technical and aesthetic opportunities are anticipated and can plan the introduction to the session. While unexpected images are occasionally brought to the critique, broad preparation will allow for better function even when surprise photographs are

introduced. The critique is benefited: as Louis Pasteur said, "Chance favors the prepared mind."

Perhaps the best example that can be brought to this discussion of preparation for critique will be to talk about Henry Holmes Smith (1909–1986). When at Indiana University he taught many photographers; student photographers included Jerry Uelsmann and Betty Hahn. A major portion of Smith's approach to education was his critique. His preparation was legendary. Part of this was because of his failing eyesight. Because of his physical limitation, he required the students to turn in their work prior to the critique so that he could use a magnifying glass to view and prepare how he would critique the work. Beyond his preparation he required the students to prepare for the critique by reading and researching directions for the upcoming discussion. He wanted the critique to focus on the work, to be a careful reading of the images and expanding visuality, not wanting to hurry to say something about images and then move on.

Setting the Parameters

131

Part of the preparation that will determine the effectiveness of the discussion will be the parameters used to develop the critique. Regardless of method used in the critique, the emphasis needs to be on the work. The critique must focus on the image, not on the person. The verbiage of the discussion must center on the work and should not deal with the maker. While it will be hard to remove the artist from the artwork, early in the critique the image is paramount.

> *"In order to teach about images, personally you have to be quiet. You cannot concentrate first on the things you want to say; you need to focus on the work and try to let the work talk to you before you start talking. You have to be observant instead of being smart."*
>
> Barbara Houghton
> Northern Kentucky University, Kentucky, KY

It must be understood that the method used in a critique will vary depending on the level of the learner and the purpose of the critique. Based on many years of working with very advanced and graduate students, and from working at the other end of photography with beginning and intermediate learners, we believe that the critique concepts can be constructed to apply to these two points in the learning path.

There is the more structured and more sequential method for use with newer learners, while a more open structure can be used with advanced learners. For advanced learners, because of their previous learning and experience with critiques, you may wish to use the information included in the steps described in the following section in different orders, to concentrate more on the meaning and effect of the images.

Critique for Newer Learners

From the structured side there are many good models for using the parameters of critique. Two good methods for critique are found in *A Viewer's Guide to Looking at Photographs*, by James T. Brooke (out of print), and *Criticizing Photographs*, by Terry Barrett. Though similar, of these two approaches, Brooke's is perhaps better as a model for critique strategy. In this model there are four stages of reading a photograph. These are to describe, analyze, interpret, and value.

Steps for critique:

1. Describe the objects in the image.
2. Analyze the technical, design, and perceptual functions.
3. Interpret the meaning of the image.
4. Value the image.

The description activity has the parts of the picture defined. By describing the picture in great detail, the students start to grasp portions of the image structure that will be needed in later stages of the critique. It is too easy to overlook this step because it is obvious. However, the obvious may only disguise image elements that can provide context to the reading of the picture. Because the activity is at a low level of involvement, students can enter into the critique without fear of embarrassment. The leader can use this entry point into the critique to include individuals who are shy or quiet.

It will become noticeable when this first stage of the critique has reached an end. At this point, the dialogue changes to the analysis of the image. By this, Brooke meant a technical and design breakdown of the picture. In beginning and intermediate-level critiques, this allows for the correction of process problems. The closer to the beginning of the course of the study in photography, the more time will be spent on the technical issues. While many students will work their way through technical problems with the instructor prior to the critique,

these corrections can be discussed in the critique to share the technical problem-solving process with the rest of the students. Particularly in a beginning course this stage allows all students to understand how others have solved or can solve technical problems.

Regardless of the growth of technical skills exhibited in the work, the design elements in the analysis and the perceptual function of the image will continue to be an intensive area of the critique. Design and perception of images are the underpinning of all image making. For the purposes of this book, the perceptual psychological functions are grouped with design. Though in classic dialogue perception is not defined within the "elements of design," it makes up the foundation for all design and lends a great deal to the analysis of a photograph. If the descriptions in the first stage of this method of critique are the "words" of the image statement, then design and perceptual organization of the image are the "syntax" that gives understandable structure to the picture. Through discussion of the elements that make the image work, the participants in the critique can learn how to use image structure to make their statements more clearly. While we wish to get to the next steps, the criticality of this step sets up the ability to delve more deeply into the image.

133

> "To design is much more than simply to assemble, to order, or even to edit. To design is to transform prose into poetry."
>
> Paul Rand

When we discuss reading pictures we are first and foremost talking about how the structure of the image portrays the meaning we will gain from the image. In the analysis, it is helpful to show how changes in the design modify how the image is seen and thus what the image can convey. Failures come out easier in the analysis than do successes, because of the dissonance created in the image, but time needs to be spent on the successes and how they work beyond just dealing with problems. While successful, analysis of the image can be used to explain how differences in design might alter perception of the photograph.

With the analysis of what has been described in the picture, the critique is ready to move on to interpreting meaning for the image. This is what the discussion is driving toward. When we try to interpret the image prior to analysis we often miss what the image really means. It becomes part of the "intentional fallacy." If we start the discussion with the meaning we change the way we view what is going on in the

Man in Yard (original in color); by John Pascarella, West Virginia University, WV, student of Young Kim

picture. We can easily miss things, even very important meanings. This is particularly the case if, entering the critique, the photographer states what the image attempts to mean and chills discussion of alternatives in the hunt for analysis to support the stated meaning. The real drawback to allowing this *a priori* interpretation was best stated by Minor White when he said, "Photographers often photograph better than they know."

Only after the preceding three steps do we value the image. Too frequently those involved in a critique start with the statement, "I like it," or the converse. This start does little for the discussion and means little in terms of learning. As criticism became an evaluation term late in its development, so should the critique reach the same level of valuation. The critique will, in the final assessment, become a valuation tool, but that is only a small and minor part of the process. Valuation has little effect on learning.

Shortly before his death in 1986, Ernst Haas had an exhibit of his flower series at the Rochester Institute of Technology. He came to lecture and also to meet with students in the gallery exhibiting his work. One of the students familiar with his earlier work asked him why he was now photographing flowers. Mr. Haas thought for a few seconds and responded directly to the student with these simple but profound words: "I like flowers."

Using this step-wise process takes time, and that is the point. Regardless of the method used to critique, providing enough time to totally address all the issues brought up during discussions can ignite learning. It is more important to go through the entire critique process than it is to rush everyone through every step. Take time, don't be in a hurry, but don't delay, plan for enough time...learning is time dependent.

135

Critiquing without Words

"Criticism of my work...now means something to me whereas previously my self-deception admitted nothing."

Paul Klee

While critiquing can deal with the single images for newer learners, normally as learners progress they start to move away from technical and process images toward personal expression. They also begin to work with series of images as opposed to singular images or assignments that center on learning a technique or finding a voice. This change in why

images are made by the learners dictates a potential change in the way a critique can assist them in moving their photography forward. In *Perception of Images*, 2nd edition, Richard Zakia discusses a method as an example of a more advanced critique aimed at the photographers' understanding of the meaning and import of their images.

Photographs that are not being made for some kind of an assignment, such as a classroom assignment or a commercial assignment, are often not specified in terms of intent or criteria. These are personal photographs that are created out of some need for individuals to express themselves. This personalized approach is the common direction of the photographer becoming artist rather than a technician.

Personal photography involves approaching a subject from a sensing or intuiting position—in Jung's term, from a non-rational position. Here we look for clues in the photographs that will reveal what is being expressed at a level below consciousness. This will require more than a single photograph—a series of photographs would be required.

Once the series is completed, the prints are viewed and studied by both the photographer and the critic. Considerable time is spent in studying each photograph individually and in relationship to the other photographs in the series. As insight into the series is gained, the critic may edit out some of the photographs that do not seem to be relevant, and repositions others. In effect, what the critic is attempting to do without words is to have the photographs speak for themselves— to reveal in the pictures the latent information that is waiting to be discovered. Words are not necessary, but attention to the photographs and what they are saying is. It is as if one were given a scrambled text and had to edit out some words and rearrange others in order to find the statement being made.

"Work with the images, don't talk about them. Let the photographs speak for themselves."

Nathan Lyons
Visual Studies Workshop, NY

Similar procedures have been used in a movement called "Photo Therapy," the use of photographs in a counseling situation. A client may be having difficulty resolving some nagging problems, and sessions with a counselor, based on words, may not provide an avenue for insight into the problem. The counselor may then ask the client to bring in a family album of photographs or series of photographs that

the client has taken recently or over the years. The counselor then goes through the same procedure a critic does, carefully studying the photographs, editing out some and sequencing the remainders.

"A photograph is always seen in some context; physical, remembered, imagined."

Rashid Elisha

A psychiatrist from Toronto, Canada tells of a relevant experience with one of his clients who had a severe problem that seemed to resolve around her childhood relationship with her father. Each time the psychiatrist would inquire about her childhood she would become defensive and tell about her close-knit family and her closeness to her father. After weeks of no progress, she was asked to bring in a family album, which she did. She and the psychiatrist went through the album, looking at the series of photographs that had been taken over the years. As the psychiatrist was looking over the photographs, he was also editing out some and rearranging others. He noticed that in most of the group photographs the client was at one end of the photographs, near her mother, and her sister was at the other end, close to the father. Her sister was often smiling and very often the father had his arm around her. When the psychiatrist pointed out this visual evidence to the client, she broke down and was then able to admit that family relationships were at the roots of the problem. This led to more productive therapy sessions and a resolution of her problem.

137

"A sequence of photographs is like a cinema of stills. The time and space between the photographs is filled by the beholder."

Minor White

Photographs are statements that can be read and that provide useful information, but like all statements they must be read in context—in context with other photographs or verbal information, and in historical context, for all photographs to some extent are historical. Traditional disciplines such as sociology and anthropology, realizing the importance of photographs as a source of information, now have offshoot groups specializing in visual sociology and visual anthropology. Their research involves not only using photographs others have taken but also photographs the researchers have taken to document events.

Participation

Critique, whether group or individual, benefits from participation from many voices. It is easy to see that the instructor's participation directs learning, but the students' involvement is more potent.

There are four participant types common to the critique activity. These are the leader, normally the instructor; the photographer, the maker of the photograph(s) to be critiqued; non-maker students; and guests. Each of these participants gives and gains differently from the critique. Obviously, students gain more than instructors and guests, but instructors and guests also gain from a successful critique. Instructors can gain because students usually see differently, and this is a powerful opportunity for the instructor.

"My idea with in-process critique is to help students gain confidence in their ability to make decisions. Rather than telling them what is wrong, I ask them what they are attracted to, what they like, what they think and use these as guides to make choices, rather than me just telling them what to do. The major difference between in-process and final critique is that in-process is one-on-one and in a final critique it is not one-on-one, it is about everybody in the room—finding that there are other opinions and letting that open up the discussion."

Jaclyn Cori-Norman
Savannah College of Art and Design, GA

Looking at instructor participation, we can clearly see needs and advantages from differing strategies, depending on where in the flow of the students' education the critique falls. At the beginning, the faculty needs to both set the atmosphere and lay out the guidelines for how to critique. Just as asking questions benefits from a structured approach to learning how to make the most from them, so do critiques. The instructor needs to lay out expectations of those involved. This includes laying out the steps to follow and the preparations to be made for the discussion. Beyond these two foundations for the success of the critique, the instructor, as leader, needs to control the flow and tempo of the discussion.

Early in a course of study this will mean more direct involvement by the instructor. As time and successive critiques take place, the leader can ask for participation from the photographers and others in attendance, to a point where the leader then rounds out the discussion

by bringing in new topics, techniques, or aesthetic points of view. The leader's participation in input is more in the analysis of design and technique early in the flow of the course of study, and in changes to meaning and eventually to comparative valuation. In a successful early critique it will be important for the leader to exit their role of critique leader and move into one of instructor. When critiquing an individual photograph presents an avenue to move to the next area of study or to new skill development, the leader needs to take the interest in the ongoing discussion and move to an instructional mode, to bring in these learning opportunities.

The maximum learning will happen when students and those coming to the critique reinforce their previously encountered concepts and see them applied to the images. Beyond the students having created the work being critiqued, the act of hearing their words and concepts being applied to an image codifies the meaning and allows for correction of flaws in their work and thinking. Therefore, it is beneficial to have as many students as possible take part in the critique discussion. It is also better if each student takes part in each area of the process, but not necessarily for each image or in every critique.

139

"I do think the patriotic thing to do is to critique my country. How else do you make a country better but by pointing out its flaws?"

Bill Maher

Because of normal individual and group dynamics, there will be those students who aggressively enter into discussion while others will retire to the background, and some will prepare better for the critique activity than others. To maximize the learning for as many as possible, the leader will need to invite comment from the shyer students while limiting input from the more assertive students. This is a ticklish situation, since the critique leader does not want to dampen input and wants to encourage all to take part.

As mentioned previously, it is easier for students who are inhibited to enter into the critique model at the first step (describe the objects in the image). There is less threat about being "wrong," and as they become more comfortable they will involve themselves in later discussions within the model. However, if an individual continually withdraws from the critique discussion, there may be nothing the leader can do but accept this inactivity. Of course, it is easier to involve even shy students when it is their work that is being critiqued.

Unfortunately, some students come to critiques fearing the negative comments that might be coming in the discussion. Therefore, many students come to the critique defensive about their photographs. This sets up an interesting dynamic when they are asked about choices they made and about the outcome exhibited in the work itself. It is common to have a student who has some ability in photography to reject critique at this stage by saying, "That's the way I wanted it." This defense can be a discussion ender or a convenient point to engage the student in discussion about other variations and directions that they took to arrive at the way they wanted it. If there are serious flaws in the outcome and the student insists that these were intentional, then this provides an opportunity to discuss the problem-solving method or aesthetics that led to the decision to make the photograph.

"If you are not your severest critic, you are your worst enemy."

Jay Maisel

140

As a caveat, note that even students whose images have no flaws can make the same statement, "That's the way I wanted it." Though successes make dealing with this statement justifiable in the eyes of the student, here again, engaging in directional and choice-based discussion is beneficial to all at the critique. Just as "That's the way I wanted it" is not helpful for the learner in the critique, it is not helpful for learning in the critique situation when the critic says "that is great" and then moves on. As much effort needs to be applied to critiquing success as to failure.

Realize that the value of critique is in the correction of flaws and in the growth of the photographer. In order for the critique to be effective, the person presenting the work for critique needs to be invested in the outcome of the process. This was brought home many years ago by watching a young artist at a Society for Photographic Education conference. The aspiring artist bounced from educator to educator, asking them to look at the artist's work. After looking through the Fiberbuilt case over-filled with over-matted prints, the noted educator quietly handed the case back, with the only comment being, "Thank you for sharing your work." When queried afterward why the viewing was "silent," the educator said, "there was no personal investment or expectation by the student in learning what was wrong."

"The gift of truth exceeds all other gifts."

Buddha

Energy

During a critique, it becomes obvious that there will be ebb and flow in the energy level exhibited, both by the leader and by those whose photographs will be critiqued. Particularly as the energy wanes, continuing a critique becomes problematic. Awareness of the energy level is required, since when attention slacks, the ability to make corrective comments and to receive information about the way to improve images drops. In the critique it is not an issue of how long each image is discussed, but that the critique of any particular image addresses as many issues as can be handled by those involved. The age of the participants is important, since the continued concentration of the younger and older participants is a limiting factor.

In dealing with the way energy impacts the critique, it is not as much an issue of measuring the energy, but of observing how it will affect participation. This places an added dimension in the role of the critique leader. Leaders not only need to have direct discussion to assure that important concepts are introduced and discussed in the critique, they also must be highly observant of the actions of the participants to assure that, as the energy decreases to a critical point, there can be a stop or break in the critique. Depending on the intensity, breaking can help or harm a session: a critique with a high energy level may not restart at that level.

"Intelligent attention to and discussion of a photograph may help some individuals appreciate more clearly some difficult pictures."
Henry Holmes Smith

Methodology

While there are various approaches to the critique, here are some ideas that may be useful for presenting a successful critique.

Place

First, the viewing conditions should be altered as necessary to maximize the participants' ability to see as much as possible of the detail in the pictures. Often the room to be used is assigned, and this determines the way the work will be viewed. But there are several concerns that can be controlled. The way the space is handled will

141

help enhance the view of the pictures and will facilitate communication during the critique.

The viewing light is of primary concern. Diffuse, bright light will open up the detail in pictures without glare or increased contrastiness. If possible, control the light so that it illuminates the images in such a way as to modulate the light, with the light environment being strongest in the picture viewing area, compared to the rest of the room. Spotlighting the images works with the other lighting off, but this builds flare and increases the contrast in the pictures.

Addressing several concerns with the space can be of benefit when planning for a group critique. Both seating distance and ability to view closely are important to a successful critique. When possible, reorient the seating to minimize the distance from the picture display area. This normally means setting up a shallow semicircle of chairs. Obviously, the more people viewing the critique, the greater the distances from the furthest seats to the pictures. Also, when a group will be viewing images there is a need to devise a way for participants to get close enough to the images to see details. And of course, the more comfortable the seating, the better.

"The human being is immersed right from birth in a social environment which affects him just as much as his physical environment."

Jean Piaget

While less problematic, the single-participant critique also needs to be done with proper lighting and space. Too often space is not available to set out a great number of images, even when they need to be viewed sequentially. This is less than optimal. Regardless of whether the critique is for a group or an individual, when a number of images need to be viewed in sequence, then the space in the available facility becomes important. In an individual critique, the images can be viewed on tabletops, but with a group critique, the images should be presented so that they all can be viewed at one time.

Some images may be produced as transparencies or in a digital format. This is a positive for the critique activity. Projection critique has some great advantages over a print-based critique. First, because of the lighting intensity created by the projection, attention is controlled and the critique environment is less of an obstruction. Second, the image being discussed is larger and easier to see in all areas of the

space. Last, particularly with computer projection, imaging software can be brought in to allow the critique to become a demonstration of a modification method.

Procedure

It is important for those involved to know their roles. Part of setting the parameters of the critique is to provide the participants with an understanding of the demands of the critique. This should include levels of contribution for each group and the purpose and goals of the critique. If there will be follow-up assignments generated by the critique, then the expectations and outcomes should be clearly articulated. This should provide a set of procedures for the progress of the critiques and the directions for any targeted outcomes. This should be done in a non-threatening manner. Grading should be separated from the critique when possible.

The most important part of the procedures, to be stated in preparation for the critique, is defining the criteria that will be used. These need to address the variation of abilities, techniques, and aesthetics and the vocabulary to be used. If a model such as the one explained earlier in this chapter is to be used, then criteria for discussion and evaluation should be stated for each area of the critique.

143

Expectations

A favorite critiquing story is about a lecturer at a conference. When the lecturer was approached for an impromptu critique, the suddenly engaged critic asked, "Do you want to hear something that makes you feel good or to hear what I think?" It is important that all participants in the critique have a clear understanding of what is expected to be their role and what is the desired outcome of the critique.

> *"Degas is repulsive." (A prominent art critic over 100 years ago)*
> *"Matisse is an unmitigated bore." (Chicago Tribune, 1913)*
> *"He has no talent, that boy [Renoir]." (Manet said this to Monet)*
> *"The Dada philosophy is the sickest, most paralyzing and most destructive thing that has ever originated in he brain of man." (Art News, Re. 1921 Dada show)*
> *These quotes are all from Art News, November 1999, page 208.*

Smoking Gun; by Gueorgui Petzov, Brooks Institute of Photography, CA, student of Joan Pecoraro

Measuring Education...Tests, Grades, and Evaluations

"I know that if I'd had to go and take an exam for acting, I wouldn't have got anywhere. You don't take exams for acting, you take your courage."

Edith Evans

More headaches and heartbreaks are associated with evaluation procedures than with any other aspect of education. This is equally true for learners, teachers, and programs. Before delving into the various types of evaluations used in education we must come to a general understanding of why we need to evaluate at different places in the educational system. Evaluation is a process that allows us to determine how we are doing. The *Encarta® World English Dictionary* defines *evaluation* as "the act of considering or examining something in order to judge its value, quality, importance, extent, or condition." It is a process, not a rating.

Evaluations are a conscious act. We may enter easily into evaluating within education: it is a regular portion of the flow of the system. Learning and progress are built on evaluation tools, and the more formal the education, the more structured the evaluation tools.

"Evaluation needs to be done on a regular enough basis so no one is surprised by what is going on. The administration should work with the program to make sure that it stays where it needs to be; the administration should be the catalyst that makes things happen."

Art Rosser
Clayton State College and University, GA

In education, evaluation is a process of making judgments on human performance. Thus we characterize a learner as a good or bad student or as fit or not to take a specific job or enter a specific program of study. In the end, evaluation is a subjective process. The difficult thing in the process is to move the fulcrum to put as much balance toward the objective side as toward the subjective side.

For the Learner

The importance we attach to evaluation methods, particularly grades, is shown by our using them as a basis to admit learners to programs, to put them on probation or dismiss them, and to award degrees, scholarships, and other honors. Many educational situations are defined by specific grade requirements.

Though many forms of evaluation tools have been created to rate performance, to allow comparison to the course objectives or to other learners, grades are the application of evaluations. It seems like a neutral statement to say that grades are simply markers of progress or completion, but grades are very heavily loaded with many other personal and institutional meanings. Before addressing the applications of grades, let us discuss a major tool for establishing a grade—testing.

The Test

Testing is intended to provide data that can "objectify" evaluation. A common factor in testing is that we wish to gather the data for the evaluation in a standard, consistent, or specified manner. The test has often become a synonym for a grading method, but it far exceeds a simple method for applying a grade to a student's performance. Testing works in many aspects of the overall evaluation of the learning process. It is only one part of the evaluation procedure. When we make a difficult judgment to assign a grade, we must bring to bear on it all information we can acquire. A test will only be part of this process.

146

Tests can be used to establish abilities within a specific setting of performance for any type of learning. Tests are not just for cognate knowledge but can be constructed to assess learning of any kind.

"If you want to improve something, start measuring it."

Peter Lewis
Progressive Corporation

Functions of Tests

There are many uses for tests. They function, in one way or another, to evaluate some activity within the learning process. Following are eight different functions for test instruments. They show how testing can be used for evaluation, encouragement, prediction, and/or, most importantly, to promote learning.

First, in its most basic sense the test measures the ability of the students to perform some defined task at some time. We test to see whether or not the student can calculate an equivalent exposure or describe an ambrotype. We use tests to sample the student's knowledge, vocabulary, and procedures or the student's understanding of the part of photography being discussed in the class at hand. This use of the test instrument is most commonly associated with grading.

In this way the test will be a tool that can tell what the student knows or doesn't know. Tests can be constructed to measure either knowledge or lack thereof. We must be careful to realize that the purpose of the test is to advance learning and not to establish that we appear to know more than the students. The test needs to be a vehicle that helps the student understand what learning has been accomplished and not a method to make the students feel poorly about learning photography.

Next, tests are used to classify students. And in many educational institutions students are grouped according to estimated ability. The theory is that teachers can make learning more effective for more students if nearly homogeneous groups can be formed. Particularly in offerings that admit students without regard to previous study, such as vacation workshops, the test can be used to separate cohorts and allow each student to work at his or her own level. Additionally, in programs with prerequisite admission to specific courses, placement tests can be used to allow students to skip areas of study where they can display an appropriate level of knowledge or proficiency.

A third use for tests is to fulfill administrative requirements. Test scores are needed, we are told, to determine when students should be

147

promoted or held back, toward honors, and so on. Further institutional tests are used to give validity to the program. Standardized tests, as well as others, have also been adopted by industrial and other noneducational institutions and are used to decide who will get a job or who will be moved up the ladder.

Fourth, and more bluntly, tests are sometimes thought to measure the effectiveness of the teacher. We must see that tests, both those our students take that measure the learning in the course and those prepared externally to our course structure, can be used to estimate the effectiveness of the learning situation. Quite clearly, it is inappropriate to use test results as pointing directly to the teacher alone, since so many factors affect the quality of learning.

To let the students and the teacher know how the learning process is going is the fifth function of tests. We may believe, or hope, that our students will understand how to carry out a particular procedure. We give the test to confirm or contradict this disbelief. On the basis of the test results we will either decide to continue with new subject matter, or to help the students learn what they have so far failed to learn. This function will not at all be served if we discover a failure of the learning process but then do nothing to correct it.

"Assessment is most effective when it reflects an understanding of learning as multidimensional, integrated, and revealed in performances over time."
American Association for Higher Education

A parallel construction to this type of test is the pretest given at the beginning of a course; a pretest is built on knowledge or skills that are required to successfully start a class. While not evaluative for the present course, a pretest establishes the starting level of the student cohort. This is exceptionally helpful to avoid advancing beyond the preparation of the learners and then needing to retreat in teaching to address presumed knowledge or skills.

The sixth function of tests is to predict future performance. The function is most often applied as an "aptitude" test that is intended to uncover the talent of students.

The seventh and eighth functions are uses that increase learning through the testing paradigm. The seventh is to motivate students. We may think of tests as devices that force students to study, and many teachers believe that without tests students would not learn. Thus we use test scores as a reward. This understanding in the student cohort

can convince many that the effort to learn and understand the materials is worth pursuing. Constructing the test and sharing the test construction rationale can motivate learners to bring their thinking into line with the goals of the learning. When we emphasize answers and minimize the importance of minor blunders, we reward the concentration that is used to arrive at the right answers and correct thinking. If the students are motivated by realizing the test will evaluate these constructs, then the effect will assist in learning.

The eighth function of tests is to assist in the learning process. Tests perform this function by informing students about what they are expected to learn and can further provide a meaningful opportunity to apply and codify the learning process. We construct tests that include a reasonable sample of the activities that we want students to learn to do well. We give them an opportunity to show that they can arrive at the right answer and we may find that the act of testing can be the learning spark. The kinds of questions we use will determine in part the kinds of effort the students will make. Thus, if the questions require recall of memorized items, students will learn to spend their time on memorization. If, on the other hand, the test questions require application of information and principles to solving problems, students will understand that their study must involve practice in problem solving. If the test is constructed to lead the learner through a series of steps and coordinated answers, the test, while being attended to, will also teach the proper thinking and problem solving desired.

The kinds of tests we construct can direct to the students' learning activities more effectively than can our preaching to them. A well-constructed take-home test that allows the students to work with other students can provide them with a study/learning tool, with the emphasis on the solution and learning, not on score.

"Assessment makes a difference when it begins with issues of use and illuminates questions that people really care about."
American Association for Higher Education

What Tests Can and Cannot Tell Us

Not every test can carry out the eighth function. Different tests will have different purposes, and will be constructed to serve those purposes. To clarify the nature of different tests we present the following six attributes that should be considered when deciding whether and how to use tests.

149

Test scores are subject to sampling errors and other sources of variability and uncertainty. Once we go beyond testing well-defined skills, we find it difficult to devise and score suitable tests. However, tests can give a snapshot of "facts" or methods that the learner possesses at the moment of testing.

Next, we can test limited education results, but not more complex, and within photography more meaningful, learning objectives. Tests of problem-solving ability are hard to construct, to say nothing of artistic abilities, photographic intelligence, and attitudes. The fundamental difficulty arises from our inability to define what we want to measure. Are we measuring visuality or the ability to perform a prescribed lighting pattern? Does being able to state how lights should be set to produce Rembrandt lighting assure that great portraits will be made? Since factual knowledge is easier to test, and with the image being created not tied totally to the "facts," tests have a noticeable weakness in evaluating all of the learning and abilities needed to succeed in photography.

The third problem with tests is found in their predictive value. Even the best tests, standardized tests of ability, are not very good in predicting value. The statistical correlation between test scores and success later on shows that the chance of correctly predicting success in a photographic career based only on test scores is small.

In general, we must adopt a frank and healthy skepticism about the entire process of testing. It is not that we discount testing completely but that we recognize that within photography we will need various methods to evaluate learning and progress.

This brings us to the fifth consideration, that a test must be considered as only one of the methods of evaluating learners, and that the other techniques need to be given heavy weight. While tests try to objectify learning, they do so by reducing and defining correctness to measurable and quantifiable answers. This equates correct answers to knowledge and abilities, though correct answers only represent knowledge of the factual bases that are the underpinning of creating images. For this reason, corporate interviewers, in their evaluations of job applicants, consider the past judgments of teachers and others who have had opportunities to observe the applicants' behavior, regardless of the "subjective" and time-consuming nature of such judgments.

"The main part of intellectual education is not the acquisition of facts but learning how to make facts live."

Oliver Wendell Holmes

Last, most permanent student records contain both too much and too little information. Many times tests have too much bearing on the record. Records may contain too much that is obsolete, and therefore of no value at present and of less for the future. Some method should be adopted to expunge from the record youthful mistakes that may otherwise haunt the student indefinitely. A record, in many cases, also contains too little if it contains only test scores and grades derived from tests, and omits other data that would help to describe the student's abilities. Knowledgeable job interviewers invariably insist on talking with others about the student, because they understand that the written record can be generally inadequate and often misleading.

What to Test

Every question on every test should be related to the objectives of the course in which the test is given. It should be clear to the students, as well as to the teacher, that the questions are fair in the sense that they bear directly on the stated and published objectives.

Well-constructed tests help course objectives become clear to the learners. We can assist this clarification by discussing with students in advance what kind of test will be given and how the questions will amplify the objectives for the course. It is especially important to review tests with the students and to point out how the construction of each question relates to what they are expected to learn.

151

"You have to go back to your objectives. You created your objectives, you write your tests and then design your instruction to assure that you are testing what you said you were going to test. To make sure that you are teaching what you are testing and testing what you are teaching."

Ike Lea
Lansing Community College, MI

The concept of a test is a general idea and has several manifestations. Most common of these are the quiz, a short test of low value, and examinations that are more comprehensive and tend to carry a heavier grade weighting. Since these two kinds of tests have different functions, they will necessarily be different in format.

During a course, we may wish to give frequent short tests as motivational devices, and as instruments to discover how well students are learning specific areas of knowledge or attaining skills. Quizzes are

used to sample information and relatively fragmentary skills and undertakings. We often make these tests objective, simply because we must grade them quickly and use the results as a basis for review.

At the end of a course, we use tests to assess the status of the students after they have been exposed to a significant amount of information. Final examinations, which must be more comprehensive, tend to be more general and less specifically focused. Therefore, when this is the case, finals will almost necessarily be subjective in character. Particularly when a class is large in scope, such as a survey of photographic history, the subjectivity enters in as the test is constructed and portions are selected in the larger body of knowledge.

Constructing Test Questions

Short-answer tests—multiple choice, true and false, fill in the blank—are more often called objective tests. Probably a better term is "restricted-response" test, implying that the field of answers in which the student can exercise a choice is limited by the form of the question. Written essays or oral examinations, usually called "subjective," may then be called "extended-response" tests, since the students have considerable freedom to decide how they will answer the question.

It must be understood that the type of response defined by a question not only affects those taking the test but also impacts the construction of the test and the difficulty in grading the test. Normally, restricted-response tests are more difficult to construct, if they are to determine the students' knowledge, and easier to grade; the correctness of the answers is obvious. On the other hand, extended-response tests tend to be easier to construct and more time-consuming to grade.

The difficulty in constructing restricted-response tests is in developing a questioning strategy that presents the correct answer within the field of available responses, while not directing the learner to any specific response. For a "true and false" question where there are only two available responses, the construction of the statement to be evaluated must present a potential for both the correct and the incorrect response. In this question form, without both potentials, knowledge is not measured.

As an example, the following true and false question shows how the possibility of choosing both a true and false answer depends on the knowledge of the learner. The question—"True or False: Micro-lenses over the gates of a Metallic Oxide Semiconductor (MOS) refocus the

light for sharper capture." For a person unfamiliar with the construction of digital capture devices, the concept of micro-lenses built within the structure of the sensor might be the difficult part to understand. Also, photographers might associate the lens on the camera with the micro-lens described in the question. With either of these lines of thinking being the impetus for answering the question, it will be answered as "true." With knowledge of the use of the micro-lenses as condensers for the light falling on the sensor, the answer is "false," which is the correct response. In this construction, knowledge of the learner is the deciding factor in choosing a response.

"Examinations are formidable even to the best prepared, for the greatest fool may ask more than the wisest man can answer."
Charles Caleb Colton

There are advantages and disadvantages to restricted-response questions. Of the advantages, most notable is the ease in scoring. Multiple-choice and true and false questions can be machine scored. Also, these questions have smaller sampling errors because only specific responses can be used as answers. Further, the student will not be able to attempt to bluff or "snow job" the answer. Next, the test construction can sample the students' ability to apply information to novel situations, as well as recalling information. Last, the teacher can test the ability of the students to make fine distinctions through question construction.

There are also defects in the use of restricted-response questions. While this type of test is often called objective, it is highly subjective in the selection of statements and questions that are constructed for the test. Fill-in-the-blank questions may have very specific answers, such as "The amount of light entering a lens at f2 is _____ times greater than at f2.8." Or "_____ had the greatest effect on artistic photographers of the 1930s." The exactness of the answer is not found in the questions.

The next problem with restricted-response questions is that they tend to be either trivial or ambiguous. If they are trivial, they can only require recall. If they are ambiguous, they are hardly objective. Further, restricted-response questions, by their very nature, cannot sample the students' ability to generalize, to organize, to synthesize, and to weigh the consequences. It can be argued that the most important educational objectives cannot be reliably measured by such questions.

The two final disadvantages of restricted-response questions both revolve round the concept of guessing the correct answer. First, and

153

primarily, with multiple-choice questions, there may be a penalty for students who think deeply, who can find implications, and who realize that there is more than one potentially significant answer. An example might be "The most light will be absorbed by an object whose color is (black, white, yellow, blue)." A superficial choice is black. More insight involves recognition that the kind of light is not specified and that in some cases a blue object may absorb more red light than does a black object. The guessing factor is often cited as the reason to avoid multiple-choice, true and false, and matching questions. Guessing on these types of questions cannot be distinguished from correctness or errors that indicate knowledge or misinformation.

Similarly, extended-response tests have their advantages and disadvantages. Questions can sample the ability of the students to weigh the consequences, to synthesize information, and to organize data. Extended-response questions also permit the teacher to estimate the students' ability to express ideas in a coherent logical form. The last advantage of extended-response questions is that the student need not make snap decisions. Instead he can consider serious problems thoughtfully. He may exhibit an analytical ability that restricted-response questions can elicit only with great difficulty, if at all.

There are three disadvantages to extended-response tests. Essay questions are time consuming, both for the student in answering them and for the teacher in scoring them. Second, scoring responses is most difficult. Agreement among different scorers is poor. Successive independent estimates of the quality of responses vary remarkably, even for a single scorer. The grades given to a specific response depend upon where the response happens to come in the sequence of responses. Some teachers have a tendency to grade liberally, others to grade harshly. Also, as the grading process extends in time, teachers may grade either in a more liberal way or strictly, depending upon the time involved to that point. Last, a student's inability to write well may conceal genuine understanding. It is most difficult for the teacher to detect the mastery of concept in an answer that is marred by grammatical lapses and misspellings. This is particularly the problem when dealing with students whose primary language is not the one used for instructions and tests.

"How well something is said is important but not as important as what is being said."

Richard Fahey

Nontraditional Testing

Timed-monitored tests are not the only method that can be used to ask questions to assist evaluating the learning in a photographic program. Of these nontraditional approaches to testing are oral examinations, open resource, and take-home examinations.

Oral examinations provide a one-to-one dialogue between the teacher and the learner. This type of examination is most often used at advanced levels. Such evaluations provide a skilled teacher with a flexible way to interact with the learner and to delve into a list of open questions, to evaluate the larger understanding of the subject, as compared to a small, objectified response set. Oral examinations aid the creation of good rapport, which assists in the overall educational process. While oral exams have these positive attributes, they are very time consuming, have a tendency to produce anxiety for the learner, and tend to be nonuniform from student to student.

Open-resource tests indicate that students will be able to use information in the completion of the test. There are many variations of this type examination. The students may be told that they may use their textbook. While an open-book exam appears to provide access for the students to correct responses for the questions, in many cases this format of exam reduces the students' involvement in correct preparation for the testing. One of the concepts behind using an open-book test is that it can estimate the ability of students to apply, rather than to merely memorize and regurgitate, information. Such a test is a good model of what professionals do in working out problems.

Another open-resource test format is to allow all the students to prepare and bring "crib notes" to the exam. If the learner must prepare their own notes that will be used to assist on the exam, then their learning cycle has been augmented by attending to the information that they have to prepare as part of the crib notes. The learners' efforts in summarizing the information further facilitate learning. A further expansion of this concept is to allow the students to use their own notes taken in the class or from the textbook, as a resource for the test. This method has three effects on the learning process. First, if the students realize from the beginning of the course that the notes will be usable on the exam, they will likely take better notes in class and thus pay better attention to the course material. Next, the fact that they write down information either from the class meeting or from the text creates an opportunity for the information to be more

155

permanently learned. Last, as the students organize their notes into a usable resource for the exam, they will see "holes" that may need to be filled for the exam. This will encourage them to find resources that they can include in their notes.

> *"Assessment...is only as good as its instruments, and is defensible only to the extent that it actively forwards and enhances...learning."*
> Theodore Sizer
> Coalition of Essential Schools

Exams may also be taken outside the monitored environment. Often called a take-home exam, this testing paradigm provides a more relaxed impression of the testing situation. Many teachers are concerned that cheating will happen when the exam is not monitored, and while there is a potential for cheating, the take-home concept provides a better opportunity for the tests to become a learning tool. At advanced levels, it is quite common to assign term papers or student-selected questions, to be answered in essay form using a series of questions. This provides an opportunity for the student to utilize information and data, to allow synthesis of ideas that demonstrate their understanding of the test/term paper questions.

When the exam may be taken home, and the teaching assumption is that help will be garnered for test completion, tests can be constructed that assist the students in learning. While this is not particularly helpful for restricted-response tests, where complicated processes are involved, the aspect of peer interaction to assist the learner is highly beneficial. Because the learner is highly invested in the outcome of the test, finding constructions for the test that utilize peer interaction can create an opportunity for learning.

Grading

In education today, grades have become a necessary part of the evaluation process. While grades are important for many aspects in education, their usefulness as predictors of later accomplishments is suspect. Grades often put undue pressure on learners and can change the way learning happens. The process of giving grades is a two-edged sword. Grades can become divisive ego-driven elements in education or they may also become a tool to encourage learning.

"If I were asked to enumerate ten educational stupidities, the giving of grades would head the list....If I can't give a child a better reason for studying than a grade on a report card, I ought to lock my desk and go home and stay there."

Dorothy De Zouche

Grading happens first on testing and assignments and then on the course. Grading assumes a measurement of learning. While grades do not accurately show learning, they are ratings of progress in learning. The rating scale, which is prescribed for any grading system, has elements of arbitrariness built into it. As soon as a grading paradigm is projected to rate learning, a somewhat arbitrary or subjective scale has been applied.

We can think of grading as a relative or absolute process. But an absolute scale of grades can be attempted, where 70% indicates that the learner has mastered the learning needed to function in photography. However, why should the absolute be at 70%? Perhaps it should be at 60%, 80%, or 90%. It can be argued that unless a 100% grade is attained, mastery has not been proved. Choosing the absolute nature to be applied to learning photography inserts arbitrariness into the process. If there is an advantage to attempting an absolute grading scale it is that it can become a mathematical rating scale.

To further the argument about the arbitrariness of grading, let us assume that there is a potential for using a "curve" to establish a rating scale of performance. Students often ask teachers, "Do you curve your grades?" By this question they mean, "Do you restrict the number of A grades, etc., to some fraction of the class?" or "Can I earn a good grade regardless of the performance of the rest of the class?"

A curve grade is derived from the use of plotting of all grades in units and then using a statistics measurement to segregate the pool of grades into ranking units (As, Bs, Cs, etc.). The "curved grade" is based on a distribution curve. A normal distribution curve shows the vast majority of grades in the middle of the grade range, with decreasing distribution of grades as the scores move in both directions from the middle of the grade range. Without going into a long discussion of statistics, commonly the mean and standard deviation are used to segment the grade range as seen in the curve. The mean is the center point of the distribution and the standard deviation is a statistical measure of a specific difference of values from the mean. Two other terms worth mentioning are "skewed," which means that the curve has

157

more of the distribution toward one end or the other, and "bimodal or multimodal," meaning that there are two or more concentrations or groupings within the distribution curve.

"I have learned that success is to be measured not so much by the position one has reached in life as by the obstacles which he has had to overcome while trying to succeed."

Booker T. Washington

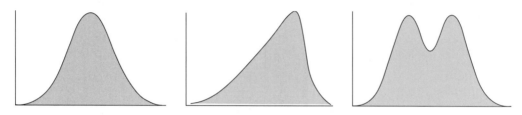

Normal, skewed, and bimodal distributions

158

If a teacher, or an administrator, decides that A grades will be given to the uppermost 10% of the class, this decision is in no way related to, or dependent upon, the shape of the curve describing the grade distribution. Out of the class of 50 students, five will receive an A no matter whether the distribution is strongly skewed or bimodal or any other shape. Thus if this is the decision that is made, the question about "curving" grades is irrelevant because an arbitrary number of A grades have been selected, regardless of the outcome of the evaluation tool.

If the decision, on the other hand, is based on cutoff points defined in terms of some number of standard deviations from the same mean of the class distribution, the percentage receiving A grades will depend greatly on the form of the distribution. We may say, for example, that all students receiving scores above two standard deviations from the mean will be scored A. Now the percentage of students receiving A grades will be greater for a distribution skewed to the low side, and fewer for a distribution skewed to the other direction. This is because, as the mean rises toward the highest grade possible, the scalar amount of scale above the "arbitrary" two standard deviations may not be available.

The two preceding methods of curving are relative, in the sense that they grade depending on the performance of other students, and thus are not constructed with this single scale of merit. To the extent that successive classes are similar in ability, as estimated by the examination, we can suppose that a grade of A in one class is equivalent to a grade

of A in the following class. But it is, on the contrary, more reasonable to suppose that a time trend exists. No doubt successive classes improve in ability and grade performance. Thus we should expect the proportion of good grades to increase if the test maintains the same level of difficulty. Also, a teacher gets better from year to year, or ought to.

Alternatively, like an accelerating treadmill, we may make the required level of performance rise as the students attain higher levels of learning, and make the test harder as the students become better. In this case the proportion of grades in a given category will remain essentially constant, on the assumption that the teacher is skillful in adjusting the required performance level to relate to the increasing abilities. Such must be this situation, for example, in the New York State Regents examinations, for which the passing grade has remained constant from time immemorial. Note, however, the frequent practice of the examiners in lowering the passing grade when this test fails an abnormally large amount of students. The passing grade has never, to our knowledge, been raised.

For testing we recommend several points for consideration. First, when assigning percentages to different grade categories (A, B, C, etc.), do not assume a normal or even symmetrical grade distribution. Most classes represent too small a sample for normality or symmetry to appear. While multiple classes taking the same test may provide a statistically valid number of scores to create a useable distribution curve for an exam, a correlation will only have validity if the test is consistent in content, environment, and timing over all tests.

One of the difficult components in effective teaching is preparing fair and valid test questions; questions are "valid" in the sense that they relate to the stated objectives of the course; they are "fair" in that they are not tricky or ambiguous. Testing and grading are an integral part of every educational program and should be viewed as such by both students and teachers. One can think of testing as a "feedback" component in which a student acquires some measure of his learning and the teacher acquires a measure of how affective he or she was in facilitating that learning.

159

"Like so many teachers, I failed to understand that testing and grading are not incidental acts that come at the end of teaching but powerful aspects of education that have an enormous influence on the entire enterprise of helping and encouraging students to learn."

Ken Bain
Center for Teaching Excellence
New York University

By Elizabeth Moreno, Colorado Mountain College, CO, student of Buck Mills

In institutions of higher learning, a higher proportion of good grades, rather than poor ones, are assigned, because the number of poorly performing students usually progressively decreases through admission policy, discouragement, or attrition. The proportion of students earning high grades should increase as the students' educational process progresses. This should not be taken as a suggestion of grade inflation; higher grades should be expected as the level of education increases.

Utilize the total grade scale. Using only the high end of the grade scale (only A, B, and C), and considering a grade of C as essentially failing, must be discouraged. The weeding-out process, normally a part of increasing educational levels, plus reasonable admissions procedures to higher education programs, should ensure that only competent students are admitted. To the extent that the admissions process is successful, advancing students should earn excellent grades or at least grades that are superior to those earned in previous education.

It must be clear that the educational process is one of the places in life where failure has the best potential of being positive. Particularly in the creative parts of photographic education, failure must be seen as part of the path to success. A failing grade can have a variety of effects, not all negative. Thus using the full scale of grades, including failure, is using one of the tools of education. However, because of the human dimension, the use of failing grades and the method of demonstrating failure in assisting learning are very important.

161

Success and Failure

Every student wants to succeed, even if it seems to the teacher that the student "is trying to fail." All students want to be "accepted" by their peers, teachers, and parents. Success is perhaps the most powerful stimulus for the student to continue their learning.

Every teacher wants students to succeed. Having our students do well strengthens our belief that we are good teachers. All parents want their children to succeed. The success of the child is a sign that parental responsibility has been properly discharged.

Why, then, do so many students fail? The reasons are many. First, standards of success or failure are externally set, imposed on the students by the curriculum, by the course, by the teacher, or by the parents. Does a 50-year-old college professor fail if he cannot run a four-minute mile? Is it failure if a two-year-old child cannot walk? Why, then, is the passing grade on a photo examination 70%?

Next, many students have rarely encountered a learning situation where success is ordinary. Thus they have fallen into a routine of failure. They have been continually told, in effect, that they are no good. It is not at all astonishing that these students turn to noninstitutional (school) situations for learning satisfaction. Many delinquent children are capable learners, as shown by the skills they acquire on the streets.

Also, many well-established educational procedures foster the feeling of failure. When we mark tests we are emphasizing failure. We check errors rather than right responses; we point out mistakes rather than give credit to almost-right solutions; we demand perfection although we are rarely perfect. (A "Family Circus" cartoon shows a disappointed father looking at his child's report card. The child, in an explanatory posture, tells his dad, "But I knew the answers to lots of questions that weren't even asked on the test.")

Finally, students set their own standards of success and failure. They give up if the learning process is too difficult for them, without having a genuine feeling of failure. Similarly, if the work is too easy, students accomplish it with no feeling of success. Thus one of the arts of the teacher is to see that the students engage in activities of the right level of difficulty at the right time.

In real life situations, the ratio of success to failure is small. A writer reworks a sentence perhaps a half dozen times before it is right; the poet often does twice that. The engineer may tackle a problem in scores of different ways, and fail many times before success. The photographer destroys many unsatisfactory prints before he or she is satisfied.

"The pathway leads through failure. That is what makes images work. How do you differentiate a strong image from a weak image? You do it by creating lots of images and your eyes and your heart will choose the same images over and over again. The idea of failure is the essential. In baseball, if you hit .333, you can be in the Baseball Hall of Fame but you failed two-thirds of the time. If you can get one-third of your art to be strong that is a remarkable thing. Failure has rescued the process and given it uncertainty and that is the heart of being creative. If you risk something you risk failure."

Kim Krause
Art Academy of Cincinnati, OH

The students should be specifically prepared for such situations. They should learn that failure is a normal part of the attempt to solve difficult

162

problems, and not a consequence of a deficiency in their character. They should learn that real problems ordinarily require many attempts at solution. They should learn that some questions are probably not soluble at all, and that others have a variety of answers of different validity.

In a healthful environment even repeated failure is not distressing. A child is learning to walk; he topples over repeatedly, but this can be a source of pleasure rather than pain. The weekend golfer many never break 100, but he eventually enjoys the game. Amateur musicians can take great pleasure even when they play badly, and even when they recognize their incompetence by professional standards. In each of these and similar situations, the process itself is enjoyable. Eventually the exercise of even a minimal talent provides pleasure without regard to goals. The essential characteristic of the situation is the absence of an external criticism or consideration. Failure is not seen in the situations, only personal successes.

Assign arbitrary cutoff points on a scale with a full understanding that they indeed are arbitrary. If we give a 50-item multiple-choice test and assign A to scores 42–50 and B scores 38–41, we make a raw score differential of 1, from 41–42, worth a whole letter grade. To do this we must believe that such a small difference in raw score is real, not merely testing error, and also meaningful—actually indicative of a genuine difference between students. This belief is not usually possible to support. Do not assign different meanings to scores that are only trivial differences.

Adopt, at least in principle and as an ideal, the concept that a completely successful educational environment will generate only excellent grades. If the admission and counseling procedures, the teaching and learning methods, and the testing techniques all operate at their appropriate effectiveness, every student will do well. At least, this ideal is our intent if not our expectation.

"If you have low expectations, students will meet them. In my experience, expecting a lot from students frequently leads to getting a lot from them. And more important, it teaches them to expect a lot from themselves."

Jef Richards
University of Texas at Austin, TX

Conversely, if a student fails consistently or if a class earns a large percentage of bad grades, something is wrong. We should try to diagnose the element, uncover the cause, and try to correct it. We may

need to revise the objectives for the students or for the class, to clarify these objectives, or to provide opportunities for more effective practices. Often the problem is with the tests; they may not be consistent with the objectives or methods.

Assigning Final Grades

At the end of a unit or course, we usually have the responsibility for classifying students into categories, usually designated by letter grades. Some institutions use pass/fail, satisfactory/unsatisfactory, or credit/no credit grading. Regardless of grading method, no teacher takes this responsibility lightly. Every teacher finds it distressing to sit in judgment and especially to put into pigeonholes human beings who are of infinite complexity and variability.

Some teachers attempt to relieve themselves of the task of making such difficult decisions by resorting to mathematical procedures. We may compute assignment averages, test averages, and laboratory averages by averaging these with the final examination, most often with an arbitrary weighting system. Such a process is time consuming, and we usually find that the hard decisions remain for us to make. We are still left with the question, "Is this student worth B or C?" Often the more distressing question is, "Should I fail this student or assign the minimum passing grade?" The search for an "objective" method of assigning final grades is sure to fail, except in the situation in which the students' performance is so unusual as to be obvious, and in this situation no complex formula is needed.

> "Using one test as a high-stakes hurdle is unfair and often inaccurate, violates the standards of measurement professionals, and damages educational quality."
>
> Monty Neill
> The National Center for Fair and Open Testing,
> Cambridge, MA

Averaging a set of numbers is statistically sound only when the members (the numbers) of the set are estimates of the same stable process, and when the differences among the numbers are attributable to measurement errors. Thus, we correctly average a set of measurements of the length of sticks with the expectations that the average is a better estimate of the dimension than is any single measurement. But students are not sticks. Testing indeed involves large

measurement errors, but what we are trying to measure, the students' ability within contexts, is not at all stable. In fact, we intend that students will change. To the extent that a student does change, a series of tests never estimates the same performance, but, on the contrary, samples different levels of performance. What a student could do in September may have little relationship to what he can do in June, and therefore measures of ability at different times ought not to be combined.

Some students are severely penalized when we average grades. Such students are those who will do well day-by-day but are panic stricken by final examinations and who collapse under unusual stresses; those who start a course badly but finish well; and those who are all thumbs in the laboratory but excellent in theory. Especially when different aspects of the course involve different objectives, averaging grades may produce a set of numbers in terms of which students seem to be mediocre. Other students are over-graded by averaging within-course grades. Such students are those who reach the limit of their ability during the course, but may earn a respectable average despite their having little comprehension of the course as a whole.

When we average sets of estimates that have different means and variables, even a weighted average may be inappropriate. If a group of students earn nearly the same grades on a final examination, for example, but have quite different scores on assignments, hardly any weighting method will make the averages of scores reflect other than the assignment grades.

If it is often invalid to average within-course grades, it is more obviously wrong to average grades earned in different courses to arrive at an average grade for the year, or for a four-year program. Averaging averages from different courses is statistically improper. The principle is merely that it is incorrect to average grades for courses with objectives as different as those for photo history, photo science, and image production. This being said, it must be realized that the GPA (grade point average) used by most institutions is exactly that...an average of averages. Using this institutional standard, we must realize that this can give a trend assumption for each student but not a real rating of true learning.

You Gotta Give Grades

Because the administration of institutions requires our rating of student learning at the end of courses, we are required to assign final grades. Let us suggest six ideas to assist in this task.

"I hate grading...it is the worst part of teaching. Particularly our young students today identify so heavily with the grade as equivalent to the value of themselves. They work toward the grade rather than work toward the passion they have about making pictures. Grades just get in the way of students learning—they get caught up with that number score rather than the significance of their images."

Roxanne Frith
Lansing Community College, MI

First, realize that in evaluating student test scores we use only one kind of data, and not always the most reliable and valid kind. Accumulate, and use in the evaluation, information about student activities in classrooms, libraries, and laboratories. A balance between different learning styles, when appropriate, provides a better understanding, and therefore a better approximation of learning.

Next, do not try to substitute a statistical averaging process for your considered judgments. Frankly admit the subjectivity of evaluating human beings.

166

Third, give heavier weight to recent grade information as compared with older grade information. If, in a Photo II course, the student's assignment grades chronologically were D, D, C, D, C, C, B, B, A, B, the student clearly acquired above-average skills, and his final grade should be B, not the numerical average of C. Even in the extreme cases where the student does poorly all term, but shows on a final examination that he has by that time mastered the material, he deserves a course grade better than the average of all his grades, which reflects heavily on the grades in the early and middle part of the term.

Fourth, the most troublesome set of grades is one that isolates between good and bad performance. If this sequence is A, D, F, B, A, C, A, and average would be C, but this set of grades indicates that the student is by no means mediocre; on the contrary, he has indeed demonstrated that he can do good work, and also that he often does not have the incentive to do good work. The teacher has a hard decision, which must be based on what he wants the final grade to show: if the mark is to indicate the student's capacity, it must be at least a B; if the mark is indicate the least level at which the student functions, it should be D. In the latter case, the student's desire to do the work is being evaluated; in the former, his ability is evaluated. A C grade does not indicate accurately either ability.

"What students learn depends as much on your tests as your teaching."
Wilbert McKeachie
University of Michigan, MI

Next, some of the hard decisions would be eliminated if a "pass/fail" grading system were adopted. Such a two-point method has been used and has recently been adopted by prestigious educational institutions. However, a strict understanding of what is expected and what must be accomplished to receive a passing mark needs to be presented at the beginning of the course, to create a defining point of acceptable learning level. The pass/fail grading often is difficult within certain institutional situations, since the GPA will not be affected by the pass grade, but will be detrimentally affected with the failing grade. This may put undue pressure on the teacher to lessen the number of failing marks given in the course. One method to address this potential problem is to use "credit/no credit" as a grading system. It must be mentioned that if a specific GPA will be needed by the students for further education, scholarship, or employment, the number of courses allowing either pass/fail or credit/no credit grades should be limited within a program or curriculum.

Sixth, for classes small enough for all students to be well known by the evaluator, a statement about a student's characteristics is better than a letter grade or numerical grade. The process of writing a paragraph about each student is exceptionally difficult for the teacher, but it has a virtue of compelling the teacher to think seriously about the performance of each student.

"The roots of education are bitter, but the fruit is sweet."

Aristotle

167

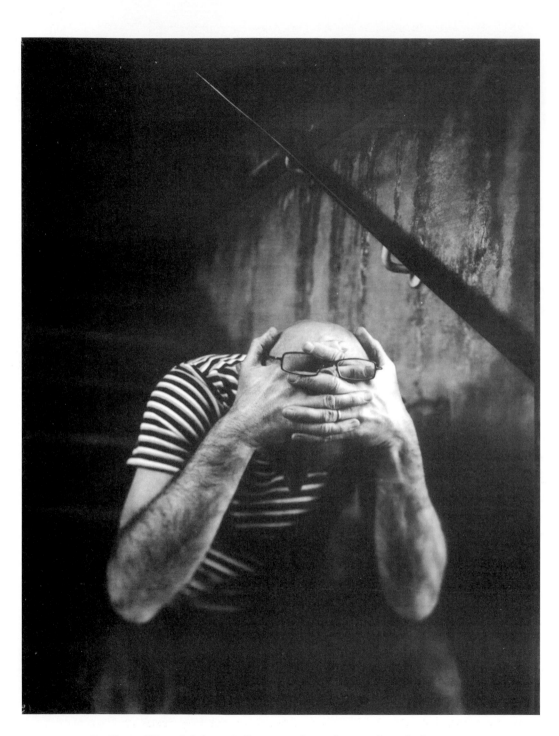

By Elmira Watts, Salisbury College, United Kingdom, student of John Martin

Evaluating Education

"If you don't know where you are going, you might end up some place else."

Yogi Berra

Just as it is important to test and evaluate students to validate that they are learning, we need to do the same for the processes that we use to help them learn. These evaluation tools will help us be more effective in our teaching and in our creation of effective photographic education. Just as learning is a progressive process for our students, becoming a truly effective teacher and developing photographic programs will also be progressive. Evaluative tools establish both strengths and weaknesses, identifying areas that will allow improvement and growth of the program.

We must look at the goals of evaluation or assessment in education to be either <u>summative</u> or <u>formative</u>. In the summative evaluation the goal is to assess the quality of the educational product. This is often seen as an evaluation at the end of the class or program. A formative evaluation's goal is to advance and/or improve the quality of education. In some cases the idea of a formative evaluation is seen as a tool for a program that is in the process of developing and forming. However, most assessments can be constructed to meet the needs to define the level of quality and to assist in giving direction in improving the quality.

"Let your words teach and your actions speak."

St. Anthony

For some teachers, the idea of being graded is not welcomed, and this is understandable. They may believe that they have done their time as students and have been employed because they know the materials to be taught. They often feel that this knowledge will allow them to be good teachers, and rating their performance and developing more or improving skills in teaching will naturally occur without introspection or examination of any kind. Those coming from advanced education, whether as graduate teaching assistants or teachers, see their roles based on previous education to be those who will "give" grades rather than receive grades. And evaluations are too often seen as grades and hoops that teachers have already passed through. Thus we must look at how teachers can improve, to raise the quality of their teaching, rather than looking at improvement in the sense of dealing with being rated.

Measuring Variations

170

Assessment of quality teaching requires measurement against standards. With our main focus on creating quality education and high levels of learning photography, we must go through a series of steps to assure that the students learn at their best level. At any point in our program we will have already envisioned the flow of our ideas about teaching photography, and will have planned our educational process through the creation of lesson plans and/or syllabi. We will have implemented, through teaching these plans, and now it becomes important to check how well we did.

The primary method used in many planning and implementation models involves planning, development, implementation, and evaluation. New planning to incorporate the information from the evaluation, to improve the quality, follows evaluation. This concept, while often enforced by administration, is one of the best ways that we can progress as teachers and have our students become ever more competent as photographers.

"In the 'good old days,' teachers just made up tests and students received a grade, but today we must validate the methods and outcomes of our educational processes."

Janet Bonsall
Central Missouri State University, MO

We need to find those things within our educational environment that enable high levels of education. This means that we are trying to identify and measure the variations that occur and that either promote or deter quality education. The bases of these quality standards are the objectives that we set out in determining our learning strategy. As discussed earlier, objectives should be measurable. This means that the outcomes of our learning process will provide evidence of success and to what level that success has happened.

This idea is not peculiar only to education. W. Edwards Deming in the 1950s proposed that business processes should be analyzed and measured to identify sources of variations that cause products to deviate from customer requirements. In our case, "products" can be related to our students and graduates and the "customers" can be viewed as parents and employers.

Using this model, we can look at our environment and determine separate types of variations that may impact learning. These are mainly common variations and systemic variations, and sometimes special variations that occur only sporadically or in special situations. Common variations are created by the environment, institutional practices, course materials, and regularly occurring activities. Special variations are those that are particular to a teacher or course. We can assume that variations of both types will impact every course. We must identify and analyze these variations because they are key to identifying problems, describing issues, defining strategies for correcting problems, and improving our educational process. It is the improvement of the educational process that we are driving toward, not a simple process to rate or compare faculty teaching styles, course materials, or classroom environmental elements.

"However beautiful the strategy, you should occasionally look at the results."

Winston Churchill

Realizing that these types of variations are not the same directs us to see that they will not use the same processes to solve problems identified in the types of variations. Treating common variations as though they were special variations does not solve problems and will likely create more problems.

The key is identifying problems by analyzing the variations between expectations and our teaching. As in most situations, many of these variations will not be clear with the application of only one evaluation tool. This tells us that continuous/regular processes must be used to identify

emerging and continuing variations from the standards that have been developed for our photographic programs. We need to measure regularly and consistently to develop both a baseline of variability and a method to identify changes in the environment, contents of courses, teaching methods, and/or student capabilities for our courses and programs.

Types of Evaluations

"When students have a good feeling about their own work and a feeling that they have really progressed, they are positive about themselves, and they are positive about the college and the teachers."

Ian R. Smith
Salisbury College, United Kingdom

Two basic types of evaluations are commonly used. These are student evaluations and teacher evaluations. These may be done in the classroom or online by students or by peers, and as classroom visitations and consultations by administrators.

Student Evaluations

Within much of higher education, student evaluations are a regular part of the educational landscape. The stated goal of these tools is to improve teaching and learning. When used properly and with understanding, evaluations can be great tools to help you become better at helping your students to learn.

Critical in understanding how to make evaluations become beneficial to learning is to realize that they are based on perceptions and that perceptions are not hard facts. Perceptions, however, are real. The perception of teaching affects learning. If the students perceive the teaching to be good in the classroom, the students will be more receptive to learning.

"We all react more to the negative evaluations than to the positive ones. The positive one comes in and it makes make you feel 'kinda' good, but when one comes in negative it makes you feel really bad. When it comes in bad you have to ask 'can this be true?' and if it is an issue, then do something to change it."

Buck Mills
Colorado Mountain College, CO

Research shows that student evaluations correlate more with how the student perceives the grade they will receive than with the amount of learning in the class. This means that if the students as a cohort perceive that they are doing well in a class, then the students will tend to evaluate the class more positively.

Two types of evaluations are commonly used. These are "numerical (scored)" and "brief response." While both are used independently, they are also used together. In a common evaluation, a numerical rating will be used with an optional brief-response questionnaire. For numerical measurement, often a Likert scale will be applied to statements about the course or instructor. The student will be asked to rate each statement on a scale (1 to 5), from "strongly disagree" to "strongly agree."

"It is the people who count, not the numbers."

Peter Day
BBC, Global Business

173

Use of Likert scale evaluations means we are trying to "objectify" the learning process. Asking questions that are objectified does not give the truest picture, but makes it easier to do comparisons between teachers and to see improvement. Therefore, those who develop classroom evaluation tools look for measurable aspects of the process. Evaluation developers try to find items in the course and classroom that can separate into distinct functions that can be measured. Thus the aspects of the process are defined in terms of a simple scale of functions: "Does the teacher return exams in a timely manner?" or "Does the teacher start class promptly?" or "Is he/she neat and professional in appearance?" These questions, while part of the process, are not measuring learning. As we know, grading and returning tests and assignments promptly provides timely feedback to the student and can assist in the learning process.

Normally in these tools, one or a few questions may compare the course or teacher to other courses or teachers. Once again these types of evaluation questions do not measure learning but rate the differences between instructors or courses. A rated statement, such as "This instructor/course is among the best," functions to establish this differential measure. Research in which these types of questions or ratings are asked many times shows that they tend to give the same results.

"I never read student evaluations until the semester after so that I will not be as influenced by my memory of the personalities, so that I can read them more objectively."

Gary Wahl
Albion College, MI

In student evaluations it is interesting that few, if any, ask the students to rate learning using a statement such as "Because of this teacher or course I learned the objectives of the course." Such questions would be beneficial for perfecting and evaluating the learning process.

While often optional, brief-response evaluations can be very helpful in improving the teaching/learning process. Eliciting from students comments on both the positives and the negatives they see in a course can give direct information about areas that can increase or maintain quality. Simple open-ended questions such as "What topics do you feel were the most (or least) valuable?" or "What has your instructor done especially well (or improved) in teaching this course?" can provide insight into the students' perceptions of their learning process.

"The wisest mind has something yet to learn."

George Santayana

Because of two tendencies, most student evaluation results will likely fall into the upper part of the rating scale or will contain overall positive statements about the course or the teacher. The two tendencies are that the normal relationship between students and teachers is respectful and often the students are in a situation where the amount of course material is large. Therefore, an evaluation that results in low ratings or negative remarks carries more weight as a sign of ineffectiveness, compared to an evaluation that results in high ratings/positive comments as evidence of superior performance.

Regardless of the design of the evaluation tool, evaluations can be defined as comparative devices. While the design of the tool suggests that it functions to assist in the creation and improvement of an individual course and/or serves as a teacher evaluation, the actual function is to compare educational situations. Even for students participating in their first evaluation, they are seeing the present situation within the flow of their education to that point. This can

174

lead to popularity contests and even in a few cases to instructors begging for good evaluations.

"Three cardinal rules for evaluation or assessment: 'Nobody wants to be evaluated, nobody wants to be evaluated and finally, nobody wants to be evaluated.'"

Frank Newman

Administrative Teacher Evaluations

The involvement in evaluations is part of an administrator's job. Within education administrative evaluations are designed to improve the quality of education. Unfortunately, at times, administrators use the evaluation tools in punitive ways. This being said, we must look at the positive side of administrative evaluation, because it provides the rationale and guidance for improvement.

For the most part administrative evaluations take two forms. The first form involves a classroom visitation and observation of teaching methods, skills, control of environment, etc. The other common form of administrative evaluations is through consultations with instructors that are based on evaluations of functions within the institution that are important to classroom performance.

Since the administrator will have access to the student evaluations, student perceptions of the teacher's function within the classroom can be ascertained, and classroom visitations and observations normally deal with specific functions within the educational environment. Therefore, administrators tend to look more at methodological portions of the teaching. Primarily, classroom observations look at how well the teacher uses methods of instruction.

At Brooks Institute of Photography, the administrative classroom observation includes two primary areas. First, within the area of "Presentation Proficiency," the administrator observes and comments on the following six concerns:

The instructor's development of rapport with the students.
The instructor's overall tone of communication with the students.
The instructor's ability to gain the cooperation of the students.
The instructor's ability to direct student attention.
The instructor's ability to deal with and correct off-task behavior.
The instructor's ability to facilitate student engagement with the
 subject matter.

175

For the area of "Methodology," there are seven defined measures for the administrator to rate:

Clearly designed handouts detailing course assignments.

Well-organized demonstrations, exercises, and simulations meeting course objectives.

Text supports course objectives.

Assignments facilitate acquisition of skills that meet course objectives.

Use of equipment enhances lecture and demonstrations.

Pace and sequence of information delivered maximize student acquisition of course material.

Method of evaluating and grading criteria for assignments clearly articulated.

In some institutions, peer evaluations are used. This tends to be less threatening to the teacher than having an administrator visiting classrooms for part of the evaluation.

These evaluations, when added to the student evaluation, give a view of how the instructor is performing in his or her teaching. At this point the common approach is for the administrator of the program to meet with the instructor to go over the evaluation tools that were used, and to discuss the outcomes and future directions based on the evaluations.

"Internally, a system of mentoring underperforming faculty by those faculty considered outstanding can help. It is also important to communicate specific goals and measurements when working with faculty who fall short of expectations. Ultimately, it becomes increasingly important that clear documentation exists if it becomes necessary to proceed toward issuing a terminal contract."

Nancy M. Stuart
The Cleveland Institute of Art, OH

Professional Development Plans

"He, who is too old to learn, is too old to teach."

Proverb

The outcome of the evaluations, whether formalized or personalized, should be a professional development plan. This needs to address how

the quality items of the evaluations can be increased. Even when the evaluations show excellence, improvement or continuation should be engaged to assure future quality.

The form of a professional development plan can vary from institution to institution or within individual institutions, but certain items likely will appear in the plan. These are how you will improve classroom performance, service to students beyond classroom performance, service to the institution, professional development within photography and as an educator, and personal academic growth. The following criteria are the parts of the professional development plan from Brooks Institute of Photography. The criteria represent potential areas that need to be addressed in any plan and that promote moving forward within the teaching profession.

Faculty Performance Review Criteria

	Reviewed Documentation Check-Off	% Weight of Job Performance

Criterion #1: Teaching/Instruction

Course Preparation, Delivery, and Assessment

- Multiple class observations—chair, peer, Director of Education (DOE).
- Submission and review of course syllabi and teaching plans.
- Student faculty—course evaluations for every class taught.
- Must ensure that content of the course matches the expected course competencies and that these outcomes are measurable.
- Other:

Administrative Instructional Responsibilities

- Posted office hours or contact time (home/cell phone numbers, e-mail addresses, hours before/after class on course syllabus).

Faculty Performance Review Criteria—Cont'd

	Reviewed Documentation Check-Off	% Weight of Job Performance

- Submission of attendance sheets for every class on the days they meet.
- Submission of course grades within 72 hours of the last class session.
- Other:

Criterion #2: Service to Students

- Tutoring/mentoring.
- Academic advising.
- Career-related counseling.
- Identification and assistance of at-risk students.
- Faculty advisor to clubs or organizations.
- Other:

Criterion #3: Service to the Program and Institution

- Serving on institutional or program committees.
- Participation in all required events, including new student orientation, registration, graduation, and other like activities.
- Sharing "product knowledge" information with other departments, such as Admissions and Career Services.
- Attendance at department meetings (minimum of two per term for adjuncts).
- Working with other members of the department to continually enhance program curriculum to stay current with the market demand.
- Other:

Criterion #4: Professional Development

- All faculty must attend in-service training/ orientation provided at the beginning of each term.

Faculty Performance Review Criteria—Cont'd

	Reviewed Documentation Check-Off	% Weight of Job Performance
• Faculty are involved in continual professional development, including in-service training, outside training, and educational opportunities to enhance their content and/or teaching skills.		
• Each full-time faculty member should develop, in a brief paragraph, a teaching and/or an education philosophy that will serve as a guide in his/her profession.		
• Each faculty member should complete an annual faculty development plan that is reviewed and approved by the DOE.		
• Evidence of scholarship or publication.		
• Other:		

Personal/Professional Development:

• Accomplishments or new abilities demonstrated since last review (for example, since the last review, the following activities to be accomplished):		
• Courses taught and improved.		
• Academic activities (writing, research, artistic production, etc.).		
• Attendance at conferences, trade shows, and producing and exhibiting.		
• Service to the profession.		
• Service to the Institution.		

At each year's administrative evaluation the teacher and administrator agree on the next year's areas of accomplishment and professional development. At this point the weighting of each area (criteria) is agreed. This allows both the teacher and the administration to have a view of the desired growth and development for the next evaluation. In the rare but important situation where performance in any of the areas

is not progressing to the standards of the institution, a corrective action plan will be implemented. In this situation the teacher must realize that this is a "shot across the bow" to advise the teacher that his performance is endangering his continuance in his role at the institution.

> "It is really important that faculty are involved in professional development activities; it is the way they stay in touch with the 'latest and greatest' and what's hot and what's not. It is a way to stay ahead of the curve."
>
> Scott DeBoer
> Career Education Corporation

Designing Instruments for Evaluation

For many reasons there is a push within any single institution or system to have a single evaluation tool that can identify problems and occasionally show successes. It is often the case that faculty members themselves are asked, either through committee or individually, to design evaluation tools. In effect, developing an evaluation tool is similar to creating an examination. There are the objectives that are desired by the faculty members and the courses that the evaluation instrument must measure in terms of these objectives. There are two major functions that must be considered as a tool is designed: when the tool will be administered and the amount of involvement or openness of answering structured by the method used in building the evaluation tool.

When determining implementation time for a student evaluation of faculty or course, the flow of the course must be taken into consideration. There are advantages to having a set evaluation time—for example, the last fifteen minutes of the class—and to having evaluation fall within a time window that is not restrictive for the faculty and/or administration, but allows the evaluation tool to function properly, without interrupting the proper flow of the course. As stated previously, the evaluation has a high correlation to the anticipated grade of the student filling out the evaluation. If the examination, the last activity in many courses, is to be considered as part of the evaluation of learning, then the evaluation will be placed after that in-class examination has been completed. This would also be true for a final portfolio critique. Evaluation earlier within the flow of a course may reduce the effect of final grade anticipation as a measure within the tool.

Jake; by Alexandra Hoffman, Brooks Institute of Photography, CA, student of Tim Meyers

Whether the evaluation is built on a quantitative/objective model using a Likert scale or has qualitative/open-ended questions with short-answer responses, the design of the questions needs to identify the objectives within the course and the teaching methods that will show quality and/or lead to you improvement. Just as essay examinations are easy to write and more difficult to grade, so are evaluations. But open-ended subjective answers can give more specific information to deal with the quality of the educational program. For this reason, many institutions use open-ended questions to augment objective evaluation tools.

Critical in design of an evaluation tool is alignment with the learning objectives and the environment of the course. As classroom evaluation tools become more general, they must deal with the environment of the class.

Regardless of all other considerations, it is in your best interest to evaluate every course you teach on an ongoing basis. Provided that the form of the evaluation stays consistent, that the objective questions remain constant, or that the subjective questions approach the same areas of concern, then growth in teaching and quality can be seen by viewing the evaluations over time. If similar problems appear on successive evaluations, then it becomes obvious as to the areas that should be addressed to improve the quality of education. It will be the continuing nature of an evaluation that allows for growth.

> "It has always seemed strange to me that in our endless discussions about education so little stress is laid on the pleasure of becoming an educated person, the enormous interest it adds to life. To be able to be caught up into the world of thought—that is to be educated."
>
> Edith Hamilton

Evaluation of the Program

Just as it is important to understand the strengths and weaknesses of the faculty's performance in the classroom, it is important to evaluate the health and quality of the program. All tools that can be used to evaluate faculty can be redesigned to apply to the program. There are also other tools and methods that can be used to define the strengths or areas needing improvement within the programs.

Program Reviews

For the photographic program, regardless if it is a new program or one that has been in existence for years, there is a need to review how the program is functioning. Accreditation, in one form or another, will require a review of every program at the institution. Even if accreditation is not an issue, state, local, institutional, or other bodies may require a review to see how well the objectives of the program are being met. But assuming an external requirement is not the most important reason for program review; rather, the review is a method to improve the quality of the photographic curricula and the ancillary activities.

The review is an assessment of the effectiveness of the program. How the assessment is handled will vary from institution to institution. Many institutions have ongoing assessment and program review while other institutions review periodically or as required by outside agencies. Some photographic programs see the concept of a program review as a periodic nuisance project. Whether attached to accreditation or other mandate or self-evaluative tool, the program review needs to be a continuous and ongoing process.

The assessment/review process should have seven steps. These are definition, alignment, assessment planning, data collection, analyzing, comparing, and return. The first step is to define the mission, goals, and outcomes that the photographic program strives for through its curriculum. Though the mission, goals, and outcomes/objectives may have been envisioned during the program's planning, it is important that they are written out and codified to facilitate planning an effective assessment tool. If these have been written out previously, it is still wise to review and update all three, since the photographic discipline and technologies are in constant flux.

To understand the importance of mission, goals, and outcomes/objectives, let us briefly state how they relate to each other and therefore how they will become important to the evaluation and program review. The mission is a vision of the program, department, or institution based on its values and philosophy. This is the broadest underpinning for the educational process. Goals delineate the attitudes, knowledge, skills, and values expected of those finishing the program. Finally, the outcomes are specific, demonstrated measures of the goals.

With the centrality of the mission, such as providing photographic education, the mission may seem obvious, but restating the mission is helpful when entering into the review process. It provides an overview

183

of how the program should look through the review process. Just as defining the mission is helpful in looking at the overall program, defining and restating the goals and outcome objectives provide the focus for the individual parts of the program.

Having definitions of the program's mission, goals, and outcomes, the next step is to delineate the alignment of these three program definers with the curriculum and activities. Assuming the correctness of the program definers, then the program review assures the coordination of the outcomes with the curriculum and activities.

The third process step is to plan how the assessment will happen. For many photographic programs there will be an institutionally prescribed process flow. Even with a template for how the program review is accomplished institutionally, individualizing the process to ascertain the photography program's unique attributes will be needed. This will include who should be involved and how to approach and acquire information about the program. The criteria for assessing success are defined to set standards against which the program review will be judged.

The planning will necessarily involve how data will be collected about the program. This characterizes the who, what, where, when, and how data will be collected for the program review. Planning needs to include both the process involved in gathering and analyzing the data and how the product of the review will be reported and used.

The actual collection of data is what most people see as program review—asking questions and receiving answers about the success of the photographic program. The collection of data naturally flows into the analysis step of the program review.

The sixth step in the program review is to compare the analysis of the collected data to the defined mission, goals, and outcome criteria. As this comparison occurs, description of how improvement within the program can happen.

The final step in the program review process is to return to the first step. As the assessment takes on its final form, it provides guidance in reworking the mission, goals, and outcomes for the program.

An Assessment Rubric

Today, one of the most common assessment tools in education is the "rubric." A rubric is a method to assess desired successes against defined criteria. Commonly the rubric is a matrix with criteria standards at each matrix location. The advantage of using a rubric is its ability to

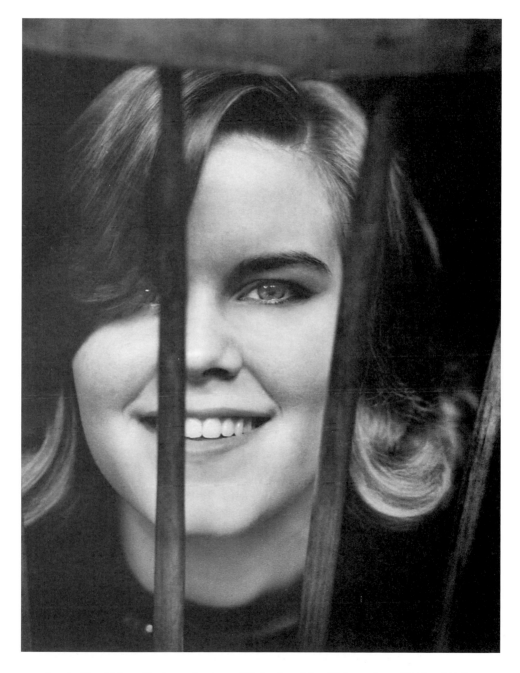

Jan; by David Page, Rochester Institute of Technology, New York, student of Richard Zakia

simultaneously deal with multiple aspects of the program review. A rubric for a photographic program might include the following criteria areas:

- Curricular criteria area:
 Examinations, portfolio reviews, certifications, completion rates, grade point averages (GPAs).
- Faculty criteria area:
 Degrees held, professional development activities, professional or artistic work, faculty evaluations.
- Program criteria area:
 Breadth of curriculum, academic support, educational and student-accessible equipment, classroom and laboratory accessibility.
- External criteria area:
 National reputation, employment or further education placements, grants, awards.

"There are two types of education...One should teach us how to make a living, and the other how to live."

John Adams

The preceding list does not attempt to show the totality of criteria, but gives a brief view of some ways that the program can be reviewed.

When the criteria areas are chosen, a matrix can be constructed with ascending measures for each individual criterion. For example, if the criterion is completion rates, the measure might be excellent if 90–100% of freshman majors complete all photographic course work within a set number of years, with a good assessment representing 75–90% completion, satisfactory representing 50–75% completion, and unsatisfactory representing less than 50% completion. This criterion, when compared to other criteria, can give a picture of the effectiveness and strength of the curriculum. To make the most out of the rubric, the criteria and standards of measure need to be in place before the review starts.

Accreditation

From an outside view, either personal or governmental, accreditation is a badge of acceptance. Whether for funding, grants, matriculation, or employment, accreditation becomes a level of certification. The body that accredits is stating that an institution or program meets or exceeds

agreed standards for educational quality. By doing this, the accrediting body allows those outside the institution to assess if the institution or program will be valuable in the pursuit of educational goals, will be valuable in providing an educational level to facilitate entering employment, and/or will be valuable in conferring merit to the degrees the students will have earned when they graduate. By insisting on meeting their standards, the accreditation bodies try to assure consistency and accountability for the quality of education within their purview.

These and other reasons for accreditation can be seen by the functions described by the Accrediting Council for Independent Colleges and Schools. These are as follows:

- Evaluate whether an institution meets or exceeds minimum standards of quality.
- Assist students in determining acceptable institutions for enrollment.
- Assist institutions in determining acceptability of transfer credits.
- Assist employers in determining validity of programs of study and the acceptability of graduate qualifications.
- Assist employers in determining eligibility for employee tuition reimbursement programs.
- Enable graduates to sit for certification examinations.
- Involve staff, faculty, students, graduates, and advisory boards in institutional evaluation and planning.
- Create goals for institutional self-improvement.
- Provide a self-regulatory alternative for state oversight functions.
- Provide a basis for determining eligibility for federal student assistance.

187

There are different types of accrediting bodies based on the type of institution, the program specificity, and/or jurisdiction. Each body has its own standards and methods of giving its accreditation within its scope. Primarily there are four types of accrediting bodies. They are presented here based on scope and not on their status or reputation. All accredit against their own standards. The smallest scope is the specialty accreditation such as the National Association of Schools of Art and Design (NASAD), which will accredit only academic institutions or programs that center their educational efforts on art and/or design. Statewide commissions or boards—for example, the Ohio Board of Regents—hold the educational institution to the mandates of the state or locale. Next are national and international groups that accredit a

certain type of educational institution, not based on program but more on the concept of institutional organization, such as the Accrediting Council for Independent Colleges and Schools (ACICS). Last in this listing are the regional accrediting bodies that accredit all levels and program areas within a large geographic area; an example is the North Central Association of Colleges and Schools (North Central).

With the exception of legislative need for approval either by state or national standards, accreditation is a voluntary process, though many funding or certification programs require accreditation. Within photographic education it is access to student support that may require regional, national, or international accreditation. However, the real advantage to the accreditation process, whether initial or for continuing accreditation, is the self-examination as well as external comment on issues of quality of the education.

The feedback the school receives from the accrediting agency provides a useful overview of how the entire school is functioning: administration, finances, management, planning, faculty, curriculum, library resources, staff, and communications. Here is an example of a 2005 accreditation review for a college made by the "Accrediting Commission for Community and Junior Colleges Western Association for Schools and Colleges":

188

> Dialogue: The College's dialogue has not yet reached the stage of defining, explicitly stating, and assessing student-learning outcomes at the course, program, and degree/certification levels.
>
> Governance: The team also found a college with deep-seated problems related to governance, communication, and trust.
>
> Library: The library collection needs attention. A collection development policy needs to be formulated.
>
> Management: The fiscal management system does not produce timely or even accurate information for sound decision making.
>
> Financial: The team encourages the college in the strongest terms possible to pursue strategies that will result in a financial system that will produce clear, reliable, timely, and transparent reports in which all constituents can have full faith and confidence.
>
> Evaluation: There is currently no formal process in place to evaluate the integrity and effectiveness of the college's overall governance and decision-making processes and structures.
>
> Planning: The college does not have a process to evaluate the effectiveness of the ongoing planning and resource allocation process.

A careful review of an accreditation report is a reminder that educating our students involves the entire school, across the board. It provides the faculty with an assessment of not just how they are doing but how well the administration is doing in fulfilling their support of the educational process. Loss of accreditation can have severe consequences on a school recruiting students, alumni support, and private and government funding.

"Open your arms to change, but don't let go of your values."

Dali Lama

189

By Don Holtz, Lansing Community College, MI, student of Glenn Rand

The Environment

"The best learning takes place on a log, with the teacher on one end and the student on the other."

Socrates

There are two important parts of the environment within the classroom. Though it is easy to define the classroom environment as its physical realities, the psychological aspects of the environment are also very important. The classroom environment is made up of people and things. Thus we must deal with both the physical and human limits of the classroom setting.

When we look at the people in the classroom, we must be otherdirected in our discussion. While there are as many types of personalities, attitudes, and attributes for the teachers in the classroom, as teachers we are looking at how we can best utilize the classroom environment to affect learning. Thus our view must be toward the variations in the student cohort rather than toward differences in teacher personalities. Though both students and teachers inhabit the classroom environment, because of the nature of the single-teacher-to-many-students format of most classroom situations, the best advancement of our topic comes from discussing student variations.

Relationships

The classroom is part of an environment in which interactions take place between students and teacher and among students. A healthful social environment encourages learning; a defective one interferes with learning.

"Mental facts cannot be properly studied apart from the physical environment in which they take cognizance."

William James

Unless the students' previous educational experiences have been wholly bad, they come to a new class with at least the hope something good will happen. We see this feeling especially when students enter college—after the trauma associated with "Will I be accepted at the college of my choice?"—but also when students move from grade to grade, to high school, etc. Particularly within photography, where students have selected the program or the course because of the desire to pursue a personal interest, the hope for a positive outcome is most pronounced.

Students in elective courses, curricula, and higher levels of education often have a romantic view of what the new educational process will involve. They expect to find their teachers to be inspirational, possessing greatness and being magnificent, but they do not always find these characteristics.

Students will sometimes, because of unfortunate experiences, have come to look at the educational process as a kind of contest. Even the usual classroom physical arrangement encourages the concept of a group of students set against a teacher. The teacher is looked on as an adversary who should be at least resisted, and sometimes attacked.

Both of these notions of education—the romanticism and the battleground concept—must be abandoned in favor of a cooperative attitude, which is possible only if students and teachers agree on the goals of education, and only if a rapport is gradually developed; ideally a rapport will develop with every student, but unfortunately in practice this happens only with some students.

Students as People

Students come to us from widely different backgrounds and bring remarkably different abilities and needs. Although we know that it is wrong to categorize human beings, even students, it is hard not to do

so, and to describe, as we do, "kinds" of students, however superficial this description may be.

Some students have experienced permissiveness in their families and in their schools. Some students have experienced only authoritarianism. Most teachers adopt perhaps the middle ground, but we can hardly satisfy every student's need in this respect. We must let the students know our sets of educational values, and expect them to respect those values. Above all, we must not vacillate; this kind of action puts students in the uncomfortable and wasteful position of having to guess what kind of action is right at the moment.

"We continue to shape our personality all our life. If we knew ourselves perfectly, we should die."

Albert Camus

Other students are argumentative or antagonistic without knowing why. To such students, teachers represent authority, and some of these students rebel against all authority. In the classroom, a discussion between a teacher and the students may conceivably contribute to the learning of many students, but an argument is usually fruitless. Teachers must recognize when a discussion turns into an argument and terminate it politely, with a request to the arguing students to arrange for a meeting later. Often this ends the matter. Personal conference permits communication between a teacher and a student whereas in the classroom both of the participants find the presence of an audience distracting.

Some students need continual attention. They ask superficial questions in class, they swarm about the teacher after class, sometimes follow him to his office, and often seem to be a nuisance. Usually, such students are seeking reassurance, and we need to be understanding and patient until they can become more self-sufficient. Above all, never tease or ridicule these students, or any others. Their needs are real.

"Must a teacher be objective, impartial, and capable of seeing the world from every viewpoint? It seems to me that a teacher functions best when he operates from his own emotional base, using whatever self-control has been granted him and whatever degree of poise he has achieved to work from his own base with integrity and passion. In this environment, the student will be more in harmony with what he knows and recognizes of his own reality."

Henry Holms Smith
Indiana University, IN

194

After assigning a few grades, we can identify the students who are aggressive about their grades, who will try to persuade us to raise their score few points. Teachers should always be willing to review the test and to review all the questions on it. Perhaps on rescoring, we will find that we have scored a question a little too liberally, and conversely some too strictly. Plain errors should, of course, always be admitted and promptly corrected. But where there are matters of judgment, students should realize, and they seldom do, that their test responses may well be overrated as well as underrated. When they understand this, they usually become less demanding. For the perpetual malcontents, who insist that they feel they should have received a higher grade, end the argument by recognizing their feeling, agreeing that they are entitled to their feelings, but being firm in your considered judgment. Discussions with students about grades offer an opportunity to help students understand what grading is about, what your attitude is toward grading, and thus to further the students' comprehension of the educational process. Thus the teacher should by no means avoid confrontation, but should welcome it. Naturally, the teacher should have previously thought through carefully what the grading process implies, and should obviously have scored the test, projects, and other papers with care and good judgment.

Students who have not yet learned that education is a cooperative process delight in catching the teacher in a mistake. Since teachers are as fallible as the rest of humankind, we will surely make errors. An appropriate response is to admit the error and to thank the student for detecting it, without embarrassment or trying to cover up. For teachers to insist that they are still learning is a sign to the students of professional honesty and sincerity, and students generally will approve. Note also that if teachers do not attach much importance to minor blunders on their part, they must not be overly critical of similar blunders made by the students. If, on the contrary, teachers are excessively fussy about details of student work, they must be similarly fussy about what they say and do; in this case small teacher errors may take on an undue importance.

"Thinking you know when in fact you don't is a fatal mistake, to which we are all prone."

Bertrand Russell

Improvisation vs. Rigidity

Many students and teachers are comfortable only in a tightly structured learning situation. This is especially true for beginning, or insecure, students and teachers, for whom relatively fixed patterns ensure no surprises: everyone knows what he is expected to do.

Subject-oriented teachers tend to think of the course content as unalterable. It is unfortunate if the teacher must say, "we have no time for this subject," regardless of the appropriateness of the material at that moment. A student-oriented teacher, on the other hand, is continually aware of the students' behavior and engagement in the learning, or the contrary. In the very best learning situations, the teacher has been so expert in the course content that he or she can almost forget about the content to be presented. The teacher can concentrate instead on the students and what is happening to them. Such a teacher can improvise creatively; trying two, three, or four methods of explaining a difficult topic can open up opportunities to find new ways to teach a process or an idea.

We must attend to the quality as well as to the quantity of learning. It is better for the students to "make" five prints in the darkroom or on an inkjet printer, if these are well executed and well understood, than to make twenty hastily and poorly produced pictures. However, time must be available for renewed tries at learning when the first or second tries have clearly been insufficient. To leave the subject only "half-learned" or incorrectly understood is damaging to the student.

195

Anxiety

Many students spend 16 or more years in formal educational pursuits. During much of the time they are assigned tasks that they find meaningless or oppressive, too easy, or too hard. Furthermore, students are almost continually being examined and criticized, and their mistakes are pointed out. Under this long-time, intense scrutiny, in such a demanding situation, it is not unreasonable that students feel stressed. They often develop a continuing anxiety. The most secure of adults could hardly avoid the same feelings in the same situation.

Anxiety is most obvious during the most stressful situations, especially examinations. Students chew pencils and fingernails, frown, and mutter. They blank out mentally and make ridiculous blunders. They get sick.

"A good classroom environment is where the students feel safe to be able to make mistakes and grow. Where they do not have to be perfect."

Roxanne Frith
Lansing Community College, MI

Teachers, if they care about their students, should do what they can to reduce anxiety. Five ideas can be used to reduce the anxiety in the learning environment. First, the physical environment should be pleasant and free of discomfort and ugliness. This is especially important when the outcome of the education, as in photography, is to be visual and creative. Second, within the limits of human capacity, remain calm under stress as a model for the students. Next, avoid unrelenting pressure on the students. Provide periods of relaxation; maintaining a sense of humor is invaluable. Fourth, reduce as far as possible sources of anxiety in tests. Do not constantly remind students of the time remaining or of how well they're doing. Steer clear of staring over the backs of students as they are taking a test. Last and above all, plan the learning situation so that success for the students is normal, to be expected. When failure occurs, make it a reason for new attempts to learn, not for punishment.

"Nothing in the affairs of men is worthy of great anxiety."

Plato

It needs to be mentioned that the physical environment can increase anxiety if the environment is unfamiliar. For example, if an examination is moved from the normal classroom to a large and unfamiliar space, such as a new lecture hall or gymnasium, the likelihood that anxiety will increase and have a detrimental effect on test performance is increased.

Caveats about Teaching Methods

Some teachers take pleasure in insult and sarcasm. Students properly resent being treated this way. Correcting student behavior is often necessary, but it should be done with the intent of helping students rather than putting them down. The teacher, by definition within the educational and institutional structure, is in a superior role, and need not reinforce this role at the expense of the students.

"If I could pass along just one thought to current photography and would-be photography teachers, it would be this: Don't underestimate the influence you have on students. They are in your class because they are passionate about photography. They want to learn from...that's right...you! The students value your opinion. Tremendously. So, choose your words carefully. Remember that you can break someone's spirit (or heart) with a single word, such as 'pedestrian.'"

Rick Sammon

Conversely, some teachers want to be popular with their students, and may avoid confronting them with necessary and perhaps unpleasant obligations. It hurts, rather than helps, students to let them get away with something important. For example, once a due date has been set for a photographic project, with suitable attention to the appropriate timing, this date should be strictly adhered to. Learning to meet reasonable deadlines is an important part of education. Allowing students to practice poor standards undermines both the educational purposes and the teacher.

Teachers who are overly authoritarian and dogmatic fail to realize that their students' personalities represent the broad spectrum of human behavior. The teacher must structure the learning process and environment in terms of timing and emphasis, but also must provide room and time for students to try to express their own capacities, even at the risk of making mistakes. On the other hand, teachers who are excessively permissive, for whom anything goes, are ducking the real issues of education, and avoiding the tough aspects of their job. Realistic goals must be set for students to aim at and the teacher should expect progress toward those goals.

"Intolerance of ambiguity is the mark of an authoritarian personality."

Theodor Adorno

An Equality of Rights

In enlightened schools and universities, the question of academic freedom for teachers has been settled in principle, if not in detail. Students also have rights, we suppose, but they are as yet not as well defined nor even as widely accepted. However, student rights are major portion of the environment that assists in the learning process. Both sets of rights have a major effect on the learning environment.

The doctrines that the administration and faculty of a school know what is best for the students, and that the students should take what they are offered, are being seriously examined. Matters of appearance, language, and behavior are considered by some schools to be properly regulated by the school or administration. Many students believe otherwise, and are urging that school administrators leave these matters to the students. Some students even demand a voice in, if not control over, such concerns as course content, curriculum planning, teaching methods, and faculty appointments. The appropriateness of a student-run or student-demanded curriculum ebbs and flows within educational philosophy and will continue through the life of institutions and programs.

Regardless of the merits of the case for more and more student influence over the educational environment, perhaps the following precepts express the minimum that most students expect: Students have the right to be taught well. Their teachers should be competent and worthy of respect. Elementary courses require the most effective teachers, since it is in these courses that the right start must be made in the educational process. Less competent teachers may handle upper level courses, since by that stage of their education students should be on the way to becoming self-educatable.

Students, at every level, have the right to ask questions about educational policies and programs, and to express their opinion about curriculum and course objectives, teaching methods, course and curriculum requirements, grading policies and procedures, etc. School officials should welcome rather than resist such questioning. For students to inquire about these matters is a sign that the educational process is really functioning and that the students are deeply involved in their learning. Furthermore, embarrassing questions may well serve as a stimulus for school officials to reexamine their policies and practices, and perhaps change them for the better.

Perception and Proxemics

In photographic education today we are between an older technology, with its unique spatial (environmental) demands, and a newer one, with a different set of requirements for educational space. However, the requirements for several areas—the lecture and critique spaces—are common to both old and new imaging technologies. Regardless of the technologies taught in the educational environment, the physical,

psychological, and sociological complements of the educational space impact learning.

When we speak of an educational space we most often concern ourselves with the physical realities of the environment. To understand the physical function of educational spaces we must delve into the perceptions and proxemics of the spaces that we use as classrooms and laboratories. Proxemics is the study of social and behavioral aspects among individuals within spatial environments; proxemics has a great effect within the educational space and therefore on teaching and learning.

Limits of Educational Spaces

It is easy to see the physical reality of walls as defining a classroom or laboratory. While the limits created by the physicality of the educational environment are apparent, we must be concerned with how the environment controls the perceptions that we will need to help us teach photography, and how the perceptions control the limits that will allow students to learn.

From the perceptual point of view, we can see the physical, environmental limits as barriers to primarily the visual and aural senses and as constraining motor activity. We normally do not define spaces in terms of single sensory modes, but this is perhaps the easiest way to suggest the limits of space and how these go together to create a successful classroom or laboratory.

Vision
Vision is the most important part in learning photography. Whether it is learning to see and communicate or the ability to acquire information, it can be said that the learning process in photography is mostly dependent on visual aspects. Because of the specific and general roles of vision within photographic education, attention must be paid to the visual environment.

If we do not consider the visual extent of the environment, we may be inadvertently lessening learning. Within photographic education the visual environment not only defines the space for education, but also affects how the space will function to serve learning. To start, as obvious as it may seem, this can be critical for exhibition and critique spaces. If vision is restricted, then learning from looking at images will be limited. Our concentration on viewing images defines what we

199

require when speaking of exhibition or critique space: an environment that accommodates images within the learning space augments the ideas we wish to present about photography. Therefore, to create a better photographic learning environment we need to create and maintain a visually stimulating environment.

"The national differences in perception of space during interpersonal encounters are not racially determined: they are expressions of social influences rooted in history and experienced during early life. These influences affect also the perception of other aspects of the environment."

René Dubos

Experience shows and studies recognize that when the visual environment is active, giving students visual stimulation, the environment will positively affect creativity. However, the visual environment can be too busy and then become a distraction. The environment can and often is a model for the visual and educational style of the photography produced within or in conjunction with the space.

Studies have also shown that brighter and more saturated colored walls increase student readiness to learn. Visual stimulation is used to raise awareness and increase readiness for learning. An interesting corollary to the concept of visually stimulating environments is the creation of a nonstimulatory environment for a critique area and for a computer laboratory. When instructing about or having students work with image creation software, where color correctness (color management) is important, the use of neutral, nonsaturated colors positively affects the learning and the image production.

Beyond the effective environment for photographic education, vision directly affects how we receive information and how we define the spaces we use for education. For this reason we must first state that limits to perception create spatial barriers. Most common is the use of a barrier placed in the line of sight to define a territory for a class or laboratory. For the space to be defined, the limiting aspect need not be a total visual block, though the denser the visual barrier, the more easily perceived the barrier becomes and the better is the definition of the educational space. The use of small dividers restricts light pollution in a darkroom and can establish a sense of territory in a computer laboratory. This is quite common in the office layout, as seen in the use of cubicles to provide partial visual barriers, without permanent walls. This layout is also used within professional and

educational studios, where "go-bos," light-blocking boards or portable walls, are employed to divide a studio for both territorial purposes and lighting control.

"Man actively though unconsciously structures his visual world. Few people realize that vision is not passive but active, in a transaction between man and his environment in which both participate."
 Edward Hall

The territorial concept is important for many courses. To assure that the high level of concentration needed for learning is possible, the class meeting environment and territory require definition, but sometimes creating physical, visual barriers to define a classroom environment is not practical. For example, in colder climates, it is not uncommon for classes to be moved outdoors when spring finally arrives. In this situation, the physical reality of holding class on an open, grassy mall, without the possibility of having the visible barriers that normally define the classroom, often invites distraction. In this case, the focus of the class can be directed by having the students form a closed, inward-looking circle, with the teacher and the demonstration at the center, and by the heightened sense of importance of the relationship between the setting and the lesson. Although teaching photography in the great outdoors may not produce as strong an educational experience as does being in a controlled visual environment, an outdoor environment is appropriate for demonstrations of things such as zone system measurements and adjustments on a view camera, which are commonly required of photographers in just such a setting.

201

Lighting

The lighting level allows for visual control and definition of space as well as for promoting attention within the learning process. As the light level decreases, there will be a noticeable decline in the sound level of persons within the environment. In the darkroom, it will not be uncommon to have students working in near silence. A brightly lit classroom will tend to promote louder conversation. However, there is need to provide sufficient light to allow note taking, reading, and/or other activities important to the learning tasks at hand.

"Creativity—like human life itself—begins in darkness."
 Julia Cameron

For a lecture using slides, PowerPoint, projected video, or video, a lower light level is more appropriate. For critique, particularly for single images in larger classes, a concentrated light source on the photograph, controlling for glare, promotes attention and proper viewing. From the traditional side of photographic technologies, a darkroom should be exactly that, dark, but lighting still is important. For a black and white darkroom where safelights can be employed, adjusting the safelights to the highest level that will not fog photographic materials is beneficial, since this level of lighting will allow students to take notes as well as work with their photographic papers. In the color darkroom we must avoid any light, direct or indirect. Things such as glow tape on the floor and emergency exits are appropriate for safety reasons. On the computer side of photographic technology, the lighting in workspaces needs to be moderate to avoid glare from surfaces near the workstations, while providing sufficient light for keyboard and other non-screen activities. The lighting must fit the educational purpose.

Sound

202

The auditory aspects of classroom environments are often neglected unless there is a faulty system employed. It is said of a movie's sound that good sound or music goes unnoticed…bad ones cannot be missed. Many aspects of the physical environment affect the students' ability to gain the information being presented. The direction, strength, and tone of the presentation source as well as the physical environment are all involved in the auditory portion of successful teaching. The personal aspects of creating the proper educational auditory environment can simply be discussed as speaking clearly at a level that can be properly heard by the whole class.

> *"The most intelligible part of language is not the words, but the tone, force, modulation, tempo in which a group of words are spoken—that is, the music behind the words, the emotion behind the music; everything that cannot be written down."*
>
> Friedrich Nietzsche

While seldom will the teacher be able to modify the physical space to control the auditory environment, realizing the deficiencies within the classroom that detrimentally affect learning allows the teacher to modify his or her activities to avoid creating hearing problems for the students. Certainly materials and configurations of the classroom are

helpful in creating the proper auditory environment. Long spaces with hard surfaces can create echoing that may be difficult for individuals with hearing problems. In using electronic amplification, it is important to consider speaker locations to avoid feedback.

If the classroom is not well configured for audition, your voice, presentation level, or style will have a large impact on the learning in that classroom. Reorganizing student seating to shorten maximum distances to the students and to control echo potential can alleviate some hearing problems in the room. Just flattening the seating arrangement, bringing all students forward, thus affecting the signal-to-noise aspect of the classroom, is better as the distance between the speaker and the listeners decreases. Often this also means that the teacher must move toward a student who asks a question, both in order to clearly hear the question and to allow the learner to properly hear the answer. This is especially true for older students or teachers who may have hearing problems. Repeating a question or answer may be required in these situations.

Sonic Territory

The concept of a sonic territory makes noticeable the effect of auditory control in spatial definition. Sonic territory represents limits on personal space when a person is engaged in verbal communication, is listening to important information, or is concentrating. For example, students will often wish to have personal music when working in darkrooms, computer laboratories, or studios. This may or may not be an issue depending upon whether the spaces are individual or group environments. This normally is an issue of policy rather than design.

203

"In my creative photography classes, I made it a principle to always begin with being still. This principle is a means and was never intended to be an absolute. However, what I said to my students was: 'Being still in the field, in the darkroom, behind the camera with the picture before you, is needed. In the viewing of your proof prints and final prints it is likewise useful. Employ this approach when viewing another's prints, in beginning anything you engage in—it helps. One starts at that beginning, sounding a note of silence. At the very best, I can say that being still—being quiet for a few moments before study or a given task—will set the stage. After I become quiet I will perceive more clearly what it is I am about to engage in.'"

Nicholas Hlobeczy
Case Western Reserve University, OH

For personal discussion and/or instruction, the auditory territorial concept will enable ease of communication. When dealing with individual issues, the concepts that are detrimental to classroom presentation may become beneficial. Particularly speaking to an individual so that he or she is facing outward toward a group will provide a small amount of privacy. This body placement is dependent upon whether the teacher wishes to share information with interested individuals beyond the single student who may have raised the issue.

The success of certain facilities such as libraries, computer laboratories, and study areas depends greatly on auditory control. The higher the level of concentration required for a learning process, the more the need to consider the auditory environment. Though "silence is golden," controlled sound may provide a better auditory environment than a silent one.

Complexity and Time

"What has once happened, will inevitably happen again, when the same circumstances which combined to produce it, shall again combine in the same way."

Abraham Lincoln

Though we have dealt specifically only with vision and audition, it is clear that all stimuli interact within an environment to create a good, or poor, learning situation. Interactions between visual and auditory information compounded over time create high levels of complexity in educational environments. The complexity of multi-stimulus inputs over time has a marked effect on the parameters of space. Dependency on the integrity of space in relationship to time and human perceptions is unique. This goes far beyond the time-locked systems of the class schedule and transformations of stimulus inputs in the perceptual system, and also takes into account memory learning motivations as prime and changeable environmental limiters.

"The distinction between past, present and future is an illusion, although a persistent one."

Albert Einstein

With the temporal limits of a class, we find that students will see the class space in different ways at different times. Considering this along

with other factors of curricula (clock time and learning dynamics) gives us an impression of the complex state that is always changing with the passage of time and is not reproducible in any terms that do not use the time/location as a starting point. This indicates that regardless of how many times you teach Photo I, the outcome will never be repeated. Accepting this variability is assisted by flexibility in approach to the student cohort, to the curricular and environmental changes instituted by the teacher, to the technology, and to the variation in time requirements within and external to the course. This means that as time progresses, so should the course structure and the educational setting.

It has been said that "the mind can absorb only as much as the seat can stand." Time impacts the learning environment in both restrictive and implemental ways. Without the provision of adequate time, learning and accomplishing certain concepts will be difficult. But within the learning environment, too much time-on-task focus can be detrimental. The amount of time spent concentrating on a lecture—vigilance—has its limits. Regardless of how comfortable the environment or engrossing the teacher, after an extended time, learning abilities start to diminish.

It is a prime role of the teacher to control external stimuli and time so that information and/or processes involved in photographic learning are attended to and absorbed.

205

The Psycho-Social Limits

"This is the best place I've ever worked. It is an intimate environment where everyone knows everyone else. It is a good creative place."

John Martin
Salisbury College, United Kingdom

It can be strongly suggested that within classrooms and laboratories we maintain an active relationship with the environment, both personally and collectively, beyond the environmental stimulation. These relational activities, both psychological and social, which interact with stimuli, are processes that organize the stimuli and infer meaning from the educational setting. This means that the educational environment used within the process will have a marked impact on the effectiveness of the learning.

Though perceptual processes are primarily a result of personal development, the psycho-social and physical nature of perception has

great importance in understanding the function of educational spaces. The limits of sensory receptors have a great deal to do with the influence of environmental spaces. If a classroom system excludes specific stimuli, then no knowledge can be gained from such stimuli in that environment. If we assume that the classroom environment can influence education, then it is important how the environment presents its information and its organization for behavioral modeling. If the walls are covered with technical charts and examples, then it is likely that the classroom will influence a more technical approach, while if the classroom environment includes examples of photographic art, then image creation will be supported.

Social Limits

In the case of social development processes involving space, it is clear that interrelationships related to space are closely related to the way that a culture uses a particular space. The more important certain spaces are to a society, the more the members of that society will be in command of the names and descriptions of those spaces. The varied descriptions of classrooms found in Western society demonstrate the high value of this type of interior space within that society.

> *"The human being is immersed right from birth in a social environment, which affects him just as much as his physical environment."*
>
> Jean Piaget

This consciousness amounts to the establishment of social expectancy about the readiness to accept certain stimuli, which will be required for learning to make and understand photographs, while reducing the effect of other nonsocialized stimuli. For example, we readily accept a slightly distorted room as being rectangular because we have been socialized to act in rectangular room settings. The fact that our culture holds constant the rectilinear nature of built structures to accommodate society's purpose prepares us to accept a distorted room as nondistorted.

Also, organizing individuals within an educational space, using certain configurations, tells those involved how to act. This same socialization process prepares students entering college to expect lectures in a structure with row seating. The arrangement of seating in a circle has been socialized to students to suggest interactions between many individuals across the circle. When individuals are put into an organization that has

been socialized to suggest restriction, as in side-by-side seating, the arrangement reduces interaction. This spatial arrangement is common in lectures and waiting rooms. The opposite setting, one that encourages interactions, such as in a seminar or conference area, has people facing each other. While both of these situations seem physical, they deal with the socialization of students.

> *"I try to set my classroom up in a circle or horseshoe and the work being discussed will be brought around, up close to each person."*
>
> J Seeley
> Wesleyan University, CT

Psychological Limits

The psychological connotation of space and mental organization can be easily seen as the types of spatial definitions that can be used in the discussion of how to process space. Three types of spaces can be defined: objective (physically measurable), ego (adaptation of observed spaces), and imminent (the spaces of fantasies). This attitude about space also opens the consideration of the internalized nature of spaces, as psychological entities. The psychology of the environment accounts for memory, learning and effect of the environment. Through play, children internalize spatial concepts in the form of actions and merely substitute play for the actions that correlate to these internalized concepts.

207

> *"Spatial changes give a tone to a communication, accent it, and at times even override the spoken word. The flow and shift of distance between people as they interact with each other is part and parcel of the communication process."*
>
> Edward Hall

One of the main effects of accepting space as a psychological concept is the ability to use spatial realities to explain behavior. Aspects from psychological literature allow use of the environment as input into behavior patterns for learners. Studies have shown that personality factors are less important than the physical environment in predicting behavior.

An environment provides certain cues as to how an individual's behavior is proper in any given situation. Physical environments and built structures create expectations of how all should act. Individuals

select their response based on the stimuli presented by a structure and on the expectations for actions that have been learned in relation to these environments.

Furthermore, behavior in a given situation will take on the shape of the environment. The "synamorphic" behavior leads to the position that an individual's behavior is determined by that individual's involvement with the environment. It is easy to see that certain activities are proper for the outdoors, such as running, while other activities fit better inside. This does not mean that all indoor activities only happen indoors, but that an open field invites active involvement and a library invites a passive involvement. It is clear that the behavior component of the environment is very important in terms of designing for spatial needs of educational systems.

Just as stairs create a "transit behavior" between floors of a building, consideration of the form of classrooms or laboratories will also create learning behaviors. As mentioned previously, designing seating that creates face-to-face situations creates open discussion. While this is a learned social interaction, its roots are strongly in the area of the psychology of the individual.

Changeability

Any given space can have different meanings for different people. This amounts to having spatial environments change in value as time progresses and as those who inhabit the environment change. Furthermore, the space can change with regard to any of the many components of the spatial milieu. We must consider that each student may see the same space differently.

The changes in perception of the environment have strong behavioral influences. As we change the definition of a territory, a studio, or classroom, we change the expectancy of behavior. The fact that spaces change, or that individuals in the environment change their perception of the spaces, can cause a change in individual learning behavior. In many cases this is shown in the acceptance of the spaces as being either secure or insecure by those involved in the environments—that is, as being either their own territory or someone else's. When the way the environment is perceived changes, the behavior in that space may change. For example, individuals may show an increase in anxiety when spaces are perceived as hostile.

A space can lessen anxiety levels through the conscious effort to control the stressors that are built into the setting (noise, lighting, etc.).

This type of design consideration is common on the college and university level. Many areas are designed to be restful in order to ease some of the tensions that go along with being a student. Noticeably, however, these spaces, which are normally designed this way on the college campuses, are not normally defined as learning spaces.

Personal

The last area for consideration as a limiter of the spatial environment is the concept of personal space. Although presented last, there is no attempt to play down this area of spatial awareness. Personal space is perhaps the most important concept that determines the individual's perception of the learning space.

Personal space is different from physical space. It is the psychological distance between two or more people or between a person and an object. It is the distance at which the individual feels at ease. Closing in on such a distance produces tension and discomfort.

The sense of personal space is linked to cultural background as well as to the psychological makeup of the individuals within an environment. While social and psychological limiters control perception and behavior in any given space, the fact that a space becomes personal indicates that individuals connect to environments, and this is an important consideration within educational spatial environments.

209

Comfort

It must be understood that the comfort of the learner will have major effects on the learning process. First, if the students are comfortable within the classroom environment there will be less anxiety, and that will promote learning. Second, particularly for long or highly intense presentations, the comfort of the students will affect their ability to stay vigilant and involved in the learning activity.

Class Size

Unfortunately, the issue of class size is both political and economic. Often it falls to a teacher to justify class size. While this is not a role that teachers see as part of their employment, understanding the political and economic pressures on the educational institution will help when you must provide information that will be needed to adjust class size. The pressures for larger student-to-teacher ratios

normally come from those who are not directly involved in teaching the curriculum in question. It is common for these individuals to see instruction as information dissemination. With this in mind, they can easily assume that a lecture is appropriate in all situations.

The type of learning activity determines the optimal size of the class. Certain activities such as lectures can adequately present material to larger groups. However, as the amount of discussion, individualized instruction, and/or critique increases as part of the learning process for a class, the size of the class needs to decrease to remain effective. While there is no hard-and-fast rule for the size of a class, approximately 15 students is an appropriate break point when discussion is part of the course. This class size allows all students to be involved in meaningful discussion.

"Personally, I'm always ready to learn, although I do not always like being taught."

Winston Churchill

210

Within laboratory situations, the number of workstations and the effective number of students who can be assigned to any given work-station become the limit for class size. This may be an issue of accreditation as well as an issue of effective teaching. Therefore, in the course syllabus or master outline that defines the class for the administration, it is important to define whether a laboratory situation is open or directed. An open laboratory situation will allow for more enrollment than will a directed laboratory situation. The more restricted directed laboratory has the students doing assignments or projects under the supervision of the instructor. This situation requires that each student be able to work within the scheduled laboratory at an appropriate workstation. This increases the need for workstations to match the number of students enrolled.

Considerations for Today's Education

Facing the educational environment are two issues that have developed within the past few years. These are special accommodations and the impact of communication technology on today's society.

As our societies and educational systems have matured, we have become more aware of and more willing to accept requirements for special accommodation to assist learning for those with needs outside

By James Young, Colorado Mountain College, CO, student of Buck Mills

the norm. In some cases these accommodations provide scheduling alternatives to meet the needs of groups representing religious concerns or advocates for people with certain disabilities. Other accommodations may be required to meet special needs brought to the class by individuals. In many cases these accommodations have been legislated or are regulated by governmental agencies. Regardless of the reason for special accommodations, these accommodations create an environment supportive of the concept that education is for all.

Beyond the accommodations that might be required, the pervasive nature of electronic communication has highly impacted education today. We find ourselves being asked to include in the educational environment electronic tools and access to electronic communication devices. This creates a conundrum. Do we allow all students to freely utilize any personal electronic tools that they may have, or do we restrict the educational environment so that all have the same access to tools, and thus equal access to information? The power of electronic tools, including computers, cell phones, WiFi, etc., can benefit learners within the classroom environment or it can provide ways to be distracted or work around the educational intent.

212

Going from Solo to Team

In teaching photography, programs often start as one-person operations. This is wonderful for the ego of the teacher but it can lead to its own problems when there is growth in class size. After a certain point, as program size increases, there will be a need to contemplate other instructional personnel for photography.

In singles tennis, each player is in total control of his or her decisions; in soccer (football), the goalie and the forwards have different roles within a team—the team works better if each person understands his or her role and acts accordingly. In teaching, you may build a program around yourself and, as it grows, eventually find that you need assistance in teaching. This changes what you will do.

You may be accustomed to being the only person the students could turn to, an awesome responsibility. With the addition of a new faculty colleague, the situation instantly changes to one where you are only one opinion, and depending on the selection process that gains you your colleague, there may be opposition to your convictions. The need to be a team player is not restricted to just curricula in imaging programs; most often, even when you are the sole individual teaching photography in an

educational system, you will be teaching as part of a faculty, and that is a team situation where there are not only differing roles in the department or school, but also differing team functions.

> *"Individual commitment to a group effort—that is what makes a team work."*
>
> Vince Lombardi

The First Class

The point in time when all concepts of the classroom environment can first be seen is in the first class meeting. Therefore, we will end this chapter with a look at how a first class can be prepared.

Take special pains to see that the first class meeting represents the best that you can offer in the way of organization, interest, challenge, and significance. It is too much to expect that teachers will be at their best during every class meeting in a long series. However, the first class sets the tone for the whole series, and much can be forgiven later if the start is strong.

213

Be prompt. Start this class, as is best for all classes, on time. Hardly any action is more corrupting for the students then a dilatory attitude on the part of the teacher. Tardiness of students plagues many teachers, and it should be pointed out that tardiness interferes seriously with the class' learning. However, modeling behavior is important in having students be prompt with their attendance. An example is found in the story of an Ivy League teacher who would lock the classroom door when the bell rang. Students who arrived late were excluded. One day the teacher was late for the class and the students locked him out. Thereafter, he became more tolerant of students who, on rare occasions, were a minute or so late. If teachers are prompt in meeting their obligations—beginning and ending classes on time, returning papers and tests in a prompt manner—the students are more likely to meet their obligations as well.

Take care of administrative procedures smoothly, in a well-organized fashion, and as briefly as possible. Avoid being apologetic about these requirements. Part of this type of organization is in knowing who is in the class. Be sure to introduce yourself, pronouncing your name distinctly and providing the students with the correct spelling and how to contact you. If you are calling roll, speak the students' names and ask them to respond if your pronunciations are correct, or to correct you if

when wrong. This minimum of personal contact between the students and teacher is worth the time even with large classes.

Make a concise overview of the course. Include the textbook and reference materials that will be used. Especially, let the students know what the objectives are, and what they are expected to accomplish. One statement of the objectives will not be enough; plan to review this material periodically with the students. While the overview of the class may cover each topic and each objective that will be covered during the course, the class during which each topic is introduced and taught will be an opportunity to return to the objectives discussed in the first class meeting.

"Give the students something to do, not something to learn; and the doing is of such a nature as to demand thinking; learning naturally results."

John Dewey

Outline attendance regulations. Even if attendance is optional, as it may be in some situations, keep an attendance record and tell the students how and when attendance is taken. For some students, this attitude toward attendance on the part of the teacher encourages their coming to every class. Further, regulations, particularly those involving foreign students, may have legal ramifications if attendance is not taken and reported.

Discuss your grading procedure. You will need to do this several times during the course, since students will forget easily or will challenge their grades if their expected and earned grades are at odds. Since most students are seriously concerned about their grades, often overly concerned, at the outset you will need to let them know what they must do to earn a good grade. If class participation, for example, is included in your evaluation, tell the students and explain how you will apply this to your grading paradigm. If assignments are graded and included in the final grade, then let them know how this calculation is accomplished. Remind the students that they earn grades...you do not give grades.

Begin the course subject matter with a provocative statement, demonstration, audio-visual presentation, etc. The student should feel excitement that is special to your course. This will be hard to sustain but at least should be initially present.

Make assignments with special emphasis and special care. Students should understand that assignments are devices that will involve them and that only through their involvement can they learn. Thus the student

should believe that assignment work is central to their learning, and that the teacher is serious about this portion of the class. Such beliefs are best encouraged by the teacher's attitude at the first class meeting. Making an assignment hurriedly and casually is destructive; it is better to skip giving an assignment if the time is too short to do a good job.

Allow time for students' questions, encourage them, and take them seriously. The question students ask let the teacher know whether or not their statements have been understood, and they also provide an opportunity for additional personal contact.

There is much to accomplish in the first session. The students should not be overwhelmed, but should be oriented to the course. Very careful planning is required on the part of the teacher if these objectives are to be met. Supply the class with a written statement of the essential items for their later review and reference. Finally, close the first class promptly and on a high note. While it is best to use all of the allotted time, it is better to end early than late.

"The students are alive, and the purpose of education is to stimulate and guide their self-development."
Alfred North Whitehead

215

Expanding the Learning Environment

One of the opportunities for support of photographic education today is the envisioning of what are now called nontraditional opportunities. These include online extra-campus activities. These may be seen as an expansion away from the traditional classroom and academic structure to support learners who do not fit within the traditions of most curriculum-based photographic programs. This is not a new phenomenon. As interest in photography increased in the 1960s, courses began being offered outside the traditional academic setting, in what came to be called Photographic Workshops. As interest in these grew, some students sought longer involvements, which led to programs such as the early ones at the Visual Studies Workshop in Rochester, New York and elsewhere.

Workshops
The workshop concept is applicable to both on-campus and off-campus offerings. The primary concern of a workshop is to present the material in a concise, time-constrained method. Most commonly, workshops are

presented in short, one- or two-week time periods, and focus on one area of photography. This organization allows the learner to immerse himself in a specific area of interest in photography, such as digital photography, fashion photography, nature photography, nude photography, or portraiture, without concern for other academic pursuits.

Some of the most successful workshops take place in what can be considered vacation settings. In fact, research has shown that of the many reasons people have selected a workshop, the location and its relation to a planned vacation is the primary reason for selection. Workshops are given in a number of attractive places, such as California, Colorado, Florida, Maine, Montana, and New Mexico. There are also Travel Workshops to such places as Australia, India, Ireland, Paris, Peru, and Turkey. This explains, in part, the success of many workshops. While the individuals taking workshops have an interest in the photographic offering, it is the relationship to a desired setting that promotes and sells the workshop. Hundreds of workshops offering various photographic experiences can be found on the Internet.

Even for locations with attractive settings, other parts of the vacation idea are major sales points. Travel and adventure photography are major selling points that create interest and ensure enough enrollment to support the educational offering within the photographic workshop. This allure tends to be true for the faculty as well as for the learners.

"A summer of anti-classroom workshops is refreshing after a winter of academic teaching. For one reason, ideas that must be developed piecemeal, one or two hours a week, can be seen whole in the span of a few days."

Minor White

The second most important draw for a workshop is the name recognition of the workshop presenter. A "big-name" photographer will tend to have a greater draw. The third most important concept in developing and marketing a workshop is the subject matter to be taught. While there are several other reasons why people select workshops, the first three dominate the consideration for those who enroll. This is true for on- and off-campus workshop situations.

Regardless of the location, the faculty teaching a workshop, or the subject matter, in order to have a successful workshop the material presented will have to be adjusted away from a traditional classroom setting to the parameters presented in the environment of the workshop. This

adjustment includes consideration of five major factors: the facilities and environment of the workshop, the scope of the material to be presented, the time available for the course, the variations in the learners' backgrounds, and the variation in the learners' expectations.

The facilities and environment of the workshop can be assessed as described in the previous discussion in this chapter concerning the limits of educational spaces. Environmental variables in workshops, however, relate mainly to the vacation-like settings or time constraints. While there may be specific environmental concerns, more commonly the issue becomes one of having enough specific equipment for the learners to accomplish their tasks within the limited time of the workshop. Also, the class environment may need to take on a non-vacation-life atmosphere to promote the intensity required within the workshop.

"Workshops provide a creative educational and social environment where new skills can be taught in the morning and readily applied in the afternoon and evening.

Fatima and Arthur NeJame
Palm Beach Photographic Centre, FL

217

Next, the scope of the material must be considered in developing the workshop to assure positive outcomes. The breadth and depth of the material to be presented must be matched to the environment and the equipment available. For a workshop dependent on computers, the environment must have available equipment and software ready and in working order. Not only are breadth and depth of the covered material important in the success of a workshop, but also the time provided for both learning and producing becomes critical. While attendees may wish to learn everything about a subject in a week, this may not be possible. It is up to the designer of the workshop to organize the flow of the workshop to present the attendees with the opportunity to successfully cover and learn the subject matter.

"A workshop is a completely different form of teaching. In a traditional semester or quarter you have time to build momentum...to allow it to peak and then bring it down and tie it together. In a workshop, in five and a half days you don't have time to build momentum, you have to hit the ground running. Your instruction needs to be absolutely crystal clear, you need to streamline what you are going to present and you

need to know everybody's name right away. Everything happens quickly. You are not there on vacation."

Craig Stevens
Savannah College of Art and Design, GA

Usually for workshop settings, the amount of material and its structure must be compressed to provide learners with a realistic expectation of accomplishing positive results within the allotted time. This would indicate that exceptional focus on the subject to be taught, and narrowing of objectives, must take place in the planning and presentations of the workshop.

Because of the nature of workshops, and the way they are marketed, there is often great diversity in the abilities, backgrounds, previous studies, and experiences for any cohort. Care must be taken in the marketing of the workshop to state clearly what expectations the attendees should have, and the development of the workshop should include a strategy to accommodate both the highest level of prepared individuals and those at the other end of the learning spectrum.

"The most difficult thing about teaching a workshop is getting everybody on the same page dealing with the egos based on differing experiences."

Gerald Courvoisier
Santa Fe Workshops, NM

Last, the development of workshop has to be realistic in terms of what can be promised to an attendee. If the workshop is in a vacation setting, the expectation of an attendee may be having a good time rather than learning. Likewise, in the same workshop there may be individuals who were intent on attaining high levels of learning and have the expectation that the workshop will provide the needed learning and experience to enable them to produce specific photographic outputs. As much as the development of the workshop needs to address this disparity, the understanding of the faculty that attendees may have differing expectations is paramount to the success of the workshop.

One of the attractions in being in a workshop setting is the opportunity to meet a number of people from all walks of life and to experience an exchange of common interests. The workshop provides a setting for future networking. There is also the opportunity for a one-on-one portfolio review with one or more highly experienced photographers.

Online

In today's educational milieu the potential for never physically meeting a student is realistic. The World Wide Web has provided the opportunity to teach within a virtual classroom. The considerations of the virtual classroom are not at odds with traditional education; they simply expand the potential audience while defining more specificity in the way teaching happens.

The Web in its most basic form strips away personality from teaching and replaces it with consistency: this is not to say that an online presentation must be dry, but that it is seen by many learners and must be considered as a one-way presentation rather than a dialogue. Though there can be interaction within the online environment, it is probable that an online presentation will be accessed without any subsequent (desirable) interactivity. This puts the onus on the development of the online educational product. The methods, projects, learning objectives, and interactions need to be carefully considered based on the ability of the technology to support learning by this method. Research has shown that a combination of online educational activities with personal contact gives the best results for the learner.

219

"The mode of delivery in education is definitely widening. This offers unique challenges and opportunities. Faculty teaching in these new modes will be stretched to create new methodologies, pedagogies to best address the mode of delivery. I believe that face-to-face instruction is very effective. The challenge in instruction over the Internet and distance learning is creating something that is as powerful without the face-to-face."

David Litschel
Brooks Institute of Photography, CA

By Pat Stanbro, Brooks Institute of Photography, CA, student of Robert Smith

Planning and Changing

"If you do not know where you are going, any path will do."
Sioux Indian Proverb

The cliché "that the only constant in life is change" rings so true as one looks back over the years. Change is everywhere, and educational programs are no exception. Ten years or so ago, darkrooms and chemical processes were an integral component in photographic departments. Now they are a thing of the past, taken over by light rooms, digital cameras, scanners, computers, and software such as Photoshop. Analog has given way to digital.

Programs are not the only things changing in education. Schools and colleges have had their share of anticipating change, planning for it, and implementing it. Dick Zakia recalls his experience at Rochester Institute of Technology beginning in 1952. At that time he was a freshman and RIT had only a 2-year photography program leading to an associate degree. A few years before that RIT was not even granting degrees, and nobody on the faculty had the title of professor. Everyone was an instructor, regardless of years of teaching experience and degree status.

Zakia's goal was to get an AAS (Associate degree in Applied Science) and then to find employment with Eastman Kodak. He was interested in the science of photography. Some of his classmates, Peter Bunnell, Carl Chiarenza, Bruce Davidson, Ken Josephson, Pete Turner, and Jerry Uelsmann, were interested in taking and making photographs. There was no fine art photography program at that time. The only thing that came

close was a program in photographic illustration, which his classmates pursued.

By 1954 RIT instituted BS and BFA degrees. Shortly after that, MS and MFA degrees were offered. As the MFA degree in photography expanded to include motion pictures and video as well as electives in the other visual arts, the program curriculum changed and so did the name of the program, from an MFA in Photography to an MFA in Imaging Arts. The BS in Photographic Science that Zakia received 50 years ago has evolved into a Ph.D. degree in Imaging Science, the first Ph.D. offered at RIT.

Photography and photography programs have come a long way over the past 50 years or so and will continue to do so. In the late 1800s, when George Eastman was a bank clerk in Rochester, New York, he experimented in his mother's kitchen trying to create a light-sensitive emulsion. He was told by his peers that he was wasting his time and that photography was going nowhere. He was made fun of but he persisted. In 1952, Zakia's aunt was shocked and tried to talk him out of attending RIT, insisting that it was only a vocational school and not a real college. She might have been right at the time, but she was totally wrong on its future.

Planning for change is a valuable undertaking but one has to realize that sometimes change is thrust upon us unexpectedly and we should embrace it and move forward with it. Zakia never planned on getting a BS degree, much less a graduate degree. His goal was to get an associate degree and go to work for Kodak. Goals are important but they should remain fluid so they can be adjusted with the times. This is as true for photographic programs as it is for photographers.

The Philosophy of Why

Planning is an ongoing concern in education. With the rapid changes in aesthetic approaches and photographic technology, curricular planning seems to have a real urgency. However, before entering into planning in haste, it makes sense to understand what change is, how to plan change, implementation of what is planned, and perhaps most importantly, why planning is required.

> *"Our Age of Anxiety is, in great part, the result of trying to do today's jobs with yesterday's tools."*
>
> Marshall McLuhan

Let us deal with the "why" first. There are actually two questions: the first is why change is needed and the second is why planning is required for successful change. A system that does not change is in real trouble. This is as true for academic programs as any other system. But change for change's sake is wasting time and energy, so there is a real need to understand that change will be required, but not for its own sake. Change and its corollary, growth, are needed for an academic program to remain vibrant and valid. The issue is not "if" photographic programs will change—the issue is "why" your photographic program should change.

It is likely that your photographic program will have to undergo change over time. The environment in the photographic world is about changing technologies and varying aesthetics, therefore the curricula that educate future image-makers will need to change to better assist others' learning within this situation. Since the world we work and educate in is changing, the major tools that we use to help others learn must change. A curriculum needs to change to be in harmony with the external technological and aesthetic surroundings. Therefore, it becomes a matter of whether you will be involved with the changes that impact you or if you will be required to follow someone else's ideas about what photographic education will be. When change happens, will you walk to the future or be dragged?

"Planning is bringing the future into the present so that you can do something about it now."

Alan Lakein
University of Reading, United Kingdom

The "why" becomes a directional choice made for adapting to change. In order to characterize how curricula will transform, the discussion of "why" is engaged. There will likely be many paths used to effect change, and each pathway has its own definition of what will be accomplished by changing the curricula. Without being able to identify why curricula need adjustment, the wrong route to the future for your program may be taken. As you answer the question of "why," the first step in the planning process is taken. It is defining the target.

It is important to realize that you want to be in control of the "why." Change happens more readily because of external threat than because of positive initiative. Particularly within an academy, higher levels of the institution will be more likely to engage in determined change if it

is believed that something is threatening the photographic program. Describing the need for change in relation to how it addresses a threat to the institution helps the argument for change. The threat may be nothing more than the program's standing in the profession, but it is advantageous to the change process to use this method of discussing the "why."

Change Happens

It has been said that change can have one of three effects on an academic program. It can make a program better, it can make things worse, or things can stay mostly the same. There are no guarantees, however, that making program changes will lead to any one of these three outcomes. We assume that change will benefit a program, but this depends on the situation; there is no way to be assured of positive effects from change.

"Education is harder to move than a graveyard."

Lillian Johnson
University of Cincinnati, OH

The dynamics of change involve a positive/negative risk construct for assessing the effect of change. We can describe a simple change chart that has the top right corner as a positive outcome from change and the bottom right corner as a negative outcome, with the levels between the top and bottom as outcomes that are more or less positive, depending on their height on the chart. If the right side is the outcome, the left side can be used to describe the starting condition of

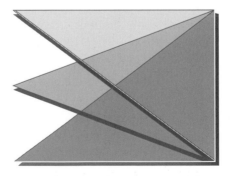

Change Chart

the program. Using perceived quality is a reasonable standard to view the programs. This will have the best quality or performance at the top left and the poorest at the lower left corner.

With the change chart we can pick a starting point for change on the left and see what potentials exist for outcomes. A horizontal displacement refers to no change, i.e., staying the same, with an increase in height being a positive move and a negative change being seen as a declining line. With this model we can assess the risk of change on quality. Since a horizontal is no change, then for any starting point there is the potential to have an outcome that represents staying the same. From the bottom left corner there is no potential for a declining line and from the upper left corner there is no potential for an increasing line. From any point in the center of the left margin there are both increase and decrease potentials.

"I believe that the management of change must consider the emotional intelligence of the staff who are undergoing the change; staff can only change at the rate at which their emotions will allow them to; therefore for the change to be successful you must pace structure of the change to embrace this important factor."

Paul Penketh
Brighton Hove & Sussex Sixth Form College, United Kingdom

The simple change chart view shows an important aspect of change. When a photography program is highly rated, then it is difficult to substantially increase its standing. Change will have a better chance to negatively affect a top program than to improve it. However, change is still something even top-rated programs need to engage in. For programs that are perceived in the middle of the quality range, implementing change can result in all three outcomes: the programs can improve, decline, or stay the same, depending on the effects the change has on the outcome. At the bottom of the program quality range, since there is only a small chance of decrease in quality, the most negative outcome will be to stay pretty much the same. This means that change favors positive outcomes for programs needing a lot of improvement.

Then why change a top-quality program? Because the photography world is changing and change will not be a choice. Staying in the same place in a moving environment is lowering relative quality. Thus the top program that does not change will decline based on the changes in the environment, not on any change strategy that it undertakes. Within

today's technologically changing milieu, change is a constant and it impacts all, not just the weakest.

As a conclusion to this discussion of change, it becomes clear that change impacts organizational structure. If a program changes, it will alter the way the institutional organization responds in relation to the changing program. Likewise, change in institutional organization will affect the role of the imaging program within the institution. The interconnections between parts of the institution are important and interdependent. Dealing with change is not just about how the members of the photography program will react, but also how all parts of the institution respond and react to the transformations.

"We are, in my view, faced with an entirely new situation in education where the goal of education, if we are to survive, is the facilitation of change and learning. The only man who is educated is the man who has learned how to learn; the man who has learned how to adapt and change; the man who has realized that no knowledge is secure, that only the process of seeking knowledge gives a basis for security. 'Changingness,' reliance on process rather than upon static knowledge, is the only thing that makes any sense as a goal for education in the modern world."

Carl Rogers and H. Jerome Freiberg

226

Planning for Change

It is convenient for those involved in academic planning to consider that planning follows constructs found in the old academic area of "Natural Philosophy" and in surfing. Such analogies can give good guidance to what we will need to consider in planning for curricular change: they provide a way to look at both the underpinning of planning in education and how to view moving toward a future.

"Plans are nothing...Planning is everything."

Dwight D. Eisenhower

The Sciences of Natural Philosophy

In the 19th century the sciences, both physical and social, were part of the study of Natural Philosophy. Two of the major components of Natural Philosophy at the time of the invention of photography were

what today we call physics and perception. Physics gives us many clues as to how to understand actions within academic planning. From Isaac Newton we get an understanding of "inertia," which is certainly important in viewing educational change. Viewing Newton's laws, we can project onto academe that "a body (program) at rest tends to stay at rest and a body (program) in motion tends to stay in motion." In photographic curricula, we can see institutions that seem to always be in motion and others that are stuck in their ways. This is academic inertia. It may be part of the photography program offering or it may be part of the institution.

Understanding the concepts of inertia shows us that the effort needed to start an object in motion from a stopped state is greater than the effort needed to deviate in direction. Institutional or program inertia is the same, because of the effort that is required to change a curriculum, and even just a course. It is far easier to divert a moving program than to start one moving that has been steady for some time. Key is that change demands energy, and the more entrenched the curriculum and faculty, the harder it is to change, regardless of the reasons for change. The energy that will be required to change a program's direction or to get one moving will have to come from people in the program or those who are brought in to assist.

227

> "Certain changes are philosophical...Everybody here has a similar history, they have the same things in their background. I think there is nostalgia for it in many ways. We really do not want to let go of everything that we know about. That is problematic as we are also driven to stay abreast of current trends that are attractive to students."
>
> Steve Bliss
> Savannah College of Art and Design, GA

Academic systems abhor change. They are reluctant to change without external force being applied. Most institutions find it easier to change because of an external threat than because of any ideas or concerns within the institution. External pressures, whether competition, accreditation, or other forces, are more effective forces than are great ideas from within. When change in the photographic program is desired internally, it often must be viewed as an opportunity to find an external stimulus that can be applied to the institution to influence institutional inertia—to force a change in direction or to start movement toward change.

Such an external academic changing force can also be viewed in relation to the Second Law of Thermodynamics. This law deals with the

energy within a system and how it diminishes over time. The effect, known as "entropy," will set into a system if energy is not applied to the system. Entropy is defined as the tendency for everything in the universe, whether energy, matter, or social orders, to move toward a minimum constant. Entropy is then the measure of randomness and disorder leading a closed system, one without external energy input, to evolve toward uniformity. As that happens, the system moves to a state of stasis, steadiness, and inertness; this relates to zero energy within the system.

That is a difficult situation for a photographic program to find itself in during a time of rapid change in technologies. The inevitable and steady deterioration of a system or program, without the input of new energy from professional development or outside participation, is unhealthy for a program. This will lead to a program that degenerates to its lowest energy level and is unable to change or even plan for change. This is unfair to the students and their learning.

A second part of Natural Philosophy is perception. It is important to realize that perceptions are not facts...they are real! Our reality is a mental construct and thus is not dependent on the truth of perceptions, but rather on their interpretations. Our minds often force interpretation, such as in a magic trick or in Gestalt closure; this allows us to relate to the "facts" that are required to fit with the mental construct. We do not see the facts or evidence as reasons to change, but our perceptions, which control the "politics" of our constructs, have great effect. Politics are required to plan things in any institution. While planning can seem to be done by individuals, implementation within the institution requires the efforts of more than just the planners. When efforts of others are required, politics are involved. Though politics often have a negative connotation, they are a natural human construct and can be a positive change agent. They are the enabling factor, though they can also impede change, of course.

The perception of change and/or institutional inertia impacts planning. Thus controlling the perception of how and why the change is happening or needs to happen becomes one of the prime factors in successful planning. By controlling how the planning and change mandates are seen, the politics needed to implement the planned changes become positive agents of change. The politics become a multiplier for the energy in the system.

"It is interesting to speculate on the "why" of reasons for doing nothing. Coupled with the possible loss of advantage is the fear of change—the

necessity for leaving the comfortable though not entirely satisfactory routines of the present and substituting for them the hazardous, decision-making activities of the future."

Edgar Dale
The News Letter, Ohio State University, December 1960

Surfing

The analogy to surfing is very important in today's rapidly changing technological environment, with change being driven not only by pedagogy but also by pulses in technology. Even for change that is not forced by technological advances, awareness of how a surfer rides a wave can assist in learning how to create change.

What we can see most clearly is the way surfers go about riding a wave. First the surfers understand how the waves will form. The right waves will not be formed in all areas—the winds, tides, shore shape, etc. combine to form a wave. Understanding how these and other factors create waves allows the surfer to plan to get a good ride.

As important as the understanding of wave formation is, identifying the moment to start also requires attention. To catch the ride, the surfer needs to be looking at where the waves are coming from, not where they will be going.

229

"Always plan ahead; it wasn't raining when Noah built the ark."
Richard C. Cushing

However, more important than the wave formation and origin, it is imperative for the surfer to start moving before the wave arrives at their location. The surfer puts effort into moving toward a chosen direction so as to be moving at the same speed as the wave crest, in order to transition to the face of the wave and not get passed by. Inertia is also part of surfing: more energy is invested into getting started than is required once the wave is caught. Last, once the surfer is moving with the wave, balance is required to fulfill the goal of the ride.

This brings us back to thinking about energy. And the question becomes, "Where do we need to apply the work?" As apparent from entropy, we need to continually apply energy into the system or it will degrade to an inert form. From the surfing metaphor we see that a lot of the work is in getting started. Also viewed in light of surfing, we can see that part of the planning is identification of what is coming and how to time the implementation of the plan.

"The important thing to concentrate on is the quality of the education that photography students are receiving. The types of courses (curricula) available vary enormously, from those with a technical bias to those with a more academic or philosophical approach, with creative commercial photography sitting somewhere in the middle. They need a combination of skills and knowledge that encompasses the technical mastery of the subject at the same time as the creative and cognitive aspects. And that also means that there is a place for the more academic courses (curricula), which ask questions of the students more in terms of what they are saying with their pictures, rather than how they produced them. Many different areas of photography exist and they should all be nurtured....They need to know about communicating with pictures and what they mean. They need to know about creativity and how to use it in their pictures. They need to know about the business side of their chosen field."

Ian Kent-Robinson
Salisbury College, United Kingdom

230

Categories of Planning

Planning can be viewed in relation to the time frames that various types of planning address. Primarily three time frames are addressed with planning. Short-term planning tends to be a reaction to immediate situations. Over the long term, we find strategic planning. Last, moderate-term solutions and implementations fall into the category of tactical planning.

In its immediateness, short-term planning may seem to be a contradiction in terminology. Reacting quickly to the task at hand seems to be devoid of a planning function, but like all other planning, short-term planning benefits from a planning structure. This can be as simple as specifying a set of steps to be used, to assure "correctness" in the decision-making process. Often short-term planning happens prior to the time when there is the need to react.

Normally when we think of planning we are thinking on a longer term and at a more strategic level. Strategic planning is a process that matches long-term opportunities with environmental changes and threats. The changes and threats are the reason that planning must take place. The inputs that demand change may be external or internal to the institution. Threats and change provide rationale and direction to start planning. In a land without road signs, people with terrain maps have a better chance of getting where they wish to go.

The major tenet of strategic planning is to create a plan that will lead to a predetermined destination.

"When planning for a year, plant corn. When planning for a decade, plant trees. When planning for life, train and educate people."
Chinese Proverb

Tactical planning is a process that organizes activities needed to realize short- and medium-term goals, as well as being the implementation tool needed for strategic planning. Moderate-term, tactical, implementation planning's importance is often missed because those who do the strategic planning see their plans clearly and assume that others who will be involved in the implementation also see how the plan will function.

Tactical planning is the route to a positive future. Like chess, tactical planning takes the strategy and produces activities that, when sequenced, will arrive at the short- and moderate-term goals leading to the overall goal.

231

Planning Steps

Regardless of the category of planning, it is a linear process. The steps may vary based on the philosophy behind the planning, but they are there. One model is presented in the following table. It has two basic structural constructs, strategic and tactical. The linear pattern of this model breaks up the total path into two parts that interrelate and can be viewed as circular.

Planning Model

Strategic	Tactical
Reason – Threat	Decision
Research and Support	Planning
Resource Inventory	Implementation
Concept – Goals	Evaluation
Decision	Reason

The key dynamic of this model is that the reason for undertaking strategic planning resolves itself through the process to a new reason that will also become the new impetus for strategic planning. With this model the institution sees itself as a constantly changing organization.

In effect, this model provides that the original reason proceeds to the development of a further reason, needed to continue development of the organizational system.

In this model the primary element starts with the recognition that there is the reason or threat that will impact the photographic program. Although in recognizing that there is a reason to change, there must also be an inherent understanding within the photographic program and the institution that the reason must be addressed with action. Without an active progress model, the planning process tends to become rhetorical, leaving the institution and the photographic program exactly where it started.

> *"Setting a goal is not the main thing. It is deciding how you will go about achieving it and staying with the plan."*
>
> Tom Landry

Once the photographic program and its supporting institutional structure have realized and committed to the need for change, it is important to formulate research, based on outside information as defining the support structures within the institution, that will facilitate both the planning for change and the subsequent implementation. This will naturally flow into building a resource model inventory that defines the various structures and individuals within and outside the institution that can assist in all aspects of this change model. While the research portion of this model is designed to address the reason or threat, the resource inventory is primary internally based to assure planning and implementation for the change.

Resource Inventory

A resource inventory includes who, what, where, and how much. It is important that when starting to plan change, the tools you will have are clearly defined. First, the question of who will accomplish what must be answered. This includes the planning, implementation, and, finally, the teaching of program changes. Beyond identifying the people who will plan, implement, support, and teach within the new program, the resource inventory should also identify potential opposition. While identifying potential involvement, it is also important to assess the readiness of individuals to identify those resources. Since several aspects of energy and enthusiasm are involved in successful implementation,

the issue of readiness defines whether individuals will need professional development in order to be equipped to implement change.

The next area for a resource inventory answers the question of what you have and what you will need. This area of the resource inventory includes fiscal realities and intellectual realities. Within the area of fiscal realities you will find an existing curriculum, a curricular change regimen, financial and planning resources, and facilities and equipment existing in the institution. These same areas can be defined as needed if they presently do not exist in the program and/or institution. Often overlooked is the intellectual resource that can be brought to bear on the problems that change will create. This is important within the institution, since this resource can be used to both plan and support the change that is coming.

Though planning is important, it is the implementation aspect of change that resource inventory identifies that will lead to a higher potential for success for the program or institution. It is important to define those parts of the support systems that will positively affect the planning process; they will benefit implementation whether they are part of the planning process or are only used for implementation. These include, but are not limited to, the institutional mission and goals, organizational structure, external mandates and pressures, communication networks, personnel energy, and political resources, both positive and negative.

"Unless commitment is made, there are only promises and hopes; but no plans."

Peter F. Drucker

233

The issue of where to implement a changed or new program may seem obvious. However, with changes in the equipment needs and curriculum, it may be important to revisit the appropriateness of present curricular location, either physical or within the organizational structure. While not as important as the "who" or "what" of the planning and implementation steps, it is necessary to consider the "where" within the organization the changed activities take place. Similarly, the fiscal reality of how much the changes will cost must be factored into the planning and into the planning for implementation.

Because part of the inventory resource process is defining obstructions to change, part of the implementation planning must deal with how to move from the past or how the past structures may cause obstructions to change. Some of these obstructions will be people based and others

will be program, institutional, or academic structural paradigms. Breaking down the old structural paradigm may be part of the planning process to implement meaningful change. As a caveat, before dismantling the structure, there needs to be a clearly defined replacement. Be careful not to destroy structures that you will need later.

"In planning we need to address where we will take the students and at the same time assure the needs of that teacher, that they will be comfortable in that classroom. The thing we tend to do the least is to prepare our teachers for that change."

Mark Murrey
Arlington Intermediate School District, TX

234

Gestalt psychologist Kurt Lewin developed a schema dealing with forces of change and forces resisting change that can be seen as part of a resource inventory. This theory is known as Force Field Analysis. The concept is exceptionally well suited to discussing the way change happens in educational institutions. In Force Field Analysis a balance is defined between the change forces and the opposing forces. The driving forces and resisting forces push against each other, creating a moving point of equilibrium. By defining the driving factors and opposition factors, ways to influence change can be identified.

Primarily the Force Field schema is presented as a diagram, with a line dividing between change and no change. On one side of the balance line are the driving forces, change agents, while on the other side of the balance line are the opposing forces. In each case the forces are represented as arrows pointed toward the equilibrium line. Change moves the line against the opposing forces and no change moves the line against the driving forces. The resource inventory defines the forces.

While this chapter deals with planning as a needed part of change, it must be realized that the planning process in some situations can be a method to avoid meaningful change. Planning committees or task forces are often formed to show that change is being addressed. It must be realized that these groups may or may not be empowered to make decisions to implement change. Often they are no more than "window dressing" or recommending bodies that will not be involved in choosing or implementing change. This can reduce the potential for change within the academic structure.

The last elements that must be defined within the resources of the academic planning and implementation structure are the limits.

You must know your limits as you approach the changes. It is more frustrating to go through the process of planning for change without the ability to meet the requirements for implementation than it is to realize that meaningful change may not be possible.

Putting the Implementation Puzzle Together

Having change take place is the goal. Beyond the strategic review planning happens, before successful implementation and with the resource inventory in hand, tactical planning must take place that deals with how to move to the future and how to move from the past. It is important that, as the planning and implementation go forward, more than the target is in view. Where the program is when implementations starts is important to the program's success. Problems can arise if planning for implementation does not consider how change will be enabled. Many individuals involved in planning fail to realize that the steps involved in implementation must include transition to the goal as well as the final change described in the goal. Without this connection to the starting point, individuals can miss taking the proper path that will reach the goals of the change.

235

> *"Ongoing faculty training will be at least as necessary as it will be for those entering the field at this point in time. We are living in a very dynamic environment with regard to the changes in our industry and the related industries such as design and printing. The best way to effect change with a faculty is to get 'buy-in.' Meetings of the entire faculty, initially to give everyone an opportunity to express their views of "where we are and where we need to be," are essential to this process. It is essential that all faculty members be given the opportunity to be heard and to be on board with the proposed changes. Once buy-in is achieved the curriculum work can start."*
>
> David Litschel
> Brooks Institute of Photography, CA

A method to consider for use, as realization of a strategic plan is started, is the four "Cs" of successful implementation. This can be seen as successfully putting together a jigsaw puzzle. The four issues that impact the successful assembly of a jigsaw puzzle are the <u>Complexity</u> of the puzzle, having a <u>Common</u> vision of what the outcome will be, the proper <u>Connection</u> of the parts, and <u>Communication</u> within the process.

By Collin McNamara, University of Connecticut, CT, student of Christine Shank

Complexity is obviously a concern of implementation. If the implementation is to change the syllabus for an introductory photo course, or is to add a new assignment, the complexity is very low and implementation is also simple. It is easy to see that if the entire course must be revised to add digital technology, the task is more complex and thus the effort to realize change will be more involved. If the entire curriculum must absorb and address digital technology, these changes will have much more complexity and difficulty for implementation.

"We are most likely to get angry and excited in our position to some idea when we ourselves are not quite certain of our own position, and are inwardly tempted to take the other side."

Thomas Mann

As the complexity of the team needed to implement change increases, the requirement for all to have a common vision of the ultimate goals of change becomes more important. If the vision for inclusion of digital imaging technology is not consistent, it is possible that newer technologies may be eliminated from consideration because all team members do not see what is needed in the same way. Because of issues such as institutional inertia, one of the parts of implementation planning may need to be the process of coordinating the visions of all those involved in the implementation and all those who will be affected by the change.

237

With the implementation of complex changes, it is important to assure a good fit between parts of the program. This connection of the parts includes coordination of content within the new program, alignment with other parts of the institution, and consistency with the photographic field external to the institution.

Perhaps the most important part of the four Cs is the communication required for successful implementation. All planning, and particularly tactical planning, is a communication process. A good idea within implementation is to develop a common language that is both used within the planning process and extended to arriving at the final goals. A language for planning can be developed and in turn provides consistency to the various parts of the planning and implementation process. Christopher Alexander originated this concept, which is explained in his book, *Pattern Language of Architecture*. The vocabulary that you will develop for your planning process needs to include the photographic technologies within

the program and those that will be implemented, the course structures, attributes of the students cohort, the functions and educational methods used within the program, and the institutional structural elements defined in the resource inventory.

"Using our language we defined the patterns that we thought were important in education. The different kinds of classes, seminars and workshops, different types of experiences that students should have, the notion of a cohort, the idea that students should work together, became parts of a common language. Once we had developed the common terms to discuss what we need to do, we began doing the actual planning...the program planning."

Dan Wheeler
University of Cincinnati, OH

Communication is particularly important if the ideas and impetus for change derive from the energy and research of one or a few individuals. The likelihood that extensive change can be accomplished by any one person within the academic setting is remote. Therefore, clear and effective communications will allow others to adopt and own the ideas originating from individuals and to assist in accomplishing the planning goals as a team.

This communication is an important aspect of leadership, from the planning stage through the implementation processes. The future may be well defined, the choices clear, but the path may be obstructed by politics and organizational structure. Leadership in planning implementation enables redirecting elements in the organizational structure to the proper path. This will allow knowledge and personal energy, the most powerful ingredients for success, to be introduced into the implementation.

Planning and Implementation Models

Models or paradigms for planning and implementation can be divided into three basic types, rational, transitional, and informal. Rational planning methods are based on delineated processes. Transitional types tend to be less structured and occur over short time periods. Informal models are not as obvious in their structures because they occur over longer periods of time.

Rational planning is seen easily by its reliance on structure of the process. This means that the elements of the process are predetermined and are followed from beginning to end. These processes are easy to

define in terms of involvement and outcomes. However, there are to downsides to rational planning systems. First, rational models often substitute "the process" for implementation. Often when all the steps are completed it is assumed that successful implementation has occurred, though the goals of the strategic plan have not been reached. Also, because a rational system is used, the steps can be forced, but brute force implementation carries the most negative impact.

Of the rational planning models, P.E.R.T. (Project Evaluation Review Technique) is the most technical. This method is popular for large-scale construction and summarily complex implementation. Because it builds on concepts including the unexpected, it tends to be very predictable within the time frame. As with most rational systems, P.E.R.T. defines responsibilities as residing in individuals or structures within the institution.

Critical path planning is similar to defining a sports play. In this rational method the end point is defined, and the required steps to reach the end point are put into place using a path and evaluation points for the implementation. Like P.E.R.T. planning, critical path planning is a series of steps against a time line. The critical path is built on scenarios of completion for each of the steps, and it is the path that determines success, not the completion of the steps against time. Critical path planning works well for moderate complexity within an open system or institution.

239

"Our plans miscarry because they have no aim."

Lucius Annaeus Seneca

An interesting adaptation of the critical path is a maze. The maze allows you to look at success from two basic points of view. The traditional manner is to enter the maze from the starting point and move toward the goal within the confines of the maze itself. The other potential place to start is at the completion point of the maze, and work backwards to the start. This aspect of critical path planning is particularly helpful with encouraging planning. It allows the reduction of the problem from completion to the point of origin. Using this concept for the development of a curriculum, it is easy to find the prerequisite alignment based on completion of the curriculum.

"When the State would not accept Photographic Sensitometry as a science course, we were not able to get accreditation for our Photographic Science curriculum. Sensitometry was not listed in their book of approved

science courses. We were short four credits. Not to be outdone, I began looking through our College of Engineering catalogue to see what courses the State accepted as meeting a science requirement. One that caught my eye was called "Metrology." Since metrology is a course in measurement, as is Photographic Sensitometry, I changed the name of the course to Photographic Metrology. The name change worked; the course was accepted as a science course."

Richard Zakia
Rochester Institute of Technology, NY

Regardless of the central organizing element for personnel, the curriculum will be defined by how the courses interrelate. The impact of this organization is seen primarily in the prerequisite structure for each course. Photographic knowledge within most technical areas is vertical. This means that the knowledge and skills taught in a first course are needed as a base for all following courses. The curriculum itself may be constructed with a group of vertical or sequential courses, each leading to a desired end.

When a vertical curriculum needs to be developed, the end point must be considered first. This will set the standard and knowledge level, which can then be moved backward through the planning process to put checkpoints into the curriculum. Horizontal curricula are made up of courses that need not be taken in any specific order. This does not mean the courses do not have prerequisites, only that those portions of the curriculum that are aligned horizontally can be taken independent of any sequencing.

As planning transitions to a more informal and less structured operational pattern, we find "fact-based" empirical models. Several years ago these were known as total quality methods (TQM). In use, this system at times approaches the planning and implementation system and functions by relying on constant feedback. In these situations planning or implementation goes forward, and evaluation is used to relate to perceived interim or final goals. In this way, the time line for activities is flexible.

These systems require strong research to help define the changes needed and the steps along the line. It should be understood, however, that as data are collected, the system might get bogged down with analysis rather than moving forward with planning and implementation. Data are like chocolate—the more you have, the more you want.

As problems arise, often institutions will impanel groups to deal with the emerging issues. In the situation known as *ad hoc*, groups

240

of interested or presumably knowledgeable individuals meet on an as-needed basis to address problems that need solutions. While these groups may propose more formalized planning, the method itself is primarily a transitional form because it does not structure the past to solution. *Ad hoc* planning believes that the process can adapt quickly with good solutions and depends on the abilities, energies, and knowledge of the group assembled. These planning groups are most effective for short-term problems or for planning with low complexity levels.

"We shape our buildings, and afterwards our buildings shape us."
Winston Churchill

Informal implementation uses the missions and structures defined in the resource inventory as guides to reaching the goals of planning. Most important within this concept of implementation is the reality that institutional or curricular structures that encourage the ultimate change will need to be put in place. Within ecological psychology this is known as a "sociopetal" structure. Informal strategy toward implementation is transitional and does not tell individuals that they will change, but convinces them that they wish to change. Having the faculty change their beliefs toward digital photography will have a longer lasting effect than will forcing through a curricular change.

241

This method of implementation relies on people's natural ability to adapt. The more difficult and complex the changes are, the less adaptability and less success with informal implementation within a short time frame. For informal implementation to work, time is needed. Since the approach is to have people change the way they perceive the future and move to that new perception, this method of implementation cannot be accomplished quickly. However, when this method can be used, it will have the most lasting effects and stability for the goals defined within planning.

As a caveat in ending this discussion of planning and implementation, it must be recognized that successful implementation and planning deals with 'what' will be done....not who 'will' be done.

"As soon as it is said that there is a new curriculum we were lost, because all there is...is curriculum evolution."
Dennis Keeley
Art Center College of Design, CA

Curricular Design

Of course we must have reason for planning. Most common within our field is the need to adjust and/or modernize our curricula. The preceding discussions have provided a few examples of how change can be implemented and planned. But the end result will be measured in the way our photographic curricula will address student and societal needs.

"It always comes down to thinking ahead, two years a head...what's going to be out there. How can I make a certain thing happen; where are people going; what is going to come in two years? Do your research, know your curriculum, know your technology, know what is out there, know what you want to accomplish...be very, very specific, you've got to stay on track—what will make it happen and what is the progression and what is the transition."

Howard Simpkins
Shariden Institute of Technology and Advanced Learning, Canada

242

In relation to the curricula to be designed we must look how the academic structure will view various aspects of the curriculum. In relation to the plans there are four major foci that may be central to creation of a new or remodeled curriculum. These deal with outcome, procedure, equipment, or aesthetics.

From an administrative point of view the prime objective will be seen in the outcome. While this outcome may be determined by threats or opportunities seen within the field of photography and photographic education, the real emphasis is on accomplishing a successful plan. With this in mind, it becomes important that the administration "buys in" to change, to benefit the photographic programs. Successes in this realm may be having the administration adopt the photographic program's ideas, and thus "own them." Therefore, to develop this strategy of accomplishing goals for curricular change within the photographic program, it may be necessary for an individual to give up some of the credit for the ideas.

"To encourage curriculum change, administrators should reward inno-vators and also concern themselves with the need for security on the part of their faculty during the difficult period of change."

Anonymous

Important reasons for outcome-based curricular planning are the economic constraints on the institution. While it would be nice to have *carte blanche* for curricular change, this is not a reality in most situations. More likely, it will be economic pressure that is the threat or impetus for change.

Common to many outcome-based curricula is the requirement for job placement. Whether this is accreditation-based or institutionally mandated, aspects of curriculum development will be determined by the ability of the photographic program to successfully place its completers into the workplace. The structure, timing, and equipment needs for the program will be decided externally to the program. Most institutional situations use advisory boards to help define the curricular design options that will be active in a new or revised photographic curriculum. Thus it is important in creating and using the advisory board that the individuals who are chosen to participate have both the knowledge and the vision to see the photographic field as the students will experience it, once they have completed the program. It is shortsighted to select advisers who are greedy or who will defer automatically to the faculty's vision. While in the short term this may be comforting to the faculty, in the long term it may be detrimental to the program and its students.

243

"I constantly ask myself what a graduate of the photographic program needs to know by the time they graduate. And based on the answer to that reoccurring question I will change the curriculum, the technology taught within the curriculum, or not, or try to integrate or interface them differently than I have done before."

Jane Alden Stevens
University of Cincinnati, OH

Because of academic structures that are not within, but have an impact on, the photographic program, procedure often becomes the central organizing factor in program redesign or new curricular planning. These may define prerequisites or curricular options rather than approaching designed constraints leading to more coherent and substantial programs. Since these procedures that will determine much of the curriculum are external to any planning within the photographic program, they will have a greater impact on the number of options that can be included in the curricular design. The procedural controlling factors do not limit the academic strength of the designed curriculum

or program. They only define the structural elements that will be found in the final design.

There is also a potential in today's rapidly changing technological environment that equipment changes will be the impetus and a controlling factor for curriculum change. Curriculum change based on an equipment-centric view has the potential to be limited in time. We have learned that the pace of change of the technologies, both hardware and software, is changing at a rapid rate. The ability of any academic institution to keep pace with the state-of-the-art is highly doubtful. This makes this type of curricular design less than satisfactory for the long term.

An aesthetic point of view can also be the central form of curriculum design. However, just as equipment has a limited time frame, developing courses around a genre or aesthetic point is both limiting in scope and likely shortsighted for the long run.

244

"To make a very serious attempt to redesign an art department to more accurately reflect issues of contemporary practice...One of the underlying concepts is to design a program of study that is not media specific—painting, printmaking, photography, sculpture, et cetera—but a program that is based on the concept of image formulation. At present we are looking at four distinguishing characteristics: still, moving, dimensional and interactive. The idea is then to form bridging structures from traditional forms as exclusively distinct, to a more interactive ground working with the theatre department, the dance department, the school of communications, and the music department. The concern here is to expose students not to a series of disciplines but to allow them to understand the underlying aspects of them; sound, movement, interactivity, spatial orientation."

Nathan Lyons
Visual Studies Workshop, NY

Changing Curriculum to the Digital Age

Photography, the art of making photographs, has not changed over the years, but the technology certainly has—from daguerreotypes, to tintypes, to glass plates, to sheet film, to roll film, and now to CCD and CMOS—from analog to digital. This, of course, has required some changes in what we teach and how we teach, as can be seen in the following comparison between two associate degree programs, one

from more than 20 years ago and one from today. The first, Lansing Community College's 1982 Commercial/Illustration curriculum, is compared to Harrington College of Design's current curriculum for the Digital Photography Program. (This comparison deals only with the photography-specific courses.)

Curriculum, Lansing Community College, 1982

Intro to Photo
Black & White darkroom introduction including camera operations, exposure, development, and printing.

Design I
A basic design course covering the elements of design.

Intro to Photo II
Intermediate Black & White photographic course concentrating on exposure and printing.

Intro to Photo III
An advanced Black & White course including introduction to medium and large formats and advanced exposure and printing.

Intro to Color
An introduction to color theory and color photographic processes.

Basic Photo Chemistry
An introduction to the photo chemistry of Black & White technology.

Large Format Photo I
An introduction to the view camera and its movements.

Portrait I
Posing and lighting for portraiture.

Business of Photography
The basic business knowledge needed to enter into the photography business.

Color Printing I
An introduction to color printing.

Color Printing II
Advanced color printing including internegative processes.

245

Large Format Photo II
The applications of the large-format camera in the studio and architectural photography.

Photojournalism I
Introduction to the principles of news gathering, picture story telling, and publishing of images.

The Portfolio
A culminating course to prepare to enter the photographic job field.

Curriculum, Harrington College of Design, 2005

Fundamentals of Digital Photography
An introduction including digital camera operations, exposure, basic Photoshop, and ink jet printing.

Design Foundations
A basic design course covering the elements of design.

Digital Imaging I
A continuation of Fundamentals of Digital Photography with emphasis on Photoshop and an introduction to color management.

Imaging and Studio Processes
An introduction to the studio environment and basics of lighting.

Location Lighting
The course uses the basics of all lighting environments and their applications.

Digital Illustration
Use of digital tools in photographic illustration.

Lighting People
Posing and lighting for portraiture.

Studio Lighting
Understanding the concepts of light control within the studio.

History of Photography and Imaging
A historical approach to the development of photography to the present.

Commercial Photography
The application of various photographic techniques for commercial applications.

Architectural and Interior Photography
An introduction to techniques used in architectural and interior photography.

Portfolio/Resume
A culminating course to prepare to enter the photographic job field.

Looking at these two curricula we can see that there are some ideas that did not change in an approach to curriculum design. These are the requirements for courses on exposure, design, portfolio, and several areas of applications. At the same time we can see that there is less process in the current Harrington program, with more instruction on lighting. Also, the 1982 Lansing program had a broader view of potentialities for professional activities.

"As educators and artists we seek to understand photography's future in an age of multidisciplinary practice."
Society for Photographic Education
2006 Conference Announcement

247

By Adam Kuehl, Savannah College of Art and Design, GA, student of Craig Stevens

12

Support Activities

"If you find a turtle on top of the post, it didn't get there by accident."
William Jefferson Clinton

249

Regardless of how strong a teacher you are, because of the techno-
logical bases of photographic education it is likely that support will
be required to effectively teach others. Even for a "one-man band"
there is a need for a complicated instrument. There are several parts
of the educational process that require support. Whether individu-
als, administrators, or institutions handle these, they will need to be
accomplished in order to provide effective photographic education.

In this chapter we will try to introduce several support systems
that enable photographic education. Since this book is about how
to teach photography, we do not delve deeply into the nuances of
management, budgeting, and development of administration and
supporting education, but rather take a general approach. In starting
this discussion, it must be clear that while, as teachers, we may not
wish to deal with administration and the activities outside the class-
room, these to a large extent will determine the success and future
of our professional involvement in photographic education.

Administration

*"The hardest part of being an administrator is the tension between the
two parts of the job. The tension is caused by pressure from elsewhere*

to get the administration right and the desire to be a good teacher. Both sides are unremitting in their demands. Management does not see beyond their requirements and students do not see beyond their requirements."

Ian R. Smith
Salisbury College, United Kingdom

The administrative functions required to run a successful academic photographic program are many. Since this book deals with teaching, we will not deal in depth with administration; however, it must be said that it is in the best interests of the program to work within the administrative flow rather than to oppose it. While this may seem apparent, too often faculty members make self-serving choices that work against administrative needs and those of the institution. Such self-interest works against the greater good.

Like football, the coach's job is different than any of the roles of individual players. In a similar manner we must look at education as a team concept that requires different activities from different players. Those who have been involved as a single instructor or have taught in a small program where all activities, teaching and administrative, fell to them, realize that the administrative overload often gets in the way of teaching. The administrative role may be required, depending upon the size and the point in growth of the photographic program. With larger organizational structures, programs, or institutions, administration is normally a consideration beyond the classroom assignments. In larger, more diverse academic settings, administrators with no photographic training are often assigned to support these educational programs.

The administration in the educational institution should have as its goal enabling high levels of education. It is not as important that the administrator be from the field of photography as it is that they support the goals of the photography program. It can be argued that the photographic program is better off if administrated by a supporter of photography rather than by a photographer. It is important to realize that when entering an administrative role, while education is still the goal, teaching is no longer the prime activity.

"The very highest is barely known by men.
Then comes that which they know and love.
Then that which is feared.
Then that which is despised.

*He who does not trust will
not be trusted.*

*When actions are performed
Without unnecessary speech
People say, 'We did it.'"*

<div align="right">Lao Tsu, from the Tao Te Ching</div>

Though many aspire to administrative roles for the money, the prestige, or as a stepping-stone to other opportunities, there are others who shun administrative roles or who accept them reluctantly. The potential for successes from the teacher's standpoint is enhanced when the person in an administrative position responsible for the photographic program is more concerned about the quality of education than the title on their door. It is not as important who gets the credit, in the long run, as it is if a quality job gets done. The only problem with this attitude is that many people believe that the way to the top is by stepping on their colleagues, and that the strategy of being sure that the job gets done and sharing credit reduces the "headline status" for people who are actually doing the job.

251

"If there is no leadership, it makes education damn difficult! A good chair or program director affords the opportunity for faculty and students to work beyond themselves and outside the educational environment. Learning does not happen in a vacuum."

<div align="right">Roxanne Frith
Lansing Community College, MI</div>

The concept of teaching and the concept of administering a photographic program are separate. While they deal with the same photographic program, they are not the same job nor do they require the same skills. Similarly, the way colleagues feel about administration depends on the outcomes concerning the individuals. If the job of an administrator is to be sure that a high level of quality education happens, then they will be making decisions that may, or may not, agree with some person's desires. This will change the favorability rating of the administrator, depending upon the outcomes of decisions made. This means that from time to time the administrator's popularity will also ebb and flow. Therefore, administrators tend not to win popularity contests.

"The biggest difference between administration and teaching is that you have to have a greater vision; instead of dealing with what was happening in just that one classroom you need a broader view of the whole school district. But it creates a separation between the students and me. Even though the students were being impacted by what I do, I don't deal with the students, just with teachers and other administrators."

Mark Murrey
Arlington Intermediate School District, TX

A role that is important for administration is the ability to project to the future and prepare both the institution and the faculty for next steps. Administration should be looking to the future to see the trends that will impact the photographic program and put in place professional development, capital expenditure budgets, equipment lists, faculty needs, etc. Particularly in photographic education, with its rapidly changing technical underpinnings, a view to the future and how it will impact the program is valuable. This becomes a balancing act between the administrative structure, budgets, faculty desires, student desires, and politics. The successful administrator leads the various constituencies of the programs into the future. While they, too, will travel to this future, it is their ability to bring along the various parts of the photographic program that will be the measure of a positive outcome.

"When you are leading a band, it is a good idea to look back occasionally to see if anyone is following."

Paul Miller
Rochester Institute of Technology

Politics

Politics gets a bad reputation...perhaps it should, but, then again, it is a necessity to get things done. Understanding politics is to be able to accomplish big things. It must be understood that unless you are teaching on the "log" that Socrates suggests, you will be involved with politics. Politics happens whenever an organization of people needs to accomplish cooperative group activities. If there are two people involved in making a decision, then negotiations are required, while with more than two, politics will be involved, with or without negotiations. Politics establish the direction for decisions and is essentially the ability to create two groups to make these decisions.

From this standpoint, politics is a tool used to make decisions. Its goodness or badness is a matter of the outcome of decisions, not the use of the tool. In order to move forward with planning a curriculum, acquiring equipment, etc., it will be required to use the political tool to assure implementation or acquisition.

Therefore, we must create alliances and dependencies that will enable the success of our programs. These include knowledge of the program, its important work in the structure of the institution, its impact on other programs, and its reputation and appearance external to the institution. This requires attention to others beyond the scope of the program itself. While you might not wish to be seen as being political, it is your ability to work with others that allows politics to assist you and your program's future.

You may not enjoy "playing" politics; however, it is important to be aware of the politics around you so that you are not blind-sided by the formation of action groups that will affect you in a negative way.

"After the satisfaction of doing what is right, the greatest is that of having what we do approved."

Thomas Jefferson

253

Budget

It is said that money is the root of all evil and the root of the family tree. This is also true within the academic world. The budget is a tool that determines how funds will be spent. We can look at the budget as being similar to our checkbook, where we put money in and spend from what has been deposited. However, budgets are developed and implemented using far more complicated methods within education.

Primarily within the budget there are two primary parts that impact educational programs. These are the operational budget and the capital expenditures budget. Though there may be specialized budgets within project or programs, mainly these two areas are used. The operational budget is used to cover day-to-day activities along with salaries, benefits, supplies, travel, etc. Depending on the system that is used to manage and audit the budget, the number of accounts within the budget and how the funds may be spent from each will have differing rules. The fact that money exists in one account and is unused does not automatically mean that it can be spent for another purpose.

White Cloud; by George DeWolfe, Rochester Institute of Technology, NY, student of Richard Zakia

The capital expenditures budget is used to fund building, remodeling, and large equipment. In the case of equipment, there is normally a minimum amount of cost that requires this account to be used. For most educational institutions, the two budgets, operational and capital, are separate and only rarely will you see transfers from one budget to the other. It is also common within education to have dedicated monies in a foundation or development fund that can be applied to either of these budgets, as defined by the donor, foundation, or grant.

As a teacher you will rarely be involved in developing either of these budgets, particularly on the income side. While you may be asked for input into requirements for the budgets, administrators, even those outside our discipline area, normally will set the budget levels. There will be opportunities, such as development and grants, to be involved in acquiring funds to support your photographic program. However, once funds are placed into either operational or capital budgets, the control of these funds may be severely restricted. For this reason it may be best to acquire restricted-use funds, for which the donor or source has specified use or direction. The same can be said when you make contributions to your alma mater—specify how your money is to be used (student scholarships, faculty salaries, photo equipment, and so on).

255

Professional Development

Photographic technology and aesthetics, along with ideas of how to best teach the courses, are in constant flux. Our students come to us with increased skills and understandings of photographic technology, having experienced a heavily technology-mediated society. This puts pressure on teachers to be up to date in the changes occurring in photographic technology and in the methods that can be used to help students learn at ever-increasing levels.

Within public education, there is often a requirement to pursue further education throughout one's career. Continuing education may be necessary to earn increases in salary or to assure retention within an educational system. In higher education, similar activity is required. While degree advances are not always mandatory, continued growth within the field is. External pressures to participate in continuing education should not be necessary, because when you are committed to teaching, you are also committed to staying in touch

with how photography is changing. In this way, learning is ongoing and a lifelong activity.

"To remain in the profession of teaching photography requires continual examination of the constantly advancing technologies and aesthetics of imaging. As scholars, we must convey knowledge with fortitude and zeal. Those possessing extraordinary passion will survive. A career in photographic education is demanding, competitive, rewarding and worthy of a lifetime of dedication."

Janet Bonsall
Central Missouri State University, MO

There are several ways to be involved in professional development activities. In many institutions, whether required for promotions or not, professional development activities for faculty are mandatory for continued institutional accreditation. Therefore, institutions often have policies and even functions within the organization that support professional development. This may be in the form of support for individuals to attend conferences and workshops or to pursue further education through other educational institutions.

Some of the ideas for professional development that permeate education today involve having faculty structure meetings to share learning that they have undertaken, bringing in experts to present new technologies and ideas, and having industry representatives give demonstrations on campus. Though these meetings add other activities to potentially busy schedules, beyond the learning that will take place there are advantages to participating. Your presence in a presentation that has been sanctioned by the institution through either scheduling or funding indicates a commitment to the furthering of your program. Also, meetings within the faculty or with other faculties provide opportunities to create alliances in the least political structures of the institution. Through these educational/professional development activities, common goals and understandings of new technologies and approaches to teaching can create future scenarios for the program.

"The reward can be put in a quote from the Koran. It is, 'I teach so that I can learn.' You are constantly changing, constantly learning, constantly evolving, constantly meeting challenges and seeing different people's interpretations."

Andrew Moxon
Savannah College of Art and Design, GA

Both professional growth and personal growth are keystones of being a teacher. Professional development, whether formalized by the institution or on a personal basis, promotes growth. The benefit in professional development is for the students and indirectly for the teacher. This being said, it is clear that the institutional requirements stated previously add validity to professional development. Therefore, just as with other activities that will be used as part of a résumé or for assessment for promotion/tenure,, documentation of all professional development activities is critical—not critical as to what will be learned by the students alone, but critical as to how you are viewed within the profession as a photographic teacher.

Mentoring

Mentoring is the ultimate form of professional development. The mentor, beyond being willing, must have experience and knowledge of the field beyond what is found in the text or syllabus. The mentee must have a willingness to accept behavioral aspects of the educational setting as well as to learn the knowledge that will be offered. Normally in a mentoring situation it is expected that the mentee will have base knowledge within the field and that the mentor will provide a higher level of information that will be useful to the mentee in performing work within the field. In the selection process for an appropriate mentor in an institution, it must be established that the mentor possesses system knowledge of the institution; compatibility with the mentee is also an important consideration.

Simply stating that there is a mentoring relationship, often by assignment, does not assure that mentoring will occur. To truly be successful, the mentor for a specific field must provide a broad view of the roles and expectations defined within the field. This requires more than simple directions on how to operate, say, the faculty copying machine, in the field of teaching. When a mentoring situation works at its best, the mentee comes away with an understanding of how a system actually functions, regardless of the way it is defined in an organizational chart or other body of literature. This is very important in education, since the success of teachers will be defined by the students' success in learning. The teachers' performances in tangential functions around their teaching will impact the learners.

Some mentoring situations are highly structured while others are less formal. Regardless of the formality in the mentoring relationship,

257

a constant must be that interaction happens on a regular basis. Even though there are times when the pressures of teaching or being an administrator become overwhelming, it is important that mentor/mentee contact remains. This element of continued contact allows for questions and input to happen without undue stress. When a problem arises, help can be sought by the mentee; many problems, however, can be short-circuited if mentoring addresses upcoming issues.

For a teacher (mentee) coming to a new class, a good model for mentoring is to meet with the mentoring teacher prior to each block of classes. In a zone system class, for example, a meeting prior to a discussion of adjusting metering in the field will allow the mentor to present problems and questions that have arisen in past classes. The discussion in this meeting would then address how these questions and problems might be answered and what demonstrations will facilitate the students' learning in the upcoming class. Even though the mentee many have extensive experience with the zone system, the preclass review of the system may bring out new ideas that the mentor/mentee can introduce during the classroom presentation and apply to the inevitable questions.

A model that can be easily instituted, though with a cost of time, is to develop a system where new teachers are eased through a formalized process into their teaching responsibilities. At Brooks Institute, new teachers first sit through the class that they will be teaching. Even though they have taken the class previously, worked professionally in the area of study, and/or studied the material intensively, they will be asked to sit through the class so they can observe how it is taught by a master teacher. The concept is to observe teaching technique, not photographic technique. After completing an observation class, new teachers will assist the master teacher with the next section of that class. In this way, they will be given responsibility for some of the lessons while having a built-in mentor ready to assist with how they function within the class. The relationship between the new teachers and the master teacher also provides a mentoring model for other aspects of working within the institution.

Being a Teacher-Mentor

The challenge is about resources and processes, not abstract learning, for the new teacher. Good mentoring is about introducing the new teacher to examples of good teaching, good work in and with the administration,

and good functioning within the profession of photographic education. There are many aspects to teaching, including promotion, tenure, and retention, and it is necessary for a new teacher to navigate them all to become a valuable asset for the photographic program. Even though the search process for a new teacher will likely have produced a good fit for the program, there will still be a need for the new teacher to become part of the team, and that is the real purpose of mentoring.

As a mentor, plan activities, including regular meetings. This should include visiting the new teachers' classroom presentations for nonthreatening peer review. Explore professional development opportunities and encourage new teachers to view their role in the photographic program as more than just teaching classes. Encourage new teachers to produce work, write articles, take part in all institutional activities, etc., to assure that they expand their expertise and that they are viewed as valuable within the institution and the profession.

There are prime examples of good teaching and realistic understandings of what resources are available to the individual. Recognize your abilities and deficits in terms of the overall educational process at your institution, and where necessary bring in other individuals to assist new teachers. Invite your mentees to attend lectures, demonstrations, and critiques with other teachers to familiarize them with the standards expected within the photographic department. While being friendly is nice, being professional is imperative.

259

Making the Most Out of Being a Mentee

Regardless of whether you are approaching your first job teaching photography or have changed positions after extensive teaching experience at another institution, finding a mentor to assist you in moving into your new institutional slot will be important. If the institution that you are joining does not have a mentoring program, then informally find an individual within the institution who can assist you as a mentor. It is better to select a mentor whose position within the institution is vastly more senior and superior in relation to your new position. This will provide you with a view of the institution that is difficult to see as a newcomer.

In any mentoring relationship, as the mentee you will want to be the recipient of input more than you want to be the dispenser of opinion. It is important in starting that you use all of your senses to acquire as much information about the workings of the institution as possible, to best discover how you might want to teach your photography class.

Working with Industry

Working with industry is one of the ways that photographic education becomes more relevant; alliances can also be beneficial in terms of development for the institution. Often we see that industry will, when it wishes, support photographic programs. While we appreciate these opportunities, we can become frustrated when we fail to wrest support from an industry that we know is dependent upon our teaching. In choosing a strategy to work with industry, it is probably wise to step back to see the big picture rather than to view the situation strictly from our program needs or wants.

First, we must understand that industry is not in the business of supporting our photographic program. While companies may find significant benefit in doing so, their first goal is to be profitable in their enterprise. This truth about the economic status of an industry relates to its ability to support our ongoing educational endeavors. A profitable industry or company is more likely to share some of its resources with educational groups than if it is struggling to meet an economic imperative...survival is foremost.

Not uncommonly, there may be a direct *quid pro quo* based on sales to the institution. For example, several manufacturers provide equipment to institutions with the understanding that it will be sold by the manufacturers or purchased by the institutions after a specified use. This may mean that the equipment is eventually sold to students, faculty, or the program itself.

More commonly, there will be the development of a long-term relationship with industry that will result in long-term sales or marketing goals for their products. This does not mean that industries will only want to be involved with an institution or photographic program that purchases only their equipment or materials. Industries will want to see, however, that any support given to a photographic program fits into their long-term goals. Working with industry should be a win-win endeavor were the school, program, and students benefit as does the industry.

It is critical to view a potential relationship between an industry or company and your photographic program first from the point of view of how it will benefit the industry or company. If you cannot find a benefit to the company or industry and are relying solely on their beneficence, then your ability to gain support will drastically be reduced.

Second, the currency of support coming from an industry to an institution is determined by the industry, not necessarily by the photographic program. A prime example of how this can be inappropriately approached comes from a major photographic supplier who manufactures sensitized materials. They received a request from a program for support to buy enlargers, a product they neither manufactured nor marketed. It is not difficult to see that the company chose not to support this photographic program's request.

Ken Lassiter, a former executive at Kodak, said, "Industry seldom has relationships with educational institutions—*people* in the industry have relations with *people* in education." The clear implication of this statement is that regardless of the strength of a photographic program, it will be a personal contact that will likely create a relationship between the company and a photographic program. At one regional conference of photo educators a new instructor at a university photographic program accosted a person representing a manufacturer, telling them how great the university's program was and disparaging another photographic program that was receiving support from the manufacturer. The outcome was that the person-to-person contact undercut any good relationships that other faculty had with the manufacturer. Any support from the manufacturer that the university's photographic program was receiving stopped while that new faculty member was at the institution.

Finally, and perhaps of more importance, industry can give education a gift that is seldom asked for but is one that goes far to promote the photographic program and the industry. This is the knowledge that is inherent within the industry. Seldom are industries devoid of specialized information and knowledge, and our photographic programs are based on teaching the knowledge, equipment, and processes that these industries have developed and/or market. When a photographic program involves itself with the knowledge and developments of an industry and is seen as pursuing that knowledge base rather than a handout, industry tends to share resources. You do not want your photographic program to be viewed as shaking hands with your palm up; you want to be seen as an active partner in the betterment of the industry in general, and the company specifically.

Using Textbooks

Useful yet often unused, textbooks are superb tools to help learners. Unfortunately, many textbooks are not read, or in many cases are not

261

even woven into the structure of the learning. While most textbooks are useful in assisting learning, it is the rare situation that the textbook alone can teach photography. Textbooks find their usefulness in being supportive of or additive to instruction, not as the sole tool used to teach photography.

"We must go beyond textbooks, go out into the bypaths and untrodden depths of the wilderness and travel and explore and tell the world the glories of our journey."

Benjamin Franklin

One way textbooks gain their usefulness is that they can present the photographic technique in a manner other than in the voice of the instructor. As mentioned earlier, learning does not always come to all individuals in the same manner, and the text can give alternative methods from those presented by the instructor. Of course, this negates the approach of reading the textbook as a lecture, which in any case would make for redundant and boring education. Successful use of a textbook can expand the visual and demonstrated techniques introduced in class; textbook content is a constantly available resource. The material is always available to provide a base for ongoing and linear learning.

"A textbook should not create a narrow window of what photography is."

Mark Murrey
Arlington Intermediate School District, TX

In some circumstances, the choice may be made that no textbook will be assigned for a particular class. Because demonstrations and laboratory work support so much of photographic education, many learners will avoid reading assigned texts. This being the case, several factors come into play as to whether or not to have a text—whether an appropriate text is available, whether a text is required to expand the presented materials, and whether text materials are needed to prepare for or reinforce learning. Choosing not to use a textbook assumes that all materials needed on a regular basis can be found within class presentations or through easily accessible resources.

Supplemental materials that are included in a textbook are often required to maximize learning. Therefore, the choice to not have a text

Leah; by Joanne Elkin, Salisbury College, United Kingdom, student of John Martin

places added pressure on the instructor to provide support materials in terms of reading and supplemental handouts. Handouts, recommended readings, and web site URLs can also be used to replace a textbook. However, if this method of providing support materials is chosen, the organization and thoroughness of the materials become the responsibility of the instructor.

"Instead of a textbook, I use a constantly evolving set of 150 pages of handouts. I like to keep things up-to-date. I give out the handouts only when we will use them in class and have the students take notes on the handouts. The students stay where I want them to be and do not read ahead."

J Seeley
Wesleyan University, CT

A textbook many times is assigned to a course year after year, even though the objectives of the course change. When the textbook no longer adequately covers or in other ways no longer fits the course objectives, the textbook should be changed to one that meets the new learning objectives. It is unfortunate if an administration requires a particular text, regardless of its suitability. In such a situation, it is incumbent on the instructor to move to change the text or to find a way around the inappropriateness of the material. It is incumbent on the instructor to assure that there is a match between the materials in the text and the course objectives. This is more of a selection process than a course modification process. Once the techniques are chosen for a course, the textbook or reading materials can be selected to support the learning objectives.

The use of textbooks because they are mandated by the curricula, without the involvement of those who must present the courses, is not uncommon in formal education. Further, it is not uncommon that the materials in the required texts do not support the learning objectives. This is often the case with texts that are all-encompassing, when the learning objectives are not.

There are two ways to approach the use of textbooks: as an active part of the education or as a passive support of instruction. Active use tends to be a format that has the learners coming to lectures, recitations, laboratories, or demonstrations with assigned readings already completed. The passive-use format does not involve preclass reading assignments. Neither approach is necessarily better, but if the active-use

format is chosen, a method for assuring that the text is used becomes key to effectiveness. This can be formally done by use of text-based homework or tests and quizzes, or, less formally, by engaging the learners in dialogue about the material in the text.

"Teach to the problems, not to the text."

E. Kim Nebeuts

Choosing texts for courses is an endeavor in matching what is needed to assist the learners with the scope and level of the available textbooks. A textbook needs to support the learning activities without deterring the learner from using it. It is not unusual to see a textbook chosen that covers much more information than will be used in the course and the curriculum. In situations where the learners must purchase the text, this becomes a costly purchase that portends lower acquisition and less use.

Also, because publishing costs have risen, review copies of texts are not as available as they have been in the past. If you wish to receive gratis review texts, you may be required to supply reasons to the publisher in support of your need for a review copy. A publisher may stipulate that the review copy be paid for or returned if it is not adopted for a course.

In today's electronic/web-based information society, it is clear that printed texts are only one type of textual material that can be used to support a class. As with the move from a film-based photographic curriculum to digital imaging, we will continue to see movement to include more digital text sources. Advantages for inclusion of and movement to digitally supported texts include the ease with which text materials can be kept current; text materials can easily be added, deleted, or corrected, and enhanced with photographs in a short time; contemporary issues can be inserted at very little cost; color prints can be accessed (unlike printed texts, where reproductions of color are costly); students can print out pages if they wish for easy reference; and musical tracks can be added with dialogue, which is a real boost for teaching using videos and for preparing slide presentations.

A headline in an August 2005 newspaper reads, "Laptops Oust Textbooks in Arizona School." Students in Vail, Arizona have been issued Apple iBooks in a high school designed to be textbook-free. The advent of electronically accessible textual materials has opened up a

265

new method for supporting educational instruction with reading and research, without requiring paper books.

Several options exist for providing the learners with reading and research materials from the World Wide Web or other electronic databases that can enrich their learning experience. Depending upon the sophistication of electronic support for such classes, ebooks, web-based materials, and print-on-demand technologies can provide the text support for a class. For example, since many museums have put their collections on the Web, it is possible for a student to research a particular photographic artist without visiting a museum. Though the experience of seeing an original print far exceeds what is seen using electronic imagery, access to a wealth of images and other support material can vastly expand learning experiences. Some schools are now phasing in non-textbook environments and are requiring laptops for the students.

Further, because of the portability of today's electronic storage and computing devices, students can share limited resources. Whether these are iPods, removable hard drives, or laptop computers, course material can be researched and found as text in many electronic databases and can be easily accessed by the students as needed. While this may raise questions about academic integrity, primarily plagiarism, tools now exist to allow the teacher to screen for excessive appropriations of others' creative endeavors.

"The content of most textbooks is perishable, but the tools of self-direction serve one well over time."

Albert Bandura
Stanford University, CA

Using Technology to Help Learners

In today's photography and imaging education, technology is both the essence of the discipline and a tool for effective teaching. Curricula in learning technologies exist that deal in depth with this area. We will only mention the importance of a program's keeping up with technology in its presentations, as well as the technologies that it teaches. Just as it is important to have a visually active environment to reinforce the visual content of the program, using appropriate technology to teach reinforces the technological portion of the curriculum.

We often tell our students that it will take more time outside class than in class to learn the material; similarly, it will most often take longer to prepare the presentations you will use in the classroom than it will to present them. Even with the assistance that software can provide, the effort needed to prepare and continually update the presentations can be extensive.

"Well before you start teaching, you need to consider how you will impart visual information to your students. While slides, videotapes, DVDs and books or magazines are all options, the current preferred method is PowerPoint."

Jane Alden Stevens
University of Cincinnati, OH

267

Wooden Doors – Our Lady of Mount Carmel Parish; by Ross Payson, Brooks Institute of Photography, CA, student of Christopher Broughton

The Profession...So You Want to Teach

"Choose a job you love, and you will never have to work a day in your life."

Confucius

Teaching is a profession. In saying that, it is clear that there is more involved in teaching than simply telling people what you know or can do. There is also more involved in being hired to teach photography and in keeping the job than simply turning up for work.

There are skills and abilities that have been discussed to this point in the book that will need to be used once a position has been acquired. This chapter is about how you organize the other parts of your background and education to enter the profession. All the skills and knowledge you have gained along with the passion you have for photography will assist in obtaining a position, but there is one thing that is imperative. The key element to the profession is attitude, which can be communicated to others who will be hiring, retaining, tenuring, and/or promoting. Attitude is a life choice that starts with an understanding that the profession of teaching photography is not a way to support the production of art. As stated earlier and often, it is the commitment to the learning of others.

"We look for teaching experience; they need to know how to handle a classroom. Second they need to bring something of genuine uniqueness

to the classroom. Uniqueness is not energy...everybody needs to have the energy. They need to bring uniqueness of understanding of learning, exciting ways to work with students in groups and one-on-one situations. We are also looking for a solid background. I am looking for someone who may have an ego, but who is willing to put that ego aside and go to the classroom and allow the students to exceed their expertise. We are looking for person who can revel in the student or graduate's success."

Bill DuBois
Rochester Institute of Technology

270

With the right concept and attitude, we can look at those aspects that are important in finding and maintaining a teaching position. Perhaps the most overlooked aspect of the dialectic of being hired and retaining a position is that the same things that you will need to remain, you will in most cases need in being employed. Another way of saying this is that being professional starts before you are one. Part of the attitude that enables the career in teaching photography is an inculcated sense that the level of expectation will change and increase as you advance, but not the basic parts of the career.

The First Teaching Position

For many, particularly those in higher education, the first teaching position comes in the form of a teaching assistant role. It is not uncommon that students enrolled in a graduate program are asked/ told that, as part of their scholarship, they will teach a class, even though they have had no experience in the front of the class. It is often the case that individuals are teaching in a way that mirrors the start of their education. The idea of learning to teach with "on the job" training misses the point that there is more to teaching than a teacher simply telling a group of the students what he or she knows.

Some institutions provide new teachers with in-service training and/or workshops to assist individuals in the transition to their new responsibilities. Also, many institutions provide mentors for new faculty to assist these individuals in making their transition. While mentoring is common, it is very seldom formalized. The most common approach to help new faculty is to assign older, more experienced faculty to answer the new employees' questions. This model is also used in many of the assistantship opportunities.

"Life affords no higher pleasure than that of our mounting difficulties, passing from one step of success to another, forming new wishes and seeing them gratified."

Samuel Johnson

Within certain situations formalized mentoring takes place. This ranges from sitting through courses that will be taught, either concurrently or a semester ahead, to elaborate seminar/working sessions similar to student teaching in the K–12 arena. The most beneficial methods tend to be those that have the new teachers introduced to the material prior to the first time they see it taught or are involved in presenting the material.

With individuals entering teaching from the professional photographic world, there are many issues that they fail to see. Because there is a need for specific areas of photographic education, often a working professional will be asked to teach a class, even though he or she has not been involved in education for many years. It is quite common for such individuals to be given a class and a faculty handbook, with the administration assuming that everything will run smoothly and that the new teacher will have few questions about what is required in the teaching realm. Because of the program leadership's assumptions about the new faculty member's abilities, the new teacher may be missing critical aspects of learning dynamics.

271

"The most surprising thing in coming to teaching from the professional world was the speed at which you deliver the course. Having come from the commercial environment, everything was done in double-time, and then coming into the educational environment it was about having to pull back and slowing the delivery down because you are dealing with fresh new minds. You have to plan and execute your courses at the time scale that suits the learners."

Andrew Moxon
Savannah College of Art and Design, GA

Finding a Position

Ads for photography instructors are found in local newspapers, national listings such as *The Chronicle of Higher Education* and *Photo District News*, publications of professional organizations, and online. It seems easy to think that the jobs will simply be advertised and the selection

process begins. To the outsider this often seems the case. However, often the process of creating a position on the part of the institution has a lot to do with how the position will be filled and how difficult it will be for you to find the position. While Equal Employment Opportunity (EEO) provisions and similar functions provide that all positions will be open, the fact that a job is advertised does not assure that a position is truly open. This is not to dissuade individuals from utilizing advertisements to find a job, but is a reminder to simply be aware that ads do not necessarily tell the full story of what will be available in an upcoming search. In some cases the ad is there to only meet affirmative action considerations, not to fill the job.

"Education is when you read the fine print. Experience is what you get if you don't."

Pete Seeger

However, if we assume that an advertised position is open, how should we utilize what has been written in the ad in the way we apply for the job? Perhaps the most useful part of the advertisement is the contact address, so that a complete job description can be acquired. You will want a formal job description; the cost of standard print advertising often precludes the details that will aid you in sensing your fit to the job or the true requirements for the job. Today, however, many online postings of positions include the full job description.

Once you have a complete job description, you should look at whether the job fits your qualifications and interests. Particularly view two portions of the advertisement or job announcement. These are the professional requirements and the teaching requirements. If the position announcement states that a certain degree or certification is required, that should be taken as a strong indication that when the screening takes place, the stated standard will become the basis for acceptable applications. In many situations the key word will be "required" or "desired." "Required" will be the basis, and "desired" qualifications will be considered only if a suitable pool of candidates with the required qualifications cannot be assembled.

If the advertisement lists specific credentials as a requirement, it must be assumed that certification within an area, such as Adobe Certified Expert (ACE), will be required by the institution in order to be employed. Particularly in public educational situations, certification is mandated by a department of education and cannot be avoided.

272

"When I hire a new teacher it is not for my job. I am hiring a person for whatever part of the program she or he is supposed to fit into. A good teacher who knows their field in photography, taking pictures, and has passion...even for technologists. We want people with real specialties in areas; we don't expect everyone to know everything...Know what we need."

Howard Simpkins
Shariden Institute of Technology
and Advanced Learning, Canada

The second important part of a job announcement is the list of courses or areas that will be taught. It must be assumed these areas have been defined because of need within the program. Occasionally a position will be announced that covers the entire breadth of the program. In this situation the program is looking for the best qualified individual that can fill one or more of the listed areas. However, when the position lists only one specialty, this will be critical in the screening process. If, for example, a course in studio lighting is to be taught, then your background, letter of introduction, and portfolio will need to demonstrate and elaborate on your ability to teach in this area. Particularly with the portfolio it will be difficult to gloss over deficiencies.

273

"Education is not a form of entertainment, but a means of empowering people to take control of their lives."

Anonymous

Within the ad is a very important piece of information...the name and location of the school. While this may seem self-evident, this is the starting point of a successful job search. One of the assessment points that will need to be made within the application process is the fit between you and the institution. Though a school and/or program may be well known by name, it is still important to research the school and photographic program to assess the fit between your skills and abilities and the goals/needs of the institution. There is more to an institution than just its photographic program, and many other factors may be involved in a successful job match-up. Remember that institutions will be researching you, and you will need to do as much research involving the institutions as you expect from them.

"The most important thing about getting a job is making sure it is the right 'fit.' It is not about a paycheck; it is about a community of people. You need to have a shared vision."

Cara Cole
University of Redlands, CA

The last part of the advertisement that may be important is the wording used. Occasionally within the ad there will be specific language that you want to pay attention to. This wording may be key in writing the letter of application as well as in alerting you to specific academic, economic, or other unique situations at the institution.

Vita and Résumé

For all applications, it should be assumed that you will be required to present a résumé or a vita. Though similar, these are not the same things. The vita, a type of document more common within educational realms, derives its name from the Latin term *curriculum vitae* (CV), meaning "course of life." The vita is a complete, chronological listing of your education, experiences, and skills. The vita tends to be a longer document, compared to a résumé. It may or may not include annotations for each entry. The short version of the vita, the résumé, normally includes a description of objectives or the rationale for looking for a type of position. A résumé (derived from the French, meaning "summary") seldom exceeds two pages, while a vita has no limits: it is as long as it needs to be to list all of the relevant career details.

In creating a vita there are several basic parts that should be included. The first of these is the basic contact information. This would include your name, address, e-mail, Web page, if you have one, and other information that might be required to reach you. It need not include Social Security numbers, information that is illegal to request, such as age or marital status, or other information not requested by the prospective employer.

Particularly for academic positions, your educational background should be listed first. Institutions, degrees, dates of attendance, and major/minor should be listed in chronological order. Since academic preparation is important in the field of teaching, the ordering of educational experiences is appropriate, with the highest degree listed first. Being accurate is, of course, necessary, because for all academic

274

situations, transcripts from listed institutions will be required; there are many examples of individuals losing employment or a chance of employment because of false entries on their vita. The vita for individuals in photographic/imaging education often includes an educational portion covering educational experiences outside degree-conferring institutions. These educational experiences and workshops should be listed separately from formal degree programs.

"Résumé: a written exaggeration of only the good things a person has done in the past, as well as a wish list of the qualities a person would like to have."

Bo Bennett

Since the position you are applying for puts a premium on academic accomplishments, so should your vita. Beyond a listing of your educational history, the vita needs to list accomplishments that are academic but that go further than just studies and degrees. These include publications, exhibitions, collected works, presentations, workshops, lectures, and research. Exhibitions and collections of work are very important. Exhibitions should be separated into groupings of the type of showing, such as group exhibitions, solo exhibitions, etc. A caveat to putting together this portion of the vita is to remember that those reading it most likely know the difference between an exhibition at a university gallery and "a permanent installation at your mother's apartment."

In an academic vita, following the list of educational experience will come the listing of work experience. This listing should include the names of your former employers, your job titles, and dates of employment. If there is teaching experience, this should lead in the list of jobs. Academic positions should include the courses taught, research undertaken, and other job responsibilities in each position. Following the list of academic positions should be a chronology of other jobs. All significant experience should be listed, including volunteer, campus, and community positions. For a first teaching position, in lieu of experience, it may be necessary to highlight your skills and areas of training.

Honors, activities, certifications, and licenses for specialized skills may add significantly to the vita. Once again, the importance of each of these determines where and how each will be displayed within the vita. An honor may involve an academic event such as a scholarship. In this case you must choose where in the vita it is most appropriate to list it. It may be better to indicate in the educational portion of the

275

vita that a scholarship has been achieved. An activity such as a visiting scholar position, while an honor, might be more appropriately listed with academic experiences.

"Whatever I did and do always became the extension of my interests. The inter-relationship of all senses and arts is very important to me. I wanted to connect photography with words through books and articles, with music through audio-visuals; in exhibitions, single pictures have to speak their pure language. I want to be open to everything in this world, and I am ever willing to unlearn."

Ernst Haas

Last, consider including a full listing of interests and references in the vita. Whether to include these is very individualized. Some people wish to present references or interests because they believe that these will either impress the reader or give a fuller view of their abilities; others prefer to wait for the next stage of the application process to present more personal information and to provide references.

While shorter in form, the résumé has the same basic parts as a vita. In addition, it may also include an objective statement. This narrative in the résumé can correlate the reason for applying for a specific job to the cover letter accompanying the application. The résumé should be short, no more than two pages.

In both vita and résumé, there will be opportunity to include only sparse amounts of writing examples, but no matter how limited, the writing must be consistent and correct. Misspellings or mistakes in the names of institutions can have a negative effect on the application process. Your ability to communicate effectively will be first seen in your vita or résumé.

Portfolio

"The screen for the selection process is portfolio driven. If the portfolio is not up to standards then that is the big issue right off the bat."

Steve Bliss
Savannah College of Art and Design, GA

In all the interviews done for this book, when people were asked what was the first thing that was used in the screening processes

they had experienced, their answers came back, "the portfolio." Photographic programs look to see what kind of work you can do and how your abilities, as expressed in your photography, will fit their educational plan. It is not simply an issue of a type or genre of photographic art...it is an issue of high quality and consistency in the production of photographic art.

In today's world there is the opportunity to present a portfolio as physical prints, as slides, or on CDs. Within the job announcement there is usually an indication of the way a portfolio should be presented. The choice that the institution makes is based on how they perceive the screening process will be handled. While you may have an inclination to send your materials in one form or another, it is best to make sure that your choice will work within the screening potential for the institution.

"Our students want us to be photographers; they need us to be teachers. If you are not a photographer you do not belong in the classroom teaching photography. If you do not love making images, how are you going to instill into others the passion for making images? But at the same time we have to always remember that we are teachers—you have to be more than just a photographer who also teaches to pay the bills."

Ike Lea
Lansing Community College

277

Regardless of the method used to present the portfolio, a professional approach should be used in creating the materials. For example, for a portfolio presented on slides or CDs, printed labels look more professional than do Sharpie® markings on the paper slide mounts or the CD face. After all, the application for the position is in the visual arts. Those screening the materials are also photographers and they are used to seeing the high-quality work of their students and their colleagues. If the work submitted in the portfolio does not have a professional quality about it, it likely will not get a favorable viewing.

"There is a proper dignity and proportion to be observed in the performance of every act of life."

Marcus Antoninus

References

For many positions, your history as defined by the references supporting your application will influence the application process. Since the photographic education community, particularly in higher education, is somewhat tight knit, there is a great amount of shared knowledge about the education and the quality of individuals coming from specific programs and academic groups.

References alone do not assure a position. What references can do is provide a more receptive reading of the application. With this in mind, two issues arise with the letter of reference. The first concerns the identity of the writer: it cannot be underestimated how much effect a reference from a well-known person can have on creating a positive view of an application. The second point concerns how the letter expands on the vita or résumé and identifies personal attributes of the applicant. Ideally, a letter of reference will be supportive of other components of the application.

Unless otherwise indicated, it is best to have the references send their letters directly to the institution and have them write directly to the position. A general letter "to whom it may concern" will have no value other than serving as a check-off item that a reference has been included with the application. It should be assumed that the reference writers will be contacted if the application proceeds to a higher level of screening. Therefore, it is recommended that each reference for a position is aware of the application that has been made and the details of the position. It is also possible that inquiries will be made around the normal application process. This informal referencing is more common than human resource personnel will admit. Since these inquiries are hidden from view until after the fact, there is little that can be done to control their effect.

Regardless of the strength of your background, experiences, and references, the presentation of all materials, not just the artwork, needs to be highly professional. The application process and the presentation establish the initial perception of the professional level of each candidate for the position. This means that every part of the application package needs to be polished, including all correspondence. As mentioned previously, the quality of the writing is critical because communications skills will be part of the position, and the first chance to evaluate these skills will be provided by the writing in the application materials.

"To get the job, the work has to be there, the person has to be there, the presentation professional, their correspondence timely...We need to know, 'is this person a reliable professional person?'"

Barry Anderson
Northern Kentucky University, KY

Positive Language

In any and all interactions with the prospective employer, be positive. Whether in a letter of application, in a vita, or later in an interview, take care to use positive verbiage. In your communications, verbal or written, choose words such as "achievement" or "experience," because they show the positive nature of the application. While trying to include positive words, it is equally or more important to avoid negative comments such as "mistake" or "never." While honesty will be important, the positive versus negative tone of communication is important in moving through the screening.

279

Screening

If there is an unspoken truth about getting a photographic teaching job it is that there are not as many positions as there will be applicants. This makes the selection process a "shopper's market." It is not unheard of to have hundreds of applications for a single position. This means that there will be a winnowing process taking place to get through the many applications for any given position. Depending on institutional requirements, an institutional-specific screening process will follow. In some situations the human relations department will do preliminary work on the files to assure that the search pool meets legislated and institutional guidelines.

"Nothing in the world can take the place of persistence. Talent will not; nothing is more common than unsuccessful men with talent. Genius will not; unrewarded genius is almost a proverb. Education will not; the world is full of educated derelicts. Persistence and determination alone are omnipotent. The slogan, 'Press on,' will solve the problems of the human race."

Calvin Coolidge

Whether HR is involved or not, the screening normally must reduce the number of applicants to a manageable group. The screening can either try to exclude or to include files. An exclusionary screening method is more likely with large pools of applicants. This can be as simple as excluding any application that does not list a required degree or certification or is lacking references. While seeming to be unfair to otherwise well-qualified candidates, this is a common method to reduce the size of the applicant pool. At the level of the program, screening may be inclusionary; the applications will be viewed as to which files represent applicants who meet program needs, centering on finding specific qualifications or areas of expertise.

Accepted applications form a short-list for further scrutiny. The short-list normally will be further reduced to include only those who will be contacted and/or interviewed. This is the point at which references will likely be called. Since getting a teaching position is the fit between the institution and the prospective faculty, this is the critical stage for everyone involved. For many involved in screening, the process is not about finding the perfect individual, but, based on the willingness of the institution undertake risk, it is to assure that the "wrong person" is not hired.

Interviewing

Be prepared, be professional, be relaxed, and be yourself.

Roughly, there are four types of interviews: a formal interview, where you are invited to the institution; a gang interview, which can occur in a situation such as CAA (College Art Association) gatherings; a telephone interview; or an interview that happens because you take it upon yourself to go to the institution without invitation. All one-on-one contact events provide opportunities to use your personality to influence the outcome of a job search, and all are double-edged swords that can give you some advantage or degrade your chances. Regardless of how you arrive at an interview, remember that there is only one opportunity to make a first impression. The interview is the first moment that you start interacting with someone from the institution.

"If there is any one secret to success, it lies in the ability to get the other person's point of view and see things from that person's angle as well as from your own."

Henry Ford

Looking at the four points that started this section, let us look at some "horror stories" from the annals of interviews to serve as examples that show the downside of certain "approaches."

Our first example is a reminder of the importance of professional restraint. An individual was relocating to the general area of a well-known photographic program. She had never previously visited the program, and decided to drop in to look around. Knowing that the program had a fairly large number of faculty members, she was sure that there would be a place for her, and that there was an opportunity coming up that she might qualify for. However, during the spontaneous visit, she chose to tell the individual that she met on campus what was "wrong" with the program, because it was not concentrating in her area of interest. This might be called "screening yourself out."

In our next example, the importance of preparedness and professionalism is obvious. During a formal interview the candidate was asked to prepare and give a guest lecture on any contemporary photographer or topic germane to the History of Photography class. Even knowing about the lecture and having chosen his topic three weeks in advance, the candidate came to the lecture without visuals and put some of the students to sleep. Beyond this, because he was "papering" institutions with his résumé and a general letter of application, he sent the interviewing administrator the same letter for a different position two months later.

Two other examples might suggest that "being yourself" is conditional advice: As part of a formal interview, the chair of the interview committee took the candidate to a reception. At the reception the candidate picked up a date and left the reception and the interviewing committee chair without notice. Another interviewee gave an excuse for her tardiness that she was not good in the morning...the interview time was at 9:00 a.m.

"Never wear a backward baseball cap to an interview unless applying for the job of umpire."

Dan Zevin

Sometimes, no matter how prepared, relaxed, or professional you are, an interview can be nightmarish: Two candidates, after a CAA gang interview session, were overheard as they packed their portfolios. The first said, "Knowing my abilities, education and record, I will accept a position as a graduate professor in the upper Central Atlantic area." Understanding exactly what they were actually doing at this

session, the second said, "Knowing what I was just through, I'll accept any position anywhere."

Finally, even a positive interview can "go south": the finalist for a position was told what the condition of employment was and what the maximum budgeted salary was during the interview. After being offered the position at the maximums, he demanded a third more salary and conditions that would violate the contract.

As we leave the discussion of applying for and getting a position, let us make two points to think about. First, don't "enjoy" the job before the position is officially offered. The interview may have gone well, but that is not a letter of offer. Then, look at being hired as the first step in being retained. The profession is a journey and getting hired is only part of the experience.

> *"What is your motivation to become a teacher? Good teachers have to be really passionate about teaching, about wanting to empower students to succeed."*
>
> Scott DeBoer
> Career Education Corporation

282

In getting a job, realize that the role you have been hired for, unless requested, will not be to change everything.

Promotion, Tenure, and Retention

> *"Memo to the Faculty:*
> *Subject: Faculty Responsibilities*
> *The primary responsibility of a faculty member is to teach well. This involves*
>
> 1) *clearly defined and understood objectives,*
> 2) *well thought-out implementation of the objectives, i.e., a well-planned course,*
> 3) *clearly defined assignments and projects,*
> 4) *logically planned reviews and tests,*
> 5) *counseling of students,*
> 6) *a grading system that is fair, and equitably applied, and understood by students; i.e., the student should know what is expected of him."*
>
> C.B. Neblette
> Rochester Institute of Technology, NY

Once you have committed to a professional position, you have two jobs. The first—teaching—is easier to see. The second job is to do the work that goes into remaining in the position. What will be required to be successful in the second job depends a great deal on the type of institution. For the purpose of this book, let us divide the educational spectrum into four basic institutional types. These are "teaching-only" institutions, professional teaching institutions, fine art institutions, and research institutions.

Public education and some entry-level higher education programs make up the bulk of what is referred to as "teaching-only" institutions. In these institutions your value is determined primarily by your classroom activities and successes. In a professional teaching situation, such as a polytechnic or professional school, your value expands to include professional aplomb. Fine art institutions put added weight on production of your art form and continued production and exhibition. At research institutions, the activities that help advance and retain faculty are considered scholarly. Scholarly activities in a research institution include, but are not limited to, basic/applied research, publishing, lectures/workshops, and exhibitions/collections.

283

"In a four-year college where teaching takes precedence, the flip side of 'Publish or Perish' would be 'Teach or Terminate.' The quality of teaching would be paramount for advancement."

Keith Tripi
The State University of New York, University of Buffalo, NY

In all cases, performance in the classroom and in support of education issues is involved in evaluations (as was discussed in Chapter 9). If teaching is weak, ancillary issues will likely be evaluated where they might not have been important in situations of strong teaching. If performance concerning these other issues shows weakness, retention becomes more difficult.

Support of education activities includes advising and efforts in departmental and institutional committees. In most institutions participation in curricular development and course maintenance is expected. Other non-teaching activities are often considered part of the teacher's role. These might include maintaining laboratories and recruiting, to name just two. These activities may be included in a job description or they may be informal expectations. The unwritten expectations are often used as "reasons" for non-retention. Too often, administration staff,

who are principally involved in this part of evaluation for retention, categorize and track these types of activities and see them as important parts of the job.

> *"We see the body of work: real people skills, ability to communicate, a teaching record, a commitment to teaching and keeping up their own work. Teaching is not for everybody. It is not enough if a person is a good photographer...if they don't understand the teaching responsibility and fun of teaching....If they come in to cash the paycheck and move on to do some freelance or artwork on the side with free time....If a faculty member does not understand that they are changing careers."*
>
> Howard Simpkins
> Shariden Institute of Technology and Advanced Learning, Canada

One of the benefits of teaching and at the same time one of its demands is to remain up-to-date technically and aesthetically. This means that professional development and further learning will be part of being a professional. Depending on the area of teaching, there will be a balance between these two areas. However, neither can be eliminated. Particularly for the newer educator in today's imaging world there is a demand to stay current with changes in the field. While it might not be possible to be the master of all the changes, those changes that impact courses under your purview need to be attended to.

The rapid change of technology means that it is unlikely that most educators will be involved in the development of emerging technologies, but some individuals may be involved in basic or applied research. Nonetheless, you will need to stay abreast of changes in imaging. Within research institutions your contribution may be to the discourse on issues and/or conceptual structures of new directions. For most in education the challenge will be to stay up with changes so that curricula can stay current.

> *"Time and resources must be available for ongoing professional development, and meaningful annual evaluation systems must recognize and reward faculty who do keep current in their field. Internal annual teaching awards are one way institutions reward and make public their exemplary faculty members."*
>
> Nancy M. Stuart
> The Cleveland Institute of Art, OH

By Yannick le Jacq, Princeton Day School, NY, student of Elaine Hohmath-Lemonick

In most institutions there is a formal structure for promotion, tenure, and retention (PTR). This may be in the form of a committee structure used to make recommendations or as a portfolio requirement to be submitted at an appropriate time. The higher the prestige and tighter the budget, the more strenuous the screening will be for PTR. Though retention is the most straightforward, in today's educational systems, tenure is being seen as complicating long-term planning for many institutions. Tenure, where applied as a career-long appointment, ties the institution's hands in terms of budget and development. Where rank affects salary, promotion becomes both a status and a financial issue. If the institution has a requirement for preparation for PTR, this should be kept in mind once you have established your role as teacher.

"Don't be afraid to give your best to what seemingly are small jobs. Every time you conquer one it makes you much stronger. If you do the little jobs well, the big ones will tend to take care of themselves."

Dale Carnegie

286

For many PTR screenings, you go through a more rigorous process than you did during the job search. Other than for retention in the early stages of employment, the work to support PTR screening covers a specific time, and those making the evaluative decisions have usually had the opportunity to work with you for some time. While this would suggest that they know what you have done to advance, it is not wise to assume this is the case. From day one it is good to keep files of accomplishments and scholarly output. For most situations, a list of criteria will be provided to you when it is time for PTR screening, but this list is normally also published in faculty handbooks or can be requested. The most common criteria beyond teaching are scholarly activity, service to the profession, service to the institution, and service to the community.

"The biggest mistake you can make is to believe that you are working for someone else. Job security is gone. The driving force of a career must come from the individual. Remember: Jobs are owned by the company, you own your career."

Earl Nightingale

One of the various areas of the PTR process is scholarly activity. This is considered a standard part of performance in research institutions.

However, even in non-research institutions this has weight. In public education and in colleges, professional, and teaching institutions, scholarly activities will carry weight toward professional development. Although it seems to push the limits of what is considered fundamental to the ideas of teaching, the concept of "publish or perish" has its benefit in all areas of education. Good ideas about the field are not the sole domain of the research institutions.

Publish or Perish

Publishing is seen as the big item for most PTR processes because published materials document scholarly activities external to the institution. This provides outside validation of an institution's scholarly activities. In today's environment more than just the printed word qualifies as "publishing." Various forms of media can be published, including Web-based material, CDs, and broadcast productions. Within fine art institutions and some research institutions, exhibitions are accorded the same status as writing for publication. Publishing codifies education and/or expands discourse in the field. Since communication is important in education, writing and producing take on added importance. In some areas of education, such as history of imaging or aesthetics, publishing can be seen as a requirement.

287

Within publishing there are several classifications that might be helpful. At the top of this list is authoring books. Depending on the institution, the type of book may be important. Workbooks and application manuals will likely be viewed differently from textbooks and scholarly discussions. Within professional education, industrial titles may be seen as appropriate while not being seen as favorably in a fine art institution. Further, self-published volumes may not receive as much credence as is given books published by an established press. Because of the selection processes and name recognition, within research institutions, often books published by university presses carry extra weight. For most publishers there is an acceptance process that has reviewers and acquisition committee pass judgment on the viability of the project.

"To write what is worth publishing, to find honest people to publish it, and to get sensible people to read it, are the three great difficulties of being an author."

Charles Caleb Colton

While many in education invest extensive time and effort in writing a thesis or dissertation, the format of these writings may not be acceptable for book publication. Their format is usually designed to serve as an educational document, for an educational purpose. However, part of a thesis or dissertation—the ideas expounded—may become the basis for book-length work.

Art books are particularly suited to photographic endeavors. Here the issue is finding a way to get the book published. Though some publishers will put forward the funding for "coffee table" books or publications of bodies of the works of photographers, this type of publishing project may well need to be funded from personal or grant sources. The cost of a self-published book can be considerable. For this reason, many publishers use their resources to publish the work of established artists.

Periodicals are another publishing avenue for the academic. Here there are several types of magazines and journals looking for contributions. Many periodicals call for submissions either for ongoing topics or for special issues. This may be for images as well as written pieces. However, it should be noted that within the academic profession of photography, more individuals make pictures than write. Thus there is an advantage for the photographic educator who uses the written word as well as images.

The most rigorous and therefore most difficult of formats to be published in are the juried periodicals. In these periodicals a panel of readers familiar with the focus of the periodical review the submitted manuscripts and choose those that will be published. For many PTR processes, published works must also be peer reviewed, subjecting entries in the portfolio to consideration in this type of critical process.

"Publishing a volume of verse is like dropping a rose petal down the Grand Canyon and waiting for an echo."

Don Marquis

There are also periodicals that use the internal staff to choose articles for publication. Depending on the institutional type and/or the evaluation to be made, publication in these magazines can add substantially to the portfolio. Often these periodicals will return to successful writers and request added topics after successful publication.

In today's publishing world there is also the World Wide Web. At the time of this writing the use of publications on the Web is still being

defined for PTR. Particularly for professional institutions and curricula that are heavily oriented toward applied imaging, work produced and published for clients will often be seen as appropriate for PTR consideration, regardless of the method of publication.

Exhibitions are very important in most PTR situations. An ever-increasing number of institutions consider exhibition and acquisition into museum collections on par with publication. Once again, the quality of the venue and method for selection or invitation may be considered.

As mentioned previously, publication is demonstration and documentation of other scholarly output, primarily creative output and research. Funded research or commissioned artwork tends to have very positive impacts on PTR. Once again, writing is involved, but in this case in grant preparation. Gaining grants brings prestige to the institution, not to mention the indirect benefits shared by the institution, and thus the positive result falls on the scholar. In a similar way the institution celebrates and shares in all honors, fellowships, etc. that the scholar can attain.

289

Being Professional

"It is important to be working, because if you do the work yourself and...the students are struggling, you may have struggled with the same thing, be it technically or conceptually, and you will have empathy with the students and be able to help them more."

John Martin
Salisbury College, United Kingdom

As a photographic educator you are likely a member of two professions, photography and education. As such, there are multiple activities that support these two professions. Within education there are several national and international organizations that are involved with issues of the profession, depending on the level (primary, secondary, higher education). Within photographic education there are a few national/international professional organizations. Within the fields of photography and the photographic industry there are many avenues to professional involvement. These include groups that are in service to large portions of the photographic community and niche groups.

"No man ever reached to excellence in any one art or profession with-out having passed through the slow and painful process of study and preparation."

Horace

Being associated with professional organizations is helpful in PTR, and being active in these organizations is even more important. Activity can be expressed by being involved in the leadership and functions of the professional organization and attending functions of the groups. Being an active participant often serves a dual purpose—benefit to the organization and your professional development.

Further activities, particularly making presentations at conferences and workshops, can also serve multiple purposes. Many conferences publish a "proceedings," and any papers presented at the conference may well become a part of a published document, assisting in building publishing credits in your portfolio. If a paper is written out but not directly read at the conference, it can still serve as a document that can be later submitted to periodicals.

Beyond the professional development that professional organizations can provide, the networking can also be influential in PTR and your career. As part of many PTR reviews, external comment will be requested and the contacts and professional relationships will also come into play as your career progresses. Your network provides a wealth of potentials for all the activities that you will want to pursue in building your career. From these networks can develop invitations for exhibitions, lectures, workshops, and articles.

"Certain important topics were not touched on—what teachers ought to know and don't; what students ought to learn and won't; why artists try to instruct all other artists and shouldn't; and why none of us, in search of better, ever leaves well enough alone."

Henry Holms Smith
Indiana University, IN

Service to the Academy

The various parts of the career that are not teaching are often part of the job description but are overlooked by teachers. Various involvements with the institution are expected, and it is difficult if not impossible to build this area up once a path away from it in

the institution is chosen. Most of us dislike committee assignments, responsibilities that do not seem part of our "teaching load," or taking time away from our art to have office hours that only a few students will utilize. However, these activities serve as criteria by which the institution can view you as an interested professional.

Of the internal activities that tend to be viewed most positively are committee work, grantsmanship, recruiting assistance, and public relations. Regardless of the committee assignment, individuals who can have an impact on your PTR will witness your efforts in the committee structure. Of course, some committees are "better" than others (for example, curriculum or campus-wide planning committees), but all committees are important to the institution and thus to the professionalism of the faculty. Advising students is normally required...recruiting is not, but being available to assist the admissions department can be beneficial because it can keep enrollment at positive levels.

Grant writing benefits the institution not only by bringing funds to the institution, helping the program by funding projects, but also by providing prestige and related indirect benefits to the institution. Last, external public relations are very important. The way the institution and the faculty are working needs to be told—not by fabricating, but by ensuring that the positive efforts within the institution are public knowledge.

291

"Instead of rewarding the hard-working single-year contracted instructors who have struggled and still have strong school spirit, the university is requiring many to reapply for the job they are doing. Who cares about great evaluations? Who cares about a sense of community? This sort of thought process makes it hard for instructors to continue with the upbeat tempo needed to keep a high caliber academic culture."

Trudy Baker-Tate
Central Missouri State University, MO

Service to the Community

The last area that is often considered in PTR decisions is the nature of the interaction between the faculty member and the community that hosts the institution. Most commonly, this can be judged by considering local volunteer activities and involvement with local civic organizations.

"The education and empowerment of women throughout the world cannot fail to result in a more caring, tolerant, just and peaceful life for all."

Aung San Suu Kyi

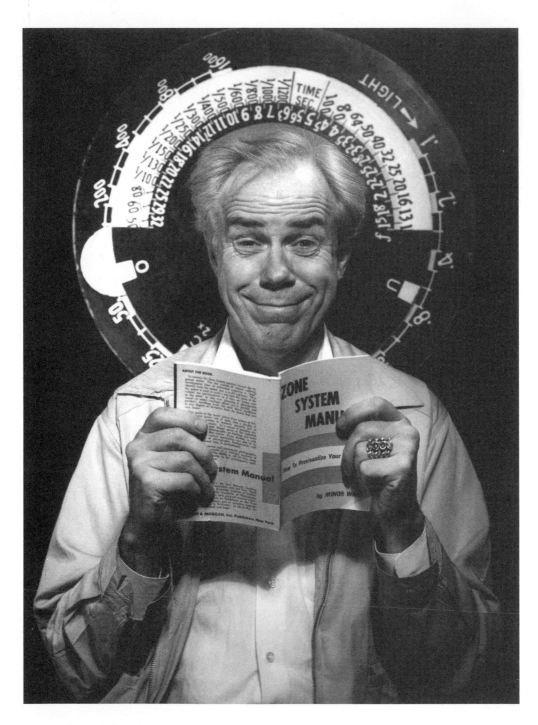

Minor White Teaching the Zone System; 1962, by David Spindel, Rochester Institute of Technology, NY, student of Richard Zakia

Teachers on Teaching

"As a teacher I am committed to providing an atmosphere in which people might be able to learn and experience by means of photography the whole spectrum of visual experience embodied in the two phrases, 'things for what they are' and 'things for what else they are.'"
Minor White

While we have written about our approach, experiences, concepts, and concerns about teaching photography and imaging, we are using this chapter to share the insights and beliefs of many colleagues. The following contributions by these colleagues show some of the diversity of thought and concern in today's photographic education.

Roy R. Behrens

University of Northern Iowa, IA

For 35 years, I have taught at American art schools and universities. Much of what I teach, I may have obtained inadvertently through photography.

I recall that I learned some of this in the 1960s as an undergraduate art student, partly because one of my finest professors was an articulate photographer, who, whenever he was asked to teach a design course, used photographic examples in his lectures instead of paintings, prints, and sculpture, the so-called "fine arts."

It took courage to teach photography then. It was not a welcome subject in American art departments, because almost everyone assumed

that making images with a camera was not genuine Art. It was seen largely as "commercial," and at best it was a mechanical feat, produced by causing light to make certain patterns on chemically treated surfaces. It was not a "self-expressive" art, since any person off the street, with or without any training, could make a photograph.

Now, some 40 years later I increasingly realize that I teach in ways that emphasize photography, both historic and contemporary. Like my former professor, when I talk to students, I tend to use photographic examples. When I invent new studio problems, I prefer to add provisions that require students to originate their own imagery, primarily through photography.

I have a vivid memory of the first time I assigned such a problem: It was the spring of 1968, and I was a 21-year-old college senior—not a teacher but a "student teacher"—in charge of a class of high school art students. A year or two before, the professor I mentioned earlier had urged me and my classmates to look closely at the books of Gyorgy Kepes, especially *Language of Vision* and *The New Landscape in Science and Art*.

The latter was to great extent an archive of scientific images, produced by such non-art techniques as aerial photography, high-powered microscopes, stroboscopic photography, x-ray, time lapse, infrared, and so on. The resulting images were "objective records" of reality, and yet they were no less exotic, and no more identifiable, than were the abstract paintings that Kepes purposely paired them against on the facing pages of each spread.

One day I asked my students to bring to class a simple snapshot camera. I then sent everyone outdoors for an entire class period, with instructions to make photographs of settings on the school playground in such a way that the objects in the photographs would be unrecognizable (because of framing, point of view, the patterns of shadows, and so on). I remember how astonished the students and I were by the eerie, new, and provocative forms that resulted..."making the familiar strange."

Over the years, as technology has evolved, so have my classroom uses of photography. Today's students are likely to use digital cameras or flatbed scanners as if they were cameras, thereby producing breathtaking details by the direct scanning of real objects.

In teaching, I show my students how their work can have a stronger and far more enduring effect if they can anticipate how people see, in the sense of just generally being aware of perceptual biases that are not culture-laden, but hard-wired in the brain.

My own acquaintance with these "principles of visual organization" also took place while I was an undergraduate. I eventually determined that the effectiveness of camouflage is directly contingent on the same organizing principles that designers use in typesetting, in page layout, or in selecting, cropping, and placing an accompanying image. As everyone knows, sleight-of-hand magicians and pickpockets make constant and highly reliable use of these same tendencies, on a level that is not determined by cultural conditioning or by self-expressive drives.

I sometimes give out problems that deal explicitly with camouflage. But the same principles can just as easily be addressed by requiring students to produce what used to be commonly called "trick photography," in which, typically, two physically separate entities are made to look connected in the photograph, or a normally continuous form appears to be two things instead. These same tendencies can also be taught by exercises in "metaphorical seeing," in which one creates visual puns, surreal juxtapositions, and other varieties of visual ambiguity.

In publication design, it is often said that the major twin components are text and illustration, or type and image. By using photography when I teach, I am able to address both of these at once, since students not only become familiar with organizing principles, they also gain experience in the creation and inclusion of photographic images, in tandem with typography, within the context of a page.

Finally, and of particular value, I think, they also come to understand that typography (the choice and arrangement of type on a page) is governed by the same organizing principles (the unit-forming factors of similarity, proximity, continuity, and closure) that are the major syntactical tools in the design of photographs.

Corinne Rose

Museum of Contemporary Photography, IL

On Teaching Photography
As a college art museum, the Museum of Contemporary Photography, Columbia College Chicago's primary goal is education. On a daily basis we use our changing exhibitions and print study room, which houses a collection of close to 7,000 original photographs as a teaching resource to initiate dialogue on a variety of aesthetic, social, political, and cultural issues with students of all ages.

295

By Jaren Hillard, Providence St. Mel School, IL, student of Joel Wanek and Aoko Hope

The intensive teaching that we do at the museum is with teens. We run three after-school outreach programs that engage urban teens in using photography as a means to examine and explore their lives and communities. Taught by graduate students and adjunct faculty from Columbia College paired with classroom teachers, participating students gain a solid foundation in the fundamentals of analog and digital photography through assignments such as exploring vantage point, observing light and shadow, and using and controlling motion and depth of field. While learning these technical skills, students photograph a variety of subjects, including their families and friends and the urban landscape of Chicago, and are mentored by their teaching team, museum staff, and visiting artists. For inspiration, students periodically visit the museum to view and discuss master works from the museum's collection. Graduates of our programs have gone on to receive scholarships and study photography at institutions, including the Art Institute of Chicago, Pratt Institute, the London College of Art and Design, and Columbia College Chicago.

Two years ago, the museum held an exhibition titled *Conversations: Text and Image* that featured artists who combine words and pictures in the creation of their work, including Jim Goldberg, Lorna Simpson, and Walker Evans, among others. In conjunction with this exhibition, we sent writers drawn from the college's Fiction Writing Department to work with our teens to create writings to pair with the images they were creating in class. The classroom teachers were thrilled to see photography's power to inspire even the most reluctant writers—many of the students we serve write below grade level and are intimidated by writing. We were surprised and moved by the intensity of stories that the students were willing to share and by how much their writings added to the depth of their final compositions. This project was such a success that we continue to include creating works combining text and image in our photography curriculum and have partnered with other organizations, including Columbia College's Center for Community Arts Partnerships, Project AIM, to bring this curriculum to a wider group of students. For the past two years the museum has exhibited these works in a now annual exhibition titled *Talkin' Back: Chicago Youth Respond.*

The image accompanying this writing was created by Jaren Hillard in a program led by teaching artists Joel Wanek and Aoko Hope at Providence St. Mel School on Chicago's Southwest side. Wanek says, "Jaren was really interested in photographing architecture and the

297

landscape. This image of his niece and nephew playing is one of the few 'people pictures' that Jaren made in our class—it wasn't an image that he was particularly excited about. I don't think he realized the tension and ambiguity inherent in this photograph."

Wanek and Hope encouraged Jaren to expand upon this image in a workshop with visiting writer Jennifer Morea. Morea says, "I asked the students to 'interview' the character in their photograph and write down responses to questions I posed as if it were the response of the person in the photograph. I began by asking students to find something subtle, or what seemed maybe to be a minor thing, that was most interesting to them about their photograph. I asked them 'what do you think the person in the photograph is saying or is trying to say just by how he or she looked in the image?' In the voice of their subjects, students wrote notes in response to questions such as *Who and what do you feel connected to? What is the most difficult thing in life for you? What is something kind someone once did for you that you'll never forget?* and *Where are you going, where have you been?*"

Jaren's final piece demonstrates the eloquent force of the voice and vision of our youth, realized when they are empowered to express themselves creatively.

John Fergus-Jean

Columbus College of Art and Design, OH

Image and Afterimage

One of the most important aspects of teaching photography is its capacity to tell a "story." In my teaching I focus on two aspects of story within student photographic images, the image proper, the tangible photograph, its form, content, and syntax, and what I call the *afterimage*, the intangible meanings within the photographic process that reveal the student's own personal story.

At the core of my teaching is connecting the personal narrative of both the maker and the observer to any photograph. This renegotiation of meaning results from creative and essential fictions, the tangible, the intangible, memory, and the linking of images to self. This applied search for meaning, the process I call *afterimage*, is the uncovering of fuller dimensions of meaning through extended internal and external dialogue, and by sharing one's own story.

Viewed in this light, it can be said that students bring their own personal meanings to the images they make. Indeed, it is the sharing and retelling of such story that encourages a renegotiation of image content, which can lead to growth and change. It is precisely because we bring our stories to images, that personal narrative is as important in the pursuit of art as any learned technique.

Afterimage is thus an ongoing process, the creation of stories we make up time after time, for the task of finding our current meanings in image. Thus, in *afterimage* is the transformative potential of image to elicit change and growth. The authenticity of such story flows from the makers' ability to imagine and reimagine their own lives in their own terms. This is the vital link that connects the image and the territory of lived experience.

In contrast, in many academic circles highly evolved and convincingly articulated *art speak* narratives often lead to mystifying dialectics that have come to shape the art school experience. In essence, such processes involve displacement, the displacement of one's own personal story into meta-stories that seem to just be there. I believe what students get from this approach is an affirmation of self-validation that their story is also their reservoir, their vital inner keel for navigating through the world.

299

By honoring personal story, the student image-makers become the nexus of image and afterimage, the extended function that posits image-makers as storytellers, who express setting, time and place, point of view, persona, the events of the story, and the story's worth to the *now* of their lives.

Metaphorically speaking, remembrance involves a familiar photographic pattern that has a less familiar inner correlation: exposure, development, and fixing.

> *Exposure* – taking, making, showing of images, wherein each phase of exposure creates new opportunities to revisit and reencounter image content. Each aspect allows the discovery of content.
> *Development* – the extended mental processes that guide one's relationship to image, the aspect of coming to understand; and the honoring of dialogue as a way to give additional form to content.
> *Fixing* – the remembering, reimagining, and transforming of relationship through insight, comprehension, and growth. Simply put, the affirmative and healing power of retelling and creating story.

Remembrance leads to critical thinking and requires students to describe, analyze, interpret, and judge their created works within the context of their own meanings and the outer language used to express those meanings. Ultimately these meanings converge with ideas at the core of the humanities, and by extension they lead to the ways media observe and represent the world.

Thus in essence, my approach to teaching involves the means for personal growth, by transcending technical and analytic considerations, to find semantic depth through personal voice. As a teacher, I feel to engage such a fuller sense of connection is a healing function based on the power of honoring the student's personal voice by allowing them to proclaim, "This is what I think, see, and feel."

Misun Hong

Sookmyung Women's University, Korea

An old Korean saying states, "Don't even step on a master's shadow." In the Korean tradition, teachers are viewed as icons, both morally and spiritually, and thus are treated with utmost deference. Everyone, including students and their parents alike, maintains absolute respect for a teacher. Although these days the position of teachers has changed somewhat, they continue to be esteemed in Korean society. Reflecting on my experiences with the teachers and students I have met, I can summarize the most important points to observe in the classroom as the relationship between the teacher and students, the conveyance of praise and encouragement, and the exploration of students' talent.

The most important point in the classroom is the maintenance of good communication and response between the teacher and students. Teaching in a classroom is like performing on a stage. A well-prepared lecture elicits a good response. If the lecture is not adequately prepared, the result is a regretful performance. Yet even when presenting the same lecture, the outcome can vary depending on the response of students. In order to maintain good communication and response in the classroom, the relationship between teacher and students should be horizontal. This relationship is particularly important in an art class, which requires imagination and creativity. For this reason, any and all questions and ideas should be discussed in class. Teachers should help students to solve problems and to follow their thoughts through feedback in class.

The next important aspect of the teacher–student relationship is praise. I am deeply indebted to the teachers who recognized my talent and praised it, and as a result of their support I pursued my study of photography without giving up in the middle. Praise from teachers gives students confidence in the subject and encourages them to study more in that field. It is natural for a teacher to praise good students, but a true educator is the teacher who stimulates interest among students who, for whatever reason, are less responsive to the subject. In this regard, assignments, tests, and critiques are vitally important. Various methods should be explored in order to search for students' hidden potential. Critiques and grades should be given with sincerity. An inappropriate critique can lead students to think that they have no talent, and have the unfortunate result of their losing interest in the subject.

The final important point is to discover and highlight students' latent talent. The teacher's job is to motivate students so that they discover their own concerns. Teachers should continually and closely observe their students to discern their interests and strengths. Specifically, teachers help students to realize their own potential, their desires, their interests. In the class "Understanding Photography," I ask students to show photographs that interest them, and then to explore their own attraction and feelings about the photograph. By the end of the semester, the students each have revealed an individual character as unique as their face. I have taught that class for more than 10 years, but it remains fresh.

Even if the primary aim of teaching is to convey knowledge and information, I think that care and love are important elements required for the realization of that goal. Students find their own path and get to know themselves through experiences with many classes and many teachers. I now realize that, like the sun, students give me new energy as time goes by.

301

Sean Perry

Austin Community College

A Chance to Be Lucky...of Game Theory and Good Photographs

I am surprised every semester at the volume of good photographs exhibited by the Fundamentals class in the student print show. The photographs are consistently better as a group than are those from any other section; I had always struggled to explain why...until I read an article on Game Theory. Game Theory is a mathematical construct that

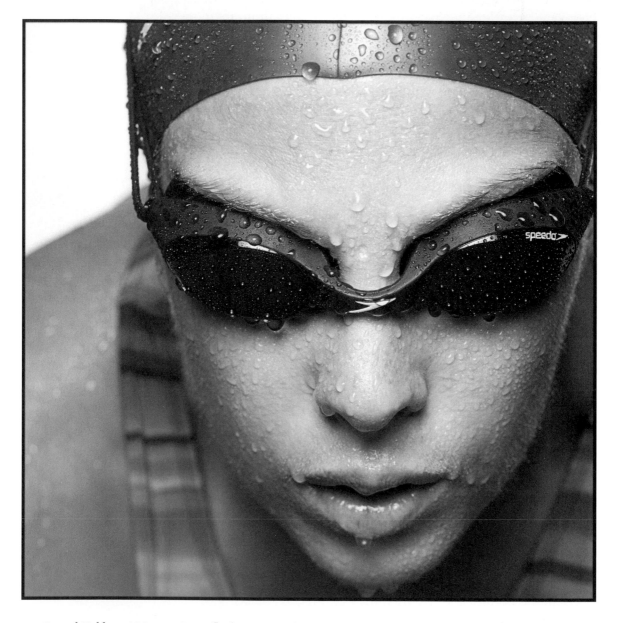

Record Holder – 100 meter Butterfly; by Lance Holt, Austin Community College, TX, student of Sean Perry

determines an optimal course of action based on the logical choice being selected from available options. It is a buzzword in many circles these days, being applied to everything from economics to evolutionary biology. A simple truth of this system is that the fewer options available, the higher the probability that success will be achieved.

The Fundamentals class illustrates this concept perfectly. The students have one camera, one lens, and a single type of black and white film. There are no flash units or tripods. Within these limitations a beautiful phenomenon occurs in which the distance between emotion and final image is reduced. Free from the fog of unnecessary choices, these students enjoy a more intimate relationship with their subject. A limited choice of tools increases the probability of making a successful image. They have given themselves a better chance to be lucky, to be in the moment.

Complex concepts can be stated in simple equations and metaphors. The medium of photography by its very nature is a simplification. Placing a frame around a scene, focusing on a particular point, exaggerating contrast and tonality. These are all tools to place heightened interest around a subject and reduce the peripheral. In one still frame, the power of life force and expanse of the human condition can be simplified and communicated across class, culture, and time. The making of this magic is frequently lost when the method or equipment clutters the attention of the moment. I have observed artisans who act with a determined will to master their toolbox in order to magnify expressive intent. I strive to instill a desire in my students to earn their tools, to grasp what will make plain the story of an image, not convolute it, to resist being seduced by the latest, greatest, shiniest widget.

Elite athletes will often say "I give myself the best chance to win." They focus on what the moment requires and edit out the superfluous. It's a fundamental element of how to elevate and respond. Photography is about getting to the heart of an image—which is greater than its subject. Strong teachers transcend material, identify a path of focused attention, and illuminate a destination of expressive imagery. It is the difference between teaching and inspiring.

Mariah Doren

Central Michigan University, MI

Traditionally critiques are used as a forum to evaluate work with the goal of helping students improve their practice as artists. I have adopted

303

a format for in-class critiques that is derived from the work of Edmond Burke Feldman. This method models behavior that promotes students' engagement of the world both interior and exterior to their art practice. It leads a student through a method of critique while promoting direct participation in discussion by all students. They are engaged in the democratic process of constructing meaning in our culture.

In the critique there are four levels of analysis: description, formal analysis, association, and reflection. The first level is description of the image. We go around the room, each student adding one item to our inventory of the image. The time it takes to create a list of observed facts also gives the class the space to really look at the image. The second level is a formal analysis that comes directly out of the description. Formal analysis describes the compositional choices, elements and principles of design, as well as things specific to photography like choice of lighting, depth of field, and contrast. The third level of analysis is when the students talk about their associations with the work. This is the heart of the critique. The questions posed are "What does the image remind you of, make you think about, and how does it make you feel?" During this section of the critique the impressions formed are a combination of the artist's choices and the viewer's experiences. There is a dialogue between the image and the viewer. The conversation sparked by the associations is the learning moment and the reason for having a critique in class. During the critique the artist is asked to be silent, take notes, and answer only technical questions. The last part of the critique is reflection. I ask the artist to reflect on what they have learned, the meaning the class/community perceived, and the relationship between their intention and the perception of the class. The artist is asked if there is anything they might change now that they have heard our discussion.

The process of critique can be inclusive rather than divisive—descriptive rather than prescriptive. Critical thought can help us get to creative thought, art. A postmodern model posits the use of imagination to explore and invent alternate existences. Dialogue can help us make connections to others—to learn through interaction, to develop meaning. Critique can be a way of learning and becoming for the group. Students construct meaning as a group, forming a community of peers, learning from the successes and failures of their peers rather than depending on the singular "truth" of an authority. Postmodern thinkers are skeptical that theory can model reality—they resist prescription. They stress that truth and knowledge are constructed by individuals and groups, that truth and knowledge are mediated by language and

culture. They accept the limitations of multiple views and the indeterminacy on our interactions. They believe that language, culture, and society are arbitrary and conventionally agreed upon—not natural—and promote the use of historical strategies to show the interdependence of consciousness, signs, and society. The theorists seek to identify multiple forms of power and domination through advocating a form of radical democracy, giving voice to all, hearing each individual.

This critique format is not unusual; what is different is allowing the voices of peers to dominate the discussion. Interpretation is a communal endeavor and a community is ultimately self-corrective. The organization, the formal structure of this critique, can seem awkward at first but only if we are seduced by the controlling organization of conventional communication to believe in the "natural" lilt of the critic. Even though the professor has more experience critiquing art when his or her voice dominates the discussion, the students do not build confidence in their ability to construct meaning, interpret, or analyze the visual world. The use of formalized dialogue helps develop constructive interactions that promote critical and creative thinking as individuals and as groups. Once used and practiced it becomes as transparent as our seemingly neutral conventional interactions. This benefits society by modeling direct participation in engaging critical matters of culture.

When I feel my points or ideas have not been voiced during the critique, and because as a professor I must assign grades, I use individual critique sheets to convey information. The lesson for students during the critique is that their voice and experience in interpreting images are sound and valuable. The students work as a community of peers to construct meaning without the search for universal truth. They learn to be self-reliant and work without the guidance of authoritarian leadership. They engage the world of images as independent critical thinkers and trust that their community of peers will be a self-correcting group. This is a model for democratic behavior which is easily integrated with their development as artists and may be unique in their experience of education.

George DeWolfe

Rochester Institute of Technology, NY

It has been my belief and practice for some years to teach visual awareness as a skill. Visual awareness is the coupling of perceptual skills in the basic elements of seeing with the practice of awareness skills.

305

Although highly involved in theory, the practice of visual awareness is reduced, in the end, to skill in practicing it. Learning about visual awareness through the information available on visual perception and awareness is easy. For a teacher, however, developing the skills for teaching these things is bought only with blood, wisdom, and extensive knowledge of human character. There are three aspects necessary for visual awareness: Wholeness, Authentic Response, and Presence.

Wholeness is the artist's desire to work from a place and expression that gives a feeling of "oneness" with the world and oneself. It is expulsion from oneself of the concept, context, content, and culture overlays that are the blocks to visual awareness. The skills are Acceptance and Mindfulness.

Authentic Response is seeing out of oneself. Authenticity is different from originality. Originality is simply seeing something that is different. Authenticity is seeing from oneself. Finding skills in this area, to bring out oneself, is the hardest exercise a teacher can perform. The skills take the form of riddles and exercises that have no rational answer. The answer to the riddles is only authentic response.

Presence is the capturing of the wholeness felt and is the authentic response made visible through an image and a print. Presence is taught by the craft, overlaid with feeling and emotion. It is the easiest aspect to develop skill for, because it remains largely technical in nature, in manipulating both the image and the print. The skills are the craft of the print, either traditional or digital.

David Page

Duke University, NC

Teaching is NOT about the teacher. It is about imparting knowledge, enthusiasm, and confidence to the student. It is all about the student. That is a lesson I learned from a cadre of abundantly caring photography teachers as a student in the early 1960s.

The common misconception, that knowledge of subject is the key to teaching, pervades the education field. Of equal if not more importance is enthusiasm for the subject and the ability and a strong desire to share knowledge. Many a fine photographer has been poorly skilled as a communicator, or worse yet demands that the student learn the only techniques and practices that have served the teacher well.

Most of my students at Duke were taking a Photography class as an arts adventure or to have a hands-on visual experience in the midst of

their strenuous other academic challenges. They were often surprised that "Introduction to Photography" was not an "easy" course. Most broadened their education by learning a new visual language.

Teaching at a Community College was most challenging and rewarding. There is a broad mix of students with a varied life experiences, levels of commitment, and expectations. In a Community College setting diversity is the standard. The 40-year-old divorcee, the immature 18 year old, some who were only meeting their parents' expectations by "going to college" and keeping their health insurance options, and the 25 year old ready to start his adult career would all be in the same class. The older students were my more dedicated students, and most of my 18 year olds were not highly motivated academically. The older students were typically ready and eager to learn and progress. The key was to help them determine their interests and aptitude, which was often different from what they thought when came in the door. The next step was to encourage them and direct them towards their goal. Sometimes that meant sending them to another institution where their needs would be better met. Honest encouragement went a long way in helping them get the most out of their willingness to work hard, which was an attribute that most possessed.

Regardless of where you teach, find out about your students. Where does the student wish to go in life? Discover what motivates that student. Learn how to trigger the student's individual "GO" button. My most effective way to reach the undedicated student was to praise small accomplishments, to let them know that they were capable of more than they thought they could do.

It's ALL about the student...Each student, individually. The payoff is having changed each student for the better. As an educator, what better reward could there be?

Elaine O'Neil

Rochester Institute of Technology, NY

Why I Don't Give Grades

If there is any power in the combination of tenure, advanced academic rank, and age, it is the freedom to reflect on successful teaching experiences and use those highlights to inform one's teaching.

The most important influence on my teaching was my 15 years at the School of the Museum of Fine Arts—Boston. Class grades are

307

By Jodi Goldenberg, Rochester Institute of Technology, NY, student of Elaine O'Neil

not assigned by faculty...they teach. Rather, at the end of each semester, students make a formal presentation of all work, done in all classes, to a review board. This committee is composed of two faculty and two students who critique the presentation in an hour-and-a-half session. The quality of the work and its appropriateness as a representation of 13 weeks of effort are discussed. Before the meeting is completed, the committee decides if the student will be awarded full, partial, or no credit for the semester and a written report is submitted.

Relinquishing the inherent power of grading has a profound effect on teaching. Foremost in my mind is that the teacher–student relationship is dramatically altered, and "getting an education" becomes an activity for which both teacher and student are responsible. Faculty must learn to motivate students utilizing non-punitive strategies.

Experiences in other schools have served to reinforce my belief that the Museum School model was the best way to educate artists. It is a system which fosters self-motivation, creativity, and curiosity—attributes critical for a successful career in Fine Arts, Advertising, or Photojournalism.

309

All students need to understand that on their first roll of film, they're capable of making images, which could add to the history of the medium. School is not a preparation for life—it is life. School is not marking time and class work is not merely practice; instead, images made for an assignment and discussed in critique become part of the visual data bank upon which new images are built.

Mastery of photographic technique is critical if a personal, powerful visual voice is to evolve, but technique can be learned through reading and practice. School provides a culture and a set of experiences through which students gain personal insight, connect to the core themes, which will inform their imagery over the course of their careers, and develop a respect for their work and the work of their peers. Further, they need critical skills and the ability to articulate the abstract ideas, which they hope to make manifest in their photographs.

Successful critiques demand a respectful atmosphere in which all ideas and opinions are seriously considered. Knowing that positional power makes my criticism perceived as definitive, I first act as the moderator of the students' discussions. Then after the students have discussed the work, I use my time to add to what has been said or to point out connections between the bodies of work on the wall.

During my eight years as an academic administrator, Deming's Total Quality Management was the style *du jour*. In a presentation at an AAHE (American Association for Higher Education) conference, the concept of students as managers of their education, as opposed to customers, was discussed. I present this idea to the class and point out that it is the students themselves who decide how much they will learn, what classes they need, and what of the experience is important to them on both the personal and career level. This perception of our roles makes the success of the educational experience the result of how much we all put into it. The students are surprised to be placed in a position of power, but most are ready to accept the responsibility.

Martin Springborg

Minnesota State Colleges and Universities

Studio Arts Mentorship

As instructors, we know that we cannot be with every student all of the time. In fact, a great deal of learning takes place outside of class—during open labs, when we are not even in the building. Students learn from one another, and those students who instruct their peers, even in the most casual of ways, end up retaining techniques and concepts much better than do those students who simply "go through the motions" in the classroom.

While a faculty member at Inver Hills Community College, I wrote a grant that focused on enriching student learning through the introduction of guest lecturers and student mentorship. The desired outcome of the project was better prepared students, able to take their skill or knowledge to further levels upon graduation or transfer from Inver Hills Community College. The project took place in two main phases—with student mentorship/teaching opportunities following a visiting artist workshop series. Within the first five weeks of the first semester of the project, three visiting artists gave inspiring lectures and workshops. During lectures, they showed samples of their own work and taught some of their techniques to advanced photography students in workshops.

Once the visiting artist series was through, the advanced photography students began working with their newly acquired skills and preparing to conduct their own workshops. With my mentorship in the preparation process and under my supervision in the classroom,

the advanced photography students taught the original visiting artists' techniques to beginning photography students the following semester.

These workshops along with the following mentoring and guidance went extremely well, as the advanced photography students proved to be good speakers and presented the core information. Since there is now a small overlap in my sections of beginning and advanced photography, they even get opportunities to teach new beginning photography students their craft. Beginning photography students who participated in these workshops are working with these techniques as advanced photography students today—more than a year post-project.

My aforementioned desired outcomes for this project were met, and I have been quite pleased with student teaching to date. However, to fully understand the impact that this mentorship project had on the original group of advanced photography students, one need only look at their actions post-project experience. Not wanting to stop helping each other with their work, they started a photography group that meets once a month. In this group, they discuss theoretical and technical problems within their photographic work, and they share newly acquired techniques. In forming this group, they help one another make better images and they have developed a photography community of their own.

311

Inga Belousa and Alnis Stakle

Daugavpils University, Latvia

Art and Spirituality

"Art is eternal; for it reveals the inner landscape, which is the soul of a human being."

Martha Graham

Contemporary development of culture and science fosters re-evaluation of existing tendencies and introduction and development of new components in education. Photographic and art education, as branches of education, meets constitutive challenges of its conventional understanding. The main character of these challenges makes an impact not directly on form or on content of art education, but the scope of re-evaluation goes directly to mega-trends.

By Marta and Viktorija Valujeva, Daugavpils University, Latvia, students of Alnis Stakle

The issues define the interconnectedness of art and spirituality, the artistic and the spiritual aspects of contemporary photographic education, and guidelines for the emerging model of contemporary visual education.

Spirituality is a very broad and vague, general, and yet specific concept. Review of the attempts to define spirituality pictures a rather paradoxical and comprehensive reality—spirituality has been considered as a result and a process, as a form and content, as a characteristic and dimension, as an experience and expression, as practice and power, as a way and basis. These discussions are neither primarily cultural, sociological, or psychological, or epistemological, ontological, or axiological in nature. They are existential or experiential and imply a deep human quest for meaningful growth or development, a search for reconnection with an ultimate state of wholeness. We define spirit as the essential character, nature, and/or quality that constitutes the pervading or tempering principle of images.

The key aspect of spirituality within photography education is reconstruction and transformation of the understanding of being human from the Modernist to Postmodernist viewpoint that occurred in the second part of the 20th century. The understanding of spirituality now reflects postmodern thinking, rejecting supernatural dualistism and atheistic nihilism in favor of nondualistic spirituality. Such an understanding of spirituality suggests a unique perspective of education.

The relationship between art and spirituality is historical. It was nearly a century ago when Kandinsky (1912–1966) opened up a new dimension of thinking about art. He emphasized that "we have before us an age of conscious creation, and this new spirit in painting is going hand in hand with thought towards an epoch of great spirituality." All kinds of art affect a human's spirituality. And spirituality of a human being affects the expression of one's inner landscape in art.

Guidelines for the Emerging Model of Contemporary Visual Arts Education

We propose philosophical guidelines that characterize the emerging transformative model of photography education in the current postmodern period of time. Postmodernity has introduced significant challenges to conventional understanding of visual education. The main character of these challenges makes an impact not directly on form or on content of art education, but the scope of re-evaluation goes directly to mega-trends. The recent discussion about postmodernistic

313

tendencies emphasizes philosophical investigations in education, including art education as an essential dimension. There are some of the most significant postmodernistic tendencies that give a renewed character to contemporary art education, including its function, content, and other categories.

We argue that all art education should acknowledge the communicative function of art. This represents reaching beyond the surface level, beyond the rational discourse of objectified values that are reflected in society. Art's function here is to reach the level of personal depths, to tell our human stories and to help us to know who we are and how and what we believe. This function opens up inter-cultural and cross-cultural views, and enriches each person and the whole community of learners.

Photography education should acknowledge art as a search for meaning. When art is interrelated with spirituality, human significance, and values, it has a potential of reconstruction of experiences of the intellect, the body, and spirit to coordinate the time, place, and meaning. Its active and dialogical nature, of meaning-making process, introduces art as a form of ritual.

As a significant guideline the integrated, theme-based content and procedure of art education should be recognized. It means that the keys of visual/artistic education merge and are human concerns.

The last guideline suggests recentering of art in the community, in educators' and students' lives and experiences. Photography should be about something beyond itself, beyond being decorative and beautiful for its own sake. Art reflects the deepest insights, longings, passions, losses, and victories and is spiritually alive. These suppositions highlight that art education is not just nice but necessary; it is for the sake of our well-being and survival.

Recognition of the interconnection of the artistic and the spiritual categories is the main constitutive aspect of contemporary imaging education. As a new model of contemporary art education emerges, it reflects the values of postmodernity. Communicative function of art, art as a search for meaning, integrated content and procedure, recentering of art in the community—all are the suggested guidelines of a transformative model of contemporary art education. Visual artistic education in the current epoch meets the tendencies of postmodernity by celebrating the self-conscious individual; merging form and content with their effect on time remains an experienced phenomenon.

314

Ralph Masullo

Briarcliffe College, NY

Learning to Teach

If you told me twenty years ago that I would be teaching today I would have had a good laugh and would have said that you were crazy, but after spending twenty-one years in a career as a commercial photographer, I did in fact become a teacher, to the surprise of many. So my story is about making the transition from photographer to photography instructor, which has become a truly enriching experience for me.

I have always had a passion for photography. It started as a hobby at a young age, followed by a formal education at The School of Visual Arts and then a successful career as a commercial still life photographer in New York City. After the events of 9/11, for both personal and business reasons, a need was felt to take my photographic passion in new directions. Looking for other opportunities, an ad was answered in the *Photo District News*. It was for faculty and a studio manager for a new photography program. Neither position seemed appropriate for my level of experience and background but I decide to apply by stating my desire to explore something new.

Brooks Institute of Photography had partnered with Briarcliffe College to set up a new digital photography program. Part of the position was training at Brooks Institute in Santa Barbara, California, and with much excitement I decided to accept the challenge. The arrangement was for a full eight-week session to train, sitting in on classes to learn their methods of delivery to become familiar with the curriculum. My experience there was absolutely wonderful; it proved to be enlightening both intellectually and spiritually, and taught me much more than I could have imagined. Attending various classes enabled me to view various teaching methods and course content, and it stressed the importance of technical skills as well as the creative. It was also quite rigorous and demanding—a good preparation for working in the industry. These are principles that are very important for students to learn and I incorporate them into every class I teach.

Being there also afforded me a unique lesson; I was given a very valuable opportunity to see through the eyes of a student. Attending class with the students allowed for a glimpse of their perspective, what they struggled with, and what excited them. This was the most

315

valuable lesson for anyone preparing to teach photography; you must excite students about photography to inspire them and the rest will follow. After this experience I returned excited and confident about starting to teach my own classes, because the Provost and faculty members who served as my mentors unselfishly answered all my questions while sharing their knowledge and experience about teaching.

It would be easy for anyone reading this to wonder how a self-employed photographer with no teaching experience could be transformed into a teacher in eight short weeks, but my experience as a studio photographer was very similar to teaching. I was accustomed to being a mentor, establishing guidelines and rules, training new up-and-coming talent, and of course listening to myself speak. But more importantly, my desire to continue to improve my skills was extremely important. Being a good teacher means always being a good student. Teaching digital photography requires keeping abreast of the rapidly changing technology; but it goes beyond that.

For me, keeping an attitude of always looking to learn from my peers and my students themselves is vital. I have found that every group of students can be different. This requires flexibility on my part, with both the content and methods I use, to keep that level of excitement present in class. The best lesson learned is that students' excitement is my excitement and their inspiration is my inspiration; both as a teacher and a photographer, this is what makes for a successful learning experience. I have found teaching extremely fulfilling, but more importantly, that being able to share my skills and knowledge with others and being able to see a successful result is most rewarding.

Peter Glendinning

Michigan State University, MI

When learning sculpture in the form of bronze casting, students come to the class with very few preconceived notions about what the breadth and depth of the technical, compositional, and conceptual aspects of the medium are. The "rules" for good bronze castings have not been a part of the everyday experience of their lives, something witnessed since early childhood. They have undoubtedly never seen a news report illustrated by a bronze casting, or a liquor advertisement. They certainly have not tried to prove their identity to a state police officer by offering them a bronze casting bust of their own head as their proof.

Of course, in the real world that photography students occupy and come from, it is the photograph that is used to illustrate news, advertise liquor, and prove identity, along with so many other pedestrian, commercial, and even artistic purposes. As a teacher of photography, I find that one of my first jobs is to help my students understand the "rules" for good photography that they have already learned throughout their lifetimes.

Hold the camera steady. Move in close to your subject. Grass, trees, sky, and water make good backgrounds for your pictures. Such rules for composition, camerawork, and content are already firmly implanted when the students in a first course in photography walk through the classroom door. While they know many rules for good photography, they must also learn that the rules define the ultimate result and will either expand or contract their ability to create personal and unique expressions.

Unlike his or her peer in Bronze Casting 101, the new photography student must not only learn the chosen medium, but also unlearn it as well. Whether the initial technical challenges relate to the traditional black and white film/print darkroom experience, or color slide, or digital imaging, the problem is the same for the student: learning how to think and create like a photographer, untrammeled by the years of learning the "rules" of photography through the thousands upon thousands of photographs they have seen every day of their lives. This is a very difficult task for the student, and the teacher.

Just as law students attend law school to learn to think like a lawyer, then spend their remaining years in the world of lawyering learning what it actually means to BE a lawyer, so too do photography students learn to think like a photographer...then spend the rest of their career in the medium learning what it actually means to BE a photographer. When new photographers learn that the rules they choose to follow will inevitably determine the content of their pictures, and learn to imagine new rules appropriate for use if they have unique perspectives to share, they start on the path to a personal vision and expression through photography. They learn to think like photographers.

If, as a teacher, I can create assignments and responses to assignments which help students overcome their preconceived notion of the scope of the medium of photography, and help them learn that there are both ways to think about imaging that are uniquely photographic and opportunities to define rules to achieve personal expressive goals

317

that are different from those ever seen before, then I may have been successful. Whether the students will take the lessons learned about how to think like a photographer and then apply themselves after graduation to the hard work of actually being a photographer is always an open question. For some, like some who attend law school, the intellectual exercise of learning to think like a photographer, or a lawyer, is in itself the reward...and they make their careers in other ways. For others, the real work of defining new ways of seeing, and imaging that vision, is what begins after graduation and continues throughout their lives—a constant reworking, redefining, and renewing of "rules."

M.K. Foltz

Ringling School of Art and Design, FL

The Importance of a Global World-View for Educators in Photography

Many people in the U.S. today, after 9/11, have reservations about international travel. This is unfortunate, since travel to other countries and continents can offer a remarkable degree of personal and professional enrichment. This became especially clear to me during three residencies in Eastern and Central Europe and the Baltics under the sponsorship of the U.S. Fulbright Commission, in Hungary, the Czech Republic, and Lithuania.

As the world becomes increasingly hardwired, our visual community can no longer be defined as local or national. Living abroad or extended travel overseas is an important asset in helping us realize both the possibilities and limits of the new global village. For example, recently in Vilnius, Lithuania, I participated in the annual graduate student reviews. While there were many similarities and differences with the way we do things in America, I was especially struck by how the Vilnius Academy of Art maintained the tradition of inviting department heads from each department to participate in formal reviews across all fifteen disciplines. In addition, each faculty member submitted written evaluations that were then given to the student. A number of Lithuanian photography and media students had studied for a semester in England and Western Europe, and they all remarked how this kind of comprehensive and interdisciplinary feedback was nonexistent there, and that VAA's interdisciplinary model of instruction seemed to them far more instructive and growth-prompting. In addition, I found that it was the norm not just at VAA, but also in higher education throughout Lithuania. I was

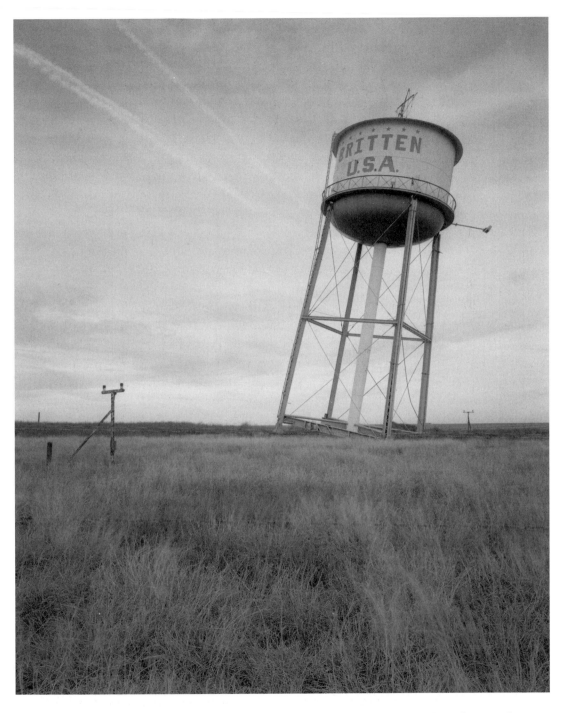

Britten, Texas; by Beau Blackburn, Ringling School of Art and Design, FL, student of M.K. Foltz

reminded of my own graduate school critiques at the Rhode Island School of Design (RISD), where a communitarian model had long ago been integrated, but this model is becoming rare indeed in the United States.

I asked myself why. Is the answer connected with the American expectation of increased leisure time? Can "glasnost" (the opening of a formerly closed society) and recent geopolitical events give us the opportunity to assimilate new ideas into higher ed at home? Isn't integration of once-foreign ideas what has allowed our culture to renew itself? Heightened nationalism since post-9/11 has threatened to greatly reduce this possibility of internationalizing our colleges and universities. The communitarian model is rather time intensive: it can take days and require several weeks to complete the reviews, depending on the number of departments involved, but the experience can be richly rewarding for all who participate. The Lithuanian photography and media students received valuable feedback on how to strengthen their cross-disciplinary concepts—actually, a preview of what will be expected in the workplace—reaching across one's own familiar, disciplinary mindset and customs to others that may be quite different, in order to effectively and powerfully communicate using images. In the United States, departments are often self-contained towers or "silos" forcing the more mature student to negotiate the prerequisites or enrollment caps for courses outside of their major. As a result, a good deal of effort is required to gain the thoughtful response of highly qualified faculty from outside one's own discipline.

I'd like to suggest, then, that educators consider adapting the communitarian model: invite faculty from other departments, not just department heads, and rotate invitations within the department each year, so that every faculty member at some point participates in contributing their expertise. Moving to a more time-intensive review session could be built into the semester calendar, so that the traditional finals-portfolio week could begin a week earlier and be reserved for reflecting on the conceptual development of each student and on valuable feedback contributed by a broader audience of experienced professionals.

We are familiar with the coarser kinds of ethnocentrism and national chauvinism and reject them instinctively and easily. But there are subtler forms of cultural arrogance that are perhaps just as dangerous. One of those is the belief, or rather the prejudice, that because the arts are felt to be somehow more advanced or modern or sophisticated at home, the arts in other parts of the world are therefore in some way "backward"

320

or "behind the times." This one example, my experience in Lithuania, which I have chosen out of many possible instances, was alone sufficient to teach me that we have much to learn from other cultural and educational practices.

Elizabeth Fergus-Jean

Columbus College of Art and Design, OH

My focus is within the emerging field of interdisciplinary studies, primarily combining the visual idiom as experienced in media and the fine arts, and cultural studies, including theory, narrative, and mythology. I believe that such collaboration across disciplines uniquely addresses the learning needs and requirements of students today. By extension, this necessitates developing curricula that speak to content integration with a cross-cultural perspective, and the application of such material within the context of our increasingly pluralistic and global community. Thus, my pedagogical approach underscores such dynamic interrelationships rather than focusing on discrete academic disciplines.

Cross-referential methodologies provide students with skills to apply their knowledge and talents in a multitude of ways. In addition, when students communicate their integrated intellectual understanding of course content in written, oral, and artistic form, it provides them with different ways to engage with the material, and helps to create connections within a variety of disciplines.

An important aspect of my curriculum design and teaching style begins with the development of critical thinking skills, coupled with the application of these skills to the subject at hand. This includes providing students with an understanding of the multivalent aspects of visuality and the language of image, and of the layers of bias projected onto images by the viewer. Each encounter with an image, whether it is seen as word/text, object, or sensate entity, can be understood through multiple layers of acquired and inherited biases by the viewer. These accretions form a perceptual distortion or lens that mediates relationships to the archetypal, cultural, ancestral, and personal perspectives. Therefore, understanding any form of image must include recognition of the lens through which we perceive such images. This process of understanding involves reflective analysis of the student's own personal and cultural bias. It further reveals the effect such perspectives have on the work students make, ways in which they perceive others, and the culture in which they live.

321

For example, in the Media Studies department I teach a course for photographers titled "Personal Mythology." In this course I use an archetypal and depth psychological approach to explain how artists can understand the work they create and their place within contemporary culture. Included is an examination of narrative within a variety of media, including advertising, films, music videos, reality TV, and sit-coms. An essential aspect of this course is the relationship between the students' personal narratives and these various cultural narratives.

I focus on the students' personal stories and artistic development, and also examine their use of narrative through the study of myths, fairy tales, archetypal imagery, and the aesthetic traditions of the fine arts. Through a variety of assignments students learn ways to recognize the archetypal roots of their own stories, as well as those occurring in culture today.

To help the students begin to learn about their own personal story, I have created a worksheet and accompanying diagram that helps them recognize their filters of perception. The diagram I have created maps four layers of perceptual bias within each individual. This diagram is based on a concept of psychoanalyst Carl Jung. To paraphrase Jung, "What we consciously believe to be our personal mythology, is our interpretation and assimilation of family, cultural, and archetypal stories transmitted in mythic patterns and deeply embedded rituals stored in the body and mind."

Through retrospection, students fill in the diagram, resulting in the perceived recognition of their lens. Important to this discussion are the levels of conscious and unconscious recognition, and possible schemata in which to pierce the veil separating the two. Once the students begin to recognize their perceptual lens, I encourage them to start trying to detect the lens of others, such as the authorial voice of text and media images from advertising, film, and TV. Beginning to understand their own lens in relationship to experiences with others helps them understand the dynamics between their inner and outer environments.

To help the students find some of the predominant cultural stories, I use an assignment that requires them to pay particular attention to concepts or images that they find everywhere within media. These concepts and images reflect the current cultural narratives that are alive within our psyches. Important to our discussion of these images is how the cultural stories impact one's personal story. I would like

to add that in class I stress the importance of intuitive and poetic knowing. Being elusive to tests and measurements, this form of knowing is often not valued in our technologically focused schools or work environments.

Ralph Hattersley

Rochester Institute of Photography, NY

Notes for the Faculty of the Department of Photography

1. I am quite fascinated with students, as individuals and in groups.
2. I am aware of the fact that whatever it is I teach students derives very directly from the kind of person I am rather than from what I happen to know about photography.
3. Most of my class sessions are student-centered rather than subject-centered.
4. I measure my teaching effectiveness intuitively. When I feel strong cross-stimulational currents among the students and between students and myself, I believe that mental and emotional growth is happening.
5. One must be very careful in what he teaches a student. The strongest barriers between a student and new learning are all too often the things he has already learned.
6. The relationship between seeing and believing is not as simple as one might think.
7. Some of the most important things a teacher does for a student are asking him good questions, stimulating his curiosity, and showing him a wide world.
8. Listening is a difficult art, and there are many rewards for those who learn it.
9. All pictures make some kind of sense or other, including those which seem to make no sense at all.
10. To interest people in pictures we must employ the unique; to communicate to them through pictures we must employ the familiar.

323

By Satoko Aria, Albion College, MI, student of Gary Wahl

Appendix

Example Assignments

Following are four examples of assignments that bring into the educational process differing aspects of photography. The first is from Gary Wahl of Albion College, MI, mixing the idea of discovery and the technical aesthetic dialectic.

Gary Wahl

Handmade Negatives

This assignment creates compositions without the use of a camera. You will be composing directly onto a handmade tape-negative. You will need to search for small objects of various translucency, shape, and texture. Try to develop a palette of shapes, lines, and points. Leaves, wire, string, dryer sheets, fabric, onionskin, garlic skin, flower petals, coarse salt, and bug parts are good materials.

You will arrange these on a piece of processed unexposed black and white film. You will need to illustrate three of the compositional principles listed below. These are to be abstract exercises in pure composition. This means that you should not create any "Things." You are not making pictures, but rather are exploring the visual vocabulary of shapes, lines, and tones. You may also include marks scratched directly into the film.

Compositional Principles: Radial Symmetry, Asymmetrical Balance, Rhythm, Pattern, Closed and Implied Shape, Positive and Negative Forms, Contrast.

When you are happy with your composition, carefully cover it with a piece of clear packing tape and cut away excess tape.

When you print these "negatives" you should test for a good rich black in the clear areas and details through the light side of the grayscale.

You should make five 5×7 prints containing areas of black, white, and some grays. You will need to make a reversed image representing three compositional principles and a *positive* of at least one image using a reversed print as a paper negative.

Note: make your negatives in the light, on the tables. Do not bring unsealed negatives into the darkroom: they can create dust and grime that will get on your real negatives later.

Putting our heads together, we can form ideas for an assignment from many perspectives. One of the greatest potentials in collaborating with students is for the development of good assignments. Such an effort has two advantages. First, collaboration provides a wealth of ideas. Some ideas will be good and some will be unusable, but there are opportunities for new ideas. Second and more important, engaged students will see aspects of what they will be doing. For many students this will increase their understanding and they will make images that have a greater learning effect. For the faculty there are also advantages: involved students will feel greater ownership of their learning, and the ability to use cohort-appropriate tasks provides another opportunity to give instruction about the reasons for certain learning objectives and to present fresh ideas. The collaborative building of assignments can consist of small or large efforts.

The following assignment is the outcome of just such a collaborative effort. This assignment has been written up by J Seeley of Wesleyan University and one of his students, Sasha Rudensky.

J Seeley

The 2-Headed Camera: An Experiment in Collaboration

Commercial photography is commonly a team effort involving an art director, assistant(s), hair and make-up people, assorted advertisement executives, gofers, and of course the models. The making of a motion picture is another example of a creative collaboration on even a bigger scale. Although a movie bears the name of a single director, it is always a product of many talents. Directors hire experienced team members for their particular technical expertise. Under the guidance of the director, who will often use the same crew from one project to the next, the team shares creative responsibilities, resulting in a collective aesthetic.

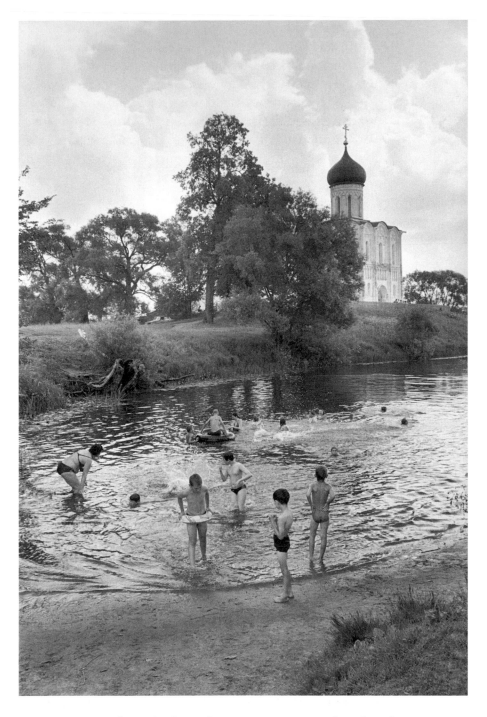

By Sasha Rudensky, Wesleyan University, CT, student of J Seeley

When it comes to photography as self-expression, photographers rarely work together as a team. In the world of art, where collaborations abound, the making of a fine art photograph has remained primarily a solitary endeavor.

There are financial and practical reasons for collaboration in commercial photography and in film production, but it occurs to us that there may be something to be learned by the application of two minds to the creative problems that arise in a photography course. Our idea is to have you explore the possibilities of a shared creative effort and ultimately test its effect on self-expression, learning, and development of ideas.

The Assignment

Either the students can select a partner from this class or have a partner selected for them. The assignment can be voluntary or required.

This assignment is normally given with one week's notice, so that there will be time for you and your partner to meet and discuss ideas. Sharing previous work and freeform brainstorming are highly recommended. A logical way to begin planning is to make an analysis of collective strengths and weaknesses. As a team, you could make use of shared or contrasting interests, or you may choose to shoot subjects that neither of you has worked with before. The partnership decides together what is most likely to produce the best results.

You may work in any location. Any subject or approach is acceptable. As you work together, try not to dominate, or be dominated by, your partner. Make this a true collaboration of ideas and execution. Do more than use each other as models or assistants. A tripod can be a very useful tool so that both students can study potential shots by looking through the camera.

The owner of the camera should develop the film. Printing in a collaborative manner is optional. You may choose to produce twin prints, or may opt to work separately without consultation. It could be interesting to see if the same frames are selected as final prints and how printing interpretations will vary.

Contact sheets and negative sheets listing both names and prints that are co-signed are required. The partnership also indicates which partner is submitting the work. A contact sheet is expected from each student (for our contact sheet notebook). Partners may use prints from the same frame for class assignments and final portfolios. This or any future collaborative roles will satisfy shooting requirements for both students.

Next, Jeff Van Kleeck of the University of Redlands, CA defines a complex assignment that uses evolution as a primary learning and maturation process. While the assignment moves through several steps and processes, it holds onto the central assignment while having the learner come to both technical and aesthetic understandings.

Jeff Van Kleeck

24 Images about One Thing [or the obsessive artist in search of the sublime]

Description

This assignment asks you to actively engage in your environment. In the first part of the assignment, I will assign you something to photograph. You will make 24 distinct images that represent your "word." For the second part of the assignment you will attempt to define your concept of the "Sublime" in the 21st century.

Objectives

Actively engage in your surroundings, explore the concept of multiple views, understand the idea of conceptual art making and concept generation, and use editing and sequencing to develop a strong design and concept and to develop a personal definition of the Sublime.

Technical Skills

Camera skills, retouching, cropping, sequencing, color control, resolution, and sharpening. Book planning and construction.

Instructions: Part 1

1. As a class, we will brainstorm for ideas and come up with visual solutions to some of those ideas.

By E.J. Sullivan, University of Wisconsin, WI, student of Jeff Van Kleeck

2. Using your camera as a tool, thoroughly explore your environment, looking for unusual angles, gestures, and emotions that describe your topic.
3. Edit your images to develop your ideas.
4. We will look at a variety of output options, including a large print and arranging your photographs in a book.

*Note: In order for this assignment to be successful, you will need to photograph more than the 24 images. It is important to edit and reshoot images to achieve the best photographs you can.

Instructions: Part 2

1. Using what you have learned about image-making in the first part of the assignment, create another series of 24 photographs. This time your task is to visually communicate your definition of the Sublime.
2. Compile your images into a book.

Van Kleeck explains that in the first part of this assignment, students are given something, represented by a word, to photograph. I try not to have more than two students with the same word. Here is a sampling of some of the words I use: black, white, blue, shadow, water, etc. I put the words into a hat and have each student draw out one word. We then brainstorm as a group.]

I push the students to look for connections that could lead to interesting photographs. I ask the following questions: "How do you photograph your idea?" or "How can you visually communicate a concept?"

The second phase of the assignment requires the students to document their definition of the Sublime, again using 24 images. During the critique, we address how each student approached both parts of the assignment.

Last, Irma Martinez-Sizer at Texas Tech University, TX involves both other students and society at large, in the guise of the U.S. Postal Service, in the creation of, distribution of, and interaction with photographic art. Beyond the technical aspects of making the "Mail Art," the project has a highly developed communications component. The collaborative nature of the project also defines the changeable nature of creativity.

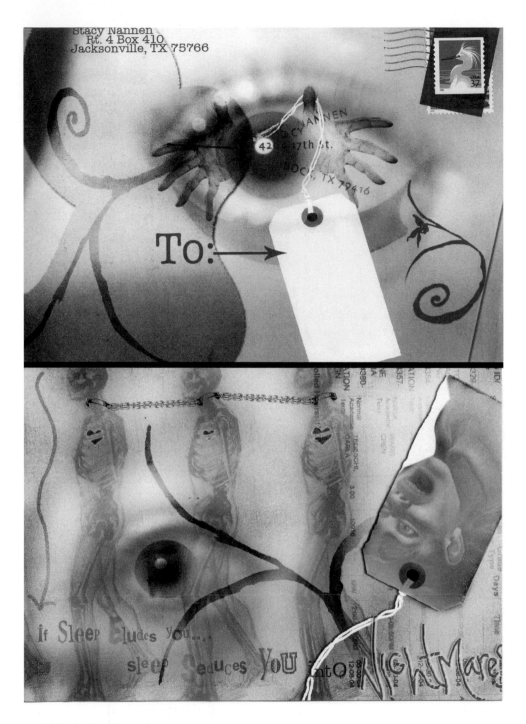

Front and back of Mail Art; by Stacy Nannen, Texas Tech University, TX, student of Irma Martinez-Sizer

Irma Martinez-Sizer

Mail or Correspondence Art, a Two-Part Project
Introduction
Mail Art is art that uses the postal system as a venue and a medium. Ray Johnson is considered the father of Mail Art. Mail Art is influenced by the Fluxus and Dada art movements. It incorporates elements found in postal objects, such as stamps, seals, and rubber stamps, but also fuses collage, typography, poetry, painting, drawing, and other techniques. Mail Art defies the idea of the gallery or museum as the place for showing artwork and promotes the participation of all artists (or all people), since there are no juries and no rules. Mail Art has been an innovative venue whereby artists can express their views on social causes. Artists that create Mail Art send their work to other artists, who can add or alter the piece. This exchange varies and expands the message as it moves from one sender to another. Mail Art can be fun and humorous.

Part One
Following is an example of the word bank. Words can be proposed in class by students or given by the instructor.

delayed, toe, rich, sleep, furious, shine, dirt, final, dried, contagious, icy, idol, dull, head, interrupted, bass, nocturnal, rocket, occupied, reign, slim, gossip, loud, noon, macabre, nut, impatient, incurable, spine, hell, slippery, spider, everywhere, skittish, worn, crown, hail, gut

Select TWO words from this word bank.
Develop a relation between those 2 words.
Using the two words, communicate an idea, a concept.
Create your own non-official rubber stamps and artists stamps, collage, and/or visual poetry to convey the relationship between the TWO words that you chose.
You can use Photoshop to create from scratch, hand draw, paint, or scan found material.
You may not typeset with the computer; only use handwriting or scanned found type or text.
You can combine scanned objects, line art, images created with a digital camera and/or scanned photos or negatives, and different textured papers.

Use U.S. postage stamps ONLY as SAMPLES to create your own stamps and images.

The final size of the document that you will mail is 6"×9".

Your image can bleed or have a border around it.

Consider both sides of the paper as the whole mail art piece, but remember to allow space for mailing information on one side and the official USPS $0.39 postage stamp.

Print 2 copies of the image that we'll call image #1.

When the instructor indicates, you mail one copy of image #1 to the assigned classmate. Keep the other copy to turn in to the instructor.

Part Two

Once you receive your classmate's image #1 by mail, scan it and alter it. Add a third word from the list to change, alter, or reinforce the original idea.

You have to be able to place the new image on the same size format of 6"×9". Consider both sides of the paper as the whole mail art piece, but remember to allow space for mailing information on one side and for the official postage stamp.

We'll call this image #2. Print two copies of image #2 (you will keep one and mail the other). Mail the one you altered (image #2) back to your classmate and turn in your classmate's image #1 to the instructor.

Bring in the image you got in the mail for critique (image #2) when you receive it.

In this assignment the learning goals include techniques that utilize type, computers, cameras, scanners and printers, knowledge basis in art history, and aesthetics. This is brought forward in the critiquing of both images and in comparing how image #1 becomes image #2, and how the words and images interact within the work. Because of the technology that can be used in the assignment, technical issues also become part of the critique.

334

Authors' Biographies

Glenn Rand has been an educator since 1966. In these years he has taught and administered in public education, community colleges, and universities. Since 2001 he has taught in the graduate program at Brooks Institute of Photography in Santa Barbara, California, where he serves as acting graduate program Chair. In conjunction with these academic roles and consulting he has developed and reorganized several curricula for fine art photography, commercial photography, digital imaging, and allied curricula.

He received his Bachelor and Master of Arts degrees from Purdue University, earning a Doctorate from the University of Cincinnati centering on the Psychology of Educational Spaces, with post-doctoral research as a Visiting Scholar at the University of Michigan.

Photographs by Glenn Rand are in thirty public museum collections in the United States, Europe, and Japan and have been exhibited widely. He has also had his photographs published as editorials, illustration, and advertising.

He has published and lectured extensively about photography and digital imaging, on topics ranging from commercial aesthetics to the technical fine points of lighting. Glenn has authored several books, including *Black and White Photography* (2nd ed., 2002) and *Digital Photographic Capture* (2005), and contributes regularly to various periodicals.

His consultant clients have included the Eastman Kodak Company, Ford Motor Company, Photo Marketing Association International, and the Ministry of Education of Finland, as well as many other businesses and several colleges.

Richard D. Zakia joined the Rochester Institute of Technology (RIT) photographic faculty in 1958, where, for 34 years, he taught

photography and, for a time, served in an administrative position as Director of Educational Research and Development and the Media Center.

In 1980 he was awarded the "Eisenhart Outstanding Teaching Award." For several years, he served as Chair of the Fine Art Photography Program and graduate program in Imaging Arts. He has authored and co-authored ten books dealing with photography and related areas in visual perception, semiotics, and advertising. With Dr. Leslie D. Stroebel (a former teacher), he co-edited the *Focal Encyclopedia of Photography* in 1993. In 2002 he published the second edition of his book, *Perception and Imaging*, and is now working on the third edition.

Prior to joining RIT, he was employed as a photographic engineer in the Color Technology Division of Eastman Kodak. Dr. Zakia received his undergraduate degree in Photographic Science from RIT and his doctorate in Educational Psychology from the University of Rochester. He served as a radioman in the Navy in both WWII and Korea.

Presently, he serves on the advisory board of the Palm Beach Photographic Centre in Florida, and the editorial board of *The Journal of Mental Imagery*. During his teaching career he served on the advisory boards of Ryerson Polytechnic University in Toronto, the Paris Photographic Institute in France, and the Polaroid Photographic Educational Group.

Bibliography

Allen, Mary J., *Foundations of Academic Program Assessment*. 2005 Northern Nevada Higher Education Assessment Conference, Reno Nevada. Feb. 11, 2004 (available at www.unr.edu/assess/NNAC/2005/2005Presentations/Mary_Allen_handout.pdf).

Alperson, Philip A., *The Philosophy of the Visual Arts*. Oxford University Press, New York, NY, 1992.

Arnheim, Rudolf, *Thoughts on Art Education*. The Getty Center for Education in the Arts, Los Angeles, CA, 1989.

Arnheim, Rudolf, *Art and Visual Perception: A Psychology of the Creative Eye*. University of California Press, Berkeley, CA, 1974.

Bailey, George W. S. and Carroll, Noel (eds.), *Theories of Art Today*. University of Wisconsin Press, Madison, 2000.

Bain, Ken, *What the Best College Teachers Do*. Harvard University Press, Cambridge, MA, 2004.

Barrett, Terry, *Criticizing Photographs*. Mayfield Publishing Company, Mountain View, CA, 1999.

Berger, John, *Ways of Seeing*. Viking Penguin, New York, NY, 2002.

Birnbaum, Robert, *How Colleges Work*. Jossey-Bass, San Francisco, CA, 1988.

Bridges, William, *Managing Transitions*. Addison-Wesley Publishing Company, Reading, MA, 1991.

Brooke, James T., *A Viewer's Guide to Looking at Photographs*. Aurelian Press, Wilmette, IL, 1977 (out of print).

Bunnell, Peter, *Photography at Princeton: Celebrating Twenty-Five Years of Collecting and Teaching the History of Photography*, Jill Guthrie (ed.). Princeton University Press, Princeton, NJ, 1998.

Byrnes, William J., *Management and the Arts*. Butterworth-Heinemann, Burlington, MA, 1999.

Cameron, Julia, with Bryan, Mark, *The Artist's Way: A Spiritual Path to Higher Creativity*. G. P. Putnam's Sons, New York, NY, 1995.

David, Thomas G. and Wright, Benjamin D., *Learning Environments*. University of Chicago Press, Chicago, IL, 1974.

Enyeart, James, *Henry Holmes Smith; Collected Writings, 1935–1979*. Center for Creative Photography, Tucson, AZ, 1985.

Gardner, Howard, *Intelligence Reframed: Multiple Intelligences for the 21st Century*. Basic Books, New York, NY, 2000.

Gleick, James, *Chaos: Making a New Science*. Penguin Books, New York, NY, 1987.

Highet, Gilbert, *The Art of Teaching*. Knopf, New York, NY, 1951.

Hofstadter, Douglas R., *Gödel, Escher, Bach: An Eternal Golden Braid*. Basic Books, New York, NY, 1979.

"Invitational Teaching Conference at the George Eastman House 1962." Paper presented at the Invitational Teaching Conference at GEH, Rochester, NY, 1962. (The meeting was hosted by Nathan Lyons and Beaumont Newhall and led to the establishment of the Society for Photographic Education, SPE.)

Judson, Horace Freeland, *The Search for Solutions*. Holt, Rinehart and Winston, New York, NY, 1980.

Keller, George, *Academic Strategy*. Johns Hopkins University Press, Baltimore, MD, 1983.

Lao Tsu, *Tao Te Ching*. Translation by Gia-fu Feng and Jane English. Random House, New York, NY, 1972.

Krishnamurti, J.M., *Education and the Significance of Life*. Harper & Row, New York, NY, 1953.

Maynard, Patrick, *The Engine of Visualization: Thinking through Photography*. Cornell University Press, Ithaca, NY, 1997.

Nadin, Mihai, *The Civilization of Illiteracy*. Dresden University Press, Dresden, Germany, 1998.

Neff, Thomas and Tony Frederick (eds.). *Teaching Photography*. Baumgartner Publications, Sun Prairie, WI, 1981 (also in *Exposure* 18:3 and 4, 1980, Society for Photographic Education, Special Education Issue).

Rand, Glenn, *Open Space Schools*. Doctoral Dissertation, University of Cincinnati, Cincinnati, OH, 1979.

Rogers, Carl and Freiberg, H. Jerome, *Freedom to Learn*. Prentice Hall, Princeton, NJ, 1994.

Todd, Hollis and Zakia, Richard, *Handbook for Teachers*. Zimzum Press, Rochester, NY, 1990.

Toffler, Alvin, *Learning for Tomorrow: The Role of Future in Education.* Vintage Books, New York, NY, 1974.

Stuart, Nancy, *The History of Photographic Education in Rochester, New York, 1960–1980.* Doctoral Dissertation, SUNY, Buffalo, NY, 2005.

Zakia, Richard, *Perception and Imaging,* 2nd ed. Focal Press, Boston, MA, 2002.

Indexes

Photographers Index

341

Quotations and Contributors Index

343

Subject Index

345

351

353